Fishes of the Rainbow

NUMBER THIRTY-THREE

Gulf Coast Books

 Sponsored by
Texas A&M University–
Corpus Christi
John W. Tunnell Jr., General Editor

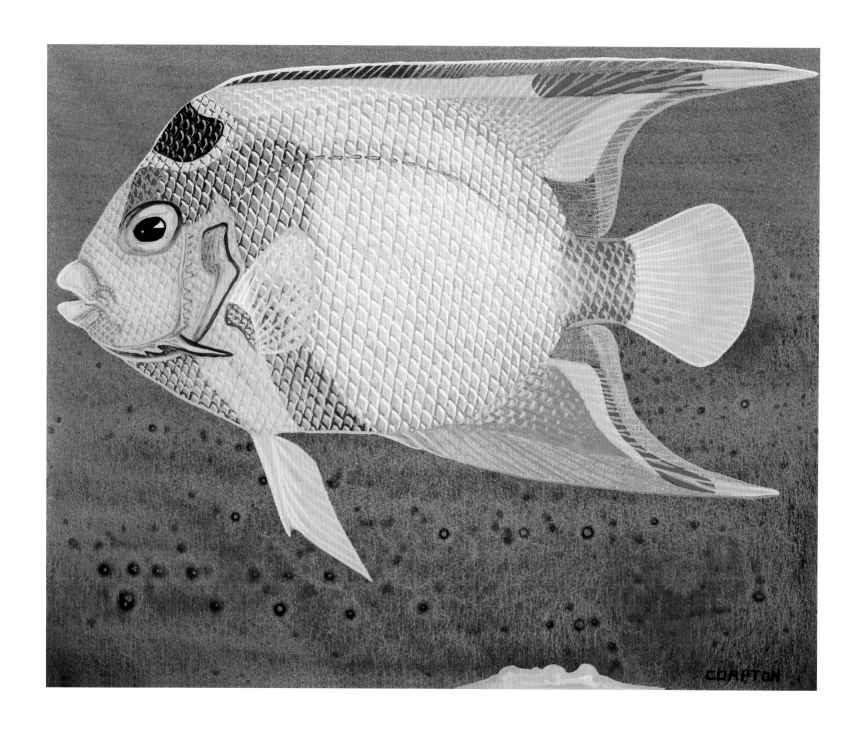

TEXAS A&M UNIVERSITY PRESS COLLEGE STATION

FISHES
OF THE
RAINBOW

Henry Compton's Art of the Reefs

David A. McKee

with Larry J. Hyde, Michael Barrett, Jennifer Hardell, Mark Anderson & Aaron Baxter

This paper meets the requirements
of ANSI/NISO Z39.48–1992 (Permanence of Paper).
Binding materials have been chosen for durability.
Manufactured in China by Everbest Printing Co.
through FCI Print Group

Library of Congress Cataloging-in-Publication Data

Names: McKee, David A., 1947– author. | Anderson, Mark (Mark Wayne), writer
 of supplementary textual content. | Hyde, Larry J., writer of
 supplementary textual content. | Compton, Henry, 1928–2005, illustrator.
Title: Fishes of the rainbow : Henry Compton's art of the reefs / David A.
 McKee.
Other titles: Gulf Coast books ; no. 33.
Description: First edition. | College Station : Texas A&M University Press,
 [2018] | Series: Gulf Coast books ; number thirty-three | Includes
 bibliographical references and index.
Identifiers: LCCN 2018018134| ISBN 9781623496968 (book/cloth : alk. paper) |
 ISBN 1623496969 (book/cloth : alk. paper) | ISBN 9781623496975 (e-book)
Subjects: LCSH: Coral reef fishes—Classification. | Coral reef
 fishes—Pictorial works. | Compton, Henry, 1928-2005. | Marine
 biologists—Texas—Biography. | Marine artists—Texas—Biography. | Fishes
 in art.
Classification: LCC QL620.45 .M38 2018 | DDC 597.177/8909764—dc23 LC
record available at https://lccn.loc.gov/2018018134

A list of titles in this series is available at the end of the book.

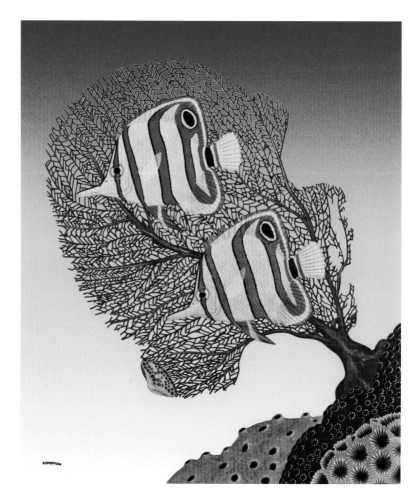

Contents

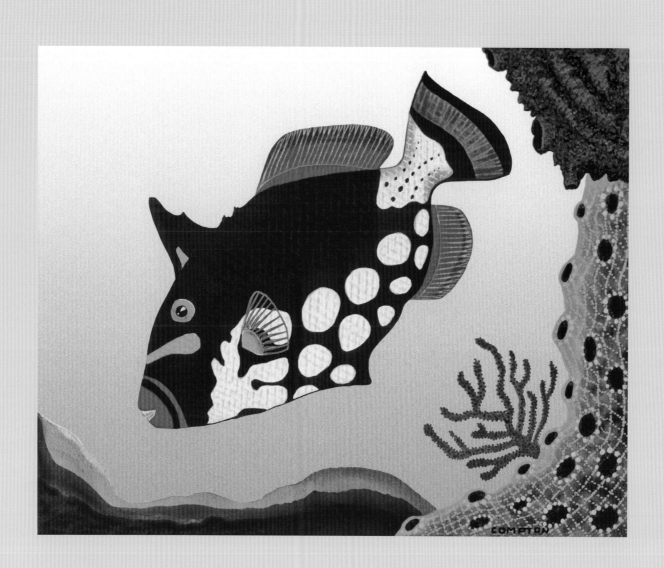

Preface

The focus of this book, without a doubt, revolves around Henry (Hank) Compton's remarkable artwork. The narrative he provides for each image is novel and compelling. The authors feel that this book, like *Fire in the Sea* (its companion volume), will be of great interest to academics (biologists) and nonscientists alike. Anyone who has a fascination for coral reef environments, especially scuba divers, will certainly find his colorful images fascinating and perhaps familiar. The art lover will be impressed on learning that Compton was a self-taught artist with no formal training. Those specializing in the study of fishes (ichthyology) are sure to be amazed at the great care he took in representing the fishes so faithfully and accurately.

Because of Compton's reclusive nature, little is known about why or how he created his paintings. We do know he gathered the deep-sea bioluminescent fishes illustrated in *Fire in the Sea* largely from the Gulf of Mexico while aboard the R/V *Western Gulf* in the 1960s and photographed in a darkroom constructed beneath the stairwell at the Texas Parks and Wildlife Department's (TPWD) Marine Lab in Rockport, Texas. Later on he painted these fishes from the photographs. When he did this we are not certain, but likely from the 1970s into the 1990s. The same holds true for those painted for this book. Years later these reference photographs were used to create his paintings. The painting and supporting reference material for *Fire in the Sea* do not indicate when the individual works were completed. However, we believe they were finished during a 20- to 30-year period beginning in the 1965 to 1975 time frame. It is likely that a similar time frame can be applied to the *Fishes of the Rainbow* series.

Even less is known about the origins of Compton's *Fishes of the Rainbow*. Only an approximate one-quarter of these images are of species known to exist in the Gulf of Mexico. The remaining three-quarters are found in the Caribbean and/or Indo-Pacific. It is doubtful that Compton traveled to the Indo-Pacific, but he accompanied Henry Hildebrand on several trips along the coasts of Mexico and to the Caribbean. Why would Compton focus on so many species outside the Gulf of Mexico? Perhaps because of the much greater diversity of these tropical species in the Caribbean and Indo-Pacific. Even though some live material from the saltwater aquarium trade could have been referenced, we can assume he relied heavily on previously published images as models, unlike fishes illustrated in *Fire in the Sea*, especially for those indigenous to the Indo-Pacific.

In comparing images from *Fire in the Sea* with those in this book, the reader will immediately see great contrast. The deep-sea species live in a cold, dark habitat with no light to assist vision for hunting and finding a mate in a hostile environment. The fish and invertebrate species found there are often without color, generally dark or buff-colored. In contrast are the brightly colored species found in the shallow, warm, and sunlit zones where coral reefs exist. Meals and mates are ever present in this favorable environment. During daylight hours, brightly colored fish are active on the reef, taking advantage of filter and substrate feeding opportunities. In contrast, nighttime predatory species with more muted colors dominate the reef, sometimes preying on their more colorful neighbors.

Writing the early chapters in both books was a challenge. The general readership is intended to be both scientists and nonscientists. It is necessary to use correct scientific terminology yet make it understandable to anyone who might pick up the book. Again we remain true to Compton and what he left behind and are treating his material as we think he would have wanted it used.

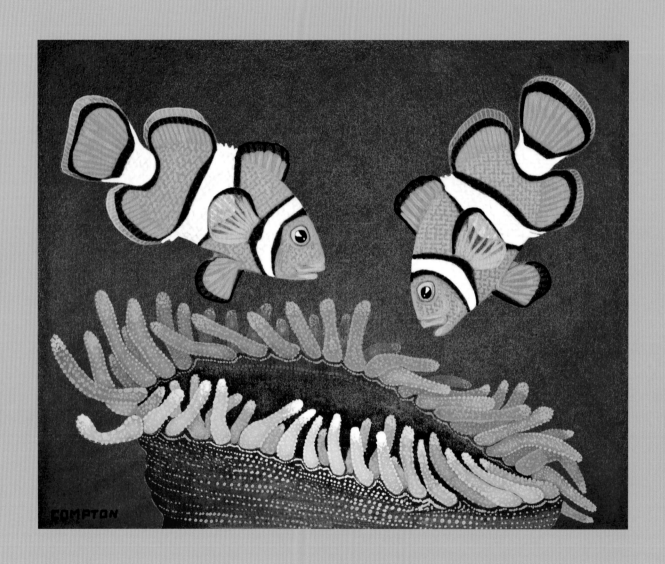

Acknowledgments

Thanks to Hank (again) for his beautiful paintings and intriguing text and to his sister-in-law, Helen, for discovering and recovering these works that no one except Hank even knew existed. Thanks to the big man up above for not allowing inclement weather to destroy the works within those cardboard boxes!

Once again the staff at Texas A&M Press was nothing short of wonderful to work with. Shannon Davies (now at the helm of the Press) believed in *Fire in the Sea* and was adamant about getting *Fishes of the Rainbow* into print. Stacy Eisenstark gave me and my coauthors excellent input from the get-go, and Patricia Clabaugh and Cynthia Lindlof were nothing but professional and enthusiastic in guiding us through the external and in-house editing process. As before, I have made new and lasting friends along the way and reinforced old ones.

Because of the extensive use of color images used in this book, it is often necessary to find external funding to make a book more affordable to the end user, the reader. Such was the case with this book due to the eighty-seven images incorporated. The Harte Research Institute for Gulf of Mexico Studies, the Texas State Aquarium, and the Art Department at Baylor University generously contributed toward the publication of this book. Otherwise, the retail price would have been prohibitive.

Last, I want to thank my coauthors, as they are the ones who provided the lion's share of the work on this book. My contribution was providing the art and text and selecting these talented and devoted people to put it all together. Four of them wholeheartedly agreed to participate again on this new volume: Larry Hyde, Michael Barrett, Jennifer Hardell, and Mark Anderson. They were instrumental in making *Fire in the Sea* a reality. Again, Larry mastered the task of digitizing the images, including the necessary and time-consuming restoration of numerous pieces of Hank's art that had been damaged as a result of time and the elements. Mike again handled the biological and taxonomic organization of the fishes and served as our intermediary to the Press along with Larry. Although we are all big Compton groupies, Jennifer seems to best identify with his writing style and inferences, so she again pulled text from his writings to use for each image. Mark took time away from his job as chair of the Art Department at Baylor University to provide his professional artist perspectives on Hank Compton's natural and untrained artistic ability as an illustrator. To paraphrase what Mark once said when asked about the quality of Compton's work, "I wish I could teach my students the skills and techniques that are so effortlessly demonstrated by Compton."

New on board with *Fishes of the Rainbow* are Aaron Baxter and Elani Morgan-Eckert, who provided chapters about light, coloration, and life on and about a coral reef. One aspect of the book that is very special to me is that Mike, Jennifer, Aaron, and Elani were students in my ichthyology class (and several others). In fact, Mike and Aaron were both teaching assistants for me in that class!

—David A. McKee

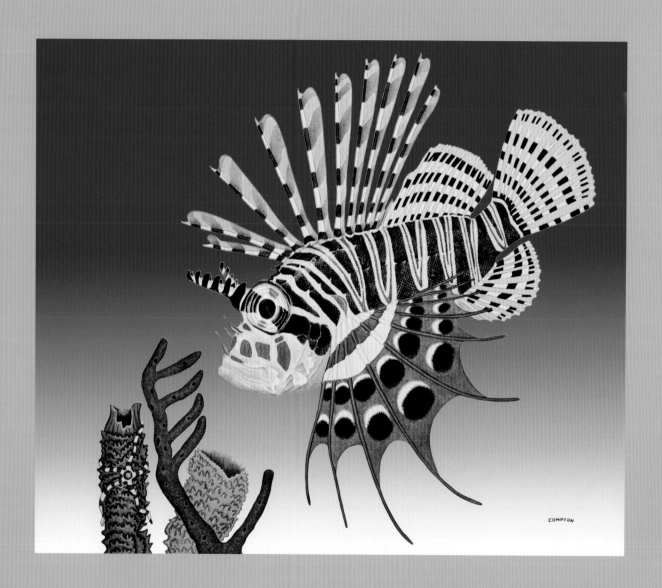

Fishes of the Rainbow

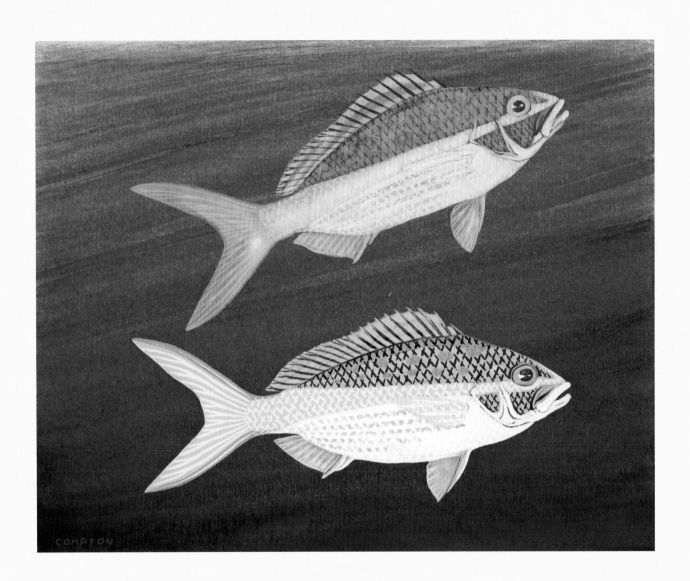

Introduction

"Fishes of the Rainbow"

Hank Compton was the artist in my two previous books: *Fishes of the Texas Laguna Madre* and *Fire in the Sea*. Although I knew him only casually, we both worked as biologists at the Rockport Marine Lab, spending much time aboard the R/V *Western Gulf* conducting sampling and collections in the Gulf of Mexico. We shared several things in common although he was 20 years older: both of us were Corpus Christi boys and both trained as marine biologists—Compton at the University of Corpus Christi and I at Corpus Christi State University (same campus on Ward Island). My memories of Hank are from Oso Pier on Corpus Christi Bay, where I would buy bait shrimp from him from time to time. He worked there off and on as the manager for more than 30 years.

Compton was still alive when I began writing *Fishes of the Texas Laguna Madre*, and I knew that I must meet him. His health was failing; he was living nearly hermitlike and would rarely allow his only living relative (sister-in-law, Helen) into his apartment when she brought groceries. After several failed attempts to set up a meeting, he finally agreed to meet with me, but he said, "Only for fifteen minutes." A date was set in October 2005, but unfortunately he died suddenly the week we were to meet. He died where he had lived, painted, and wrote for many years. The apartment had become a cell from which he rarely, if ever, ventured.

The cleaning service that cleared his apartment found two large cardboard boxes, must have peeked into them, and set them on the landing of his upstairs apartment rather than have them hauled off with the remainder of his belongings. Helen went by a week or so later to check on the apartment and retrieved the boxes. Not knowing what they contained, she placed them in her garage. About a year later Helen called to tell me of these boxes and wanted me to come over so we could open them together. Sitting on her living room floor, we opened the taped-up boxes and discovered two new

sets of Hank's illustrations: *Fire in the Sea* and *Fishes of the Rainbow*. What an exceptional find! Each illustration on canvas board had accompanying text that included taxonomic information and text in the form of a story about the image. Each illustration was individually numbered and wrapped in protective paper. The text had the same numbering system, and clipped to the text was a color photograph of the original illustration. Also found were 35 mm slides for each of the illustrations. Only a scientist would create a system so organized and redundant!

The *Fire in the Sea* series comprises 57 illustrations (with 66,000 words of text), of which 24 were found in the box. For the *Fishes of the Rainbow* series Compton completed 87 illustrations (38,000 words), of which 71 were found. Although only about 60 percent of the original art was found for these two series, we were able to present the complete works of both series. Larry Hyde provides information in the appendix describing the preparation of the images for publication. This was a very challenging artistic and technical endeavor, to say the least. For missing art, Larry was required to use 35 mm slides and photographs to recapture the lost images. Some of the original art had experienced significant damage, yet Larry did his magic and the result is that Compton's art is presented in full.

With training as a scientist, Hank had great patience and an eye for impeccable detail. His taxonomic expertise and organizational skills were incredible as well. As an accomplished self-trained artist he possessed tremendous ability. Artist Mark Anderson gives his perspectives on Hank's artistic abilities, as he did for *Fire in the Sea*. Hank could simply paint what the eye could see. With an incredible imagination, as witnessed in his narrative about each illustration, he could also paint what the human eye perhaps could not see. As unique as Compton's art is so is the narrative he composed for each illustration. In reading this text, one can better get inside the man

and grasp his talent and imagination. His writing is complex, descriptive, abstract, perplexing, and captivating. It is impossible to follow at times and impossible to put down at others. His descriptions are vivid, again aided by his incredible imagination.

Hank Compton earned a degree in marine biology at a time when few were studying this discipline at such a formal level. He was a very modest, understated man whose great talents and contributions have only recently been discovered and appreciated. I think this is how Hank had planned it from the very beginning.

Hank Compton

One of the more frequently asked questions about Hank after viewing his art is, "What else can you tell me about this guy?"

Hank Compton was born on April 10, 1928, in San Angelo, Texas. His father was an accountant, and his mother was a public school teacher. The family later moved to Snyder, Texas. From an early age Hank was fond of animals, especially birds and fishes, and enjoyed drawing and painting them. When he was 18 and had graduated from high school, he joined the US Air Force and was stationed in Maine as a pilot, holding the rank of captain.

Following his military service, he enrolled at the University of Corpus Christi (UCC) in the late 1950s. He earned a bachelor of science degree in biology (emphasis in marine biology) in 1960 under the guidance of Henry Hildebrand. Hank assisted Hildebrand in his work in the inland bays and the Gulf of Mexico off the Texas coast. They also made collecting trips to the Yucatán Peninsula in Mexico and farther south into the Caribbean and painted many birds and fishes from Mexico and Central America. Some of the illustrations used in this book may have resulted from trips there as a student.

In the early 1960s Compton was hired by Texas Parks and Wildlife Department's (TPWD) Marine Laboratory in Rockport as a marine biologist. Because of his talent as a biological illustrator, Hank provided fish illustrations for several TPWD bulletins and field guides, including color paintings used in the classic and collectable *Saltwater Fishes of Texas* and *Freshwater Fishes of Texas*. Although he painted and drew (pen and ink and pencil) many fishes and birds during his lifetime, several people close to him said his bird illustrations were perhaps his best.

Except for the artwork used in *Fishes of the Texas Laguna Madre*, *Fire in the Sea*, and those in this book, no one knows the fate of the rest of the artwork he produced over the course of his lifetime. Some think he may have given them away or sold them. His sister-in-law, Helen, said that he thought very little of his own work and was doubtful that he would have taken money for them. She thought he had either given them away or simply thrown them away. Regretfully, little of his other work is known to exist today.

His career as an "employed" scientist/biologist was quite short. Like his mentor Henry Hildebrand, he had little patience for bureaucracy and hated monthly reports and all such things related to personal responsibility. Both men complied only when absolutely necessary.

To gain a better understanding of the life of this mysterious man and his hermitlike behavior near the end, one can look at his years in the air force. He lost a very close friend in an aircraft accident during World War II. Never does he mention the effects of war, but a sense of guilt and depression is obvious in his writing and in his art. One painting in *Fire in the Sea* shows sharks circling a P-51 Mustang fighter jet lying on the deep ocean floor, and in the cockpit is the skeleton of the pilot. In the narrative that follows, he notes the loss of his good friend Jeb. Countless soldiers of wars before and since have returned only to combat depression for the remainder of their lives.

Compton was very comfortable in the company of commercial fisherman and had great admiration and respect for anyone who made his or her living on or in the water. It seems Hank had a tough time coping with life in the mainstream and ultimately decided he wanted nothing to do with the "normal" American lifestyle. Few knew of Hank's accomplishments as a scientist and artist because he refused to talk much about himself. Instead, Hank simply danced and painted to the music of his own drummer.

Hank Compton died at the age of 77 on October 20, 2005, and is buried in Corpus Christi.

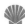

Once all the seas were muddy and all the fish were grey from the ash of volcanoes and the flowing mud of rising mountains. The fish could not tell one another apart and were confused as to whom to eat and whom to be friendly.

One morning the volcanoes puffed more than usual. Great clouds rode the heavens. Winds howled and the seas leaped and tumbled like white-eared dogs. A great storm yelled in fury and all the fish were frightened. Suddenly the sun shone through the rain. Round and round the earth the rainbows arced. From the Malay Islands to the Mississippi Delta. Then angry lightning shattered all the rainbows and the broken spectrum of their color fell into the seas.

The seas calmed and a great clearness came to them and the fish could see one another clearly and saw with delight that the broken rainbows had colored each and every one differently so now they knew whom to eat and whom to love and whom to run from. 🐚

Life on the Reef

Coral reefs are among the most beautiful, diverse, and delicate ecosystems on Earth. They are colorful habitats in which animals themselves form the structure that supports the surrounding sea life. Despite the limited range of coral reefs throughout the world's oceans, the communities therein account for a disproportionately large percentage (nearly a quarter) of the world's marine species. To fully appreciate the variety of fishes associated with these areas, one should first gain a basic understanding of reef structure and dynamics.

Building Blocks of a Coral Reef

Corals are colonial animals belonging to the phylum Cnidaria (the same phylum that contains jellyfishes and anemones). A coral colony is composed of singular polyps. As is characteristic in other cnidarians, the mouth of each polyp is ringed with tentacles containing cnidocytes—specialized stinging cells that are used for gathering planktonic food and for defense against predators. Corals are almost entirely sessile, fixed in place. Excluding their motile gametes and larvae, corals remain in polyp form and do not develop further into the swimming medusa life cycle phase seen in some other cnidarians. Corals can be divided into two main groups: soft corals and hard or "stony" corals. In both soft and stony corals, the gastrovascular cavities of polyps are linked via channels that promote the sharing of acquired nutrients between members of the colony. Soft corals possess eight axes of radial symmetry. They consist of polyps bound together in a soft tissue matrix. Stony corals typically possess six axes of radial symmetry. As their name suggests, stony coral polyps assimilate calcium and bicarbonate ions from the water column into a protective calcium carbonate layer surrounding their soft tissues that shields them from predation and other damaging environmental influences. The polyps spend the daylight hours encased in this protective surrounding and extrude their delicate soft tissues only at night. Because of their hard exterior, stony corals are more suited to settlement in turbulent waters than other soft-bodied sessile organisms. It is the members of this group that are responsible for reef building.

Polyps of most soft and stony corals form symbiotic associations with dinoflagellate algae called zooxanthellae. These algal endosymbionts may either be passed from parent coral to offspring or (more commonly) assimilated into the coral's tissues from the water column. Zooxanthellae utilize inorganic components from the coral's waste, are granted ample access to sunlight, and are also protected from grazers. In turn, they provide the coral with the nutritious products of photosynthesis. In times of stress, such as rapid environmental change or disease, these symbiotic algae may be expelled from the coral's tissues, causing a condition known as coral bleaching. Bleaching is a highly detrimental condition and in severe cases may result in the death of the coral.

Formation of a Reef Community

Reef formation is influenced by a number of physical environmental parameters. Though a few coral species are able to tolerate temperate or even polar waters, tropical areas are best suited to support the formation and endurance of coral reef communities. The majority of the world's coral reefs occur in shallower waters between 30°N and 30°S latitude throughout the Caribbean and Indo-Pacific. Reef development requires areas of relatively stable salinity and temperature. Though reef communities tolerate variations in these two factors in different areas of the world, salinity around 35 parts per thousand (ppt) and temperatures around 70°F (~21°C) are most conducive to the persistence of a stable reef. As most species of reef-building corals rely on associations with photosynthetic algae, ample

access to sunlight is also necessary. This restricts reefs to the shallower photic depths where sunlight is still able to penetrate. Reefs also tend to develop in areas where dissolved nutrient content is low. While nutrients such as nitrogen, phosphorus, and other trace elements are necessary to support photosynthetic organisms, an overabundance of these can promote the growth of macroalgae and phytoplankton that outcompete and overgrow coral and increase turbidity in the water. The symbiotic nutrient recycling between corals and zooxanthellae (as well as microbial nutrient cycling) allows corals to thrive in these low-nutrient areas while their more rapidly growing competitors are subdued. Reefs are also partial to high-energy water that delivers nutrients from offshore sources and continually replenishes dissolved oxygen.

Corals may reproduce either sexually or asexually. During sexual reproduction, they overcome the predicament of a sessile existence by releasing their gametes into the water column where mixing and fertilization occur. This process is known as broadcast spawning. Fertilized eggs develop into swimming larvae that rely on prevailing currents for dispersal. This larval stage persists for a few days to weeks (depending on species) and culminates when the larvae settle and cement themselves where the substrate and conditions are favorable, thus becoming a polyp. Polyps reproduce asexually, thus expanding their numbers into colonies. As older stony coral polyps die, they leave behind their calcium carbonate exoskeleton, which is built on by new generations of corals and other sessile invertebrates. This hard structure of a reef is bolstered by the presence of red coralline algae, which grow in mats and likewise form a protective calcium carbonate layer. These algae help cement coral heads together and solidify sand and rubble deposited by wave action. This provides greater surface area and structural complexity. Some coral species actively select red coralline algae as a surface of settlement. Though they are not considered reef builders, sponges and soft corals also settle and contribute habitat diversity to the reef community. Over time, numerous species of marine algae, mollusks, crustaceans, echinoderms, and fishes come to inhabit the holes and crevices of the hard substrate. Reef building proceeds very slowly over time, and it may take decades for an extensive coral reef to develop.

Types of Reefs

Though reef configuration does not always conform to a rigid set of specifications, a reef might be classified as one of three main types: a fringing reef, a barrier reef, or an atoll. These reef classifications can be regarded as successional stages of reef formation. In areas with the favorable conditions previously described, a fringing reef may form along a shoreline. These reefs are extremely shallow, and no navigable water exists between them and the associated landmass. Due to their close proximity to shore, these areas are more subject to effects from runoff. These reefs continue developing while the adjacent shoreline may begin to recede. As the reef develops and deeper bodies of water form between it and the landmass, the reef becomes known as a barrier reef. In some cases, barrier reefs may surround a gradually subsiding offshore island. When the landmass has completely submerged, leaving a navigable lagoon between the surrounding ring of barrier reefs, the configuration becomes known as an atoll. Additionally, smaller patch reefs may be associated with any of these types of reef.

Zonation of Reefs

A reef may be further divided into zones based on distance from shore, physical structure, and the diversity of species found therein. The lagoon, alternatively referred to as the reef flat or back reef, lies between the shallowest point on the reef and the main shoreline (or the central lagoon in the case of an atoll). This area is shielded from wave action and is typically very shallow (no more than a few meters). These calm conditions allow for the development of other habitat areas such as mangroves, seagrass meadows, patch reefs, and sand flats. These associated habitats in turn help stabilize sediments from land-based runoff. Because of their shallow depth, however, lagoons are also subject to more drastic sunlight irradiation and fluctuations of temperature, salinity, and dissolved oxygen. Parts of the lagoon may become exposed and subject to desiccation during low tides. These arduous conditions are suitable only for sturdier organisms, and therefore biological diversity is not as great as in other areas of the reef.

The reef crest, the shallowest portion of the reef, is the most

highly turbulent zone and acts as a wave break for the shoreward reef flats. The reef crest is constantly pummeled by waves and is subject to exposure and high irradiation from the sun. Thus, it is nearly inhospitable to most reef organisms, and it is mostly characterized by layering of new rock. Sand, sediment, and broken pieces of coral are driven into crevices in the existing structures, and these depositions are further cemented in place by coralline algae.

The last portion, the reef slope (or fore reef), is the area that lies seaward of the reef crest. This area can be further subdivided between the upper fore reef and lower fore reef. The upper fore reef is typically gently sloping and supports a wide variety of different species. There is plenty of light present, and the greater water depths provide protection from heavy wave action. These more favorable conditions lead to increased competition between coral species and, therefore, the associated organisms that depend on coral as habitat. This area is by far the most highly diverse portion of a coral reef. The lower fore reef has a more drastic slope to it. As the water depths increase, the amount of surface turbulence, light, and temperature begins to diminish. Because of the more difficult conditions, some more specialized species of coral begin to outcompete others in this zone.

Biology of Reef Fishes

Coral reef communities support populations of fishes that are specific to reefs, as well as more transient species that may travel between different habitats in the pursuit of food or mating areas. A reef fish community typically consists of multiple families with high levels of speciation. This speciation is driven by the variety of food resources and structural habitat found in reefs and contributes a wide range of morphological diversity. Fishes specific to coral reefs are less prone to traveling great distances so are better adapted to occupying a relatively small area. The fishes most closely associated with reef living are typically smaller bodied. Reef fishes tend to show a high degree of lateral compression, and some, such as the butterflyfishes and angelfishes, exhibit a deeper body shape as well. Stronger pectoral fins and pelvic fins that have evolved into a more thoracic position serve to improve the fishes'

ability to maneuver, stop abruptly, or remain stationary in the water column. Fishes that venture farther from the protective structures of the reef to feed or reproduce have developed more streamlining and a more forked caudal fin to increase swimming speed. Coral reef fishes are perhaps best known for their bright, beautiful coloration. The coloration has many influences and advantages and is discussed in greater detail later.

The wide range of food sources on a reef support fish populations ranging from grazers to top predators. Jaw and tooth morphology is modified in accordance with feeding strategies. Though reef fishes tend to develop a degree of specialization in their feeding, some fishes utilize both algivory (feeds on algae) and predation. The primary consumers (grazers) on a reef have, for the most part, rather small, simple food items on which they feed. These include various species of algae that may grow in mats, filaments, or macroalgal assemblages. Grazing species have terminal, generally smaller mouths. The jaws and teeth are developed for repetitive biting. Common grazing reef fish families include Acanthuridae (surgeonfishes, tangs, and unicornfishes), Pomacanthidae (angelfishes), Siganidae (rabbitfishes), Pomacentridae (damselfishes), some members of Balistidae (triggerfishes), and Scaridae (parrotfishes). Additionally, parrotfishes bite off, crush, and ingest pieces of stony coral to target zooxanthellae and any epiphytic algae. To aid in this process, their teeth are fused into a parrotlike beak (hence the name), and they have well-developed pharyngeal teeth (occurring in the throat of the fish). The crushed coral passes through the digestive tract where any nutritious content is extracted, and the calcium carbonate remnants of the coral are then expelled through defecation. This fine coral sand contributes to shorelines and sand flats in areas of the tropics. Overall, grazers (both fish and various invertebrate species) are important members of a reef community that help limit rapidly growing algae that may otherwise outcompete corals.

The remaining reef fish species are carnivorous, and the targeted food sources for these species vary considerably. Some species prey on zooplanktonic food sources, which can be small crustaceans such as copepods or the pelagic larvae of a wide range of organisms. Like the grazers, planktivorous fishes tend to have smaller,

terminal, upturned mouths. Most species (especially the wrasses) have developed protrusible mouthparts that, when expanded, function to suction prey species into the mouth. The gill rakers of planktivorous fishes are longer and spaced closely together to prevent the escape of smaller food organisms through the gills. Some species venture above the reef into the water column to feed, while others prefer to remain closer to protective reef structures at all times. Reef fish families that practice planktivory include Labridae (wrasses), Chaetodontidae (butterflyfishes), Pomacentridae (damselfishes and clownfishes), and Holocentridae (squirrelfishes and soldierfishes). Members of Holocentridae tend to remain hidden on the reef during the day and venture out at night to feed. The squirrelfishes and soldierfishes tend to be heavier bodied than their daytime counterparts on the reef and do not school together as frequently.

Some fishes prey on benthic invertebrates near the seafloor, including crustaceans, echinoderms, coral polyps, polychaete worms, sponges, and mollusks. These families include Chaetodontidae (butterflyfishes), Pomacanthidae (angelfishes), Pomacentridae (damselfishes and clownfishes), Zanclidae (Moorish idols), and Balistidae (triggerfishes). The remaining fishes found around reef communities tend to be much larger and piscivorous (they feed on fishes, though to a degree some may prey on benthic invertebrates). These include members of the family Lutjanidae (snappers), Haemulidae (grunts), Carangidae (jacks), Scombridae (mackerels), Sphyraenidae (barracudas), and several species of sharks and rays. These fishes are more highly mobile and are less specific to coral reefs, although some may seek shelter around reef structures. Some benthic species belonging to the family Gobiidae (gobies) have adapted to "cleaning" the parasites off other reef inhabitants.

Sexual dimorphism is exhibited in a few families of reef fishes. Some families are hermaphroditic and may change sex over the course of a lifetime. Most notably this occurs in the parrotfishes and wrasses. Most of the reef-specific fish species are broadcast spawners. Males and females release gametes into the water column, where fertilization and larval development occur. Larvae are planktonic and rely on currents as a means of dispersal to their final habitat either on the same reef as their parents or (most often) on other distant reefs. The tendency among most reef fishes is to produce a large number of offspring per mating event; parental care is practically nonexistent, with only a small fraction of the offspring surviving the larval dispersal stage. Some families (including the gobies, blennies, clingfishes, damselfishes, triggerfishes, jawfishes, and pseudochromids) practice an exception to the broadcast mating strategy. These species engage in prespawning behaviors and prepare nesting sites either around rocky reef structures or on the sandy bottom. Females lay eggs that are then fertilized externally by the male. Fishes in these families exhibit fierce guarding of these nesting areas and will bite and chase any offending species (including human divers) that encroach on their space. The offspring of these fishes stand a higher chance of remaining near the reef on which they are born.

Light and Color

Light is responsible for the color we see all around us, even in places where no person has ever been. The vast majority of natural light on our planet emanates from three sources. Incandescence, the light of volcanism, occurs when electromagnetic radiation is emitted from an object as a result of high temperature. This source provides little light on Earth and can, for the purposes of this chapter, be considered insignificant. Biological light, or bioluminescence, occurs in dark environments, such as the ocean depths. This bioluminescence can be produced by an organism itself or by the organism's association with light-producing bacteria. For additional information regarding bioluminescence in deepwater fishes, see the companion edition to this volume, *Fire in the Sea*. Both of these minimal light sources produce "true color" in that the colors expressed are produced by the geological, or biological, object itself. Aside from these two radiation sources, natural light on Earth is cosmic in nature. The bulk of this celestial light is provided by Earth's proximal star, the Sun. Also imparting extraterrestrial radiance are the moon and distant stars.

Light travels in waves, and the distance between two light waves is its wavelength. It is possible to separate solar radiation into an electromagnetic spectrum by using the frequency of these wavelengths. This spectrum comprises wavelengths, such as infrared and ultraviolet light, that we cannot see but also includes those wavelengths that we can. This range of wavelengths, called visible light, occurs between 380 and 760 nanometers and embraces all colors of the rainbow. Remember ROY G BIV (red, orange, yellow, green, blue, indigo, violet)?

Aside from these two minor light sources, the color of any object viewed through human, or fish, eyes is the result of certain wavelengths being absorbed and others reflected. Plants are green because the chloroplasts in their cells absorb red and blue light but reflect green. It is the wavelengths reflected by an object that we perceive as color, hence the term "reflective color." This is true in both the terrestrial and marine environments. The color of water changes with depth as longer wavelengths are absorbed and shorter wavelengths penetrate deeper. This means reds, oranges, and yellows "disappear" before the blues and violets do. Very shallow waters appear clear because all wavelengths are reflected, while deep oceanic water shows a dark blue because only these shortest of wavelengths can penetrate. Of course, other factors such as the abundance of plankton and suspended solids contribute to the color of water, but the reflective properties of light play a substantial role. Most sunlight is absorbed within the first 200 m (about 650 ft) of water and is referred to as the photic zone. Beyond that is only darkness.

One might ask, "What does any of this have to do with fish?" Color availability in fishes is directly related to the depths at which those fishes occur. In shallow water, a fish whose scales reflect red wavelengths appears red, yet that same fish at depth (in the aphotic zone) would emerge as black. This is a function of red's inability to penetrate deep into the water column. How can a fish be red, when there is no red light to reflect? Our "red fish" would again regain color if returned to the surface or if a light were shined on it at depth.

The fish species depicted in this book's artwork occur in the photic zone, where light is abundant and hard structure is plentiful. Shallow seas allow for the multitude of colors and patterns seen in many of the illustrations. These shallow-water fishes display dazzling colors, while deep-water species show only black in their aphotic habitats. Unlike the hypothetical "red fish," the subjects of these paintings are not restricted to just one color; the entire visible spectrum and countless color combinations are made

available to them. The following discussion addresses how these shallow-water inhabitants are influenced by light, as evidenced by their colors, and why these colorations are significant.

Fish scales are dermally derived and serve the primary function of protection. There are several scale types typical of extant fishes, including placoid scales in the sharks, the ganoid scales typical of garlike species, and the cycloid and ctenoid scales of the higher bony fishes, or teleosts. Compton's present collection focuses on the bony fishes of the sunlit layers, as their scales possess the greatest color-producing ability.

Imagine yourself unable to speak yet armed with the ability to convey a wide range of emotion solely by changing your appearance. Fishes utilize color in this exact way to communicate with their underwater cohabitants. The scale of a fish often contains chromatophores, or "color-carrying" cells. These chromatophores are differentiated by the light-reflecting pigment found within them. Melanophores, containing melanin, are the most common throughout the vertebrates, but fishes are not limited to this single pigment. Instead, they may possess a number of others, including pteridine, which lends yellows, and carotenoids, which reflect reds and oranges. The chemical guanine forms iridescent plates often resulting in an optical scattering of bright greens and blues. These pigments are dynamic and, through alternations of expansion and contraction, vary their density within the "color carrier," resulting in different hues. Not only is pigment density important but also the distribution of the chromatophores themselves. Through this process, fishes have the ability to "talk to the neighbors" on an optical level.

Coloration is important to fishes, although not always for the same reasons. Color may remain static, or it can transform in dynamic cascades of luminous shades. It may adjust gradually, at a species level, as day steadily advances toward night, or it may change abruptly, on an individual scale, in response to sudden stimuli. What is the reason for these assumingly beneficial changes, or reasons, as there are sure to be many?

Colorative displays such as aposematic, or warning, colorations transverse species lines and commonly occur in variable patterns of bright shades. This color-coordinated threat display serves as a primary defense against those who would seek to do harm. These colorations are often complemented by secondary defense mechanisms, including toxic glands or spines, as in the lionfish depicted in the accompanying artwork. These fishes are typically slow moving, leaving fast escape as a hopeless alternative to perceived threats. Instead, their toxicity is advertised through brilliant displays of color, keeping would-be predators at bay.

Those species unable to concoct venom often adopt an alternative style. Obliterative coloration refers to combinations of colors and patterns intended to mask an individual or to confuse potential predators. Perhaps the most widely known example of obliterative coloration is camouflage. Known also as cryptic coloration, this strategy seeks to blend organism and environment in an effort of concealment. Fishes exercising this approach are often able to rapidly alter their visible appearance to match that of varying habitats. The seahorse is capable of these brisk alterations, allowing it to blend in whether over open sand or color-strewn coral.

The trumpetfish combines coloration and behavior to lure in prey. This species swims vertically among erect corals and sponges while displaying similar and deceptive color schemes, permitting proximity to the small fishes and shrimps it feeds on.

Obliterative, or disruptive, colorations are abundant in the artwork showcased throughout this book. Some fishes, including the eightband butterflyfish and regal angelfish, possess vertical bars that provide contrast with the dominant background color. These bars help break up the fish's outline in its brightly colored habitats. Some bars pass through, thus hiding, the eye and produce a puzzling picture that marauding species can make neither heads nor tails of. Horizontal stripes serve the same purpose and are seen in many species of brightly colored fishes, including the golden-striped grouper and candy basslet. Like the vertical bars, a band may encompass the eyes. Again, this disruptive coloration assists in fragmenting the outline of these fishes, making it more difficult for predatory species to launch an attack. These do not always occur in horizontal or vertical colored lines. Stripes may emanate from the head in a diagonal direction extending back toward the tail, as in the ornate butterflyfish, or intersect at angles, resulting in

the stunning crosshatch seen in the pearlscale butterflyfish. Sometimes, as in the juvenile emperor angelfish, contrasting color takes on a seemingly random pattern as straight lines combine with rounded ones, producing a truly beautiful and distracting, color scheme. While the adult form of this species also exhibits disruptive coloration, it is during this most vulnerable stage that this species is the most difficult to discern.

Another example of obliterative coloration is the occurrence of "eye spots." These spots often occur opposite the head and may help direct predators toward the tail end of the fish. While it may be possible to endure an assault to the body's posterior, there is minimal chance of survival if the head incurs damage. Examples of these "false eyes" are seen in the artwork for the clown coris, copperband butterflyfish, and dusky damselfish. Another spherical disruption strategy is to possess many spots rather than one or two. This approach is seen in fish such as the comet, humpback grouper, and both illustrated species of filefish.

These examples of obliterative, or disruptive, coloration often occur in combination. The blueblotch butterflyfish possesses a dark, eye-shaped spot near the tail and also a vertical bar through the true eye. A mixture of vertical bars and horizontal lines helps disrupt the shape of the scrawled butterflyfish. All of these examples demonstrate the multitude of ways that coloration aids in survival for the fishes of shallow seas.

These color schemes communicate intraspecifically, or across species. Coloration is also important interspecifically, or within species, and plays a crucial role in many aspects of life history. If a cardinal fish wished to form a school, it would be at an advantage if able to recognize others like itself. Of course, the fish has no concept of self-image, but still, something intrinsic drives the fish toward others like it. Innately, the fish "knows" that certain colors, in certain patterns, equate to "self."

And what of reproduction? Would it not facilitate the process of procreation if one were able to recognize like individuals? The beautiful colorations seen in many tropical, marine fishes, many of which are artfully presented here, are thought to aid in breeding via species recognition. Although this color-coordinated assistance does not usually extend so far as gender separation, it does help ensure that a fish is not "barking up the wrong genetic tree." The majority of species highlighted in this book possess no color-based sexual differentiation. Of course, there are exceptions, but they are not the rule.

Instead, an age-based system of color change is far more common. From across taxa, fishes such as the emperor angelfish and French angelfish, the yellowtail damselfish, and spotfin hogfish provide wonderful cases of color transformation accompanying the youthful on a journey ending in adulthood. Examples of this chromatic coming-of-age are seen in the artist's renditions of the juvenile and adult stages of these two angelfish species.

As exceptions to the rule, there do occur examples of sexual dimorphism illustrated by differences in color. Unlike the majority of angelfish species that appear in the artwork, the spotbreast angelfish male is distinguished from the female by differences in color and pattern. The bird and cuckoo wrasses, harlequin tuskfish, and stoplight parrotfish pictured in this book also exhibit their gender through chromatic disparity. These species are known as sequential hermaphrodites, meaning they have the ability to change from one sex to the other. In these fishes, sexual transformation is always from female to male, a phenomenon known as protogyny, and occurs most often where there are no males present. Accompanying this change in sex is an amendment to the fish's coloration. Although only males are portrayed artistically for the bird and cuckoo wrasses and harlequin tuskfish, this transition in color is superbly captured in Compton's paintings of the male and female stoplight parrotfish.

Coloration is significant in the lives of fishes for several reasons, only a few of which have been discussed in detail. Rather than provide superficial descriptions for the multitude of color plans expressed by occupants of the photic zone, the significance of coloration was instead explored under the artist's guidance. As readers wind their way through this book, it is hoped that they will appreciate the significance of visible light and how it colorfully influences the lives of fishes.

The Art of Hank Compton

MARK ANDERSON

David McKee introduced me to the paintings of Hank Compton several years ago, not long after he had inherited them. While Compton's training and life's work had been in the field of marine biology, his avocation was that of a "closet painter," a person not interested in exhibiting or selling his work, yet his passion for marine life is evident in the two-dimensional panels he painted that are the subject of this book. A case can be made that he developed a passion for painting as well, culminating in the group of 18 images scanned from slides he took.

Compton's ability to translate observed reality into imaginative, if not decorative, representations of the Caribbean and Indo-Pacific species of fishes he painted borders on visual poetry. It is remarkable that the pieces survived years of being packed in cardboard boxes, separated by envelopes or newspaper, and subjected to years of coastal humidity. It was hardly an archival environment for artwork on paper or canvas, and then to think they were nearly discarded following his passing in 2005.

Several things, including color, are striking about the 87 piscine paintings Hank Compton did in this series, of what can be categorized as the more decorative or illustrative of his artistic depictions of the various species.

There is little doubt Compton found joy and creative release in his painterly efforts. Most of the paintings in this series seem more relaxed and design conscious than the earlier *Fire in the Sea* group, because that group is collectively very much aware of the content, context, and resulting tensions of the deep-sea surroundings in which the creatures are placed.

For the most part, compositions in the *Fishes of the Rainbow* seem less complex and mysterious and serve more as visual show plates for depicting the various species. Contrasts are usually high, though subtlety does exist (for example, see images for bluebanded goby, French angelfish, yellowstriped cardinalfish, humpback grouper, and crown squirrelfish). There is in general a central placement of the figures and proportional similarity in the amount of surface the organisms occupy in regard to the resulting negative space. In a sense, they are biological illustrations. Compton has been less concerned in this group with creating the illusion of space, although there are exceptions.

In the French angelfish image, where he purposely repeats the descending form of the fish, he uses some artistic conventions to create the illusion of space on a flat surface. The fish in the distance is not only smaller and higher in the picture plane but also lighter in color and lower in contrast, thereby appearing farther away. The colors are muted, less intense, thus heightening the sense of depth.

Compton seems to have less concern in the *Fishes of the Rainbow* series for integrating the figures of the fishes into environments, although there are exceptions, as seen in the mutton snapper and the 18 images scanned from his slides. Very few of the pieces show any interaction between the fishes and the environment, and they are all in profile, essentially biological illustrations. That coupled with careful, colorful design and pattern surface treatment is precisely the characteristic that makes them illustrative and decorative. There is, however, a dynamic of visual tension created by the size of the fishes relative to the size of the rectangular form they are placed in, rather like an aquarium that is much too small for its occupants, a visual compression.

Fine artists know that the color and value (lightness or darkness) of a form are affected by the colors and values of forms or space around them. The aqua background acting on a bright cadmium red form seen in the sixblotch hind would result in a slightly browner red only if the "local color" of red was affected by the neighboring colors. The lack of integration of color interactions results in many

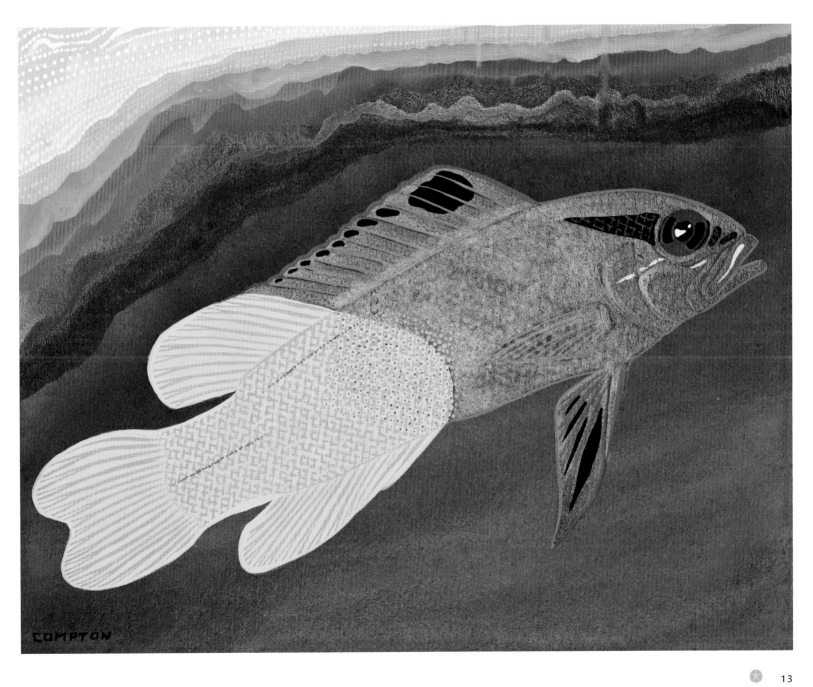

COMPTON

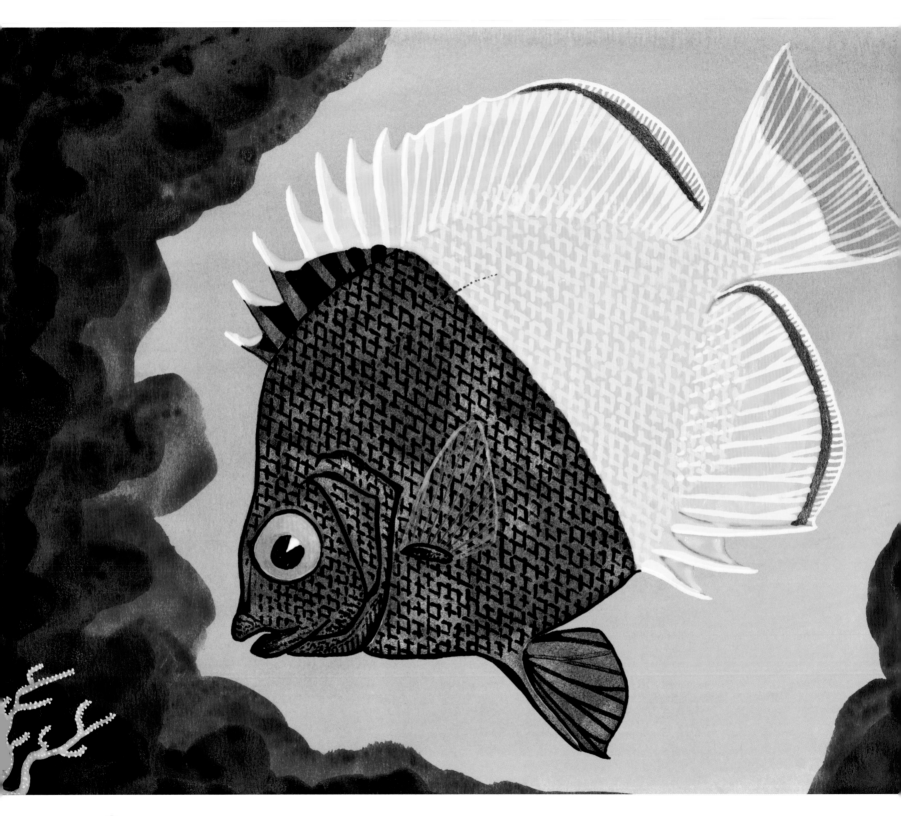

images where the fishes are "pasted" onto an aquatic background, thus creating at least two planes of space.

There is an interesting exception in the image of the royal gramma. The upper colors of the rock structure are picked up in the left side of the fish, thus integrating both forms into a common space. The fish appears to be penetrating the invisible plane of shadow created by the rock formation, a Compton invention.

Another similarly curious painting in this series is the Smith's butterflyfish. Once more, Compton has placed this fish not only in the middle of the composition but also most definitely into the environment of its surroundings. The viewer is led to question whether the rock cave the fish is entering blocks the bright light that is illuminating the brilliant yellow aft portion of the fish, casting the front half in a grayish-violet shadow, a provocative solution that seems to cut the creature in half. He brilliantly creates the illusion of the invisible plane of the opening of the cave by having us see what we believe to be the shadow effect on the fish. In fact, the fish is probably colored as he has painted it.

As is the case in so many of the paintings, the negative areas, or spaces around the fish, are "looser" or more painterly, with the exception of the obviously flat areas. In many instances this painterly effect creates movement not noticeable in the fishes themselves, as if they had posed for their portraits and in some cases became stylized icons frozen in time, sometimes alive and fleeting, darting in the manner predictable with schools of fishes, such as the image of the yellowstriped cardinalfish, which are nevertheless always in profile.

There is a subgroup of paintings in this series that have a markedly different tone. The fact that Compton shot slides of these images and not the bulk of the series indicates he thought they were special, and on inspection they seem to be. Unlike the other 70 paintings, these are distinguished by what seem to be extra time and care spent on them.

Eleven from this group showcase the fishes with darkened and dramatic negative spaces or backgrounds (opah, yellowhead butterflyfish, silver moony, blue green damselfish, blue chromis, spotbreast angelfish, sapphire devil, Achilles tang, twotone tang, and candy basslet). Not only are they showcased against a dark background; Compton creates a dialogue with the viewer and integrates a sense of mystery in these paintings in a way similar to those of his series featured in *Fire in the Sea*. The means he used in this group differed from the *Fishes of the Rainbow* series, as did the specimens, but nevertheless engage the viewer in a more overt way. The darkened negative areas contrast with, and highlight, the colors and add a narrative element to the images, making them more than the visual show plates that simply illustrate a species.

In this group of paintings, Compton seems to be aware of a painting tradition known as Texas Modernism, which began before World War II and was influenced by European Modernism. This tradition became more and more embraced in the 1940s and 1950s, as evidenced in the work of artists and groups in Dallas, Fort Worth, San Antonio, Austin, and Houston.

Attention to details on the fishes is a constant throughout the series. However, in the group of 18 that seem less illustrative and more narrative, Compton takes care to inform the viewer of minute details on the organic elements within the frame shapes, whether they be coral, anemones, or vegetation. The organic form on the ocean floor in the illustration of the yellowhead butterflyfish has painstaking black detail painted into the white surface to emulate the decorative natural design. He creates the illusion of three-dimensionality in the form by adding the brownish edges. The diaphanous blue form in the lower right complements the orange colors in the fish and provides a compositional device to move one's eye to the left or upward. The gradation of color within the form creates a sense of depth not evident elsewhere in the frame.

Several images are color anomalies in the context of all of Hank Compton's paintings in that they are entirely or mostly monochromatic. The painting of the blue chromis is executed entirely in shades and tints of blue. The subtle shifts in value in the upper right background evoke deep space. The image of the blue green chromis contrasts the monochromatic green fish with the reddish organic form. The combination of the treatment and color choice of the fish and the organic form allude to an oriental aesthetic sensibility.

Several images are examples of spatial anomalies (French angelfish, clown triggerfish, yellowstriped fairy basslet, copperband

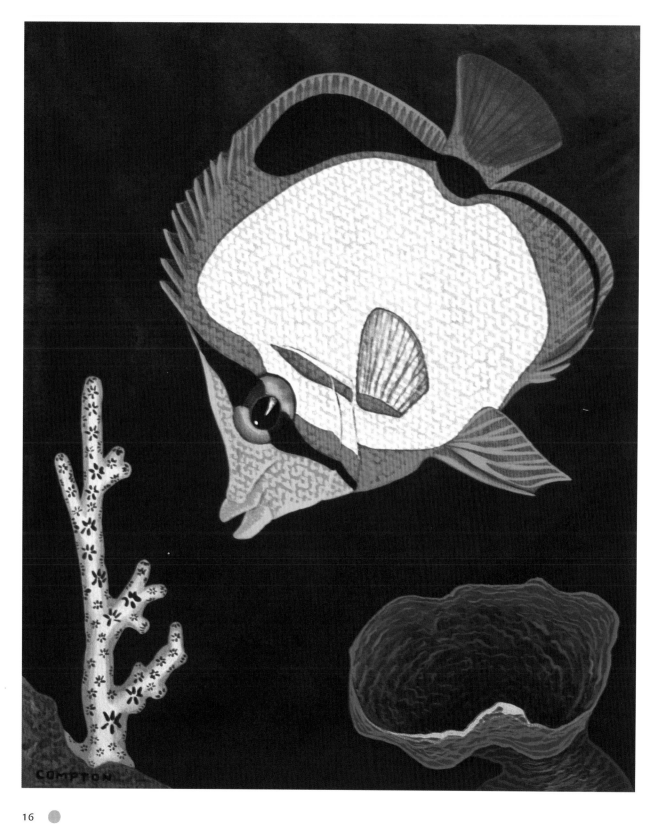

butterflyfish, and red lionfish). The background in each of these images is smoothly blended vertically from light to dark or dark to light, creating an illusion of infinite space or depth and the changing of light conditions underwater. Without brushmarks and the visual fluidity created by a more painterly approach, the space these fishes float in makes them seem as if they could be floating in air. Compton seems to have perfected his application of the pigment with the utmost control, possibly even resorting to the use of an airbrush. This smooth blending of color was used widely in commercial offset printing, where ink rollers would evenly distribute colors to create such a blend referred to as a split-fountain or rainbow roll. It is this latter group that hints at the possibility that Compton was aware of the surrealist artwork of artists such as Salvador Dali.

Compton demonstrates considerable skill with the brushes and the manipulation of the painting medium. The materials, illustration board, and gouache paint that he used were fairly commonly used by designers and commercial artists in the 1950s and 1960s. (Alice Campbell's Art Supplies in Corpus Christi went out of business in the late 1970s or early 1980s. It supplied local artists and designers with these and other types of art materials and was likely Compton's local source for supplies.)

The term "gouache" comes from Italian word *guazzo*, meaning "water painting" (how appropriate). The medium is more opaque than watercolor due to the higher percentage of pigment; it also has a chalky medium added to it, which increases the opacity, and gum arabic, which acts a binder for the mixture. The paint dries by evaporation and can usually be remoistened or ground in water. The transparent glazing method of watercolor uses the white of the paper for whites and tints of color, while the opaque method relies on the addition of white pigment for whites or tints of color. Gouache,

however, can be diluted with water to create washes, which allow the white of the illustration board to penetrate through to lighten the tonality. Compton used all three methods of application to create his works.

The wash, or fluid, method is especially evident in the ground (background) of many of the pieces, and one can easily see the lightness and transparency of the tinting, which relies on the white of the illustration board rather than white pigment.

Being self-taught and not formally trained in art, Compton nevertheless employed a sophisticated layering process not unlike some printmaking or batik techniques. He used a liquid rubber art masking material that, when painted and allowed to dry, acted as a resist. Since the masking material was not water soluble when dry, watercolor or gouache could be painted on, and when the paint was dry, the rubber masking material could be rubbed off, revealing any color that might have been painted on previously and protected by the mask.

Of the *Fishes of the Rainbow* paintings, 66 have a downward movement: 30 to the lower right of the rectangular illustration board and 36 to the lower left. It seems perhaps that Compton wanted visually to take us deeper through his compositions.

Through analysis of artists' works, we can read the visual grammar and decipher things that hint at motives and intentions and in a sense have a conversation with them. Compton's romantic writings are as poetic and enjoyable as his paintings.

Hank Compton, though a scientist, was driven to interpret in paint the fish he loved, photographed, and studied and was fascinated with in a manner that transcended reality. Fortunately, the evidence survived him.

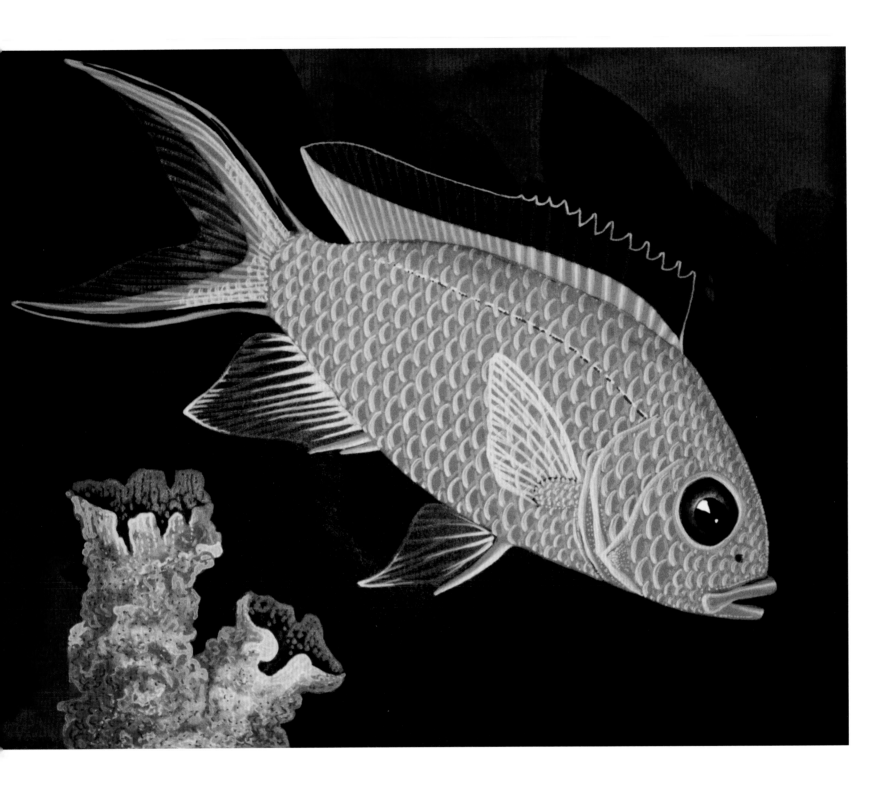

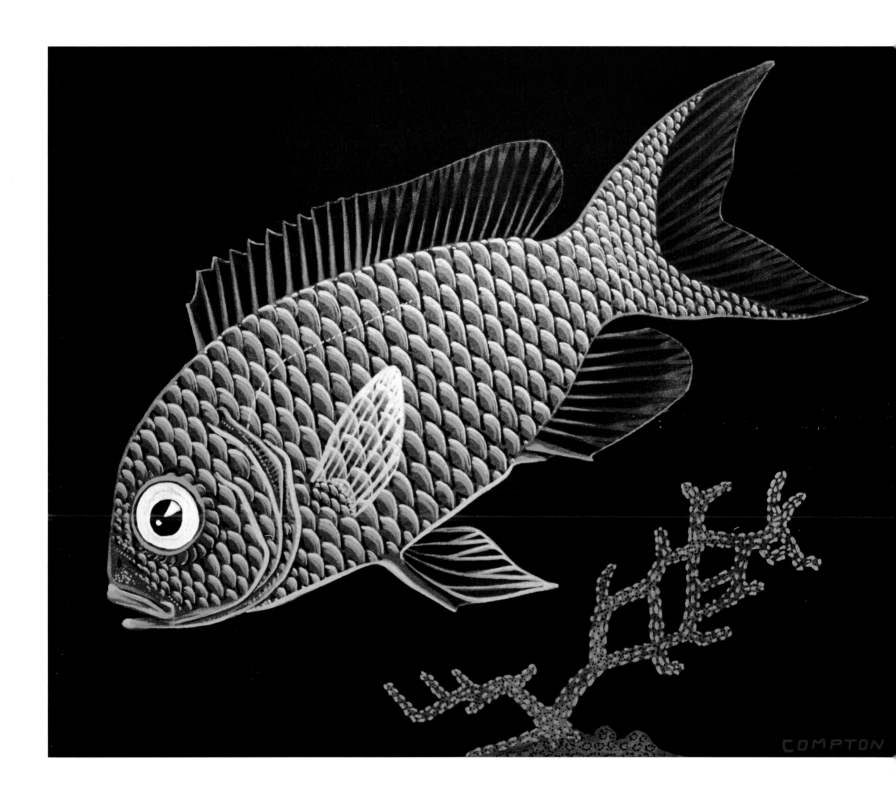

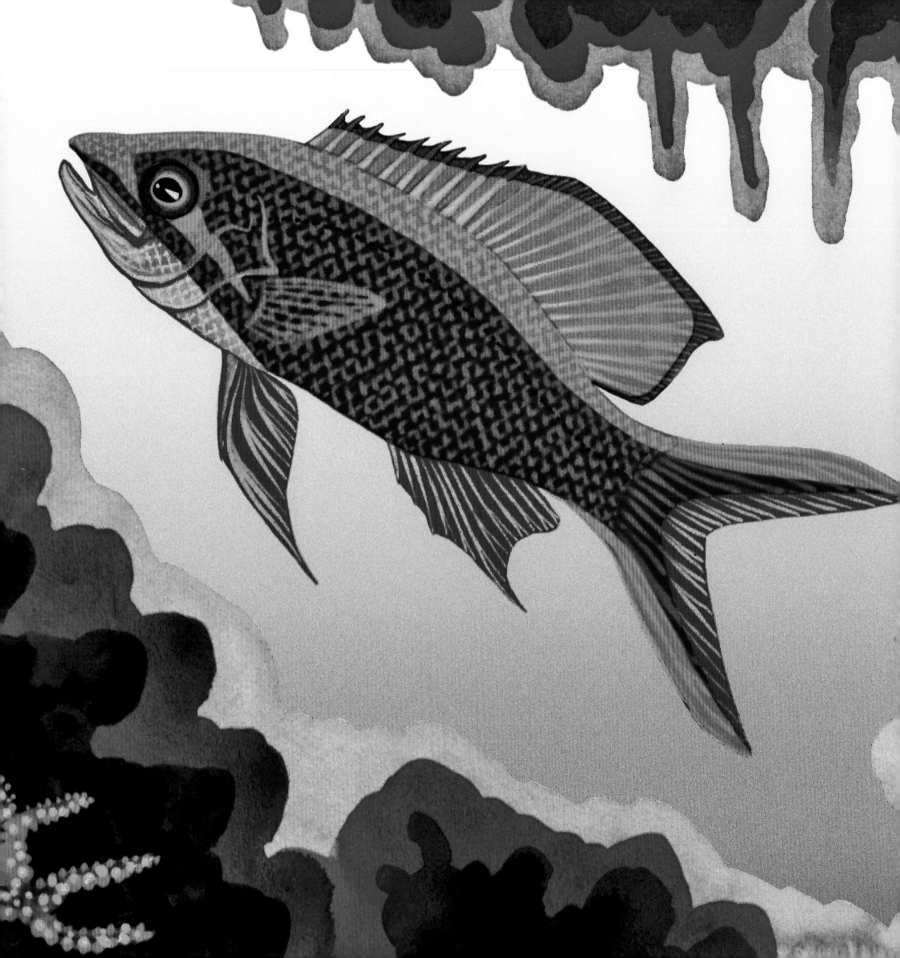

Taxonomic Classifications

Taxonomic classification establishes an identification system that can be easily understood throughout the world. Scientific classification is intended to cross language barriers by giving scientists and researchers worldwide a single name for a given species. Although common names are valuable, these names can vary dramatically between countries and even different geographical regions of the same country. For example, mahi-mahi (*Coryphaena hippurus*) is a commonly known species, but depending on the region and country, it may also be called the dorado, common dolphin, or even just dolphin. This can make classifications difficult in that several common names may occur for a single fish. Closely related species are grouped together at the "genus" level, and these are placed into a "family" level with more distantly related species. This trend is continued as similar families are grouped into an "order," similar orders into a "class," similar classes into a "phylum," and similar phyla grouped into a "kingdom." This of course is a simple example of a scientific classification system, as many of these divisions can be broken down to even more levels. Understanding taxonomic classification of organisms allows scientists to understand and distribute information and new research to others around the world.

The following is a classification of the representative species of fishes found within this book to the family level. Detailed classification of the order, family, genus, and species levels are found with their respective image. The taxonomic information belonging to each painting refers to the main feature of the piece. It should be noted that classifications are not static, and in some cases species may be shifted between different genera or even new families over time. Organisms that may appear in a painting alongside the featured species will not be described to any degree. Although Compton did take part in scientific research, one should remember that these are not photographs and depict Compton's representation. In some cases, species might not be 100 percent anatomically accurate in regard to the knowledge we have today. However, the large majority of the artwork represents correct anatomical features and identifying characteristics.

Kingdom: Animalia
 Phylum: Chordata
 Subphylum: Vertebrata
 Class: Actinopterygii
 Order: Beryciformes
 Family: Holocentridae
 Order: Lampriformes
 Family: Lampridae
 Order: Perciformes
 Family: Acanthuridae
 Family: Apogonidae
 Family: Blenniidae
 Family: Chaetodontidae
 Family: Cirrhitidae
 Family: Coryphaenidae
 Family: Gobiidae
 Family: Grammatidae
 Family: Labridae
 Family: Lutjanidae
 Family: Microdesmidae
 Family: Monodactylidae
 Family: Opistognathidae
 Family: Plesiopidae
 Family: Pomacanthidae
 Family: Pomacentridae

Family: Scaridae

Family: Serranidae

Family: Zanclidae

Order: Scorpaeniformes

Family: Scorpaenidae

Order: Syngnathiformes

Family: Aulostomidae

Family: Syngnathidae

Order: Tetraodontiformes

Family: Balistidae

Family: Monacanthidae

Family: Ostraciidae

Compton Story Notation Guide

Although the species are organized through a taxonomic system, the following list denotes the order in which Henry Compton had organized the paintings and their corresponding stories and wished them to be read (the stories are numbered in the species accounts, "Fishes of the Rainbow," for reference). In some cases, there may be several connected stories for different species.

STORY NUMBER

1. Opah
2. Masked Butterflyfish
3. Meyer's Butterflyfish
3-A. Eight Banded Butterflyfish
3-B. Clown Butterflyfish
3-C. Blue-Streak Butterflyfish
3-D. Yellowhead Butterflyfish
3-E. Three-Spot Angelfish
4. Freckled Rock Cod
5. Featherfin Bull-fish
5-A. Cardinalfish
5-B. Diamondfish
5-C. Harlequin Tusk-Fish
5-D. Longnosed Filefish
6. Moorish Idol
7. Green Reef Fish

7-A. Blue Reef Fish
7-B. Beakfish
7-C. Longspine Butterflyfish
8. Seahorse
9. Imperial Angelfish (young)
9-A. Imperial Angelfish (adult)
9-B. Marine Jewelfish (young)
9-C. Dusky Damselfish (young)
9-D. Beau Gregory
10. French Angelfish (young)
10-A. French Angelfish (adult)
11. Flame Angelfish
11-A. Crossfire Angelfish
11-B. Redtop Angelfish
11-C. Cherub Angelfish
12. Stoplight Parrotfish (female/young male)
12-A. Stoplight Parrotfish (male)
13. Royal Empress Angelfish
13-A. Striped Angelfish (female)
13-B. Striped Angelfish (male)
13-C. Saddleback Butterflyfish
13-D. Blue Ring Angelfish
13-E. Red Lined Butterflyfish
13-F. Pearlscale Butterflyfish
13-G. Tinker's Butterflyfish
13-H. Latticed Butterflyfish
13-I. Half-Yellow Butterflyfish
14. Blue Devil
14-A. Yellowhead Jawfish
14-B. Spotfin Hogfish
15. Golden Headed Sleeper
15-A. Fire Fish
15-B. Catalina Goby
16. Powder Blue Surgeonfish
16-A. Red-Tailed Surgeonfish
16-B. Golden Sailfin Tang
16-C. Blue Surgeon Fish
16-D. Olive Surgeonfish

17. Bluehead Wrasse

17-A. Yellowtail Wrasse

17-B. Cuckoo Wrasse

17-C. Twinspot Wrasse

18. Peppermint Basslet

18-A. Golden Striped Grouper

18-B. African Squirrelfish

18-C. Barred Squirrelfish

18-D. Trumpetfish

19. Clown Triggerfish

20. Clown Anemone Fish

21. Masquerade Butterflyfish

21-A. Melon Butterflyfish

21-B. Blackfin Butterflyfish

21-C. Rock Beauty

22. Fairy Basslet

22-A. Long-nose Hawkfish

22-B. Orange Coralfish

22-C. Purple Queen

23. Yellowtail Snapper

23-A. Mutton Snapper

23-B. Red Emperor Snapper

24. Fantailed Filefish

24-A. Polka Dot Grouper

24-B. Comet

24-C. Coral Cod

24-D. Pakistani Butterflyfish

25. Saber-Tooth Blenny

26. Blue Trunkfish

27. Queen Angelfish

28. Dolphin (Dorado)

29. Copperband butterflyfish

30. Lionfish

Fishes of the Rainbow

Order: Beryciformes (Sawbellies)

The order Beryciformes comprises 7 families with all species being marine. Many consider Beryciformes to be the sister group of the Percomorpha. Many of the fishes belonging to this order are found in deep offshore waters, while a few are found closer to shore. Most possess deep bodies and very large eyes. These fishes are demersal thus reside in the water column near the bottom. Strong spines are associated with all of the fins prior to the soft rays. All fishes in this order exhibit a modification of the anterior portion of the supraorbital and infraorbital sensory canals referred to as the Jakubowski's organ. Although bioluminescence is not a common trait of this order, members of the family Anomalopidae possess bioluminescent qualities.

Family: Holocentridae (Squirrelfishes)

Squirrelfishes are mostly small or moderate-sized fishes with an elongate and compressed body plan. These fishes are known for obvious spiny elements in the fins. Members of most genera within this family have preopercular spines, those found on the bone between the cheek and gill covering, and in some cases even the scales have heavy spines. The anal fin also has several large spines, with the third typically being greatly enlarged. Due to these obvious spines, this group has been named from the Greek words *holos* (whole) and *kentron* (sharp point). Distributed throughout the world's oceans in tropical and subtropical waters, they typically inhabit shallow coral reefs of a depth typically less than 200 m. Large eyes enable excellent nighttime vision, which allows these fishes to be primarily nocturnal; they hide in crevices of reefs during daytime hours. While adults are demersal, larvae are planktonic for the first several weeks of life before settling to the bottom. There are approximately 80 species within 8 genera.

Species: *Sargocentron diadema* (Lacepede 1802)

The crown squirrelfish can be found in tropical waters in the Indo-Pacific from the Red Sea, East Africa, Northern Australia, throughout Micronesia, and to the Hawaiian Islands. A common species among coral reefs, these fish are also found in lagoons as well as seaward reefs to a depth of approximately 30 m. Like other squirrelfishes, the crown squirrelfish is red with white longitudinal stripes along the body. These fish also possess a red head with two vertical white stripes along the preopercle. A distinct characteristic of this species is the dorsal fin, which is red and black with two white streaks running parallel with the fin. The preopercular spine is also venomous as seen in similar species. Like other species of *Sargocentron*, these reclusive fish reside under ledges or in caves during the day and are often found in large groups. During the night, these fish patrol the sandy bottoms and reefs, hunting invertebrates and small fishes.

(18-B) Squirrelfish are nocturnal and whoever named them for their "great big beautiful soulful squirrel eyes" must have been thinking of Flying Squirrels who brush the night with their soft spread in search of the insects of darkness. In the night of the coral the Squirrelfish search out insect analogues—the crabs, the shrimps, the coral-lobsters, and tuck away many unwary fish.

Flying Squirrels are delightfully furry and touchable. Squirrelfish with their array of heavy bright scales and various spears and stickers are anything but. Even with this shining

Crown squirrelfish

Sargocentron diadema (Lacepede 1802)

"Flying Squirrels are delightfully furry and touchable. Squirrelfish with their array of heavy bright scales and various spears and stickers are anything but."

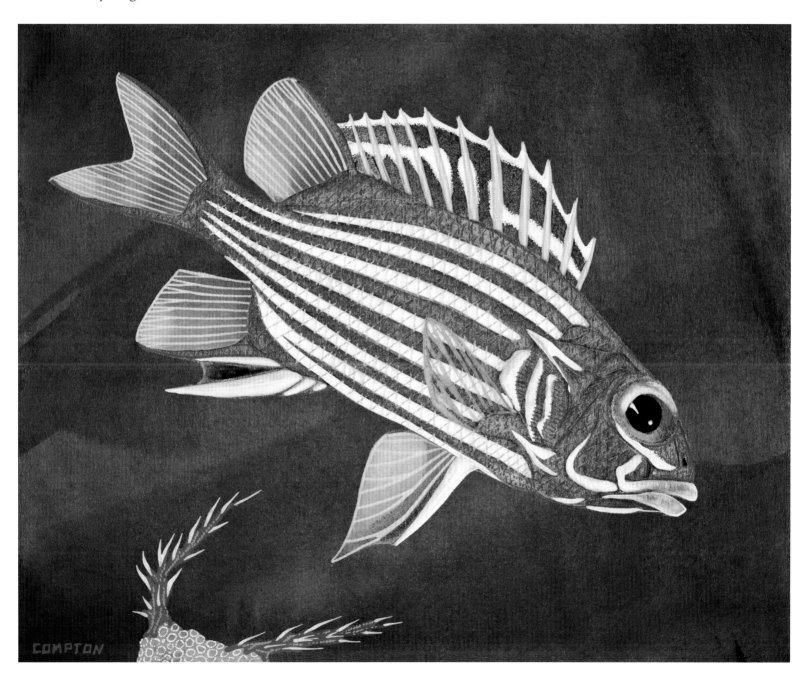

armament, Squirrelfish are timid and easily frightened by sudden light and commotion. Since many Squirrelfish ancestors graduated in the school of atom-blasted Pacific islands, this trait is easily explained by racial memory. 🐚

Species: *Sargocentron rubrum* **(Forsskal, 1775)**

The redcoat, also referred to as the red squirrelfish, is a species found in the western region of the Indo-Pacific. These fish can be found from the Red Sea to the western Pacific from Japan to Australia. Interestingly, the redcoat is now found in the eastern Mediterranean, which they invaded after construction of the Suez Canal. Similar to other squirrelfishes, these marine fish are found among coastal reefs as well as shipwrecks in lagoons and bays to a depth of approximately 80 m. Often found in large groups, they typically inhabit caves or rock crevices during the daylight hours. These perchlike fish are most known for the large, spiny dorsal fin and very large eyes. The spine along the preopercle is also said to be venomous. Coloration is commonly dark red-brown, while some individuals are a much brighter red. Distinct white stripes run longitudinally along the body. Highly predatory, the redcoat feeds on a variety of invertebrates and small fishes.

(18-C) Squirrelfish have kids which would give their parents a fit of disbelief. If they ever laid eyes on them. Look like a quarter-inch experimental jet fighter plane or a mosquito balled in snot. Long snooter on them. Real long snooter. Which is not for smelling. Nobody knows what it's for although like the blindmen and the elephant, there are plenty of guesses.

These merry little spirits are born in the plankton of eggs wafted to the surface waters of, in this case—the Pacific. There they look no crazier than anyone else drifting and jumping up and down in place—diatoms, dinoflagellate radiolarians and globigerina, sponge babies, larval snails & clams, starfish & urchins, worms, crab, shrimp & fish of all sorts and body styles. Alphabet soup won't even compete.

If random passing whale fails to suck in 20–40 acres of this chowder, baby Squirrel quits nursery and flitters down to find reef where he grows fine red/white lines and spines and spurs and knives everywhere else but his nose.

Pipe Organ Coral is a wild one also. The flower-animals, who are bright green, build and live in red Tubes. When one story becomes too deep for their butts, they suck-up, lay floor and erect second story. Leaving empty rooms and memories behind. So the tubes are coral-tied structurally into Buildings. A tube is only a line expanded into solid geometry. A building is more complicated. 🐚

Order: Lampriformes (Tube-eyes and Ribbonfishes)

Many consider the order Lampriformes to be the sister group to the Acanthomorpha, which consists of Polymyxiformes, Paracanthopterygii, and Acanthopterygii. However, the structure of this order has been changed numerous times and will likely change in the future after further study of the group. These strange fishes possess no true spines within their fins. Some members of this order have a unique protrusible jaw with the maxilla sliding in and out of the premaxilla instead of being attached through ligaments. This order contains 7 families.

Family: Lampridae (Opahs)

Opahs have deep, compressed bodies, long dorsal and anal fins, and a protrusible jaw. Compared to other fishes within the order Lampriformes, the opahs are distinguished by a convex head when viewed in profile, a small oblique and terminal mouth, and an eye located laterally along the head. An interesting characteristic is that juveniles of this family possess small teeth, while the adults lack teeth entirely. The fins are typically slender with a deeply forked caudal fin. Opahs tend to occur worldwide in tropical and temperate seas in lower epipelagic, or the uppermost, zone of the ocean. Opahs feed primarily on squid and small fishes. There is a single genus within this family and only 2 known species.

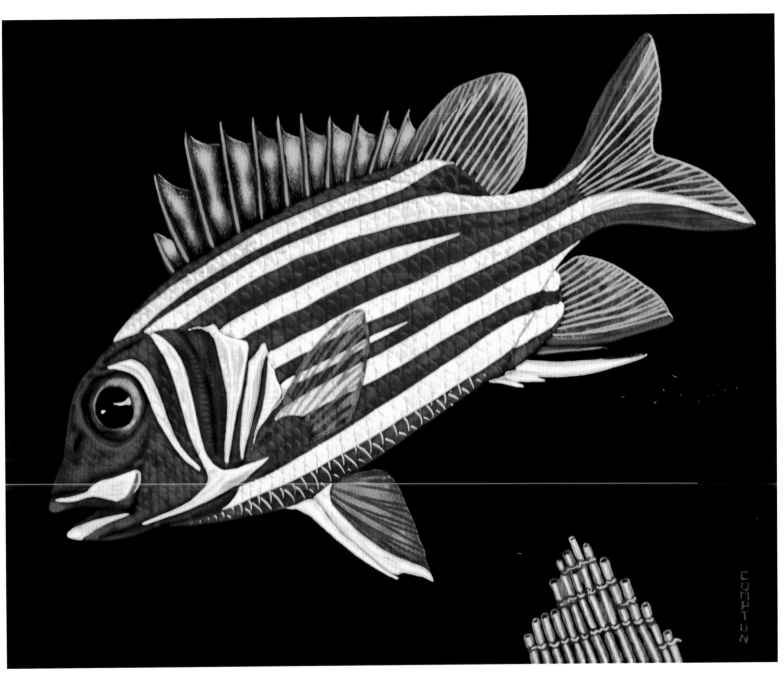

Redcoat

Sargocentron rubrum (Forsskal, 1775)

"If random passing whale fails to suck in 20–40 acres of this chowder, baby Squirrel quits nursery and flitters down to find reef where he grows fine red/white lines and spines and spurs and knives everywhere else but his nose."

Species: *Lampris guttatus* (Brünnich, 1788)

The opah, an oceanic species, has a worldwide distribution in both tropical and temperate waters. Occurring primarily in the epipelagic and mesopelagic zones, or uppermost and secondary oceanic layers, they are commonly found in depths of approximately 100–500 m. These fish possess a fairly deep body with a broad lunate, crescent shaped, caudal fin and long, falcate pectoral and pelvic fins of which the beginning rays are longer than those toward the rear of the fin. Countershading provides these fish with a unique pattern in which the dorsal surface is a dark blue while the ventral surface appears somewhat pink and purple. The iridescent body is covered in irregular spots, and the fins and jaws are vermilion. These fish feed primarily on small squid and fishes but may also feed on small benthic organisms. A recent study has shown the opah, unlike most species of fish, to be endothermic, capable of producing heat via its muscles and radiating that heat throughout the body.

(1) "What is this fish with night on his back and blue noon for his belt and sunrise on his belly?"

"He's not real," says Sandy Shannon who was ten and believed in birds and kittens but not in fish. "You shouldn't say 'belly.'"

Johnny Shannon, 12 years strong, knew anything could be real from spaceships to frogs in your pocket. "Come on, Sis. What would you call him?"

"I like him," said 5-year-old Sharon. "He's all over stars. I like stars."

Opah

Lampris guttatus

(Brünnich, 1788)

"What is this fish with night on his back and blue noon for his belt and sunrise on his belly?"

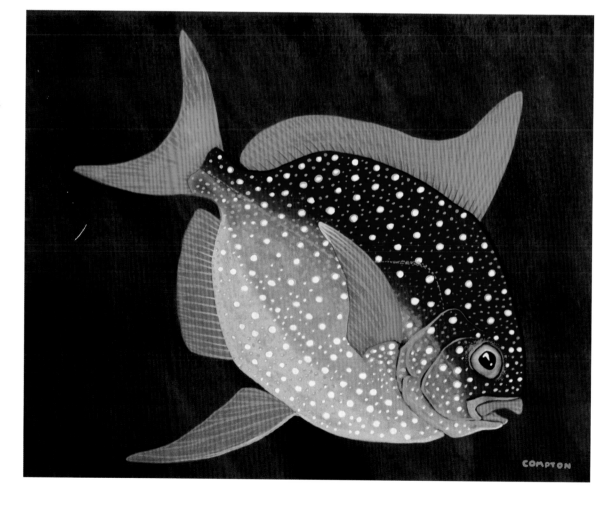

"Spots," shouts 8-year-old Kevin who was going to be a doctor and who saw disease in the patterns of butterflies. "Measles."

"Silly. Measles are red."

"Not on fish."

"Oh-Pah," grunted the fish. "Opah-pah."

"He talks," Sharon squealed and sat right down on him she was so astonished and he was so like a big colorful cushion the size of the dining room table with fins. But no one likes to be sat on. Not pigs nor squirrels nor little girls or even fish. Opah weighed 200 pounds of lively muscle under his shiny skin and he was built perfect to flip like a pancake. He flipped Sharon in a somersault right off of him. Sharon landed right on top of Kevin.

"Oof," yells Kevin. "You broke all my arms and legs."

"Oh—p-p-p-PAH!" grunts the fish loudly in approval and with that he flipped himself up and up and sprang over the ship's rail. The children ran to tell him goodbye and the big splash wet them all most satisfactorily from hair to heels.

"He's so pretty."

"Look how he does shine in the sun."

"He's so glad to be free. He's goin' round and round. Oh he looks like a carnival wheel all lit up."

They watched Big Opah flash back and forth in the clear blue Atlantic water as he faded away into the safety of the depths.

"What have you pestiferous youngsters done with our supper and breakfast and lunch and dinner?" asked the gruff voice of the Captain behind them.

Sandy giggled. "You can't eat fish for breakfast."

"When there is 200 pounds of him you have to."

Everybody was laughing.

"We couldn't eat him. He's so beautiful."

"I could," shouts Kevin. "But he has the measles. We'd all get the fish measles and grow fins."

"Well now, I didn't notice," says Captain. "We are lucky to have a medic aboard. I'd have to slit my new sweater up the back if I had fins. But seriously, I believe we would have thrown him back anyway. He is a very rare fish and usually caught in deep water on long lines strung out on buoys for miles behind a boat to catch those black and silver swordfish everybody likes to eat in cafes along the waterfront. Do you remember, Johnny, when we made trotlines with floats and the hooks hanging down on 3-foot of line from the mainliner every 6 feet? To catch catfish in the lake?"

Everybody remembered.

"Ol' Catfish stung me with his fin," says Kevin, "and I cut his head off quick."

"I don't remember that," says Sharon.

"Now those longlining swordfishermen have a kinda trotline but they fish their hooks way down 300 feet deep. How would you like to pull in all that line?"

"A whole football field of it," said Johnny. "I'd do a winch."

"I'd do a big 'lectric winch and 'fore that of Swordfish can stab me in the gut," Kevin made a truly terrible face, clutched his middle, rolled in agony on the deck and jumped up, "I'd quick cut his head off."

"Ugh," said Sandy. "Don't say 'gut.'"

"Gut, Gut, Gut," says Kevin.

"Shut your squabble," says the Captain. "In the Pacific whenever my friend Don Ko catches an Opah on his longline, he lights a joss stick to burn sweet smells to the sea-god for giving him this fine fish because his wife will buy a new kimono in all the blue and red and pink and white and silver colors of Opah."

"Let's go quick see Don Ko and his wife's kimono," cry Sandy and Sharon.

"We will," says Captain. "We were lucky to catch Mr. Opah on our one little line. Now are you ready to bait up again and see what the sea has for us this time?"

Everybody was ready.

"Grampah!" said Johnny who always looked forward to supper, "this time we gotta catch us a UGLY fish."

"With no SPOTS," shouts Kevin the Medic. 🐚

Order: Perciformes (Perchlike Fishes)

Perciformes, the largest of all orders of bony fishes and all living vertebrates, is also the most taxonomically and morphologically diverse. This order comprises approximately 150 families and 10,000 species and is constantly being rearranged taxonomically. Perciformes is

named for the Greek word *perke*, meaning "perch." A vast majority of perciform fishes are marine and reside nearshore. However, approximately 2000 species occur in fresh water for all or a portion of their life history. These are true spiny-rayed fishes with pelvic, dorsal, and anal fins all having spines. Members of this order typically possess ctenoid scales, and a lateral line is normally present.

Family: Acanthuridae (Surgeonfishes)

Members of this family are labeled with a myriad of common names but are most often referred to as surgeonfishes or tangs. These fishes are laterally flattened with eyes placed high on the head. The family name is from the Greek *akantha* (thorn) and *oura* (tail). The etymology of the family name refers to sharp, retractable spines located on each side of the caudal peduncle, or base of the tail. These spines are actually modified scales, present in most species, which serve as a defensive weapon against predators. In several species, both the dorsal and caudal spines possess toxins. Members of this family are found throughout the tropics and are some of the most common group seen among coral reefs. These fishes typically travel in large schools and are commonly seen grazing on algae. Although a large portion of surgeonfishes exhibit dull coloration, some species are known for their bright colors and are highly sought after for use in aquariums.

Species: *Acanthurus achilles* (Shaw 1803)

The Achilles tang is found throughout the Pacific Ocean and occurs in clear water around reefs. These fish are primarily dark brown or black but possess a light blue ring around the mouth and the gill opening. Often called the red-tailed surgeonfish, this species is recognized by the red color on the base and forward edge of the caudal fin. There is also a red teardrop-shaped area directly in front of the caudal fin along the middle of the body. Juveniles lack this distinguishing red teardrop spot. Like other surgeonfishes, the Achilles tang is equipped with a spine along either side of its caudal peduncle, which lies in a small groove. These fish are commonly

known to actively drive away intruders that venture too close, whether another fish or even an occasional human. This species feeds primarily on marine algae.

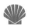

(16-A) Red-Tail is a survivor of scientific wars. He was first well strangled with an exotic South American/African fish poison. To see how many he was. Obviously they failed to gasp all of him since he still greets the reef sun of a morning. This was only prelims. Through 12 years and 64 Bang-Ohs! he was tested. See could he and islands, reefs, palms, pea-crabs, Grunts, Gobies and Gulls absorb death and radiation and grin.

Obviously he did—this fighting beauty with the big red stylistic heart on his sides, or blood-bright shape like old time planchette that skidded under fingertips round-an-round the Ouija Board to tell of past and future, or familiar cheerful glittering red string-plucking Guitar Pick to ramble sad ballad or rollicking jumpfoot. Red-Tail still plays with bubble curtains in the coral surf of Bikini and Enewetok Atolls. 🐚

Species: *Acanthurus leucosternon* (Bennett 1833)

The powderblue surgeonfish inhabits shallow coastal waters as well as flats around coral reefs. It is found primarily throughout the Indian Ocean with a small range in the western Pacific Ocean. Despite this restricted range, it has been found on occasion in areas surrounding the Hawaiian Islands. Like other members of this genus, this species possesses a compressed ovoid shape and a small mouth. The pectoral fins are long, and the remaining fins are noticeably rounded in shape. The primary body color is blue, while the head is covered by a black mask and a white band from the pectoral fin across the throat. The dorsal fin is a striking yellow, and the remaining fins are white. These fish can be found either alone or in large groups while feeding. This monogamous species is sexually dimorphic, with males being significantly smaller than females. Diet consists primarily of algae.

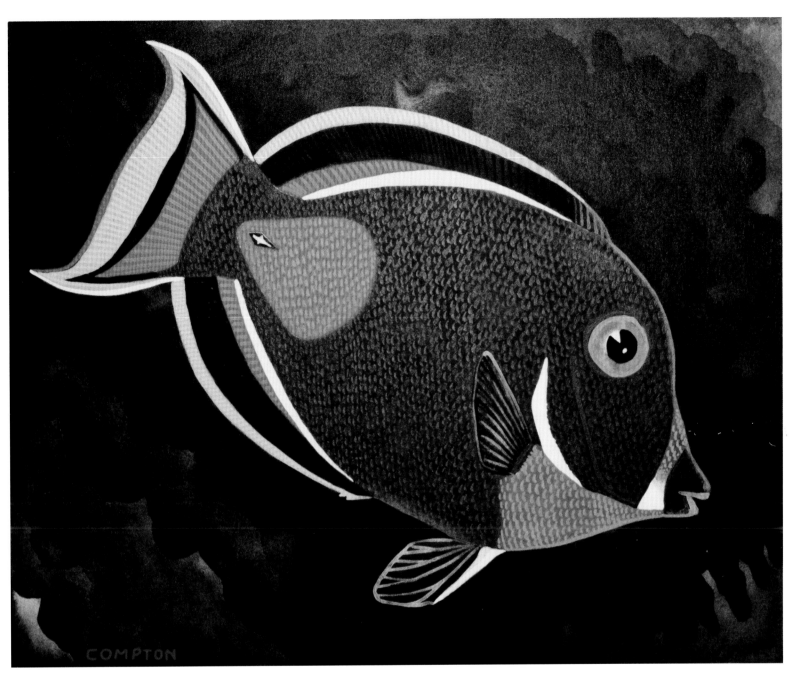

Achilles tang

Acanthurus achilles (Shaw 1803)

"Obviously he did—this fighting beauty with the big red stylistic heart on his sides, or blood-bright shape like old time planchette that skidded under fingertips round-an-round the Ouija Board to tell of past and future, or familiar cheerful glittering red string-plucking Guitar Pick to ramble sad ballad or rollicking jumpfoot."

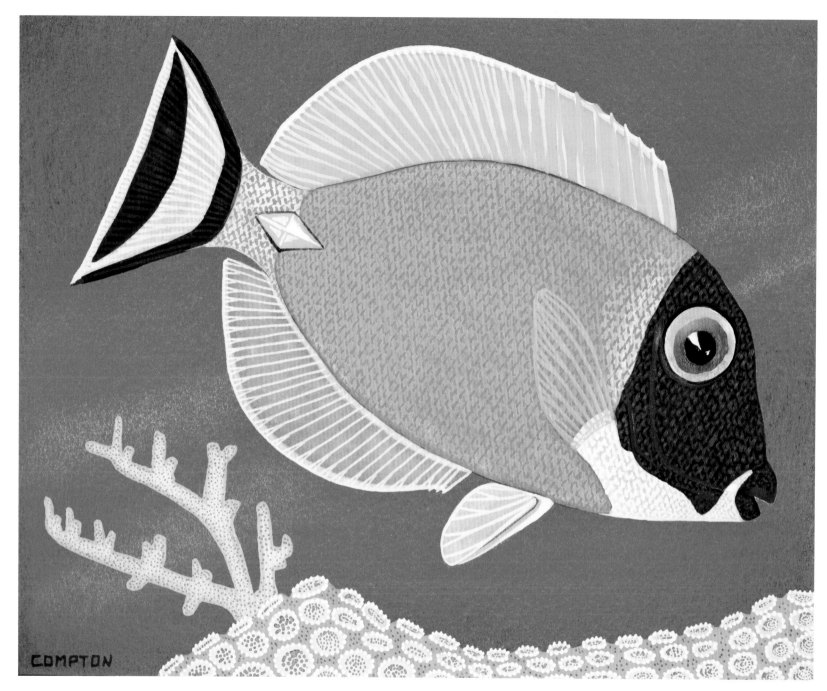

COMPTON

Powderblue surgeonfish

Acanthurus leucosternon (Bennett 1833)

"The Pacific fish who swim these hungry forests bear on each side
their bodies at the tail, the switchblade, the flick-knife, the erectile
hidden dagger. In long diamond sheaths. To spring angled point-
forward. Razor ready."

(16) Some kinds of coral grow as graceful Winter branches flowering to Spring each time and tide the waters run with minute life—thin soup—the flickering pin-point moths and infants of the sea. The flowers flick them in and suck them gone and grow and multiply and spread wide reef their stoney tree. Some coral spreads deadly living carpet hard as cobble and soft as lifted feeding fingers. A mosaic of hungry petals to snatch at life.

The Pacific fish who swim these hungry forests bear on each side their bodies at the tail, the switchblade, the flick-knife, the erectile hidden dagger. In long diamond sheaths. To spring angled point-forward. Razor ready. The fish do not attack the old, the halt, the hapless, the helpless. Nor bully the young. But let the giant come, swim and swish, trespass he is, and they love a challenge when he is three times their own 6–12 inch selves. They cut ribbons from him in a hurry.

The coral does not know how to handle fish-sticks fallen on it and waits for crabs to clean its faces. The fish do not eat fish-sticks. They eat greens like so many knife-carrying rabbits.

They are somewhat wildly called Surgeonfish and Doctorfish and Stickfinger and Medico and Barbero, but sometimes more to the point, Tang, which means the cross-tongue of the dagger between blade and butt. Saves fingers in knife fight. The fish are the handle, the diamonds the tang and the blade is what tickles the grouper, the snapper and the shark. 🐚

Species: *Acanthurus olivaceus* (Bloch & Schneider 1801)

The orangespot surgeonfish is found throughout the Indian and Pacific Oceans. Adults of this species inhabit seaward reefs and areas of rock and sand. Like other surgeonfishes, adults can be found alone or in groups often while feeding. Juveniles of this species typically inhabit protected areas of bays and lagoons. Adults exhibit a gray background with the anterior portion of the body a much lighter shade of gray. As the name suggests, this species is noted for the large horizontal orange spot that can be seen just behind and above the gill opening. Juveniles are strictly a uniform bright yellow, and adult colors develop with age. This species feeds on diatoms, detritus, and filamentous algae that occur on and around the rocky environment in which they live.

(16-D) Another veteran of Bikini/Enewetok. Put up with all man's Pop!headed furies dumped on him. Forced to face atoms, he endured and still owns his twisted reefs. So far he has not mutated 17 eyes, a mustache, and two and a half pair of feet.

Solemn Fish-Experts, who should know if anyone does, say that this fairytale prince or princess mostly looks like an olive. If so, must be when he/she are scared out of their skin. If so, that red blob must be the stuffing pimento. 🐚

Species: *Paracanthurus hepatus* (Linnaeus 1766)

The palette surgeonfish, also known as the Pacific blue tang, occurs throughout the Indo-Pacific with a small range along the coast of East Africa. This species is known to inhabit clear waters along reefs. These fish possess a compressed, oval-shaped body. They have a bright blue background with a black mask along the eyes that extends along the dorsal region of the body, the caudal peduncle, and caudal fin. The caudal fin also has a large triangular wedge of yellow. Adults are often seen in small groups along the bottom, while juveniles and subadults are found near *Pocillopora eydouxi* coral. These fish feed largely on zooplankton and may occasionally graze on algae.

(16-C) Big Blue swims many seas and oceans. From the red coral of East Africa to the breakers of North Queensland to the green holes of the Philippines to the foaming reefs of Fiji. To sit on a coral hump with 36 of him in flight maneuvers dive, loop and spin for fish flakes and chopped frozen spinach hand-tossed is to lose the breath and suck divetank empty before its time like first time Tank Tommy. The only thing blue-er in all the world, under the skin of great waters or above it, is 106 Indigo Buntings. 🐚

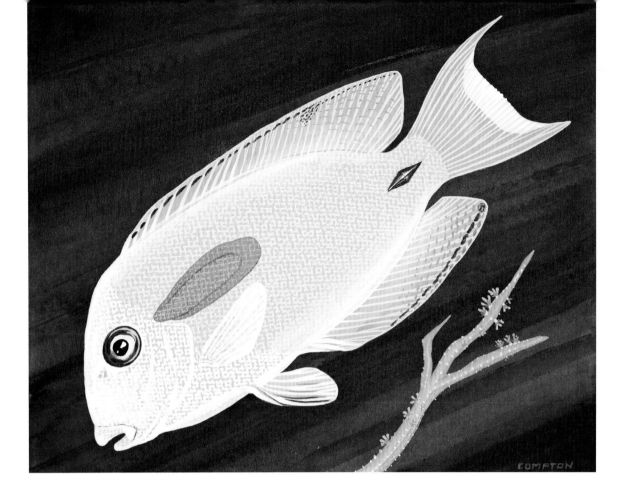

Orangespot surgeonfish
Acanthurus olivaceus (Bloch and Schneider 1801)
"Solemn Fish-Experts, who should know if anyone does, say that this fairytale prince or princess mostly looks like an olive. If so, must be when he/she are scared out of their skin. If so, that red blob must be the stuffing pimento."

Palette surgeonfish
Paracanthurus hepatus (Linnaeus 1766)
"Big Blue swims many seas and oceans. From the red coral of East Africa to the breakers of North Queensland to the green holes of the Philippines to the foaming reefs of Fiji."

Species: *Zebrasoma scopas* (Cuvier, 1829)

The twotone tang, sometimes referred to as the brown tang, is commonly found throughout the Indian and Pacific Oceans. These fish are distributed from the eastern coast of Africa to southern Japan. Most often found in areas of dense coral, they can be seen in both reefs and shallow lagoons. This tang exhibits a compressed and discoid body shape with a small tubular mouth. The dorsal and anal fins are rounded. The body itself is primarily dark brown with a hue of fine green lines following the rows of scales along the body. These lines break up into smaller dots along the head. Juveniles of this species have yellow bars and specks along the body. Adults are most commonly seen in small groups and may occasionally exhibit schooling behavior. Larger aggregations may be seen during spawning events with individual pairs and small groups spawning together. Juveniles remain as solitary individuals and live among the dense corals. These fish feed largely on algae. Although less colorful than similar species, they are somewhat popular in the aquarium trade despite being highly aggressive and territorial.

(16-B) In the bar on Heron, a doctor told some new friends, "You must take the forest tour tomorrow. I'm making my kids get off the Reef for a day. They need some bird experience. The whole performance took me right back to my youth and halcyon days of rap-rip and ghetto-blasters. Those birds do it all. These Aussies just have to go to the woods to get the effect."

On the Reef, below Heron Island, on a glass-bottomed boat sat peering between feet a tourist group smelling strongly of salt, sweat and suntan lotion.

"Where are these Golden Tangfish we are promised?" asked Fat Lady.

"Right there, Mum," says Guide. "Ain't they dink? See 'em in the Ladyfeet Coral? We scared 'em a bit. They'll settle."

"Those brown fish? Plain old chocolate? THAT is the fish you said, 'You gotta see 'em. They are bonzer, mates, and we'll look 'em up tomorrow. Take you to private reef of 'em. Liken to Ned Kelly's roadgold, they are.' This brown nothing?"

"Now, Mum. I tole you they are unaccustomed to sudden startles. They'll soon turn bright and pretty for you. You watch." Guide told his Deck-Kid handling anchor to slip her 4-foot. Fat Lady's Niece told Guide, "Ooo-er, the lovely Darlings!" Niece was a frizz-hair lovely darling herself. Guide told Deck-Kid to point out other Reef beauties to Miss F. L. Niece.

Suddenly all the big brown Tangs flowed molten gold and began to fight and flicker for the rabbit pellets Guide was thumbing under boat. Looked like water ballet of golden hubcaps.

"Oh!" Many "Oh's!"

"No!" says Guide. "No! Mum!"

But in fine exuberance, Fat Lady over-balanced, slammed Niece into Guide and herself into Niece. Overside. Bonzer splash. Deck-Kid jumped to balance view-boat before swamping and set remaining tourists to sponge bailing to clear their foot window.

"Joey," says Guide, standing bathers deep on coral head, "TAKE this mermaid." Niece giggled and was thrown into Joey's arms.

"Don't drop 'er, Joey," says Guide. "Use some blasted sense. Two of you get that glass dry so others can enjoy these Reef-Beaus."

"Hah!" shouted Fat Lady, now up on coralhead with Guide.

"Watch it, Mum!" But shouting vibrates the body and unsteadies the feet on roundish coral. Bonzer splash. All the fish turned brown.

In Heron bar that evening the going sun clawed the Reef with running gold and dimpled blue. Light of sky and Reef swept into, through and out the great windows. Fat Lady and the Doctor and his wife discussed with shouts of laughter their amazing adventures.

Guide told his cobber, "Don't know if she plans to mash me to dust or drown me. Can't tell with her. I've gone fond of 'er. We had them Gold Sticktails not goin' crook no more. They've got so taken with us and them alfalfa pills, they just give up an' stay Gold to please 'er. I'm flyin' 'er Croc-looking tomorrow. Don't believe she'll go to market with thirty feet o' lizard."

"Where you want the hide sent when we gotta shoot the Croc to recover you two out of him?" 🐚

Twotone tang
Zebrasoma scopas (Cuvier 1829)
"Suddenly all the big brown Tangs flowed molten gold and began to fight and flicker for the rabbit pellets Guide was thumbing under boat. Looked like water ballet of golden hubcaps."

Family: Apogonidae (Cardinalfishes)

Cardinalfishes are small reef fishes that are commonly identified by their short, compressed bodies; short, separate dorsal fins; and most notably their large eyes. As the common name suggests, many members of this family are red. These fishes are most commonly found in tropical waters, but a small group of brackish specimens and a single freshwater species can be found in the Indo-Pacific. The family name derives from the Greek words *a* and *pogon*, meaning "without" and "barbed," respectively. Most cardinalfishes are relatively secretive during daylight hours and prefer a nocturnal lifestyle. They feed on an array of zooplankton and small benthic invertebrates. A large majority of cardinalfishes are mouthbrooders, with the males typically carrying the eggs. Interestingly, several species are inquilines and spend much of the time living within the body cavity of sponges and mollusks, with several species being closely associated with sea urchins. A large family, Apogonidae consists of approximately 200 species among 20 genera.

Species: *Ostorhinchus cyanosoma* (Bleeker, 1853)

The yellowstriped cardinalfish is found throughout the Indian and western Pacific Oceans, typically in sheltered lagoons and reefs to a depth of approximately 50 m. This small cardinalfish exhibits a typical body plan seen in other members of this genus; however, it reaches a maximum length of approximately 8 cm. These fish possess an elongate and compressed body with two short dorsal fins and a somewhat long caudal peduncle. They have a short snout, and the terminal mouth is somewhat oblique. The fish is silver with six orange or yellow stripes running parallel with the body. These stripes terminate near the caudal peduncle, which has a pink or orange spot at the base of the caudal fin. Like other cardinalfishes, the yellowstriped cardinalfish also has a characteristically large eye. Found in both small and large groups, this species frequently can be seen among ledges or holes in the reef. Individual pairs may be seen during courtship prior to spawning. These fish feed on a variety of planktonic organisms, including crustaceans and invertebrates.

(5-A) We swam to the prettiest grotto, if that's a cave with a hole in top. One side was dark and scary. But we weren't afraid. Our bubbles ran up the walls and under the ceiling and out the hole and all mingly in the bubbles were the prettiest some kind of Cardinal-fishes playing around and biting the littlest bubbles. We don't know why. We don't want to know why. We are gonna make somethin' up later. 🐚

Family: Blenniidae (Combtooth Blennies)

The combtooth blennies are small, bottom-dwelling fishes. These fishes typically occur inshore in shallow temperate and tropical seas around the world with only a handful of species occurring in brackish or fresh water. These small fishes possess relatively deep bodies with blunt snouts. Most species have cirri, or featherlike projections around the eyes. Distribution and appearance of these cirri are often species specific. The dorsal fin is continuous in most species, with some possessing a notch between the spines and rays. The pectoral fins are very large relative to the size of the fishes, and jugular pelvic fins exhibit a very small spine. These fishes have a varied diet, with some feeding on algae and invertebrates, some being planktivorous. Females, which are oviparous, lay their eggs in small crevices where they adhere to the surface of the substrate. Eggs are often guarded by the male or in some cases both parents. This rather large family consists of approximately 350 species within 50 genera.

Species: *Plagiotremus rhinorhynchos* (Bleeker, 1852)

The bluestriped fangblenny is found primarily in the Indo-Pacific with some small populations near the Red Sea down to South Africa. Adults tend to inhabit clear waters near coral in lagoons and reefs. These small fish often occupy worm tubes or small holes in the reef and retreat quickly when distressed. Coloration is often variable, ranging from black to yellow, with two blue stripes running longitudinally along the body. The body of these fish is covered in a toxic mucus. Females, which are oviparous, lay eggs that attach through an adhesive pad. Upon hatching, larvae are typically found

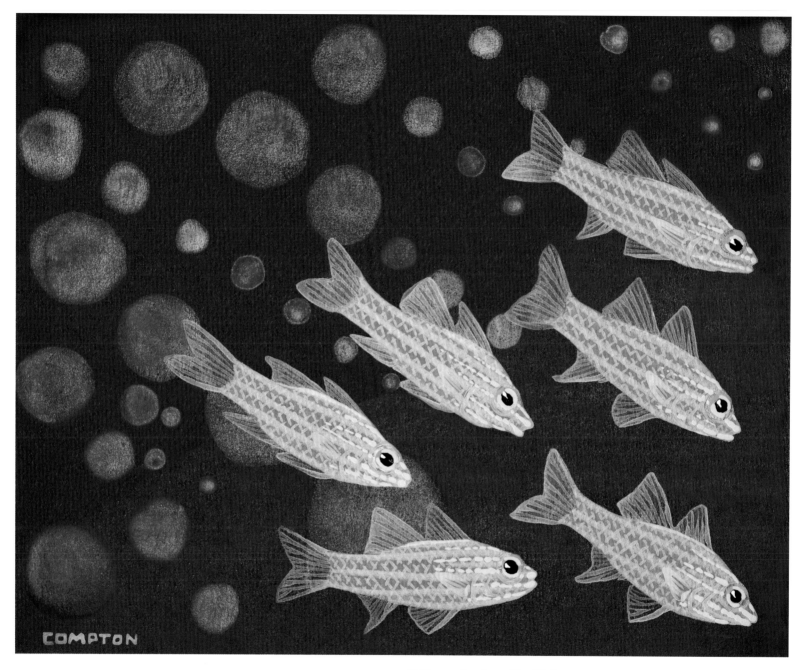

Yellowstriped cardinalfish

Ostorhinchus cyanosoma (Bleeker, 1853)

"Our bubbles ran up the walls and under the ceiling and out the hole and all mingly in the bubbles were the prettiest some kind of Cardinal-fishes playing around and biting the littlest bubbles."

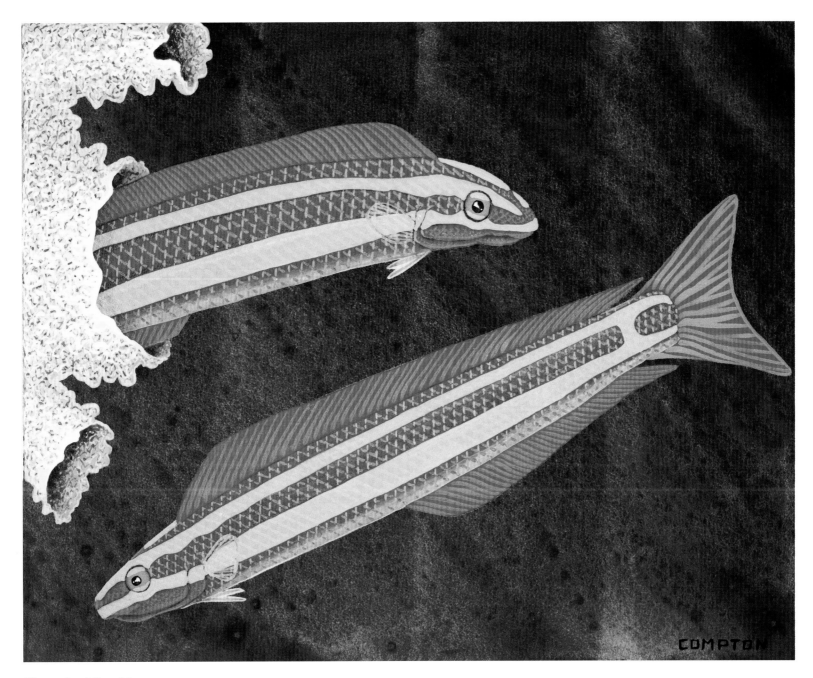

Bluestriped fangblenny

Plagiotremus rhinorhynchos (Bleeker, 1852)

"Little Saber is a Blenny who eats scales off passing fish. He jerks them semicircle from living hide. Most Blennies do not practice such."

in coastal shallows. Interestingly, the diet of this species consists of the skin, mucus, and scales of other fishes. Juveniles have been found to mimic *Labroides dimidiatus*, which is commonly known as the cleaner wrasse. Even going as far as changing coloration, these clever mimics wait at cleaning stations and feed on passing fishes.

(25) Little Saber is a Blenny who eats scales off passing fish. He jerks them semicircle from living hide. Most Blennies do not practice such. Most Blennies are small big-headed Jawfish-looking clowns with their fingers on top of their heads like sudden tree. Saber has no fingers. He has no need of fingers. He nips out of the goodey hole, nips and nips back to ambush.

Minnows and small fish of all kinds will, underwater of course, nibble at leg hair and arm hair no doubt considering them a field of baby worm. Won't bother armpit and head hair. Too much like snakes. Saber does not nibble. Nor is he interested in worms. He wants torn off scale with meaty base like flat soupbone. On the scaleless he will settle for a chunk of hide itself.

The Kellys & the Shannons on the Reef have made many interesting experiments. Usually using Danny & Kevin as what they call "culture media" or sometimes "control animals." D & K are skin-examined for previous flaws and then, with suitable incantations, staked out like mostly naked goat before the caves of various Sabers. D & K unfortunately have had to be heavily threatened, black-mailed for so far undiscovered (by Authority) misdemeanors and felony, and even as last resort, bribed.

"Where's your scientific integrities?" said Johnny.

"Yeah," said David. "Pasteur shot hisself with cowgirl pus." David was becoming an aficionado of U. S. wild west doings and often mistook his geography.

"Reed let them moskeeters bite on 'im 'til he dropped on floor and he never says, 'Oh. Ouch.' Not him. You two is sissyfish. Why," says Johnny, "I'll bet Deck Dog and Miss Fortune would be proud if we give Them a chanst to be scientific marvels. Have to shave 'em first."

A growl and a jungle snarl derailed this train of thought.

"Scaredy Cat," says Sandy & Nancy who were arranging tape, scissors and iodine in tray. They wore improvised "Nusses" hats. "Pretty baby is only long as your hand."

Miss Fortune indicated with white-spiked Yawn where she considered handfish belonged.

"No," says goats.

Sharon & Nell wore not only "Nusses" but red cross armbands as well. Area looked ready for disaster.

"No," says goats.

"How much?"

Stakeout proved to be both surprising and educational. Sabers fell on goats with gusto but seldom tasted blood. Most Sabers, finding neither scale nor any feastable substitute, lost interest. But, two separate Sabers developed a taste for BOY and became what Johnny had Sandy & Nancy enter into notes—MANEATERS.

Experiment 3–2K-14: Some speculations on Ferocious Behaves of MANEATING FISHES on Humans Skins with curtsy—Dr. J. Shannon * Dr. D. Kelly, records N. Kelly * S. Shannon, Nuss in attends Nell and * Sharon.

"Dammit, you messin' tablet up."

"We ain't Them an' they got our 'nitials."

Experiment 3-etc. was concluded before "compleatings" as K. Shannon & Danny complained, having to return 3 watches, 4 apples, dive belt chewed on by Deck Dog, 2 half-eaten sandwiches (by Deck), a string of PEARLS reputed to be worth the 4th watch, and $1.15 in real coin of 4 countries.

Nell & Sharon were sorry also. "We thought them fish was to eat-um-up. Ever bit-of-um." Spoken with more relish than research zeal. 🐚

Family: Chaetodontidae (Butterflyfishes)

Butterflyfishes range from tropical to temperate waters of the Atlantic, Indian, and Pacific Oceans. However, a vast majority of species within this family reside within the Indo-West Pacific region. The family name derives from the Greek words *chaite*, meaning "hair," and *odonotos*, meaning "teeth." Butterflyfishes are most commonly found among coral reefs and represent some of the most common species in this type of habitat. Most species exhibit bright colors

with a dark band across the eyes. A large majority of species within this family display yellow coloration. These fishes have deep, compressed bodies and a continuous dorsal fin. Having a small terminal mouth, these fishes are named for their small, brushlike teeth. Most feed on polyps, invertebrates, algae, and fish eggs. Several species are also specialist feeders or planktivores. A large number of species occur in heterosexual pairs and commonly are known to spawn in the pelagic zone. There are approximately 130 species found within 12 genera.

Species: *Chaetodon collare* (Bloch, 1787)

The redtail butterflyfish, also referred to as the Pakistan butterflyfish, is found in tropical waters of the Indian Ocean and western Pacific from the Persian Gulf to Japan and Indonesia. Like most other butterflyfishes, this species tends to occur near coral reefs. However, members of this species are often seen in pairs, especially during the breeding season. Groups of juveniles can often be seen; however, adults seem to be somewhat territorial. The body plan is typical of butterflyfishes. This fish is gray and has scales along the body with a dark edge and golden center. A black bar extends from the leading edge of the dorsal fin through the eyes onto the operculum, and another black bar is present along the snout. Each of these is divided by bright white bars. A characteristic of this species is its dorsal fin, which is black, red, and white. The caudal peduncle is typically bright orange with a black line running vertically along the center, and the edge is nearly transparent. Feeding primarily on coral polyps, this species will also potentially eat a variety of invertebrates.

(24-D) Spots are holes, stars, sneezes and moons. The Pakistani is in crescent phase. Fish of the Seven Hundred Petals he was called by the forgotten people of the Arabian Sea where India would be and they carved him and painted him on lost cave walls above the Indus River.

Before I left Florida to wander young and lost touch with all those folk and their fishes, I remember *Riff-Raft* was in port and

them bigger girls gave me a chain with right stud Paki Fish enameled and hung on it for neck. Said males wore 'em. Mighty pretty fish and I have never lost 'im nor only hocked 'im twice. 'Fore I hit road out, me an' them bigger males traded threeway black eye, black as Pak's fins, and all was happy. 🐚

Species: *Chaetodon ephippium* (Cuvier, 1831)

The saddle butterflyfish is a tropical species with a range extending from the eastern coast of Africa, across the Indian Ocean, and throughout the Pacific to the Hawaiian Islands. Like most other butterflyfishes, saddle butterflyfishes occur in lagoons and reefs and prefer areas of dense coral. They have been documented to occur in pairs, groups, and in some cases as solitary individuals. However, unlike those of similar species, juveniles tend to occur inshore and lead a primarily solitary existence. These fish are light gray with a black saddle along the rear portion of the dorsal surface that is lined with white. The posterior edge of the dorsal fin, as well as the caudal peduncle, is typically bright orange. A black eye band, seen in younger individuals, is lost with age. Interestingly, the age of this species can be determined in some cases by the length of the filament present on the dorsal fin. The saddle butterflyfish has a varied diet and feeds on algae, invertebrates, coral and coral polyps, small fishes, and fish eggs.

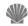

(13-C) When Sandy was Pacific she liked a butterflyfish who looked like she (or he) should be an Angelfish.🐚

Species: *Chaetodon larvatus* (Cuvier, 1831)

The hooded butterflyfish is found in the western Indian Ocean and commonly occurs throughout the Red Sea and Gulf of Aden. This tropical species, like many other members of the family Chaetodontidae, is typically associated with shallow reefs. Exhibiting a body plan typical of other species of *Chaetodon*, the hooded butterflyfish is named for the brown or yellow mask that covers the head. The body has a white background near the anterior

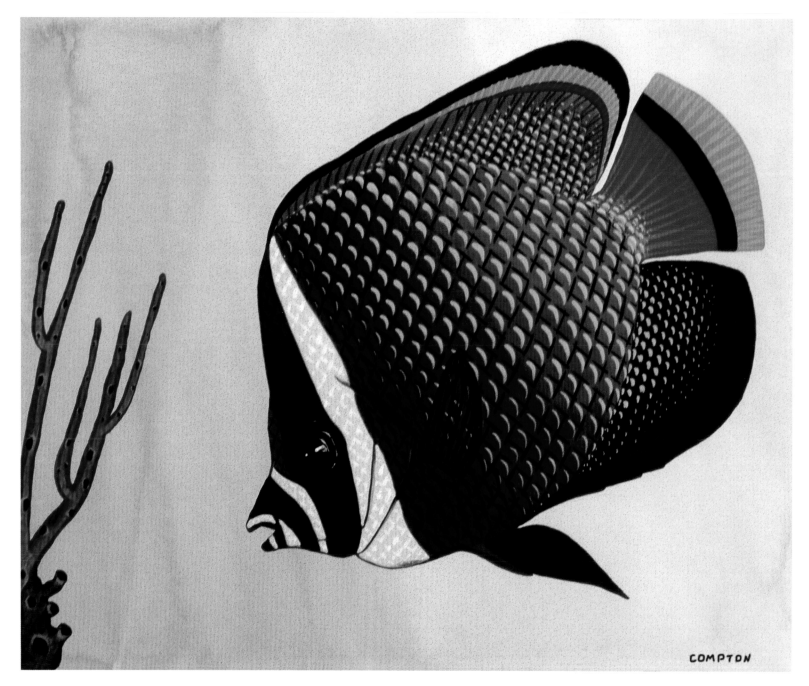

Redtail butterflyfish

Chaetodon collare (Bloch, 1787)

"Fish of the Seven Hundred Petals he was called by the forgotten people of the Arabian Sea where India would be and they carved him and painted him on lost cave walls above the Indus River."

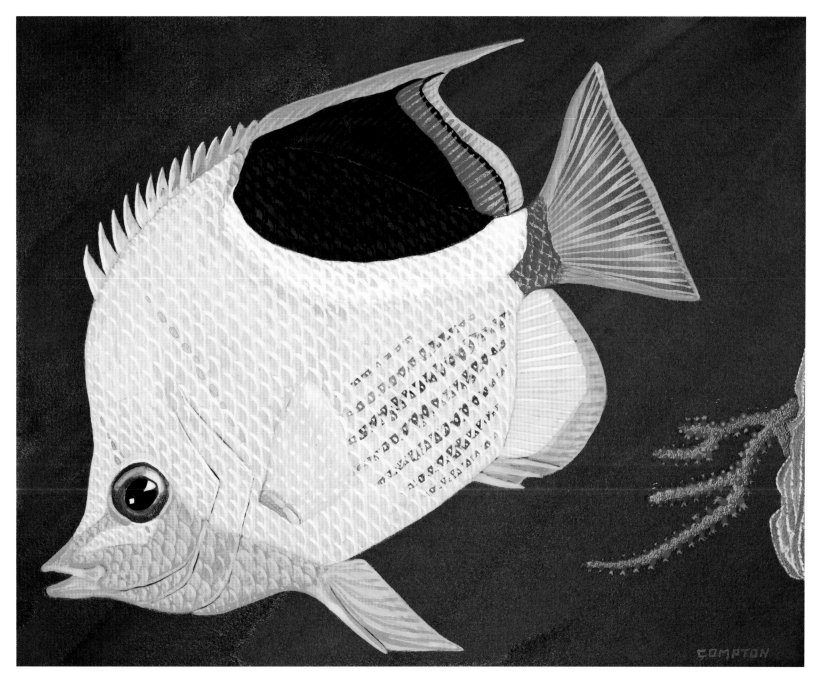

Saddle butterflyfish

Chaetodon ephippium (Cuvier 1831)

"When Sandy was Pacific she liked a butterflyfish who looked like
she (or he) should be an Angelfish."

Hooded butterflyfish

Chaetodon larvatus (Cuvier 1831)

"At 50 feet they reached the limit of the coral. Redhead would go no farther. Hard and spikey corals were his house and hunting thickets, his haven-home."

44

region, and the posterior is typically a dark blue. There are a number of narrow, white arrow-shaped lines along the sides. A noticeable white line can be seen from the tip of the dorsal fin, across the caudal peduncle, and down into the anal fin. During the breeding season, hooded butterflyfish form pairs and may be highly territorial. Feeding almost exclusively on polyps, this species is commonly seen in association with *Acropora* coral.

(13-E) Every kid knows a million years is what it takes to learn where your clean socks are kept. And startin' a beard under your nose. Well, 80 million years ago old Earth cracked a slit in her skin and made the Red Sea. That's a lot of socks. Atlantic and Mediterranean poured in to fill slot and all the little seababies floating around came in to grow into coral and crabs and oysters and octopus. Whoever they had trained to be. All kinds of fish, big, little, shy, FEROCIOUS, sad-colored and bright, came in. Everybody set up house happily in the reefs and on the beaches and down in the deep middle.

Some of the fishes left and some came and went like butterflies didn't know which flower they wanted to live around but one butterfly stayed and never wandered and that's where you will find him to this very day. Ol' Redhead of the Red Sea. Now the Red Sea as you know had the Suez Canal dug between her and the Med and great ships walked her back and forth to India.

One sandblowing day, in a big hurry, a big oil tanker put her steel feet onto the reefs by Egypt but the coral was harder than the horns of all the dead buffalo and old Tanker walked on trouble. The antlers of the coral opened up her rusty bottom like sardine box and the oil poured out. Gusher. Rushed out wild and thick and black and gold and killing.

The little animal flowers of the coral died within their cups. Stuck in their cement. Unable to flee. Fast fish fled the area. Slow joes, infant minnows, scatter-brained shrimps and elderly Groupers turned belly-up to float to the sun. Those fish who admired and used HOLES retreated into them and were entombed. All the clams slammed their double shells shut with a watery bang! and firmly starved.

In the middle of all this hoo-ha the brightest Redhead of the reef sniffed disaster and saw ribbons of oil clotted to rusted metal flakes falling all around him. Like black toilet paper trashing underwater forests. He tightened his scales, flicked his fine black tail and led his immediate neighborhood into the escape route of the tortuous tunnels winding through coral jungle to clean deep water and safety.

What a little following he captained! There was his beautiful mate, a red-head brilliant as himself. She flanked him, close to touch his side at times. He had never known his parents; he was born of drifting egg in open sea, but there were brothers and sisters schooled now behind him. And some Butter-cousins of flat body and many colors. Three little yellow reef-bass; two adolescent Trumpetfish scared out of their usual heck-raising and along for the comfort of leadership; and young DimDome the Grouper, 15 inches of puppy playfulness who was a plague to everyone except the Trumpers who liked to lay their long tube-bodies along his sides and ride him.

The Redhead as long as he had his mate in touch never bothered his mind with who else was in the sea unless it was planning to eat them. Oil was new experience. All his senses told him, "Git, Bro, Git." Tracking the scent of clean currents he led them always down away from evil falling. Through the fingers of the coral clinched to dead-end and small-gate open to life he led them. Doomed hole-dwellers watched them flit past. DimDome lost some scales on squeeze corners.

At 50 feet they reached the limit of the coral. Redhead would go no farther. Hard and spikey corals were his house and hunting thickets, his haven-home. Here day was smaller. As the clocks above in Egypt and Arabia clicked 3:00 pong-pong-pong, here dusk was creeping up from the dark channel and opening the feeding flowers of the coral. Redhead flicked his fine black tail against his mate's and they ate two-three early night daisies coral was blooming. They found this succulent crab and that juicy climbing worm and the other shy shrimp hid same-color on coral prong.

Redhead found the perfect picket-fence lattice-walled vertical cave to back themselves into so that he closed the opening with his red head, his mate a little behind him so that they fanned side-fins on each other's scales and waited the night of hungry coming

teeth so that he, without teeth or even claw, protected her until the 10 o'clock dawn with his body.

The weeks passed and the months. The Trumpetfish had become cliff-dwellers in the sea-whips of the reef-edge. DimDome, to alls' relief, had set up happy groupering lower down. His mouth had grown too wide a hungry grin for any small fish to consider him safe. All coral was dead above them. Growing over with a sponge or two. Their coral was growing to the sun to get the reef going again.

One liquid sunstruck day, Redhead showed off in zigzags, head-stands, loops, rolls, spins and 4th of July tail-wagging. His mate was not herself wildly impressed by these monkeyshines. She didn't cartwheel and carry-on. She swam here and there with her nose tilted in Poo!, watching this nut cavort.

She chose an open space about the size of a bicycle wheel and began to lay eggs. Many eggs. Many, many eggs. In clouds rising. Redhead like a good FishPaPa began to fertilize these many-many eggs in clouds rising. As the marvelous tiny crystal-marbles rose to the sunlit surface, HOPE went with them. Redhead's great-great-great-g-g-g-g-g . . . grandchild with luck might see new reef and Red Sea dawn at surface sunrise. 🐚

Species: *Chaetodon melapterus* **(Guichenot, 1863)**

The Arabian butterflyfish is found throughout the western Indian Ocean and is common within the Persian Gulf, Gulf of Oman, and the Red Sea. These fish are commonly encountered in areas of dense coral along shallow coastal reefs. This species possesses a body plan similar to that of most other butterflyfishes with the base coloration bright yellow. The caudal peduncle and dorsal, anal, and caudal fins are all solid black, and the edges of each are lined with yellow. The head is yellow with several black bars from the lips to the operculum. Occasionally seen in small aggregations, they are typically solitary individuals. Breeding pairs may form during spawning season. Like many similar species, the Arabian butterflyfish feeds exclusively on coral polyps.

(21-B) Third hair jerked. WHOP! Right pole decorated with stunning dropcloth painting of Blackfin Butterflyfish miraculously accomplished in basic tone materials, the exquisite sheening black being the result of long experimentation with blue clay, fishbone charcoal, ground tree-rat turds and spit.

"Stand," shouted strong voice.

Priest and people just managed to support one another weakly erect, jingling like stormwind was upon them, shaking the beach from themselves. Against a pearl dawn sea stood three shimmering fish. Before shimmering fish stood a stalwart Youth & 4 lovely Maidens. Lightning bug mashes did not show under rising sun. The five merely looked kind of divinely dirty.

"Spare us, Ahl," says Priest.

"I'm not Ahl," says Youth.

"He is Ahl," loudly states oldest Maiden, kind of with the idea of being with a god.

"Yes," shouts other Maidens.

"But, Ahl," says Priest, trying for safe subject, "I see before me drooping on beach your midnight meal. Spare us and eat them. Do you want more?"

Strong Youth took a deep breath. "Listen, you old Idiot." His voice took on a tonal quality hollow and frightening, and drooping freed captives figured they were eaten after all.

"Ahl has returned us all," says Youth. "Says we too generally sandy & smelly to EAT. Says we yap too much to make pets of. Says, though, we're the onlyest ones with any sense an' can't be spared."

"Save us, Oh Ahl," begged beach.

"Hear me," yells Youth bringing beach to sandy knees.

"Ahl likes his fish and certain ones he don't want nobody's teeth into. See these here bark fish?"

"Only Ahl could depict such beauty for our eyes," intones Highest Priest.

But, beach, being now not to be eaten, had developed an eely backbone of sorts, Youth saw. Murmurs arose.

"My aunt paints real lovely on those big shells we use for dishes."

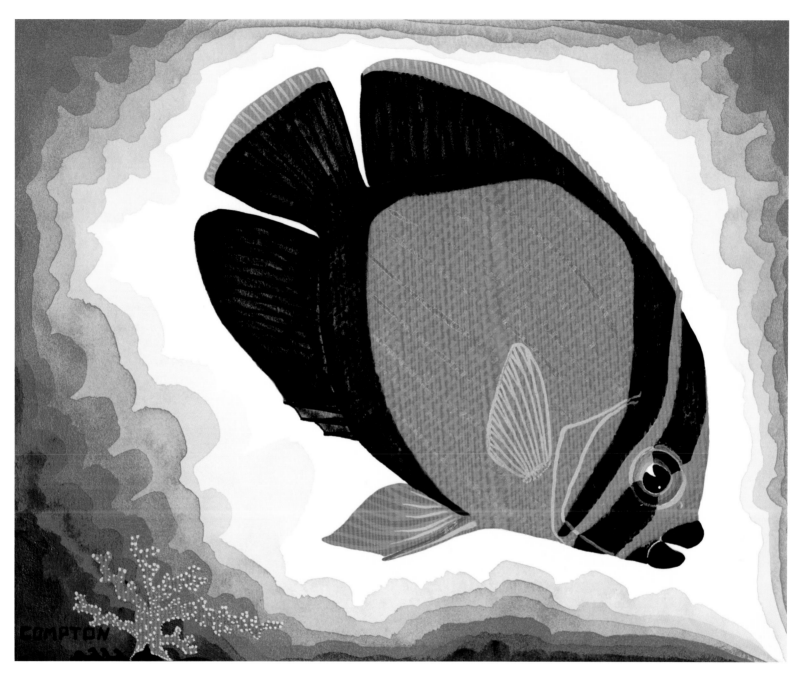

Arabian butterflyfish

Chaetodon melapterus (Guichenot, 1863)

"Right pole decorated with stunning dropcloth painting of Blackfin Butterflyfish miraculously accomplished in basic tone materials, the exquisite sheening black being the result of long experimentation with blue clay, fishbone charcoal, ground tree-rat turds and spit."

"You ought to see what sister can do with hair-thread on a banana leaf. Think it was real, you would."

"Grandma used to make the prettiest flowers out of shells. We all hunted the reef for . . ."

"My kid can draw better'n that. I cut him a stick. You ought to see what he does on the sand. First he . . ."

". . . pees. My kid pees his sketch first and . . ."

Youth's dark brows joined in thunder over his eyes.

"Quiet!" thundered Highest Priest. "Ahl speaks."

Took all day.

The tidal pool (Youth's favorite midnight swimming when he'd sneak down in past from Terrible Mountain) was to be sacred. (Un-fished, un-spit-in.)

The three kinds of fish depicted (Youth's favorites) were to be semi-sacred. (Form no part of island's diet.) No more sacrifices. They could believe stars ate if they wanted to but no more feeding them.

"And," loudly states oldest Maiden, "A big house built for us and the kids. Quickly."

"Those three?" says Highest Priest looking at the three uncaptives holding one another for comfort.

"Yeah. I guess. I meant the others."

"What others?"

"Them we left on Mountain. As being too young for last night's excitements."

"These are Children?"

"Sure. What you think they were? Tree-rats? There's Bahl and Bahl-een, Cahl and Cahl-een, Dahl and Dahl-een, Bahl and . . ."

"But we have lost no other children," said bewildered Priest. "Who's are they? Where do they come from?"

Four Maidens jerked thumbs at Youth.

"Ask Ahl."

Youth sighed.

Eighty-seven years later when the winds of October blew *Riff-Raft* to the rainbow shores of Ahl Island, Cap'ns Jim and Eddie sat in cool breeze and solid comfort on the veranda of the largest timbered house in the Pacific. Before a sparkling pool where children played. With their new friend whose short white curly beard and thick hair

lent dignity to his powerful body and open, rugged and humor-ready face. Behind them in the vast dimness of a great room hung three great undimmed paintings of three great reef fish.

"Which Ahl are you, sir?" says Cap'n Jim, pouring a little Irish polite storm-oil since he wanted to photo those fabulous fish pictures which he'd heard somewhere was never allowed.

"Original," says oil recipient with great humor. "Didn't you read that simple tourist brochure? Yep. 104 year next week. If you believe the last one left of them pesty Maidens. Who forgets what she ate for breakfast."

After many protestations of pleasure and agreement for photos, "provided fish were only to be published in highty-tighty class book on South Sea art and the secret pigments not disclosed." Cap'ns left in contemplative mood to retrieve black-eyed delinquents. 🐚

Species: *Chaetodon meyeri* **(Block and Schneider, 1801)**

The scrawled butterflyfish occurs throughout the Pacific and Indian Oceans. Although this species is widely distributed, it is not commonly seen. Occurring in tropical waters, these small fish inhabit clear lagoons and reefs. Resembling other butterflyfishes, scrawled butterflyfish exhibit a white background with curved black lines arranged across the body. The head, as well as fins, is striped with black and yellow. While juveniles live a solitary existence typically among branching coral, adults usually form pairs and take up residence in a home range on the reef. This species feeds exclusively on coral polyps.

(3) All around the fat middle of the world where the sun shines hottest where the seas are warm as bathtub and there's most often summer, the coral grows. Coral is a very small animal with one flat round foot making cement and on the other end one round mouth all circled with snakes open out like a thin-petal flower and closing to feed mouth. The snakes don't have mouths. They are stinging-sticky to catch other animals about the size of flour. To feed the foot.

All of these feet live together. They plaster so much cement

Scrawled butterflyfish
Chaetodon meyeri (Block and Schneider, 1801)
"On a flat roundish plate of a fish all those lines break him up like plate was dropped. Where's his front to swallow. Can't see it."

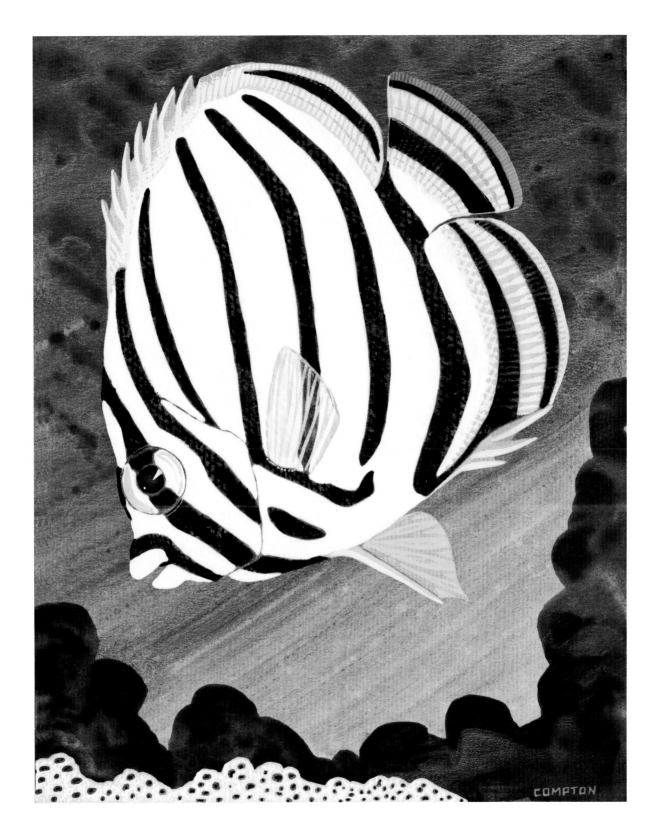

here and there in fingers and sheets and horns and ledges that they build the great warm water reefs of the world. The reefs become islands and rings and 1000-mile barriers to protect beaches from being washed to sea.

Sometimes the feet make balls. Marbles, baseballs, bowling balls, basketballs and balls as big as three elephants. These balls are anchored to remain at home. This is fortunate as three elephants rolling around loose could scare a lot of fish and mash a lot of crabs.

Everywhere there are coral reefs there are Butterflyfish. Off Mexico, S. America, Africa, India, China, Australia, all the big and little islands of the tropics, and in the Shedd Aquarium Chicago with snow pounding on the roof.

Way back in the dim dumb misty past of the world some kid spearing breakfast on the reefs of Hawaii watched the pretty fishes flitting-flitting in and out of the arms of the coral and, remembering the pretty butterflies flit-flitting in and out of the jungles of his mountains, says:

"Grampah! I'm gonna name all these fish Butterflyfish because they are flitty-fast and all colors and hard to stab and I can't catch 'em any better than those flyin' jobs on Grandmah's Frangi-panni bush."

Spearthrust, splash and empty barb. Twice. Kid was correct in his judgment of the situation.

"I christen this fish that swims like goofy insect 'Butterflyfish.'"

"It is not for a boy to decide."

"I am a man of 13 rains, my Grampah."

"My grandson, you have the Bigmouth on you. It is not respectful for youth with small spear to name the fish."

"Well everybody over 13 rainy seasons is too dimdum to do it."

"Do you wish your small spear broken over your headbone?"

"No, Grampah."

"Then tend your fishing and forget your naming."

But the Pacific even way back then was well supplied with 13-year male loudmouths with sisters quite as vocal and the name spread fast as seabirds fly and the world was stuck with it. Lucky stick. The kid named fine.

And color. He was sure a noticing child of the reefs. Stripes?

History and the seabirds are mum on the kid's mentioning stripes but the fish are heavy into them now and likely were when the world was young. Stripes all kinds up-and-down, slant and circle.

On a flat roundish plate of a fish all those lines break him up like plate was dropped. Where's his front to swallow. Can't see it. Shark can't see it. Bigteeth eel, long as rattlesnake without scales nor rattle, can't see it. Where fisheye. Where fishtail. Shark bites. Eel bites. Grab a mouth of water.

But dimmed by water's flowing fingers reefs are pale buildings and the fish are flags of moving glitter. They don't blend themselves into background like slicky frog in green weed or spilt red jelly on red rug. Why should they? Eel can't say where eye is going, daytime, and only grabs them night when they sleep in coral cradles or propped lazy against a tall sponge. Eel would say, "It'd be nice could I open me an easy can of tuna, 'stead of chasing these boogers look like they are drawn by some first-grade nut with fistful of crayons." If eel could say.

Mr. Meyer's own personal named fish is Black and White and Yellow. And scattered worse than Zebra. 🐚

Species: *Chaetodon octofasciatus* (Bloch, 1787)

The eightband butterflyfish is found in tropical waters throughout the Indian and Pacific Oceans. This species frequents sheltered lagoons and protected inshore reefs. This small fish is distinguished from others among its genus by its white or yellow body and seven notable black stripes along its head and sides. Another black stripe can be seen along the trailing edge of the caudal peduncle. Juveniles are often viewed in groups living near corals and are especially common among the coral *Acropora*. Adults tend to occur in pairs in lagoons and inshore reefs. This species feeds entirely on coral polyps.

🐚

(3-A) The Eight-Band likes Orange and Black. Swimming in and out of golden coral he disappears like tiger in a cane patch. Many stubborn people do not believe he has octo stripes. Because they refuse to count correctly. 🐚

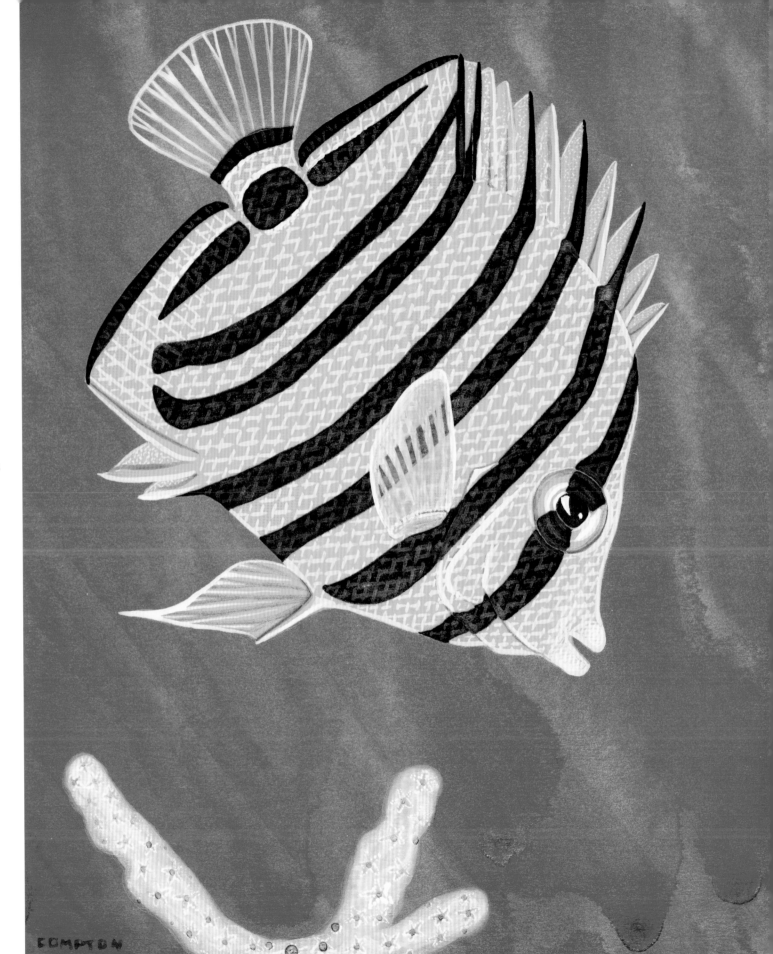

Eightband butterflyfish
Chaetodon octofasciatus
(Bloch, 1787)
"The Eight-Band likes Orange and Black. Swimming in and out of golden coral he disappears like tiger in a cane patch."

Species: *Chaetodon ornatissimus* (**Cuvier, 1831**)

The ornate butterflyfish can be found in tropical waters throughout the Indian and Pacific Oceans and ranges from the eastern coastline of Africa to the Hawaiian Islands. Although commonly occurring in clear waters less than 40 m deep, this species is most often seen along seaward reefs. The body is white with a number of orange diagonal bands along its sides. Several large yellow and black bars run across the eye and the snout. Juveniles lead a solitary existence among corals, while adults occur in pairs. Adults tend to develop a home range in which the pair stays. Both juveniles and adults feed on coral tissue.

(3-B) And this very ornamental decorated adorned tricked-out bedecked jazzed-up bedizened dizzy Beauty chose Four Colors and so makes the clown. 🐚

Species: *Chaetodon plebeius* (**Cuvier, 1831**)

The blueblotch butterflyfish, sometimes referred to as the coral butterflyfish, is a tropical species found mainly in the western and south Pacific. This species is primarily yellow with several distinguishing characteristics. A darker yellow is seen on each scale, which gives an appearance of horizontal lines along the body. A broad black bar runs from the crest of the forehead and through the eye to the lower portion of the operculum. There is a dark ocellus (eyespot) rimmed with blue along the caudal peduncle. Perhaps the most telling characteristic is an elongated blue blotch along the side of the body from which this species gets its name. Yet another characteristic that sets this species apart from others in the genus *Chaetodon* is an anal fin possessing four spines; most possess only three. Adults tend to be monogamous and are seen in pairs during the breeding season. Like similar species, the blueblotch butterflyfish feeds primarily on *Acropora* coral. However, this species has also been seen cleaning parasites from other fish.

(3-C) Some fishes hide an eye by running a line through it and putting an eye catching spot back by their tail. Fish backs up. Confused seabass snaps at what he thinks is head and fish flees merrily forward and away. Seabass learn this fish is plenty "bluestreak" indeed and seldom have dinner on him. Sometimes a shark will gobble him up because sharks gobble and chomp on everything anyway. They are too dumb and poor-eyed to be fooled by a fish playing escape games. They just go hog at all in sight.

But shark does not charge about in and out of reefs. The knives of the sharp coral would cut a long scratch on his white stomach and any shark with a long bloody bleeding coral scratch on his white stomach is a goner. His brothers and his buddies smell the blood of the long bleeding bloody scratch on the white stomach and grin widely and bite him up into big chunks and smaller chunks and little apple-core chunks and in fingersnap he is gone out of sight into the unscratched white stomachs of all his brothers and his buddies. Where all the small fish of the ocean wish him always.

Free of shark and pesky seabass, Bluestreak can freely munch and lunch on the feeding fingers of the Sea Anemone named for the windblown flowers of the marble hills of ancient Greece back about the time the first runner ever panted barefoot into the oval bowl with the torch of Olympus held high in sweaty hand.

A sea anemone is forerunner of the coral but he never learned to mold himself a cement house so his foot is naked like the runner's and mostly sucks base to reef and rock. Or Bluestreak can find him a sponge and puff out little shrimps and crabs and worms from their home inside for supper. A sponge is a very antique critter who came before even the jellyfish who came before the anemones who came before the coral. The First Fish found them all waiting for him.

There are many shapes and colors of the sponge. Once brave divers harvested round ones from the waters of Greece and Florida for bather to squeeze and squeeze and scrub himself all clean. Nowdays the merchant sells slabs of squishy colored

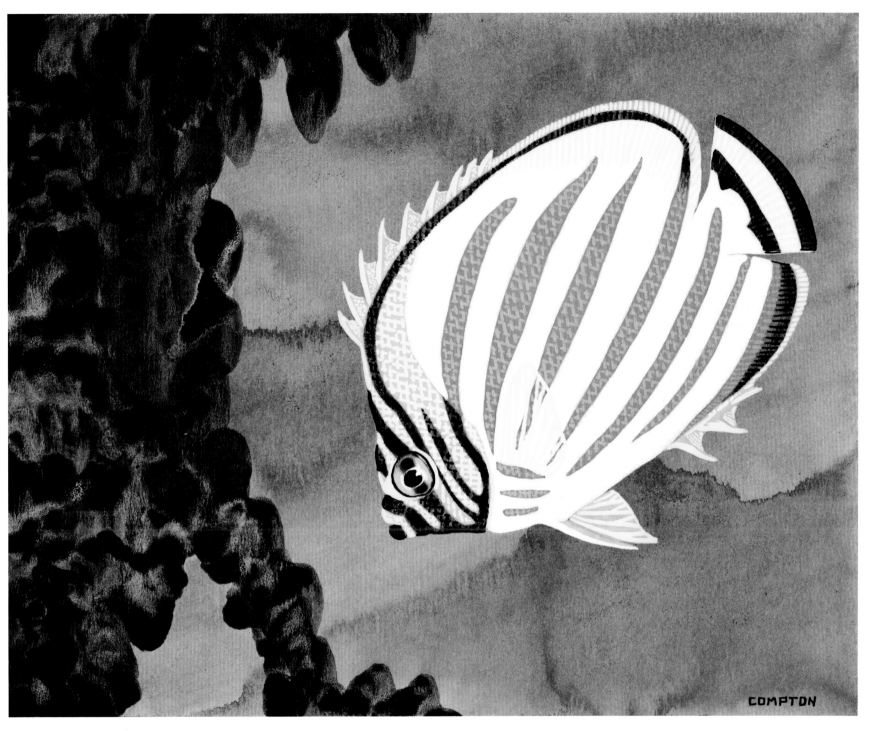

Ornate butterflyfish
Chaetodon ornatissimus (Cuvier, 1831)
"And this very ornamental decorated adorned tricked-out bedecked jazzed-up bedizened dizzy Beauty chose Four Colors and so makes the clown."

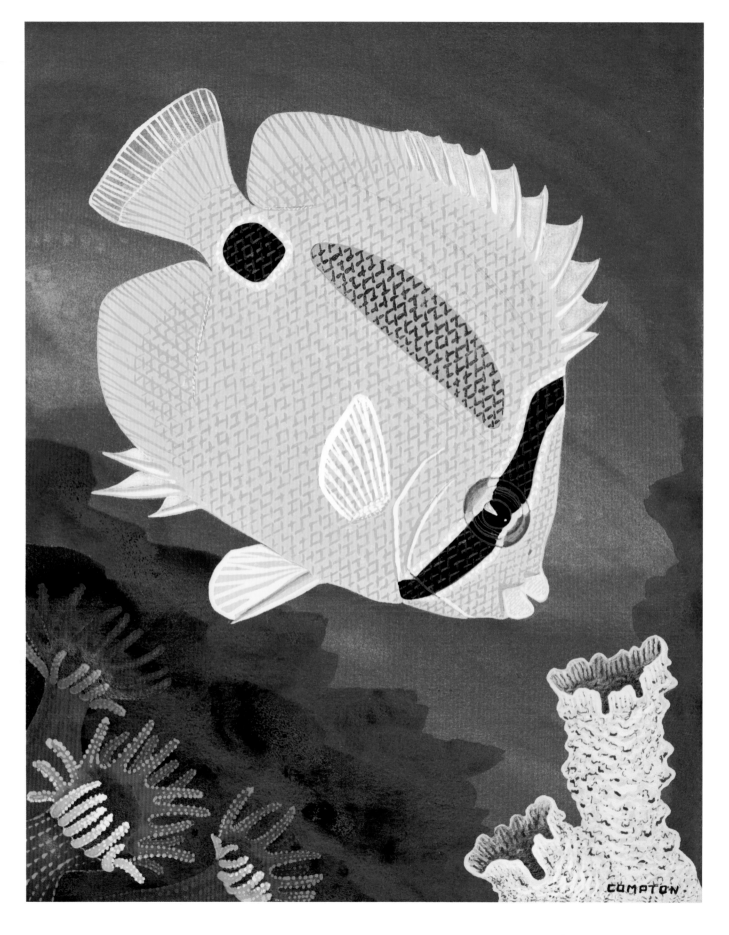

Blueblotch butterflyfish
Chaetodon plebeius
(Cuvier, 1831)
"Seabass learn
this fish is plenty
'bluestreak'
indeed and seldom
have dinner on
him."

plastic made maybe from the oil pumped up from some dead and hundred-million year buried reef where sponge once lived and in dying made the oil.

A sponge is a whole household of tiny animals doing different work. At homely chores. Fanning current in an out. Building hide of spongy fiber. Eating specksize food fanned in. Running around feeding hide and fanners digested specksize and those laying eggs and the sperm to fertilize them with. A busy bunch. Worse than hive of bees. Kind of like all that bunch of different cell-animals making the human body possible. Only a sponge knows what's going on. 🐚

Species: *Chaetodon rafflesii* **(Bennet, 1830)**

The latticed butterflyfish is found in the Indo-Pacific region and occurs from Japan to the Great Barrier Reef. This is a somewhat uncommon species that is usually seen only in areas of rich coral growth of lagoons as well as protected reefs, but typically the fish inhabit a water depth of 15 m. The body is brightly colored with a yellow hue and is distinctly patterned with a cross-hatched design for which this species is named. A black bar runs from the crest of the head across the eye and to the bottom of the operculum. The dorsal, anal, and caudal fins have dark stripes. Interestingly, this species may display a change of color during times of stress. Although an uncommon species, the latticed butterflyfish is most often seen in pairs. This species feeds on anemones, polychaete worms, and polyps of both soft and hard corals.

(13-H) "Where's my fish, Sandy?" said Sharon, holding Miss Fortune for comfort as she, Sharon, was always last in hand-out and Miss Fortune was furred, warm and heavy as sunshine when you were left out in shade.

"Here tis, honey."

"Is he pearls, Sandy?"

"Pearls is for older ladies. These is beads like but she's got you some eye-black for when you is fifteen and outa sight of land and Lord an' can wear it legal. We'll embawder our fishes on our

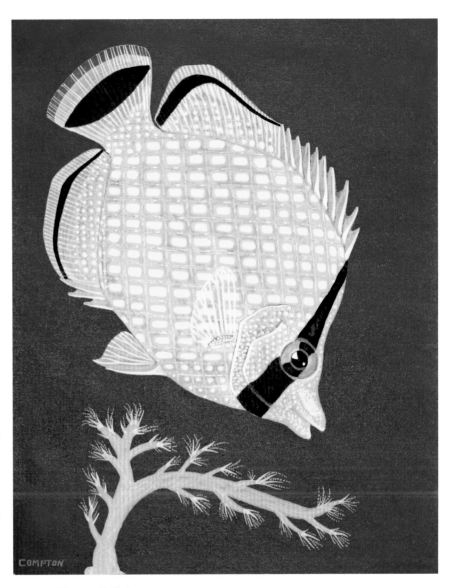

Latticed butterflyfish

Chaetodon rafflesii (Bennet, 1830)

"Pearls is for older ladies. These is beads like but she's got you some eye-black for when you is fifteen and outa sight of land and Lord an' can wear it legal."

petticoats so's when we liff skirt all them brave Pearl-diver's eyes Pop!" 🐚

Species: *Chaetodon semeion* (**Bleeker, 1855**)

The dotted butterflyfish is found in tropical waters of the Indo-Pacific. These fish are most commonly seen among the Maldives and Tuamoto Islands and throughout the Great Barrier Reef. An uncommon species, these butterflyfish typically inhabit areas of rich coral growth and are most commonly seen in protected reefs and lagoons in water depths to approximately 25 m. The body is a golden-yellow, and the bases of the dorsal and anal fins are black. There is a black bar across the eye, and a number of black dots occur along the lateral portions of the body. A distinguishing characteristic is the long, thin filament on the rear edge of the dorsal fin that is not present in similar species. They are typically seen in pairs or small groups.

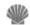

(21) But when the winds of October blow the constellations to wheel they remember a high blaze of orange, The Masked Fish once, the high glitter of Ahl Mahahl that is, and recall a lost island riding a long rolling sea.

"Ahl is plenty bright this year," said the Highest Priest. "He is red-hot angry."

"Oh, Ahl," wailed all the people and shook their shell bangles and their fish-backbone beads. They didn't have much else to shake. They didn't wear much else.

"He has had no proper sacrifice yet in his season. Tonight for All Hallow Eve he must eat again or woe, our nets will be light to lifted by any old woman and the spirits of our awful dead will be loosed among us and our spears drip only water."

"Oh, woe, Ahl," wailed the people and clanked dismally. "Chinka chinka ching," mourned the shells. "Click-a-chug," rattled the bones.

"Sacrifice-Sacrifice," shouted the usual hysterical mutt in the back of the crowd. "Oh, save us, Hi-Priest."

"I'll do 'er," loudly cried the Priest, with a prolonged musical

Dotted butterflyfish
Chaetodon semeion
(Bleeker, 1855)
"From top of pole swiftly unrolled a great barkcloth painting of Masquerade Butterflyfish. Wonderfully done in full color with red-clay, yellow-clay, blue-clay, charcoal, octopus ink, fish blood, insect glitter and bird droppings. Hung by nose so that at first glance two long black teardrop inscrutable EYES regarded the Priest & people over a horrible wide blue nose."

note to his voice. "Tie up three gifts this year. That oughta salvage us from doo-oo-om."

"Hear, oh, Ahl," shouted the people happy for solution. They all chimed happily in the wind before midnight. Ahl Mahahl blazed down on torches burning up.

The children of the beach shouted nothing. Nor did they rattle. They knew from which age group would the sacrificial victims be snatched. They stood protectively in a small group backed against the dark and impenetrable jungle of Terrible Mountain rising behind where no one had ever climbed.

The children of the beach watched the people set three stakes where one had been before where the great tidal pool of death rippled at reef edge and the unseen black fork-tailed birds screamed above. Soon they would be chased and caught and three would be tied to feed Ahl Mahahl in his journey and Lo! by dawn he would have eaten. The three would be gone from the good reef & pleasant playing and only empty pole remain. It had always been so. They shuddered their few shells without hope.

"Hisst!" said a strong voice behind them.

"Don't do that," said a beach girl.

"I never," said a beach boy indignantly.

"Did so. Heard you. Try to scare us. We already scar't."

"Did not."

"Did."

"HISST! DAMMIT!" says strong voice.

Screams. Children of the beach whirled to face the unknown terror of the blacky-inky-greeny clutching vegetation of Terrible Mountain under torchlight from whence had come the awful Voice. Before their startled eyes stood a sturdy handsome Youth of 14 flanked by same age lovely Maidens. 4 of Maidens. 1 of Youth. All dressed very skimpily in beaten bark of many colors. Flowers in hair. Loud yelps of dismay.

"For AHL'S SAKE!" says Youth. "Shut your yelpin' yaps. You want to bring that nut bunch up here to join this get together? I've finally grown tired of their doin's an' I'm gonna do something about it. Besides, Mountain's getting crowded what with saving one of you varmints per year."

All the beach bunch quavered, "Are you Gods, Sirs?"

"Don't call me 'Sir,' you little beach-flea," says one of the Maidens.

"We are the children of the Mountain," said Youth. "Come to stop this sacrifice silliness. Any fool believes sky lights have stomachs will believe anything."

"Why," says a beach girl studying Youth. "You're my brother given Ahl this 5-year gone."

"And you're my sister," says beach boy staring at one Maiden. "All eaten up before I put long shells on."

"An' my cousin," screamed another beach girl of another Maiden.

"HELP!"

"DEMONS!"

"GOBLINS!"

"GHOULS!"

"GHOSTIES!"

"GREMLINS!"

"DEVILS!"

"DRAGONS!"

"ZOMBERS!"

Beach chickens fled screaming.

"Told you it wouldn't work," said left-hand Maiden.

"Told you it wouldn't work," said right-hand Maiden.

"Told you," says middle Maidens.

"If you think," says Youth, "that I'm spending the rest of my days up on this mountain with you four, you are denuded or whatever the word is. When I untied myself 5-year ago, I figured to show old Priest he was star-stupid. What was gonna eat me anyway? Had to come from the sea. Octopus is too timid, an' crab too little an' shark can't crawl. I figured to explain to that mob at dawn that they was nuts. Then I figgers, No, people don't like to be told so and they was like-to really kill me, put spear to me on spot to keeps their gods and their foolishness. Stole y'all away each year for same thinkin.' Looks like I coulda got me a male or two thru them years. Help me hunt."

"Hah!" says Maidens.

"Now then. Here's what old Ahl is gonna do come dawn."

All those on the beach, listening to the running children jabber

breathless of portents & peril, looked to the Priest. He frowned and raised a stern hand. Shaking children pointed. All on beach looked to the fearsome shaking skirt of Terrible Mountain. Torchlight writhed on phantom leaves and snaking vines. From out of the depths of the ghastly vegetation came a terrible Laugh.

"A-ah-eee!" screamed the Priest and the people. Quickly they grabbed the three handiest kids, tethered them to the three posts and fled to the huts to cover their heads with woven leaf and shake the rest of the night away. In the hour before the dawn when the white bird flies unseen from the mountain to the sea, there approached the captives a dreadful quintet flickering in squiggles of smeared lightning bugs. Dreadful clamor from those tied.

"Shut UP!" says strong voice. "One more squawk an' I'll slap you to be able to spit teeth 4-feet."

Tied were untied and led by four of the fearful figures into tidal pool of death. "If they so much as sneeze," says voice, "drown 'em." Mysterious shufflings. Strange squeak. Once a muffled curse. Presently voice joined ambush up to neck in pool. "This oughta scare the shells off that old goat."

In the hour of dawn when Ocean spits the Firegod from her belly, having put up with indigestion all night, the congregation advanced from their huts to beach. Three empty poles stood against an eternity of silver water.

"Ahl accepts," shouted Priest, shaking his shell rattle. "Saved. Saved."

"Saved," shouted the people, rattling with rapture.

Eighteen feet of invisible braided hair string tightened behind center pole. Taut, Taut, TAUT—WHAP! From top of pole swiftly unrolled a great barkcloth painting of Masquerade Butterflyfish. Wonderfully done in full color with red-clay, yellow-clay, blue-clay, charcoal, octopus ink, fish blood, insect glitter and bird droppings. Hung by nose so that at first glance two long black teardrop inscrutable EYES regarded the Priest & people over a horrible wide blue nose. Priest & people bit the beach and hid their eyes.

"Wow," says voice. "I'll hafta remember this fin-fan for my grandkids."

"Yes, dear," says 4 voices.

Voice Sighed. 🐚

Species: *Chaetodon semilarvatus* (**Cuvier, 1831**)

The bluecheek butterflyfish is a tropical species restricted to the western Indian Ocean and in particular the region of the Red Sea and Gulf of Aden. This species is found in areas of dense coral to a depth of approximately 20 m. The body of this butterflyfish is almost circular with only a small pointed snout. The body is uniformly yellow with narrow dark bars running vertically. The most notable characteristic is the blue patch that covers the eye and operculum. The pelvic fins match the yellow coloration of the body, and the pectorals are transparent. This species is very common to the region, especially in areas that possess rich coral reefs. This species has been noted in both pairs and small groups and is most often seen hovering in the water column near ledges or outcrops of *Acropora* coral.

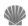

(2) "This fish is you, Johnny." Sandy informed him with that smug, smiling, smelt-smelling tone of voice all sisters inform all brothers.

"He's got that dreadful 3-color hair of yours."

"Got a wild look to 'im," says Johnny, pleased.

"He's got that dreadful black eye you get not more'n thirty minutes after we hit Port. Grampah, doesn't matter what Port, does it? We come in nice an' polite and within the space of thirty minutes Johnny is gettin' black eyes. You said so, Grampah. You said in all your vast experiments of young human varmints you never saw livelier one."

"Experience, Miss."

"Experience and that Johnny in all your vast knowing would get black eye and us in same old bum-tumble if church service was goin' on dockside an' we was all dressed white an' carryin' purses."

"And give 'em," says Johnny, very pleased.

"I don't carry no Purse," says Kevin. "No matter whatever you plannin.'"

"Plenty of 'em," says Johnny, very, very pleased and grinning wide white to show nobody ever got his teeth. "Many's they want."

Sharon said, "Sandy hit that big ole dirty girl try kick me an' Miss Fortune when we is walkin' polite and takin' air. Sandy hit 'er with Purse we had our Rock in we found 'cause Miss Fortune smelled it an' scratched it. Hit was Gold, Sandy said. Outa Whale, Sandy said.

**Bluecheek
butterflyfish**
Chaetodon semilarvatus
(Cuvier, 1831)
"He's got that
dreadful black eye you
get not more'n thirty
minutes after we hit
Port."

"Knocked 'er flat. Me an' Miss Fortune kicked her. She went inter water. Fell inter Bay an' good riddunce, Sandy said."

"She come back out of water?" Cap'n asked politely.

"Don' know."

"I am very pleased with my fish, Sis," says Johnny. "An' thank you kindly. I forgot 'im. I always feed best Suwanee Worm to that coral when we go Red Sea reefs. Fingers grab that good worm fast. If you got no worm, fingers slurp-gone into redbone. Only nobody and Gawd knows how all them fingers hide in them little ole slits." 🐚

Species: *Chaetodon smithi* (**Randall, 1975**)

Smith's butterflyfish is a subtropical species found in the eastern Pacific. This species is known to occur only in waters surrounding Pitcairn, Rapa, and Marotiri. These fish are common among areas of coral and algae-covered rocky outcrops and are encountered to a depth of approximately 30 m. The compressed body plan is typical of that seen in most butterflyfishes. The anterior half is black, while the posterior half is bright yellow. It is common to see large congregations of this species occurring near reefs. A midwater-dwelling species, these fish feed primarily on plankton.

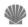

(13-I) "Miss Fortune & Deck Dog," shouted Sandy.

"From Pitcairn Island," shouted Johnny. "He won't live nowhere else. He likes livin' a legend. I'll betcha he was there when Mr. Christian drownded ole *Bounty*. Weren't he, Grampah?"

"By some millions of years."

Miss Fortune, pleased, and taking it only her due to be associated with history since she had relatives mummy-ed in Egypt long before the Shannons learned to warm their toes in Ireland, arched back and condescended to allow hands on her historic hide.

Deck Dog, who was tamed 200,000 years before Miss Fortune joined the Pharaohs in leather, barked proudly. Then he sat. Looking out to the evening sea. A furry furrow V-ed deeper between his amber eyes.

"Quick," says Capin, "turn that picture over. Before Deck realizes he is butt of this fish to Miss Fortune's head."

Midnight. *Riff-Raft* floated on star light, anchored midstream of channel behind reraised Reefgate. From out of the pools of blue shadow around the cabin appeared a small figure in nightblue pyjamas swarming with silver comets and space craft. And a great golden dog.

In hunter's silence the two climbed the slant ladder to fore deck. The small figure carried a round object which looked in the starshine like a severed head. Beyond the Reef barrier the black Atlantic breathed long rollers west. Fingers of fire played in the barrier coral. The two friends were intent on the dark Ocean outside.

Suddenly they found themselves with company. The dog grunted. "What are you doing, Kevin?"

"Nothin,' Grampah."

"You and Deck admiring the night?"

"Yes, Grampah."

"Why are you carrying that Parrot fodder?"

"You locked my rifle in holder."

"I did."

"Me and Deck figured that Shark to come back. Me and Deck was gonna throw my socks at 'im. Johnny says my socks will kill any fool Shark."

"I see." Missile was removed. A large kindly hand firmly swatted the spaceships in their seat and their owner was propelled suddenly bunkward. Peace. A great golden dog began to howl defiance into the shimmering night. SPLAT! YELP!

A large hard heavy soupbone with much clinging red meat to it hit great golden dog square in his shortribs. Peace. Broken by gentle gnawing under the high trail of the glittering heavens of Cancer. 🐚

Species: *Chaetodon tinkeri* (**Schultz, 1951**)

The Hawaiian butterflyfish was historically found along steep slopes and reefs throughout the Pacific Ocean. These fish are seen around Johnston Island and the Marshall Islands. These fish are commonly encountered among black coral and gorgonians between a depth of approximately 25 m and 135 m. Although considered endemic to the Hawaiian Islands, the Hawaiian butterflyfish has since been replaced by other species in most of its historic range.

Smith's butterflyfish
Chaetodon smithi (Randall, 1975)

"From Pitcairn Island," shouted Johnny. "He won't live nowhere else. He likes livin' a legend. I'll betcha he was there when Mr. Christian drownded ole *Bounty*. Weren't he, Grampah?"

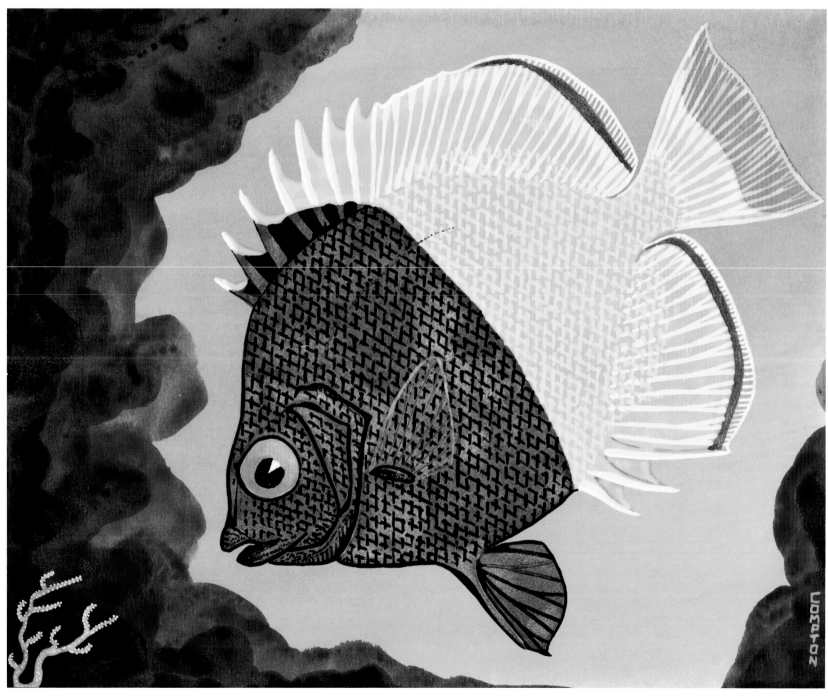

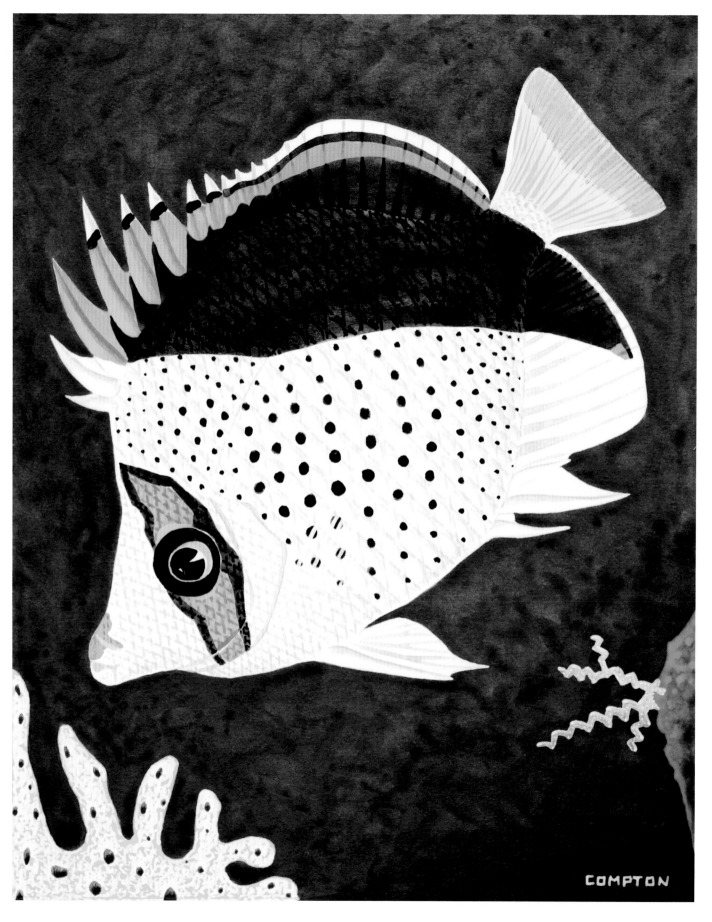

Hawaiian butterflyfish
Chaetodon tinkeri
(Schultz, 1951)
"I picked this fish special. He's got that ole carrot hair of yours. He's got him a painted mask like them Head-Eaters paint onto theirself when they are eating Heads."

COMPTON

These beautiful fish exhibit a bold pattern with the front portion of the body bright white and the upper rear portion black. Black spots cover the white portion of the body. A bright yellow band runs vertically across the eye, and the dorsal and caudal fins are also yellow. These fish are known to occur in pairs near reefs. The Hawaiian butterflyfish feeds on a variety of organisms, primarily on benthic and planktonic invertebrates.

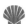

(13-G) "Here you are, Kevin," Sandy said kindly. "I picked this fish special. He's got that ole carrot hair of yours. He's got him a painted mask like them Head-Eaters paint onto theirself when they are eating Heads. David Kelly told me. I gotta write our nice Kellys all we been doing and how I saved you from Shark and how Sharon saved Johnny from Shark."

Two yelps.

"You better not."

"No you better not," but Kevin was weak when it came to painted people eating Heads. "They eat Heads? They got they eyes painted like my fish, Sandy?"

"Do. And you're from our Hawaii. You live deep where we gotta use exotic gases to find you."

"Yeah," says Johnny. "I'm about dyin' to squeak my voice at deep fish like yours, Kevin."

"If we had some moneys of our own made divin' pearl to buy us prime equipment," says Johnny.

"Yeah," says Kevin. "I need prime equipment. Shark tore off my flipper."

"Grampah," says Sharon. "My Johnny wants that prime gun he bent an' some new pants he don't have holes in."

Shout. "I done tole you. If you been in my cabin I'll whale you."

Growl. Hiss. Captain knew from long experiments how to crowd-control by tossing a quieting bone here and there. "Sandra," he said. "Please tell Kevin all about eating those HEADS."

"Do they, Sis? What they use?"

"Oh, best silver," says Captain. "Same as in our chest we use for guests. Hold old bloody-hair Head in our laps, do we, Sis?"

"Do they, Sis? Do they use fork?"

"'Course," says Captain. "We gotta small fork to eat nose and that pickle fork for eyes. Them eyes are hard picking. They look up at you so. To see what you are about. Roll sideways to watch your eye-knife. And Head's teeth are chatterin' and chatterin.'"

Six pairs of Shannon eyes looked at him solemnly. Miss Fortune obviously did not believe in such crude dining.

"See where that rolls you," says Captain. "Miss Fortune don't believe we should dine so bloody. Miss Fortune has forgotten her last wharfrat.

"Don't you badmouth Headhunters. They were simple fellers and didn't kill they heads by the millions. They are very rare now and scarce and first one I can hire, he's in charge of deck control of complaints, wants and grumps."

Species: *Chaetodon trifasciatus* (**Park, 1797**)

The melon butterflyfish, also referred to as the redfin butterflyfish or oval butterflyfish, is a common species found throughout the Indian and Pacific Oceans from East Africa to the Hawaiian Islands. It is notable, however, that the population residing in the Pacific is recognized by some researchers as a separate subspecies (*C. t. lunulatus*). This butterflyfish is found in lagoons with rich coral growth as well as protected reefs. Instead of having a more sloped head and pointed snout as seen in most butterflyfishes, the melon butterflyfish has a much longer and ovoid shape as well as a rounded head and snout. Exhibiting vibrant colors, this species is primarily yellow with horizontal bands of blue along its body. A vertical black band runs across the eye, and there are black bands on the anal and caudal fins. The anal fin also exhibits a pair of red and orange bands. Territorial in nature, this species occurs in pairs, which are exclusively monogamous. This species feeds only on coral polyps, most often on those belonging to the genus *Pocillopora*.

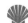

(21-A) Second hair string tightened—Tightened—TIGHTENED—SPLAT! From left post hung suddenly a great painting of Melon Butterflyfish. Spectacularly wrought in earth clays, marine and air resources, and with the addition of butterfly wings, pollen

Melon butterflyfish

Chaetodon trifasciatus (Park, 1797)

"From left post hung suddenly a great painting of Melon
Butterflyfish. Spectacularly wrought in earth clays, marine and
air resources, and with the addition of butterfly wings, pollen and
dried urine."

and dried urine. Priest peeked and closed both eyes tightly. Shell rattle shuddered.

Species: *Chaetodon xanthocephalus* (Bennet, 1833)

The yellowhead butterflyfish is found in tropical waters throughout the Indian and Pacific Oceans and along the eastern coast of Africa. It ranges across the Indo-Pacific region. This species is found in rich coral growth and areas with algae-covered rocky outcrops among shallower reefs at a depth of approximately 25 m. Interestingly, this species is known to hybridize with *C. ephippium*, with hybrid individuals seen in the Similan Islands and Sri Lanka. Possessing a slightly elongate, compressed body, these fish are primarily white. The snout and chin as well as dorsal and anal fins are yellow. The caudal fin is shaded blue or black. Although seen primarily as solitary individuals, these fish occasionally occur in small groups. They are highly territorial, in particular in regard to other members of the genus *Chaetodon*. These omnivorous butterflyfish eat a variety of organisms.

(3-D) Xantho = yellow, cephalus = head. Sure looks more like what most folk think is a butterfly fish. The rear eye is fading as he grows. When he was an inch or so he looked more two-eyed. Now at 3-inch he depends on blinding ol' bass with white disc and flashing away.

Scuba-divers, who research and frolic, say that in some tropical seas are Bowl Sponges big enough to relax and sit right down in all comfortable wearing flippers, diving tanks, sinkbelts, cameras, compasses, free-smiles and floatjackets. Loll around. It may be so.

Species: *Chaetodon xanthurus* (Bleeker, 1857)

The pearlscale butterflyfish is a tropical species found in the western Pacific, primarily near Indonesia and the Philippines. This species prefers clear coastal waters near slopes and generally occurs at a depth below 15m. These fish tend to frequent areas rich in staghorn corals. This unique butterflyfish is primarily white or gray and is the only member of its genus that exhibits a crosshatched pattern along its body. A black line runs through the eye, and a black ocellus can be seen on the head directly below the start of the dorsal spines. The fish is yellow or orange along the latter portion of the body from the dorsal fin, across the caudal peduncle, and onto the anal fin. This species feeds on a variety of organisms, including invertebrates and algae.

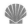

(13-F) "Here is me," said Sandy. She stood and twirled some dancing steps before an astonished and unprepared audience.

"Real purty fish," said Johnny, uncertain but loyal since she had found him such a fine bruised fish for his own.

"She's got my purty red-hair. Just color to go with my sex black make-up for eye."

"You planning on sex goo?" says Cap'n. "I'll have Johnny paint you couple blacks, you try it before you are twenty year and outa my sight."

"And," says saucy dancer. "Grampah promise we going to dive for pearls off Perth, Australia, and town of Broome where Grampah was oncst when he was younger'n Johnny and 'bout as bad. There is pearly dressy awaitin' me, Miss Beetrice says. Somewheres. I'll play guitar real nice to innertain them handsome Pearldivers who is so brave to dive pearl.

"My fish has this stagcoral scratched Kevin when I saved 'im from Shark. Them brave handsome Pearldivers like me to sing them the ballad of me savin' Kevin."

"You will be fifty-year and outa my sight and memory before I allow you amongst pearl-peelers for frolic. Where you get these notions? If any one of you, or whole bunch, has reconnected any of those filth channels, over goes tee-teety-telly. Straight Davy Jones. Blub. He can handle 'er. He's about 10,000 year-old."

"Miss Beetrice said you'd commote. Then you gotta take us

Yellowhead butterflyfish

Chaetodon xanthocephalus
(Bennet, 1833)
"The rear eye is fading as
he grows. When he was an
inch or so he looked more
two-eyed. Now at 3-inch
he depends on blinding ol'
bass with white disc and
flashing away."

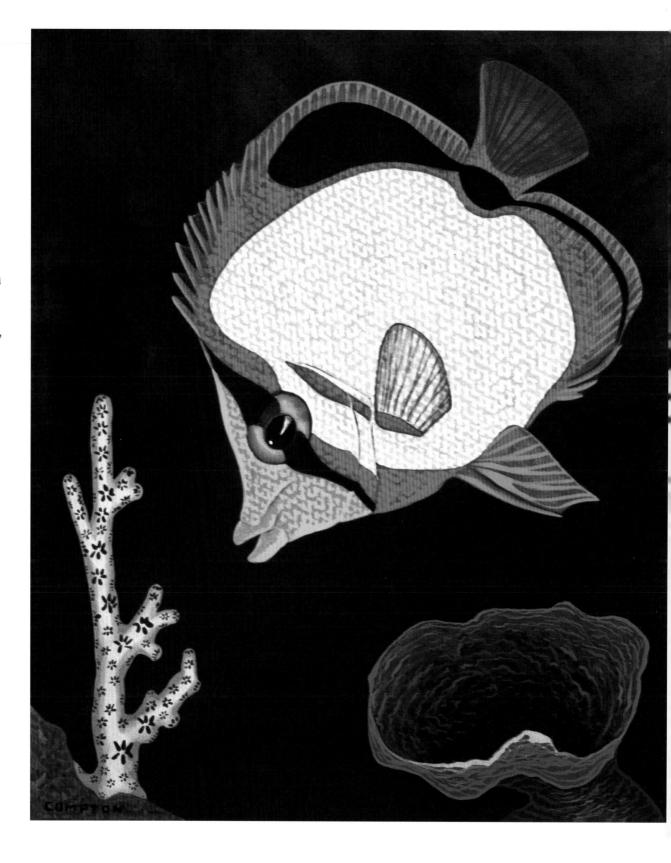

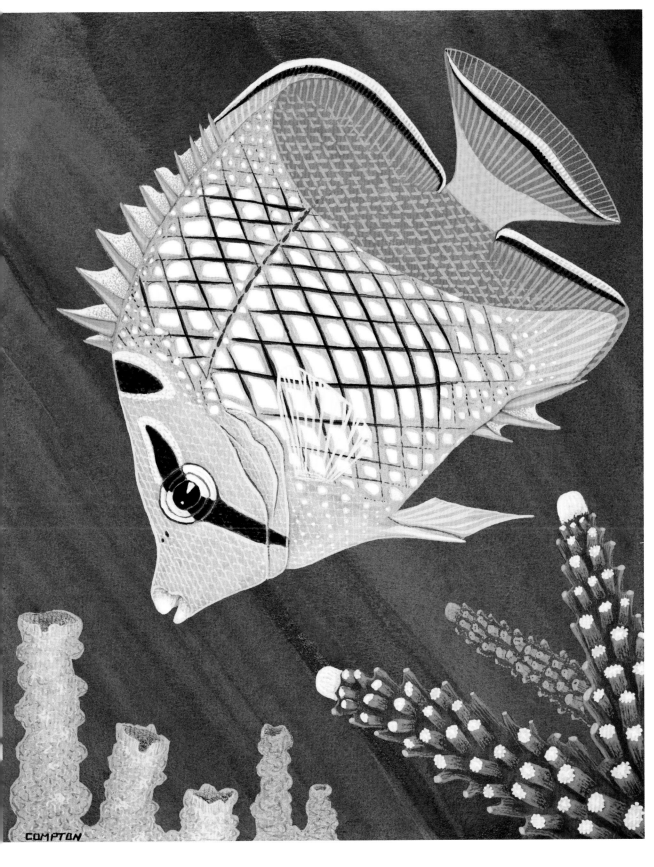

Pearlscale butterflyfish
Chaetodon xanthurus (Bleeker, 1857)
"She's got my purty red-hair. Just color to go with my sex black make-up for eye."

to Paris for pearls. Miss Beetrice knows place. We all gotta wear shoes."

"I don't believe that shark's gonna make-a-scar," said Kevin, examining for umpteenth time his meager line of scab. "Grampah? Will you do me scar with beercan opener? I don' trust Johnny. I'd like a scar I can tell-a-tale with 'er. I don' wanter deep." 🦪

Species: *Chelmon rostratus* (**Linnaeus, 1758**)

The copperband butterflyfish is a tropical species found in the western Pacific from the Andaman Sea to the Ryukyu Islands and Australia. This species is commonly found within estuaries and sheltered coastal reefs to a depth of approximately 25 m. These fish possess the rounded body shape seen in most butterflyfish, with a steep forehead and a long snout. Females have a less pronounced forehead and a more sloping snout. The majority of the body is silver with five orange bars running vertically. These bars begin at the eye with the initial bar being small and the remainder becoming progressively wider. There is a large black ocellus directly below the soft dorsal fin. This species may be seen as a solitary individual or in pairs. This is a very territorial species that will protect its area. These butterflyfish form distinct monogamous pairs during the breeding season. The copperband butterflyfish feeds on small crustaceans along reefs. Although difficult to maintain in captivity, this species is one of the more popular butterflyfishes among some aquarists.

(29) *Riff-Raft* had all flags flying from Yellow Fever to grog after six pee em, as Kevin & Danny says, stringing the pennants they told Nell & Sharon.

"Get flags up now!" says Sandy.

Miss Fortune was inspecting the loops and coils of thinny rope with the long triangles of color. End of her panther grandfather's tail flicked twice, jungle soft. Kevin clipped Yellow Fever end of pennant rope to Miss Fortune's collar and Miss Fortune went howling like storm aloft from stern to bow, Kevin & David yelling

storm and freeing snags. Every-body who could shout, shouting encouragement. Deck Dog barking.

Riff-Raft was strung. Sandy & Nancy were in the rigging.

"They're coming."

"Jump it," yelled Cap'n Eddie.

Riff-Raft was a swarm of action. Far out, from the golden April-norther morning haze hanging pillars of shifting light over April-norther sea, a small dot got bigger.

"They's coming. They's coming," sang the crew of the *Riff-Raft*.

"We'll rob 'em an' run 'em," sang the crew of the *Riff-Raft*.

"We'll gob 'em an' goal 'em," sang the crew of the *Riff-Raft*.

All the crew of the *Riff-Raft* but Deck Dog was high in the rigging.

"Would you care to be that young again, Eddie?" Cap'n Jim asked Co-Cap.

"Ain't they monkeys? Here comes that dot gettin' bigger. Pour us a round of that coffee and give Deck one of your rock pancakes for his teeth and us old Joeys will watch this little show. Who you bettin' on, chum?"

"*Raft*."

"I'll go *Beaubrat*. Give you a chance, chum."

"Taken."

In *Beaubrat*, Johnny & David crouched black-snake behind spray screen for air foil.

"We got 'em," yells Johnny.

"Yea Hah," yells David.

The homecoming, gathering on No Name, yells, "Here they comes."

The Man-a-war birds had the best seats. As *Riff-Raft*, with wild crew fisting nylon and *Beaubrat* with wild crew calling twin motors Go-Joe and Lightning and Please—bastard rounded the straight to No Name's wide channel, they skidded water side by side.

Water was skidding like snow under skis, big prow to small prow when out it came and the whole April sky blew black & gold lightning schooled with turquoise fish as Sandy released *Riff-Raft*'s spinnaker. All the long dock was cheering. David & Johnny watched *Riff-Raft* greyhound exactly 19 feet in one black & gold leap. Great sails dropped rippling to deck. *Riff-Raft* kissed dock and threw lines.

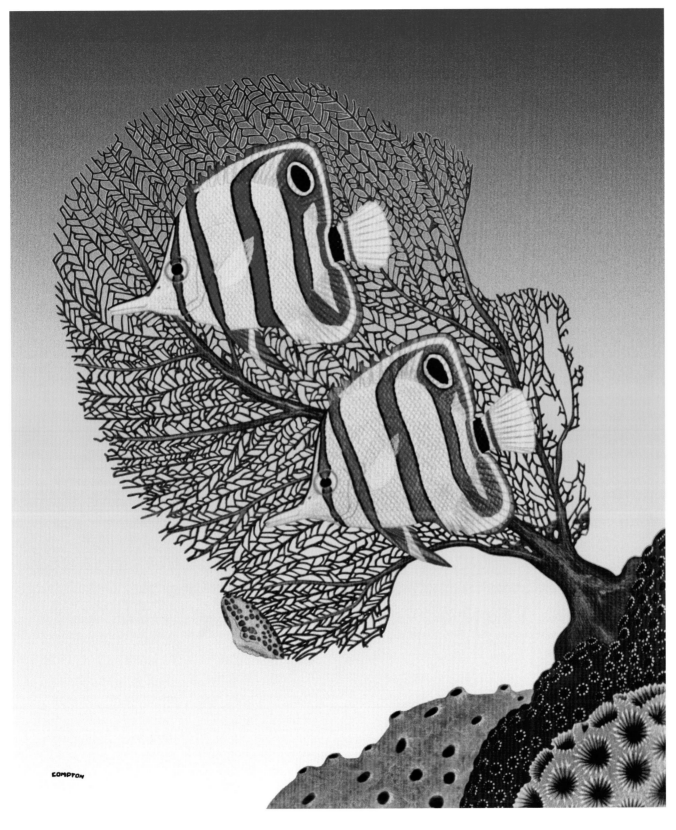

Copperband butterflyfish
Chelmon rostratus
(Linnaeus, 1758)
"Yes. This is to teach you them fish can live with bits an' pieces all over world and they is happy."

B-*brat* bumped tire-casings on dock piers and threw line. Biologist fielded and tied. Johnny and David leaped dockside and hugged Jan.

"Uncle Dan," says Johnny. "We done lostered by 19 feet, 2-inchers and a frog's tail."

"Lookit them Dolphin." Biologist had *Beaubrat*'s ice chest open on neat rows of silver Dolphin come to snowy grounds. Golden Suns to dead Mercury.

"You believe a fishtale, Uncle Dan?" says David.

"Will," says Jan. But here came running *Riff-Raft*'s crew yelling Aunt Jan.

Everybody was there on No Name. Cap'ns Jim & Eddie carried two great paneled paintings onto dock to prop and show.

Sharon Shannon ** Nell Kelly **Narrators**:

"This is our most favorites Pacific Butterfly what Miss Mattie has and is her favorites too but ain't Salty Dogg's he says is twice too showy for his tasters and is stuck up to boots also but not friends like Fat Eel.

"And he is paintered to our designs with a Sea Fan for him. Purple. Fan is from No Name. Here. Where we is."

"And yellow ground Tunicate from the Medds."

"That's a sea where Rome is."

"And Green Sponge from the Red Sea ha."

"We don't know where that coral ball come from but we ourselves captured that adorable little Flamingo Tongue Snailer an' he will eat off our hands."

"Yes. This is to teach you them fish can live with bits an' pieces all over world and they is happy."

"You see our Tee-shirts? There's his picture."

"An' here's our backs what says 'Copper is Adoptable.'"

Quick twirl for display.

"Adaptable," growled prompter.

"Yes. And we was tole that big pichur is painted rocks & bird doings from that funny island."

"Our Tee-shirts is not bird doings but is inks and we got all over us when we done them."

"We finish."

Applause and admiration. 🐚

Species: *Forcipiger flavissimus* (**Jordan and McGregor, 1898**)

The longnose butterflyfish is found throughout the tropical waters of the Indo-Pacific from the eastern coast of Africa to the Hawaiian Islands. This species is also found in waters of the eastern Pacific near Baja California and Mexico. Although the most widely distributed species of butterflyfish, the longnose butterflyfish is not common in any area of its range. This species is sometimes seen in lagoons; however, it is typically seen among exposed seaward reefs to a depth of approximately 120 m. It is similar to *Prognathodes aculeatus*, the longsnout butterflyfish, which has a much shorter snout. Having a typical butterflyfish appearance, the longnose butterflyfish is named for its extremely long snout. The primary body color is bright yellow. A black triangle runs from the tip of the snout to behind the eye and straight up toward the forehead. There is a black eyespot along the anal fin near the caudal peduncle. Although sometimes seen as a lone individual, these fish are more often seen in larger groups near overhangs and caves. Their diet consists of mainly benthic invertebrates.

(7-C) Here is the true elegance of fish. Of the reef itself. The gaudy gutty fireworks of an animal sudden swimming in very best dress-up. You shouldn't have any problem knowing where his nose goes. For his groceries? He sups out of no saucer. That's for sure. 🐚

Species: *Heniochus acuminatus* (**Linnaeus, 1758**)

The pennant coralfish is found in tropical waters of the Indo-Pacific. It occurs along the eastern coastline of Africa, the Persian Gulf, and throughout the western Pacific from Japan to Australia. These fish prefer deep channels, outer slopes, and reefs. This species possesses a similar body shape to members of the genus *Chaetodon*. However, unlike members of *Chaetodon*, the pennant coralfish possesses a long snout and extended dorsal spines that form a long, pennantlike structure. The body is white with several dark stripes running diagonally. A dark bar may also be seen above the eye. These fish actively school when in open water and spend a greater amount of time away from

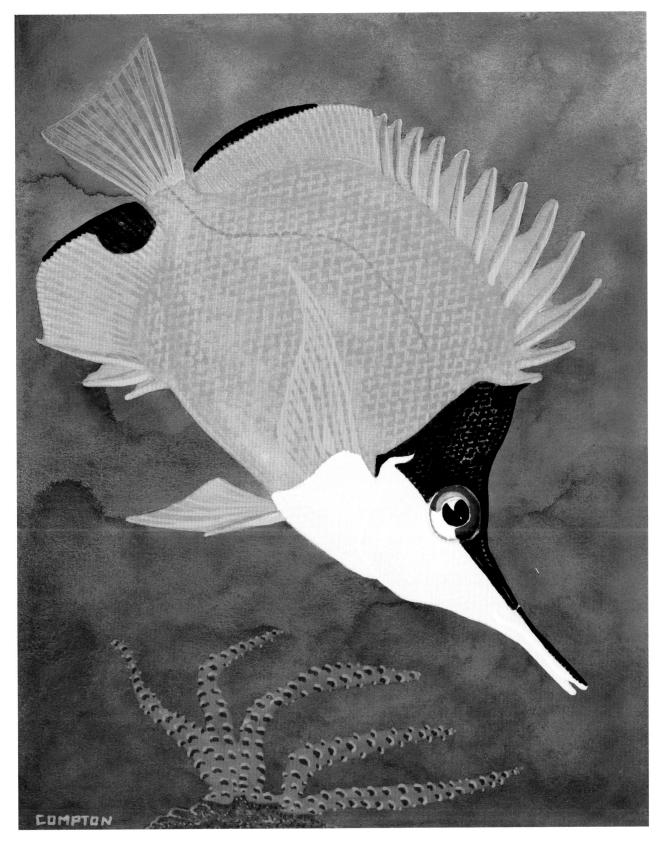

Longnose butterflyfish
Forcipiger flavissimus (Jordan
and McGregor, 1898)
"Here is the true elegance
of fish. Of the reef itself.
The gaudy gutty fireworks
of an animal sudden
swimming in very best
dress-up."

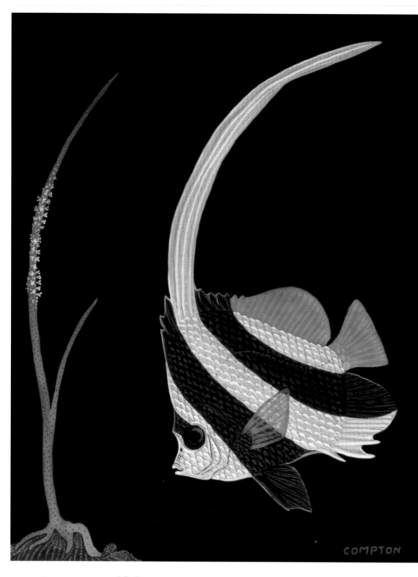

Pennant coralfish
Heniochus acuminatus (Linnaeus, 1758)
"One quadrant of circle swam over about a hundred Bullfins swimming disguised in whipcoral. They'd rise up an' butt heads and butt heads and then hide in coral. Stirring 'er up like. Sure make commotion."

reefs than other butterflyfishes do. Adults often occur in pairs, while juveniles are frequently seen leading a solitary existence. Juveniles are planktivorous and sometimes feed on parasites of other fishes.

(5) JOHNNY & DAVID'S FISH

As ordered by higher authority we took OBO at 0810 swimming defense shark-pattern 2-fathom above Reef floor. Operation Brat Observation. No joy on shark. Hoped to try new stun poles and punch him and blow his butt off with shotgun shell.

One quadrant of circle swam over about a hundred Bullfins swimming disguised in whipcoral. They'd rise up an' butt heads and butt heads and then hide in coral. Stirring 'er up like. Sure make commotion. You reckon they was breedin'? How come they look like Moorish Idol? Don't act like him. Don't answer. We'll look it up like we're supposed to and get it right.

You know that big red booger them kids let getaway? Well sir, we found where Bassie lives on a ledge and fed him three fat crabs. Seems friendly enough. Don't think he recognized us. That's 'er. We too busy chasin' Danny an' Kevin back into safe area where they were all time chasin' some poor old Tuskfish an' themselves outta area. Going Tahiti.

"Weren't so."
"Looked so."
"Well weren't, we was . . ."
"Don't tell 'em."
"You right. We got our report."

Hey. Last item. Right down below ol' Freckles' home we saw them two yellow devils planting a sponge. Like they knew what they was doin.' We're gonna write 'em up to Queensland *Weekly ReefRat Review*, the Smithsonian and the British Museum. Hey? Get famous. Found first fish ever farmed. 🐚

Family: Cirrhitidae (Hawkfishes)

Hawkfishes are perchlike fishes found in tropical waters of the Atlantic, but most inhabit the Indo-Pacific region. The family name derives from the Greek *kirrhos*, meaning "fringe."

These bottom-dwelling fishes inhabit nearshore waters in both rocky and coral habitats. Small, colorful, and robust, they share many of the same features of members of the family Scorpaenidae. The most visible characteristics within this family are the dorsal and pectoral fins. The dorsal fin contains approximately 10 spines with cirri at the tip of each. The pectoral fin contains several of the lower fin rays, which are visibly thickened and unbranched with the rays extending past the membrane of the fin. A relatively small family, there are approximately 30 species within 9 genera.

Species: *Oxycirrhites typus* **(Bleeker, 1857)**

The longnose hawkfish can be found from the coast of Africa, to the Red Sea, across the Indian and Pacific Oceans, to the Hawaiian and Galápagos Islands, as well as from the Gulf of California to northern Colombia. This species tends to inhabit steep slopes along outer reefs, especially those exposed to stronger currents near areas with large quantities of gorgonian and black corals. The longnose hawkfish resembles most other hawkfishes in its small, robust, perchlike body plan, with the exception of its elongated snout. The fish is bright red with white boxes along its body surface. Individuals are monogamous with distinct pairs being present in a given area. Although small, this species is highly territorial. Interestingly, courtship has been noted to occur just before or after sunset, with spawning shortly after. Both courtship and spawning typically take place within the female's home range; and after completing the spawning event, individuals often return to their respective territories.

(22-A) There are no thanksgiving fish. Luckily. Some gourmand would wish to stuff them with cranberries and stuff on them. There is a Turkeyfish. Humans never dine out on him. He is too small, too elegant and too dangerous. Humans merely kill him in various unsavory ways whenever they get the least chance to mess up his water for him. There is however, a Christmas Fish.

Back about 1899, a young redhead bellicose Irish immigrant name of Shannon pushed his cart through the Battery area of old New York, selling potatoes baked on corncob coal, Granny's honey cookies and knit socks to the crowds in the street before the new Aquarium. When his two brothers came to relieve him on pushcart he contrived to go see the exhibits free by the simple expedient of starting a riot at what he thought was paybooth. Wasn't, but he sure never paid.

Inside he found many strange wonders but only one caught his blue eye. In a small case in a corner lost among great tanks of river bass and lake sturgeon, well protected by glass, was a small show of " **** Curiosities of the South Pacific *** Precious Coral of the Depths *** Worn by Ladyes of Fashion in Paris & London *** With Most Colourful Fish as captured by Cannibals in the Islands of Captain Cook **** ."

Shannon didn't know about the Ladyes of Fashion but he admired the Coral & Fishes. He could easily have promoted another riot and carried the whole case out bodily to pushcart but he didn't want chance of having River Bass & Lake Sturgeon hurt. He had a retentive eye. He memorized fish and coral.

When the snows of Christmas came to lower Manhattan, the slumming rich found three pushcarts with potato, cake, socks, mitts, cocky caps and the many lovely ** Christmas Trees ** " *** Precious Coral of Depths for Ladyess Paris & London & Now New York & Curious Cannibals Fishes *** ." Coral was peeled dyed trimmed bush jerked from Central Park. Fish were painted tin. Slumming Rich from Fifth Avenue North of 40th Street went wild.

Thus was founded the world's largest house of treasure from diamond saddles to jade donuts, THE HOUSE OF SHANNON on Fifth Avenue North of 40th Street, the Rich having long since moved above 59th St. It is given as advice to the customer that if he is unable to begin an effective riot upon entering, he had best have pockets of pirate gold to trade. In the vast entrance gallery, 90-feet below the celebrated and magnificent Galaxy of the Pacific crystal chandelier, stands the great magnificent and celebrated crystal showtank of 100's of 3-inch Long-nose Hawkfish at home in thickets of precious red coral. Children of all ages from 2 to 122 with checkbook in hand are encouraged to dip with golden ladles,

Longnose hawkfish

Oxycirrhites typus
(Bleeker, 1857)

"In the vast entrance gallery, 90-feet below the celebrated and magnificent Galaxy of the Pacific crystal chandelier, stands the great magnificent and celebrated crystal showtank of 100's of 3-inch Longnose Hawkfish at home in thickets of precious red coral."

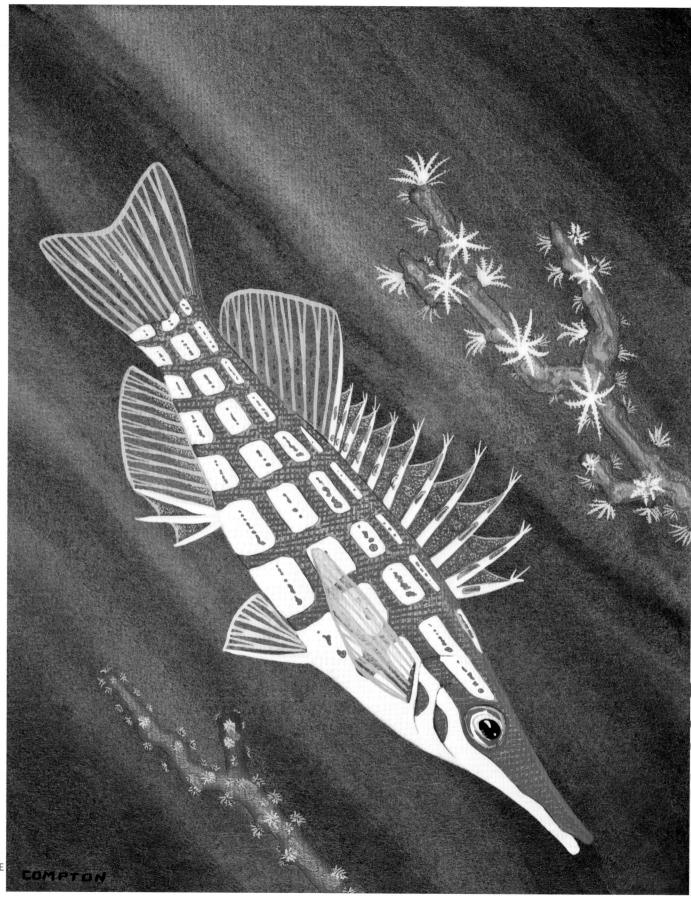

COMPTON

orange clouds of bitsy milling brine shrimps out of the silver buckets and feed the bumptious tame Hawkfish and the starmouths of the coral. 🐚

Family: Coryphaenidae (Dolphinfishes)

Dolphinfishes, also referred to as dorados, are a family of epipelagic fishes found throughout the Atlantic, Indian, and Pacific Oceans. The family name derives from the Greek word *koryphe*, meaning "head." These elongate fishes possess slender compressed bodies, short blunt heads, and large terminal mouths. The dorsal fin is very long and extends from the nape of the neck to the caudal peduncle. The dorsal spines are flexible and not easily distinguished from the rays. These fishes also possess a very deeply forked caudal fin. Living specimens are known for their iridescent coloration of blues and greens with tinges of yellow. Although very little is known about their behavior, it is believed that these fishes utilize rapid changes in coloration to communicate with others. Both adults and young are commonly found in surface waters near drifting *Sargassum* and other ocean debris, where they consume small fishes. Males are distinguished by a very steep forehead. Only two species are known to occur in a single genus.

Species: *Coryphaena hippurus* (Linnaeus, 1758)

The dolphinfish, sometimes referred to as the mahi-mahi, is a species found in the Atlantic, Indian, and Pacific Oceans. The dolphinfish is found in pelagic open waters as well as near coastlines in tropical and subtropical waters. The tapered body is elongate and compressed with a large blunt head. The forehead of this species is very steep and is nearly vertical in adult males. Coloration differs and is often iridescent blue and green with yellow along the lower half of the body. There may also be small spots along the body. In younger fish, there may also be small dark bands along the body. The dorsal fin of this species is a notable characteristic, as it runs nearly the total length of the body. The caudal fin is also deeply forked. Dolphinfish apparently exhibit rapid growth and live only

a few years. Species within the genus *Coryphaena* have been known to form schools around floating debris and are often seen following ships. The large terminal mouth allows these fish to prey on a variety of organisms, including other fishes, squid, and crustaceans. A highly prized sport fish, the meat is considered excellent, one of the best-tasting food fish. However, its Hawaiian name mahi-mahi is often used to avoid confusion with the marine mammal the dolphin.

(28) Dolphin is the fine & fiery spirit of the whole warm wide world ocean. King of the upper waters. Fastes' fish on five fins, says Johnny Shannon, claiming them 40-knotters. Have to be, catch them 35-knotter flyin' fish in mid-sortie.

There are two Dolphins. One is a fish and other is mammal. So: The fish is also called Dorado for clarity. The mammal is also called Porpoise for more crystal clarity. Thus: A Dolphin can be a Dorado but never a Porpoise. And: A Dolphin can be a Porpoise but never a Dorado. Both are the beloved of Poseidon, half-scale half-skin god he is.

This makes it clear to all, says Johnny, that the Dolphins of SecretReef who play volley with Miss Fortune, although marvelous speeders and fighters, do not have gills. Johnny and David set out one morning to catch a beach grill full of the gillers. *Riff-Raft*, all nylon up and engines strumming, was inbound from, as David said, straiters of Jambo Florida to her homeport on No Name.

"Release us, Granpappy," yelled Johnny. "We catch us, Gulferstream."

"Catch us, New Yorkey, Granpappy," yelled David.

Nineteen foot skiff, *Beaubrat*, hit water with a splat heard many miles by many fish. Wallowed for second in *Riff-Raft*'s wake, lifted nose out of plowed water, slammed nose flat onto prairie water and screamed toward Stream below Largo. Cap'n Jim on the power davit had just dropped *Beaubrat*, says to his Co-Cap Eddie, "They butts is too salty to sting much. Hope they didn't bite they tongues. Didn't. They fight too often."

"Only about 1200 milers by Stream to New York, Jim. They could shout-up Miami. Passing."

Grandfathers laughed and toasted first coffee. *Riff-Raft* under

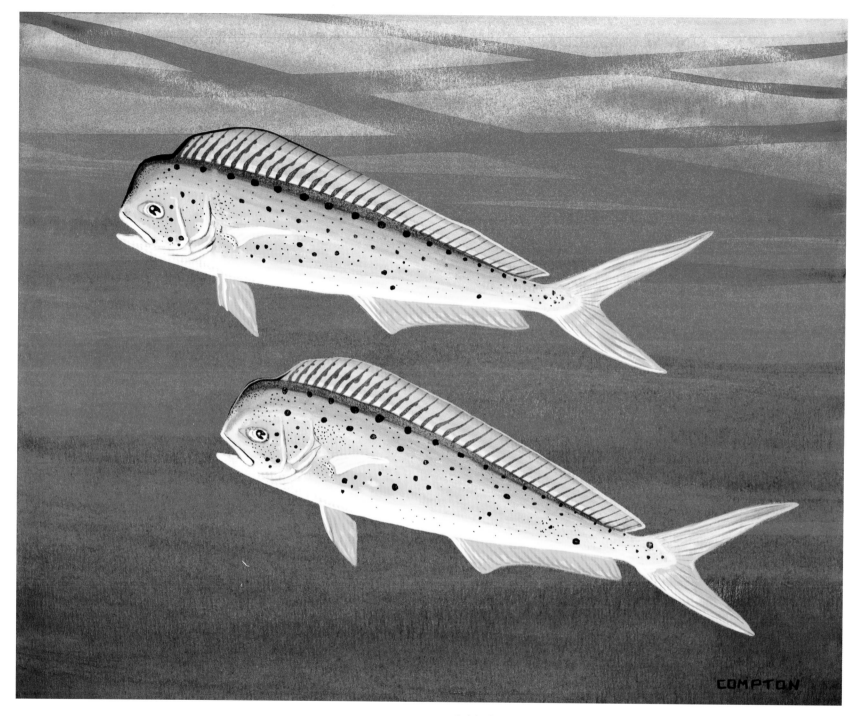

Dolphinfish

Coryphaena hippurus (Linnaeus, 1758)

"Dolphin is the fine & fiery spirit of the whole warm wide world ocean. King of the upper waters. Fastes' fish on five fins, says Johnny Shannon, claiming them 40-knotters. Have to be, catch them 35-knotter flyin' fish in mid-sortie."

power and sail had deck-slant on her would hardly wave coffee. It was a very beau morning. On *Beaubrat*, Johnny cut twin motors to murmur.

It was April 3rd. North Pole by way of Alaska blowing over Polar Bear backs had iced Chicago, snowed on Tennessee, caused Miss Beetrice to don long sweater (sleeveless) on Black Snake, and made MamaGator in Okefenokee think twice about laying eggs. Swirl of cool far air, cool as to stand in front of open reefer in *Riff-Raft*'s galley, raised the fine hairs on the fishermen's bodies. "She's beaut," says David.

B-Brat MURMURED. Sea silked itself to all sides to the end of the world's boundary. As autumn puts a bluey haze on the hills of Indian summer so norther in April smoked golden the fog devils over the Gulf Stream. *Riff-Raft* faded fast north to No Name and was gone.

"Smell 'at little North wind," says Johnny, stripping his shirt to get more of it on his brown hide. "Better'n apples."

David was right with him. Both boys jumped to lines and tackle.

"Bend on that pinky squid feather. Hit's a goer."

"Same color as them big flyer's wings. Them Gulf black, ole Dolphin does favor."

"You reckon that's why?"

"Sure. Biologist says fish is critters of habit worsen us and dead frogs. Got 'er set, Dave?"

"Slippin' pinker squid, guide. Do me a Grandho."

Johnny walked throttles. *Beaubrat*'s stern growled ACTION. Ahead in the willies of the fog, Johnny saw the edge of the Stream like a jet of indigo dye rivering north for Hatteras and Long Island. The Stream carried with it the tumble-weed tangles of the Triangle's spooky Sargassum Sea. In little mats. In big mats. Riding low in golden tangle.

"Rafter," yelled Johnny.

Ahead rode half-acre of weed just puckering surface where fog kissed and flagged off and willied again. *Beaubrat* went for it. Johnny put David to skirt it. David's squidder bounced and flurried and scored the swells 80-foot back. 100-foot back out of the ghost whispers of old Triangle suddenly burst out three low flying squadrons of the big black fighter-sleek flying-fish of the Stream.

Dipping to swell, dipping tail scull fast as Ruby Hummers wing, lofted past *Beaubrat* on all sides. Spit. Spit. Spit. Gone.

"Here they come," yelled Johnny.

100-foot back, stubby fins cut water like knifers. Pinky the squid/flyfish lookalike, hit hard forward of hook, flew 20-feet high in tumbling arc, hit surface and David's reel whistled whoopee. Johnny murmured *Beaubrat*. Two foot Dolphin went to air and tore a fog-whirl willie plumb to rags & tatters as the fishermen later recalled it. As they told it, everthin' sugared up from then. Had a boat load of iced grille-fish.

Ever-one came aboard, says Johnny, we right smart gave that Seagod one of them fishshape cereal of Miss Fortune's she won't eat. Plonk it over. For spirits. Dolphin, he gives his up fast. Two-three slaps on deck, he's a deader. He can't stand 'er no more outa his freedom seas. No more'n drownded eagle. We musta give old Pos. 20–30 prime Miss Fortune junkies, for things livened considerable.

Hit was David's last turn on rod before we was headin' homeward. Dang 'im. I was a-trollin' us outa Stream so's we wouldn't go on to Norway. Wham! Side-runner throwing fence o' water. David had him a good one when outa edge of Stream came a Marlin 10-ft long n' 5-ft spear n' slapped that hookered Dolphin twice n' took 'im. David, he stood up between motors an' watched his line peel against drag and reeling to chrome core. David, he dived right over still a-reelin.'

I traced 'im 40-foot down in that clear water. Still a-reelin.' Then, looked like he was jerked about 40-foot deeper an' sudden lost his imputiss. I circled *Beau* and picked him up. He had rod with him. Didn't have no fish, I told him, that I could see. He didn't have no line with him at all.

"You think they gonna believe us?" he asks me. "Would us believe us?"

"Nope." 🐚

Family: Gobiidae (Gobies)

Gobies are a large, diverse family. The family Gobiidae encompasses more species than any other family found within tropical marine waters. A large portion of individuals can be found within

tropical reefs. However, many live in cold temperate waters, with many even occurring in fresh water. These fishes are also one of the most abundant groups found within bodies of fresh water on oceanic islands. Most species possess elongate bodies with two dorsal fins. A noticeable characteristic of members of this family is the presence of a membrane uniting the pelvic fins into a suctionlike disk that allows gobies to cling to the substrate. This diverse group of fishes can be scaleless or fully scaled. A large majority possess sensory canals and pores on their head. The form and placement of these canals and pores often represent species-specific characteristics. Some species also have barbels located along the head. Typically possessing a very cryptic coloration to match the surrounding environment, males often exhibit bright coloration during the breeding season. Those gobies found in tropical waters among reefs are typically much brighter in coloration than species found elsewhere. Although there are freshwater species, the young of such species are typically carried to marine waters, where they spend their early development before returning to fresh water as small juveniles. There are approximately 1800 species within 250 genera.

Species: *Lythrypnus dalli* (**Gilbert, 1890**)

The bluebanded goby, sometimes referred to as the Catalina goby, is a small goby found in the eastern Pacific from California south to Ecuador and Peru. These gobies are a temperate species and thrive in much colder temperatures than most coral reef species. This goby prefers to reside near and within areas of rocky outcrops with crevices to a depth of approximately 300 m. The bluebanded goby possesses an elongate body with a rounded snout. The body is orange and red with several vertical blue bands and a blue mask around the eyes. The dorsal fin is separated into two sections; the first has six spines of considerable length with the ends free from the membrane of the fin. The pelvic fin is unified to form a sucking disk. These territorial fish are benthic and spawn along the bottom. After courtship, the female deposits her eggs and the male guards them prior to hatching. Recent research has shown simultaneous hermaphroditism within this species and exhibition of bidirectional sex changes due to a lack of members of the opposite sex. These fish feed primarily on small crustaceans.

(15-B) The dictionary defines Varmint as an animal or person considered to be objectionable or troublesome. Little Johnny, 2 year old, screaming til the lightbulbs shatter and then screaming because dark fell on him is a Varmint. Big Johnny, 18 year old, accomplishing this same unwanted feat, is a full furred Varmint.

A Goby, having no light bulbs, is not a Varmint. But it is sometimes uncertain if he is a Goby. There are true Gobies and not-so-true Gobies.

Seems one way of telling is by those two fins on his bottom or neck or whatever which is where his legs would split if he had any. These fins are his Pelvics. Called so because some wild biologist way-back-when thought that's where Tadpoles got 'em an' I betcha Tadpoles has come from fish. Up a long ways to make Frog. On Goby, if they are joined to make him a nice handy suction cup to stick him to rock in currenty waters, he is real Goby. Other-wise he is some kind of fake.

Catalina is no fake. He colors like carnival elf the cracks and crevices and crannies and crinkles of California rock swirled by California currents. All the way down to 3–4 hundred feet. Many fathoms deep. Where Johnny Shannon wants to go.

If he can con Grampah out of NEW dive-rigger MARVELS. And Grampah's company 1st time down. Says all them fishes will be so pleased and surprised to meet friends so deep. Grampah says there is no hide like an old hide to get itself wet into water over its head and he will think on it.

All this beauty of the Catalina Goby is only about as long as any longest finger on that 2-yr.-old tormenting light bulbs. 🐚

Species: *Valenciennea strigata* (**Broussonet, 1782**)

The blueband goby is found in tropical waters of the Indo-Pacific. These small fish are found from eastern Africa across the Indian Ocean to Australia and the western Pacific. Typical in clear waters around lagoons and reefs, this species is found along hard bottoms

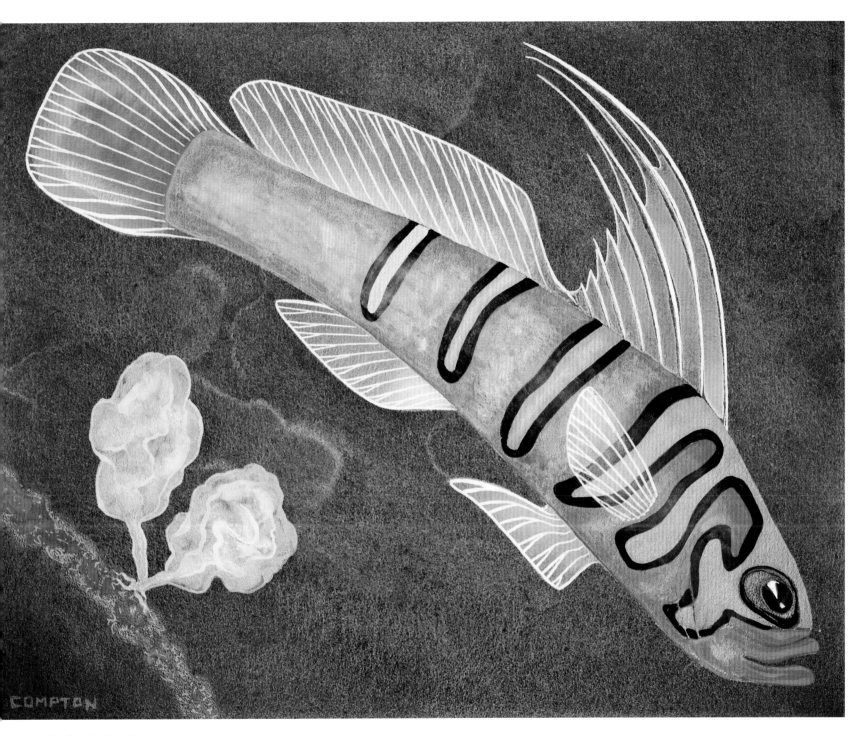

Bluebanded goby
Lythrypnus dalli (Gilbert, 1890)
"He colors like carnival elf the cracks and crevices and crannies
and crinkles of California rock swirled by California currents. All
the way down to 3–4 hundred feet. Many fathoms deep."

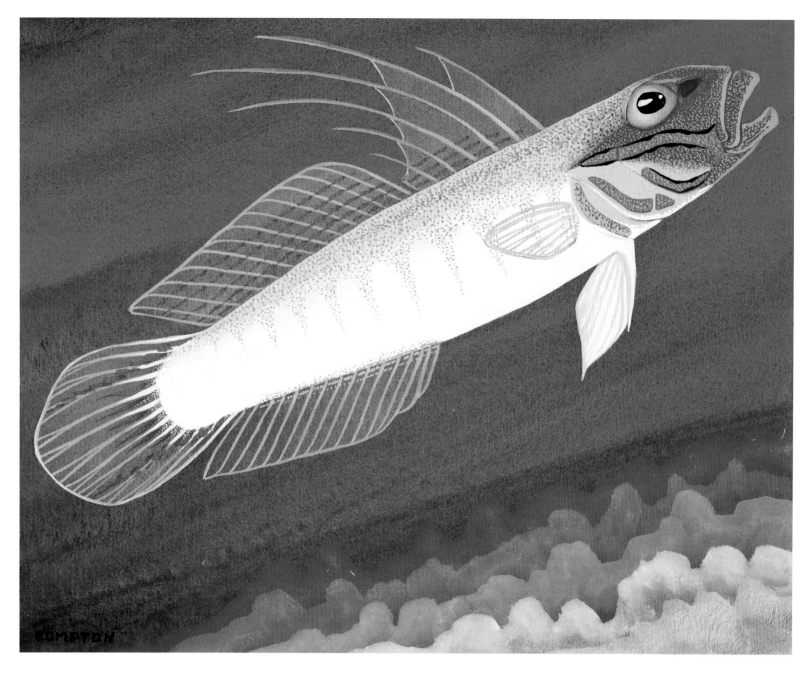

Blueband goby

Valenciennea strigata (Broussonet, 1782)

"This fine active fish, the Golden-head, is called a Sleeper. Somebody saw him stretch out on the sand one night. He much prefers a tunnel which he shares with Pistol-or-Snapping Shrimp. He lives all around warm Pacific Islands and, at 6-inches, he is twice the size of his roommate but doubt exists that he gets much sleep."

or sandy areas. The blueband goby is most commonly found to a depth of approximately 6 m, while specimens have been found to a depth of 25 m. These small fish have a pale gray body with a yellow head. The most notable characteristic is the blue bar below the eye and along the upper edge of the operculum. The dorsal spines are elongated into long filaments. The caudal fin is rounded and longer than the head. Scales along the body are ctenoid with cycloid scales below the first dorsal fin, and the head lacks scales. Typically seen in pairs, these fish exhibit monogamy, with each individual chasing away potential rivals. After spawning, eggs are laid inside a burrow and are carefully guarded by the parents. Feeding primarily on small fishes and benthic invertebrates, these fish often also eat eggs of other species they find by sifting through sand.

(15) Sleepers are the cross-ties on a railroad or the rollingbolling rollingstock with snug & satisfying bunks sounding Click-Click-Shushaday-Click across the steppes of Russia, the plains of India and China, the golden deserts of Australia and Africa; through the blue snows of Canada and the green mountains of Mexico. The jungles of South America and that wonderful track from Berlin to Paris to Rome. You can see by starlight through big pillowside window the world hurtling you to this fish or the other. From the reefs of Singapore to the fjords of Norway.

Sleepers are racehorses who lie down at the starting gate to have a scratch; and racehorses, gaunt, thin-tailed and coughing, who, despite all Odds, prance in to win kicking ThinTail in noses of 7 Sir Fleetfoots. Sleepers are nappers, slumberers, solid snorers, and the Dead.

This fine active fish, the Golden-head, is called a Sleeper. Somebody saw him stretch out on the sand one night. He much prefers a tunnel which he shares with Pistol-or-Snapping Shrimp. He lives all around warm Pacific Islands and, at 6-inches, he is twice the size of his roommate but doubt exists that he gets much sleep. ❧

Family: Grammatidae (Basslets)

Basslets are a primarily tropical species distributed throughout the western Atlantic. These fishes are typically associated with clear waters surrounding reefs and are known to occur to a depth of approximately 350 m. Many species are found near ledges and drop-offs. The family name is derived from the Greek word *atos*, meaning "letter" or "sign." Basslets possess an elongate and compressed body with a short snout. The lateral line in this group typically is interrupted or lacking completely. The dorsal fin is continuous, and the pectoral fins are moderately large with the pelvic fins found below the pectoral fins. The caudal fin may be emarginated or rounded depending on the species. Ctenoid scales can be found along the entire body and cover the head as well. This family consists of small and colorful species that can often be seen in aquariums or within the pet trade. Only 13 species are known to occur and are split between 2 genera.

Species: *Gramma loreto* (Poey, 1868)

The royal gramma, sometimes referred to as the fairy basslet, is a small perchlike fish found in the western Atlantic, Caribbean, and Gulf of Mexico, as well as waters off Central and South America. This species is often found in caves, crevices, or ledges. Interestingly, this species is known to orient the belly to the substratum and thus is occasionally seen upside down under ledges. This small fish has a slightly elongated body with a rounded head and elongated pelvic fins. The most notable characteristic is its coloration. The body is distinctly divided in two: the front half is bright purple, and the rear half is yellow. A black stripe is often seen extending from the snout through the eye. There is also a black spot near the leading edge of the dorsal fin. During breeding, males often establish territory in which a nest site is developed in either rock crevices or holes in the substrate. Females travel to these areas to spawn; upon egg deposition the males tend to the nest. Prior to the eggs' hatching, males guard and maintain the nest and clear debris away. These small fish feed on small shrimps and other invertebrates.

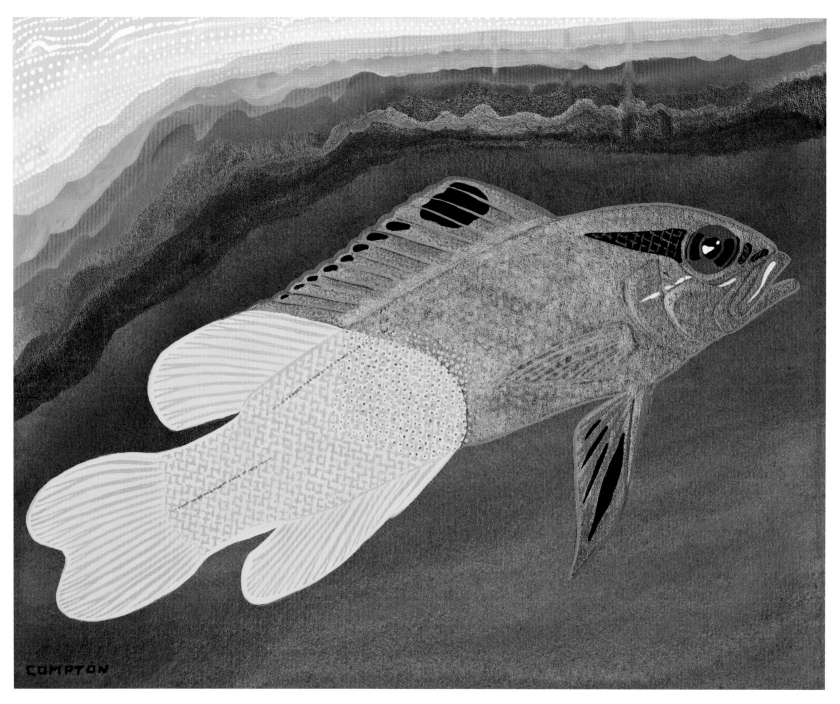

Royal gramma

Gramma loreto (Poey, 1868)

"Now who would think these little 2-inch jewels was mother-kin to one of them 12-foot thousand pound Sea Bass what we got also just here with us outside? Didn't have no room to bring 'im inside but I bet you folks are rarin' to know how I caught these Halloween spirits I call 'em."

(22) "They look more like Gobies than Groupers," said Uncle Robert.

Everybody called him Uncle Robert although I don't believe he was ever anybody's uncle. He let us kids hang around because he liked to think we believed his stories. He said ragged brown kids with they eyebrows and shag hair tow from the sun was required mise en scene for the waterfront. Tourists would expect it and would be disappoints if he couldn't produce us. Uncle Robert owned that pier and baitstand and boat rental where you turn off 2-mile south of Largo and that seapark where you can't fish over and you can't fish under. We never went there, you bet.

He sold anything a visitor might want. Had lots of shells and coral and some pure ugly painted junk and pieces of eight which was pennies rotted with acid and then sunk on reef a month to grow bugs on 'em. He always said this was for fun not livin' because he knew precise where Montezuma had done hid & sunk his Golden Calendar which was round as a big man tall and a thousun' pound a solid gold an' hieroglyphers in the Laguna Madre of Texas. When old Cortez got after 'im. Said he figgered to get her when he had a loose week and had figgered how to raise her without arouse the curiosity of them Laguna water-rats.

We said did he lent us the two biggest skiffs and draw us a map, why, we'd be proud go get 'er for him. An' wouldn't arouse the curious 'cause we'd be messy scene there well as here but Uncle Robert said "NOPE." You could see he didn't trust us no more'n them Texas-rats.

Well, I know us kids prolly made fun of the old man in our minds and musta tormented him some but I remember him now as kindly friend and sometimes when the smell of sand & sweat & coconut oil brings me Florida, I wish him "Fair Winds, Uncle Robert." Wherever that trash sailed 'im to.

So. Well, anyway there all us were one October morning way back with rain blowin' to us from Cuba and Uncle Robert showing tourists latest tank for their pleasure while we waited for sun due at noon. Plenty pretty tank with cave in it and 10 Fairy Bass swimming very satisfied, some of 'em upside down on cave ceiling the way they do.

"Now who would think these little 2-inch jewels was mother-kin to one of them 12-foot thousand pound Sea Bass what we got also just here with us outside? Didn't have no room to bring 'im inside but I bet you folks are rarin' to know how I caught these Halloween spirits I call 'em."

"Twas after fierce underwater battle dark o' moon above and Davey Jones a-laughing at me down in his locker last week. Was like being shut in toilet tank at midnight and that's where I went white hair."

"You were white-hair before last week, Uncle Robert," laughed the tourists.

"Don't remember it so."

Tourists laughed. Us kids of course had caught those fine Fairy Basses for the old liar. Catched 'em easy one noon in only 6-feet of sunny water in a kind of overhung reef cave where we jammed the Allen kid in behind 'em where he caused such a ruckus thinkin' he was drown that them fish just lept out into net. We retrieved the Allen kid too before he required more'n 5-minutes jumping on to get him breathing. And we didn't wear no tanks neither which we had no money for but did it bareback.

"I was wearing my long lungs—them three-rigger tanks that night. Lucky," says Uncle Robert. "Or I and fish wunt be here before you this day."

"We caught them . . . ," starts the Allen kid who was a slow learner but hadn't forgot the jumpin.'

"Yessir," says Uncle Robert. "I was finnin' along slow by side that wreck off No Name with flashlite jest a puddle o' dimness to show me wreck looked like used to be big yeller car. I was agropin' and a-feelin' in the black dark and could feel sompin oozin' round my legs and sompin else breathin' slow an' scary round me when YOWHH!" 17 tourists an' all us kids jumped a foot.

"Shook hands with a nekkid hand, folks. Bones. Almost lost my reason, folks. Lost the flashlite. Saw fingerbones fallin' past the light beam like big snow. Then they was gone. Wanted gone myself. Wanted my flashlite super DElux model more. She was lost down inside that mangled jaggy car wrecked where coral was a-growing pale and a-waving long like the moss a-reaching in the graveyard a-winding and a-twining on me cold as frog's toes and I had to reach a way down into that tomb for my light."

His voice kinda dribbled away and 17 sunburners and all us kids

got set to jump again but he said, "Grabbed her right out, folks, and you know first thing she shone on?"

"Gold."

"Yessir. Hung onto that car's side mirrer which was all tunicated up and couldn't reflect no more was a diver's chain all gold with 2-inch SOLID gold dolphin pendant, mighty hoity-toity-tooty fer the Keys. Figgered it was sold from Dive & Fish down point but Salty & Matt says nope they didn't recollect it and had I seen some blue fish round that wreck. How blue, I asked 'em. Just blue, they says, but I couldn't help and I wasn't lookin.' Grabbed dolphin and you know next spectacle that lite lit up?"

"Gold."

"Yessir. Next to that yeller car which was more petunia bed than yeller was what I thought was big van gloomy grey in the black with back doors open and inside was inch long coins o' gold a-moving under the ceiling. Jest dimmy sparkin' where lite hit. I swam in real slo-o-ow, wantin' them coins, bein' a sinful, lustful, avaricious old man, you bet, and swam slow a-feeling of that slimey movin' floor of that van with my free hand and the other a-shakin' that lite so them coins looked like Double-Eagles and that awful Breathin' was back when all at once I realized I'd swum between teeth an' YOWHH!" Whole room shook when all of us landed.

"Them teeth shut WHAP and I turned flashlite off accidental, dropped it and sat on it. My it was dark. Still got the bar bruise, any you fellers doubt me. Ladies gotta take me as gospel. Which twas. There was me in the belly of somethin.' Which was fish, folks. Shoulda known but this was my first time inside one. And them coins was fishes too.

"It's hard to sweat in cool water at night, folks, so I didn't. Took 'er easy. Paced off my prison. 29 feet × 13 feet × 8 feet and a smidgen. Roomy. Cool like I said with them big gills shusst-puh-shusst-puh an' mouth most open again and nice cozy inside current. Most put me to sleep but the Fairies liked the light so I hung my dolphin round my neck and let 'em play with 'im. Thought he was one of them lost his purple. Of course I coulda got out any time scoot out mouth or cut door thru side findin' fish steaks for my fryer EN route but Big Basser never hurt me so why fret him.

"I know a nut Biologist down that Key West Metropolis who'd pay if he could get inside most any critter to examine hit alive so I sat me down on a lobe o' liver to make some notes on my slate and bill 'im for 'em. Had plenty air left for indepth research and my fairyfriends was happy playin' bump with their dolphin.

"Forgot that air, folks. First I know I got tank bubbles jamming down where I could hardly see my scientific scribbles. Had no smokehole in fish to get out, you see. All of a sudden, I was non-atomic core of biggest explosion ever occurred on Keys. Big Bass burped. Yessir, Big Bass shot backward to Cuba an' I rocketed N by NW to No Name. Found me sittin' peaceful on lowtide coral beside a octopus scared plumb white. And swimmin' round my flippers was these Fairy Bass you see has follered me we was friends. Brought us all home."

Just about then in came that diver from the Seapark waving the Miami paper like he was mad at it.

"You see what they wrote on them two brothers is always lying?"

. . . two of us . . . I saw Jim swim by north side of . . . Biggest seabass I ever saw . . . sucked Jim in tanks and all . . . only see tips of flippers sticking out . . . wasn't scared—went crazy I guess . . . got hold of Jim's ankles . . . don't know how I pulled him out.

. . . diver believes bass, a Giant, must have migrated from Cuba as fish had last week's plastic menu from a well-known Havana restaurant caught on old hook in side of jaw . . . eaten diver was found to be clasping menu when recovering on boat . . . biologists interviewed said . . . and seems incredible the speed . . . sources are being checked to ascertain if menu possibly dropped recently in Florida waters . . .

"Ascertained," snorted Park-diver.

"What? Look here. Here's picture of 'flippers showing teeth marks with rounding to show angle of bite from inside monster fish.' Liars."

"Showed Kevin how to do it with a can opener," says Uncle Robert. "After he lost the one shark did it to."

"What?" says Park-diver, giving Uncle Robert up for crazy. "These bums are biggest liars in Florida," he told tourists, "and you remember hit."

"No," says tourists, considerin.' "They aren't."

"What?" says Park-diver, gettin' mad. "Well," he says very

sarcastical, "an' who is, pray tell? Where you keep 'im? I'll shake his hand."

"We got 'im here," shouts a big sun-peelin' palm-hatted tourist with pride. "Bet 'im against all comers." 🐚

Family: Labridae (Wrasses)

Wrasses represent one of the largest and most diverse families of marine fishes. These fishes are found throughout the world in the Atlantic, Indian, and Pacific Oceans with most species occurring in tropical and subtropical seas. The family name derives from *labrum*, which refers to a "lip" or "edge." Body shapes and overall size vary dramatically within this family. Some are relatively small and elongate, while some are large and compressed. There is typically a single dorsal fin, and a notch may be present between the spines and rays. Wrasses, although related to parrotfishes, have canine-type teeth that are never fused into a beak as in members of the family Scaridae. These fishes also have a protrusible mouth with teeth extending out of the mouth. A large number of species are sand burrowers. Typically carnivorous, most prey on benthic invertebrates, some are planktivorous, and some act as cleaner fish, removing parasites from other fishes. Interestingly, a large number of species change color as well as sex as they grow. Three colorations are typical in most species, with a juvenile phase, an adult phase of both sexes, and a phase seen only in terminal males (individuals that have altered their sex, typically from female to male, and matured). Terminal males are more often than not brightly colored and may dominate over an individual or several females at a given time. Nonterminal males also mate with groups of females. There are approximately 500 species within 60 genera within this family.

Species: *Bodianus pulchellus* (Poey, 1860)

The spotfin hogfish, often referred to as the Cuban hogfish, is a tropical species found in the western Atlantic from the coast of South Carolina; to the Gulf of Mexico, the Caribbean, and Bermuda; to the northern coast of South America. This species possesses a snapperlike body plan with a long, pointed snout. The body is primarily bright red with a white stripe along the ventral surface of the head and along the side of the body. The caudal peduncle as well as the rear portion of the dorsal fin and caudal fin are yellow. Adults of this species typically inhabit coral reefs and rocky outcrops to a depth of approximately 25 m. While adults feed on larger crabs and shellfish, juvenile spotfin hogfish have been known to serve as cleaner species picking parasites from larger fishes. This species is oviparous and exhibits distinct sexual pairing during spawning. *B. pulchellus* potentially hybridizes with the Spanish hogfish, *B. rufus*.

(14-B) On right in aquarium lived two Hogfish whose kin had fed many a starving Cuban pig. The Hogfish, by racial memory, were used to the Jawfishes of their Gulf and Caribbean reefs. Those Blue Devils, they did not know what to make of. All of the fish were 3-inchers which made for peace. Trouble was those Devils didn't seem to realize they were same size as every-body else. Seemed to have notion they were yard-long.

When Jawfish evicted Pistol, the necessary ado was not appreciated by the Blue Devils nest-guarding. The male immediately increased parameter of his patrol to include crater. Until Jawfish dropped a rock on him. Then he shrank it. But not by much. The hogfish faced their handsome bodies out to protect their corner and wished they also had a fat worm of their own. Kind Salty dropped them two.

A brief heavy wind slammed the south wall of the big concrete building. Beachsand frosted the big plate window and suddenly blew clear. The street ran blowing sheets of silver water. The steps of the seawall threw up small silver plumes. A figure in yellow plastic ran by, lurching, halting and sprinting. It waved to the front of the dive shop and aquarium.

Mattie says, "There goes Jimpsonweed with a hammer four hours too late to nail his shack to the nearest tree."

Storm shutters were up on all rear windows of Dive & Fish, and on the big two-storeyed veranda-ed cement Keywester house behind. The main blockhouse of the shop took a series of southern gusts. The humans felt tremors faint as knock on door. The

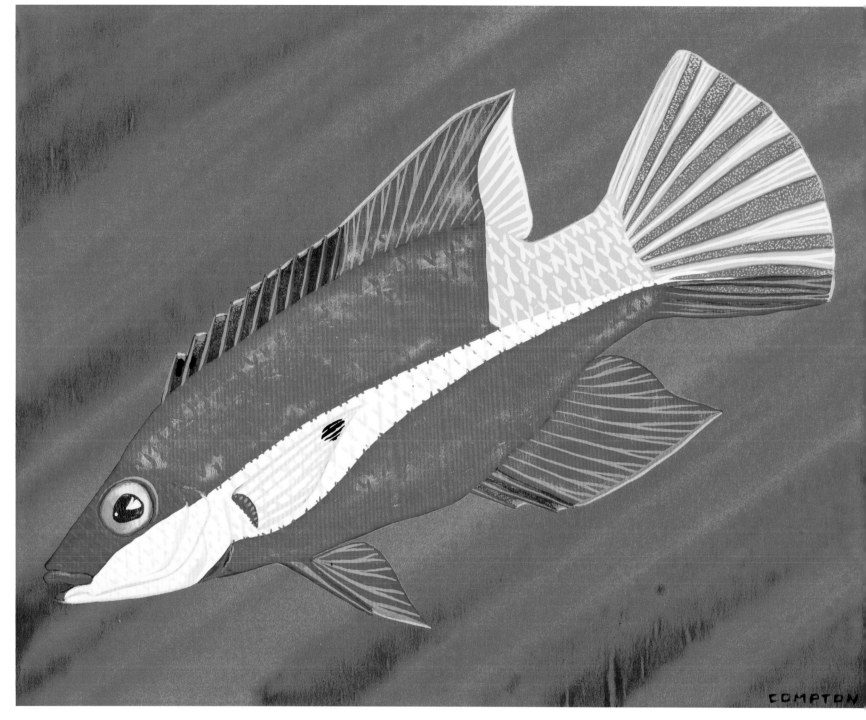

Spotfin hogfish

Bodianus pulchellus (Poey, 1860)

"The hogfish faced their handsome bodies out to protect their corner and wished they also had a fat worm of their own. Kind Salty dropped them two."

surface of all the tanks ringed in little waves. All the fish felt the call of a wilder sea.

"I believe I will remove those eggs out of temptation to jumpy fish. Salty, find me that little foam box had the mixing syringes in it."

Mattie reached hand into tank. Both Devils attacked hand. Mattie lifted roe-shell to surface and quickly over to basin where syringe box sat with inserted open plastic bag waiting. Blue Devils immediately attacked Jawfish, Hogfish, Pistol and tried to get through glass-air-glass to the Fat Eel who lived in tank next door.

"You plan to rob nest complete, Matt?"

"You think not?"

"You might think on leaving them a little sample to soothe their parental instincts."

"Think so?"

"Otherwise Jaws and Hogs are in for a lively afternoon."

Mattie laughed. "You're right. We'll share. Their eggs. See if we or fish are better hatchers."

Mattie returned shell with half-load. Fish attacked shell and hand. Shell placed; hand withdrawn. Fish inspected shell. Peace was restored in tank. Jawfish went back to the endless reconstruction of her pit and rock, coral and shell flew here and there. Hogfish swam a happy resurvey of their area. Fat Eel, with no neighborhood excitement to watch, stuck his thin Moray face out of his surface and snapped audible fangs. Salty fed him a foot-long squid.

"Write her up, Matt. Now we know Blue Devils can't count. Look at them strut. Look like David returned to camp after Goliath."

"Don't they?" said Mattie. She added ingredients to eggs and water in box.

"You making omelet?"

"Fungicide, bacteriacide, hormones, anti noise-shake-and-rattle. And oxygen pellet. Can hatch anything up to Ostrich." Mattie firmly seated foam top. "There. Let's go watch this blow from house."

Salty rolled down the outside grate over the big show window. Whirling devils of rain and small debris walked in the street. Seawall steps sent up sheets of blown foam and sea-wrack under clouds low and fast. Mattie and Salty locked up and ran, bent and blown, up short alleyway to house and television, telescope,

radios, recorders, players, drinks, smokes, computer internet, telephones and the fun of cooking a washpot of Key West Hurricane Chaos Caldo, a fish stew of great stoutness containing everything edible, or thought to be edible, from sand-flea to shark. Called Si-Si by the natives of the island. To be eaten with French bread and prayers to the sea and sky gods.

In shop, airpumps breathed into seventy tanks of various life in sigh and bubble. A sound soft and liquid as sucking straws. All lights burned. Surface water shook into rings come and gone when 160 mph gusts hit the building. Fish swam and fish hid. Two octopus fought over an abalone shell. Pulsing their knobby bodies red with rage and white with despair. Depending on who had shell. They were very careful to avoid 8-arm to 8-arm contact. They were very fastidious wrestlers. As Salty always said, "Afraid of Sweat. You would think neither one of them had ever bathed."

Most of the show was outside the metal lace protecting the show window. Metal roofing flew into street, flapped on pavement in brief frustration and flew on. Three barrels from Central Docks danced with floor dolly from Marine Motors across a street paved with sea shells and sanddollars, and on into the ballroom of the sea on the beach. All of the palms were down in front of Dive & Fish.

Miami Radio said calmly, "Eye of Hurricane George going inland at or near Marathon, Florida," and dropped another coffee cup.

Inside D & F, the air compressed and released its tiny pressures. The mouse who lived in the customer's sofa crept out on brave paws, whiskers wary, to eat from a fallen can of flake food. A mighty rattling Thud! hit the front door beside window grid. Door split at bottom. Chains rang on the grid. Eight feet of ship's spar with chain and tangled cable bounced off wall to give wind a new bite and was thrown over whole building to land in Mattie's front yard.

All the lights went out and the pumps stopped. Mild cough and purr. Standby generators came on. Lights and pumps came on. Wind stopped. All wind stopped. Mouse-who-lived-in-the-sofa thought she had gone suddenly deaf. A long board long pinned by wind to front of building for past hour dropped with a wet Bang! across sidewalk and curb. A stolen yellow Buick convertible, top blown to white strips, slid wetly into curb. Driver jumped for D & F door. Passenger, lofting axe, jumped for D & F door.

"Hay-ay-ay!"

Axe split door in great screech of wood in the sudden hush of George's eye. Axman, thick as Gorilla and less intelligent, found himself in aquarium section. Driver, thin, strong, and moustached as a weasel, ran loads of tanks and regulators and watches and wrist computers and neck jewelry in conveyor belt from dive shop to Buick. Over the Keys, a watery sun looked down afternoon slant through George's eye, his socket the far circle of cloud, black and torn, racing at 170 per.

In the still warm hum and friendly smell of fishtanks, the Axman peered and blinked. "Huh?" he said.

"Git in here," yelled Driver with his arms full.

But Axman had just spied Fat Eel who had just spied human, he thought, who might be shed of a squid if wheedled. Fat Eel showed his pleasant face in air and clacked his long teeth in longing.

"Snake! Big Snake! Kill Big Snake!"

Axehead lofted.

". . . in Eye. Do not be caught by wind change. Do . . ." said Miami Radio loudly.

Axman was slow startled but fast moving.

"Squawk!" says Miami Radio and split loudly in half.

"We're gone, dummy," yells Driver, jerking Axman around to face door so he could find his way out. "Ain't you got nuffin'?"

Axman grabbed only thing in sight looked normal. The foam syringe box with international symbol for aquarium squirt needle on side. Back door of Dive & Fish slammed open. Here was Salty and Smith and Wesson 44 Magnum Model 29 with Mattie and broom in trail. Invaders jumped for Buick. Tires screamed shell fragments and sand dollars. Mattie, impatient to see, prodded Salty's behind with broom. Salty, with the loveliest and most powerful pistol in the world, blew a running crater 4-inch deep in wet street behind Buick.

"Dammit, Matt," says Salty.

He ran to the sidewalk and knelt and blew two holes high right where tail light met trunk lid before Buick was lost on curve. "Hay-ay-ay!" rang back.

"You'd believe out of two I could hole 114-& gastank. Blow it maybe."

"You'd not burn them surely?"

"Alive."

"No. We have insurance."

"Those weasels! We have no insurance on my feelings." He was stomping floor kicking thrown diving equipment out of his way. Mattie was taking good glaring look at aquarium area which seemed intact. "Why, where's that box of eggs gone?

"Salty, what happened to my Devil's eggs?

"SALTY!"

"Likely those P-holes took it. Those P-holes you are saying, 'Oh, dear, don't hurt the P-holes.'" Salty threw a smashed regulator into one corner.

"You mean they would kill innocent fish?"

"Kill anything."

"My fish are not even Hatched! They are Helpless!"

"So's me and my fine S & W."

"Salty. What do you need to blow that gastank?"

"Rifle Grenade."

"Where can you buy us a Rifle Grenade?"

Seven miles east of Key West Naval Air Station before you come to Ramrod Key, George moved his eye and socket-winds blew banshee over tumbled sea and drowned land. The highway was wet and smoking with spray. It was quite clear of debris. Hundred and sixty mile winds leave little litter on open low-railed causeway highways.

The yellow Buick shimmied and hustled and fish-tailed and rocked. Bound for far Miami. The Axman half stood, braced, and lifted his axe to the palm fronds and hurtling lumber flying above him. His cries met the shriek of a streaming sky. Driver was also mad with the lowered pressure on his blood and drove shouting without words. The Axman took a great swat at a flying deckchair, over balanced, and wild axe severed with violent clang the valve unit of a high pressure three tank diving rig jammed under tumble of loot in rear seat. The Buick shuddered once as airtanks fired, squatted, and shot in high curve over roadrail. Aiming for Cuba.

"Hay-Ay-Ay-A-AA-Y!" Lovely yellow car, torpedo-ing dive tanks, Driver, Axman and box of Devil's eggs all went to sea.

One year later. Anniversary of George. Raining. Not storm water. Only September island mizzle-drizzle. Blue Devils had new

batch to hatch in their shell. Jawfish had some new brightly dyed shell lumps, red-yellow-blue-orange, driving her nuts rearranging the pattern of her deep dwelling wall. Hogfish had new Ball Coral they could play chase around. And, Lo, near Hogfish, who were tolerant creatures, was a tunnel opening and on one side peeped forth the bug-eyed face of a comic Goby and other, the peeky tiny face and great laid forward claw of a satisfied Pistol-Shrimp. Only Pop! heard now was when someone approached his Goby. Jawfish had inspected tunnel, thought it poor engineering, and now ignored it.

Mattie and Salty sat on high stools drinking Key West Lime and throwing unsalted peanuts to Mouse-who-lived-in-the-sofa. Unsalted so she wouldn't be continually coming to sink for a drink and getting in all's way, said Mattie. In came the diver from Ramrod and No Name Keys. Mouse knew him and squeaked Welcome. He often carried cheese crackers in pocket with shreds of tobacco. Mouse liked both. Fat Eel knew him for friend and watched with envy. He had never been offered cheese crackers, tobacco nor mouse. He wondered how combo would taste. He rose to chatter teeth beguilingly.

Diver—skinny 16; Mouse-who-lived—plump 3 year; and Fat Eel—age unknown, had taken to one another from first encounter. Diver let Fat Eel tug a fresh dead mullet from pocket from his fingers. Diver sat on sofa and spread crackers and tobacco squiggles between his bare feet. Mouse sat dainty on one big bare toe and ate off other as table.

"Salty, you know Forty-Foot Hole south of road? One we found nobody knows? I found wreck and a whole bunch of blue fish. Them blue fish yours, Matt? Looks same as them there."

"Are they, Davey?"

"Yessum."

"This car yellow, Davey?"

"She's solid rust and tunicates, Salty. You told me we ain't never to lose any foreign critter in our waters to grow up pesty. How's your blue fish get into that hole?"

Mattie looked at Salty. Salty looked at Mattie.

"Drove there I suppose, Davey. Seem to me Matt did kind of mislay a box of Devilshot here a while back. You'll stay the night.

Feed you up. There's hot shower and real soap. Tomorrow with sun we'll catch those Blue Devils out of your hole before they pest you."

"Save our reefs, huh?"

"Hell, no, they are worth twenty bucks apiece. Long as Miami thinks Matt hand-raised 'em. Worth zero, Miami finds it can catch 'em off Ramrod. I'll give you five bucks a fish and bonus, we clean 'em out."

"Deal, Salty." 🐚

Species: *Choerodon fasciatus* (**Gunther, 1867**)

The harlequin tuskfish is found in tropical waters and is common throughout the southern region of the Great Barrier Reef but is uncommon and even rare in other areas. These fish inhabit waters of seaward reefs to a depth of approximately 15 m. This species has a compressed body with a large sloping forehead. The body is red with approximately eight alternating bands of red, blue, and black. Like other members of the genus *Choerodon*, the harlequin tuskfish's most notable characteristic is the large, protruding canines. These fish generally lead a solitary existence; they are often territorial and will protect a large portion of the reef. Utilizing their large canines, these carnivorous fish will typically feed on hard-shelled invertebrates by prying them from the bottom and then crushing the prey with their pharyngeal teeth.

(5-C) KEVIN & DANNY'S FISH
We ambushed us in thickets thick in Coral to hide. Here comes Tuskfish. Oh he is red and green and blue and very ferocious. He bites and he bites. He has big teeth like elephant he bites. He do not bite us. We poke him with our slate. We have not got no shotgun to poke him.

Here comes 'nother Tuskfish. He bites and fights 'nother Tuskfish. They fight around. We chase them to write up our notes. We do not never go oft to Tahiti. We want to catch the Tuskfish for the little kids see fight so good and if they bite we will put tapes on them to stop the bloods. We do not swim no wheres near David and Johnny say. If we knowed Johnny and David is carry shotgun

Harlequin tuskfish

Choerodon fasciatus (Gunther, 1867)

"Oh he is red and green and blue and very ferocious. He bites and he bites."

we go to cave. We don't want our butt shoot off. Are we finish? "Decidedly." 🐚

Species: *Coris aygula* (Lacepede, 1801)

The clown coris, or twinspot coris, is a tropical species found throughout the Indo-Pacific from the eastern coast of Africa and the Red Sea to both northern and southern Japan and the remainder of the Indo-Pacific region. Commonly found among reefs, these fish occur in lagoons on sandy and rocky patches surrounding reefs as well as exposed flats near reefs. Adults tend to be solitary, while juveniles commonly aggregate in shallow tidal pools. This species undergoes a transformation in color when aging. Juveniles have a vibrant white body with black spots covering the head and fins. There are two prominent ocelli along the lower half of the dorsal fin that are surrounded by a ring of bright orange. As these juveniles age, the body becomes much darker and the dark spots are often lost. The body of adults is typically dark green. Females exhibit a rounded caudal fin, while males possess a truncate caudal fin with filamentous rays and very long pelvic fins. Dominant males develop large, bulbous foreheads, and the first dorsal spine becomes elongated. This species feeds on an array of invertebrates, including crustaceans, mollusks, and even sea urchins.

(17-C) Most spectacular of the Pacific wrasses. Of any wrasse anywhere. Earth, Moon or Mars. When they are 4-inch, 3-ounce, they are yelled for Pet of reef and showtank. When they are 4-foot and 30-pounder they are caught with shouts, splashes and much morning merriment on stainless steel hook and monofilament line.

Screams of Voila! Roost 'IM. Jollied Go Bonzer! The lucky boy with the rod runs wild up beach and wild down. Big Twinspot drives his fins wild down lagoon and wild up. Then, quick as toes running, he buries his bigspot scalewhite body 3-foot deep in the snowcoral bottom Sand of the deep pond between Tahiti Nui herself and the emerald feathers of her islet Motu Au.

Tight as a cork dug. No tugging, rodjerking, dancing, screaming nor youthful cursing would unpop him. Rodboy yells he's still on. 18 yelling beachboys and girls in barefoot herd, scaring all the Robber Crabs to scrabble back up palm trunk, hit surf and turn fish. Three fathoms deep they search for track of hidden monofilament.

High trumpet wail like Triton Shell blast from 9 floating heads central lagoon. The 9 not seen on musical surface are attached to scrambling arms and legs pawing up sand eighteen feet lower to milky the air-clear sea. Rodboy braces legs, gets rodbutt firmly in his navel and shouts encouragement. Underwater explosion at sea. Rodboy is jerked off his spread toes to dig face and kiss beach. Rodboy up and running. Taut bow of rod held high. Monofilament sizzles sideways. Twinspot is loose and 18 heads riding an incoming swell scream advice; 19th head barks. When sunset sets the windward fountains of the reef afire and throws the blue arc of palm shadows over lighted torches, Twinspot is served as Piece de Prelim to Short Pig coaled.

The young of the Shannons and the Kellys (8 of the joeyfoots as Co-Capin Eddie said, plus dinkum Deck) all alive off the hung hammocks of *Riff-Raft* were a big part of the loud and successful fish hunt. Deck Dog gnawed his pigbone on one side of spread palm fan, Miss Fortune growled over her fishhead on other. Miss Fortune allowed the merest flicking of tailtip to show how she felt about eating off same plate with Deck Dog. She was on party behavior. She had adopted a Tahitian toddler who sat naked-to-naked beside her and kicked sand with his heels and thumped Miss Fortune with his fists and shouted and spilled coconut milk on her.

"Look at that animal, Eddie," Jim told his chum. "Why cats will cozy a No-Neck is one of the wild mysteries. Only reason anybody else puts up with 'em is that eventually, hopefully, they grow up and leave."

All of *Riff-Raft*'s crew ate as hardily as their Tahitian friends. But it was, as Co-Cap'n Jim later said, "about like chewing up artwork." 🐚

Species: *Coris gaimardi* (Quoy and Gaimard, 1824)

The African coris, often referred to as the yellowtail coris or the clown wrasse, is a tropical species with a very large but patchy distribution. This species is found throughout the Pacific from the Hawaiian Islands to the western Pacific. Historically found

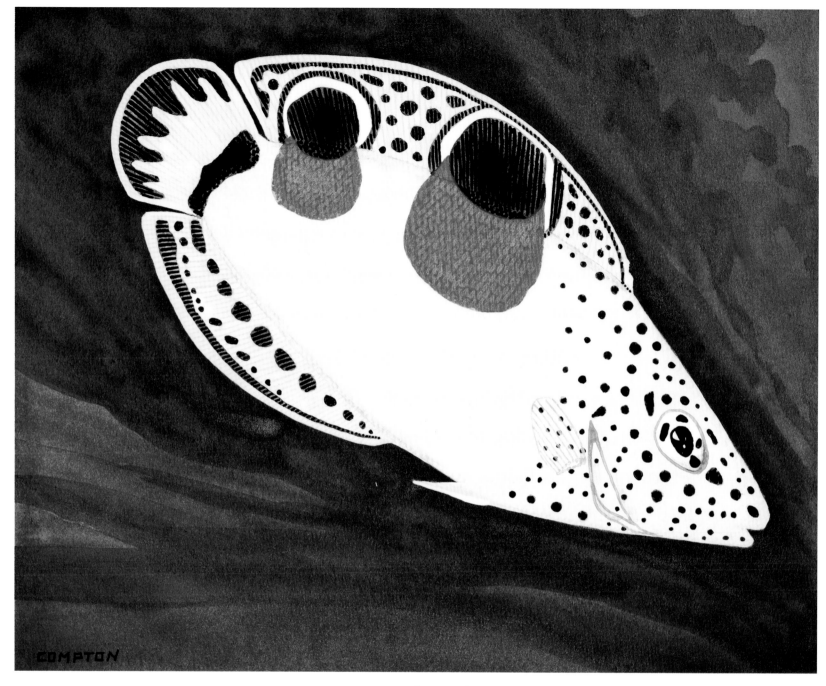

Clown coris

Coris aygula (Lacepede, 1801)

"Most spectacular of the Pacific wrasses. Of any wrasse any-where. Earth, Moon or Mars. When they are 4-inch, 3-ounce, they are yelled for Pet of reef and showtank. When they are 4-foot and 30-pounder they are caught with shouts, splashes and much morning merri-ment on stainless steel hook and monofilament line."

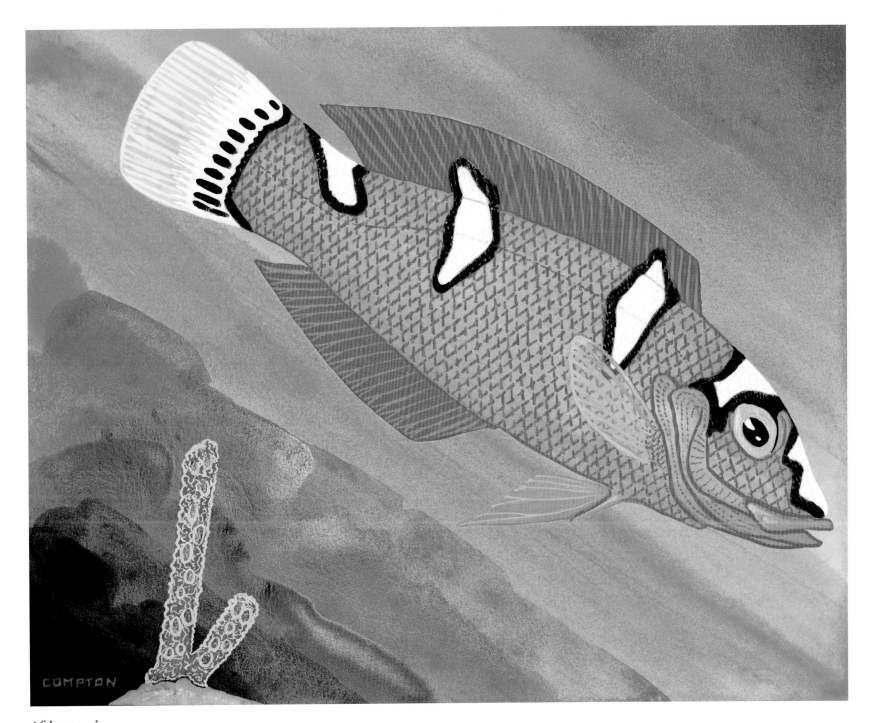

African coris

Coris gaimardi (Quoy and Gaimard, 1824)

"This is one of the finest of Pacific cleaners."

throughout the Indian Ocean, it has been replaced in many areas by *C. cuvieri*. These solitary fish are found primarily among coral, sand, and rubble of flats surrounding reefs as well as lagoons. Juveniles and adults look drastically different in coloration. Juveniles appear bright orange with white saddles along the dorsal surface and a yellow tail. Adults are initially green and blue with bright blue spots along the body, with red dorsal and anal fins and a yellow caudal fin. Terminal males appear much darker and possess a bar of light coloration along the body. Benthopelagic, adults have a varied diet and feed on mollusks, crabs, and many other invertebrates.

(17-A) This is one of the finest of Pacific cleaners, Biologist says next tick-time, he's gonna fly over an' give 'em a chanst at Him. Says they likely will figure out how ole Mr. Tick is screwed on. 🐚

Species: *Gomphosus varius* (Lacepede, 1801)

The bird wrasse is a tropical species that occurs throughout the Indo-Pacific region across to the Hawaiian Islands. In many areas of the Indian Ocean, this species has been replaced by *G. caeruleus*. This small fish is typically found in areas of dense coral in lagoons and reefs to a depth of approximately 30 m. The bird wrasse is easy to identify simply due to its unusual body shape. The body is not unlike most other perchlike fishes; however, these fish possess a long, curved snout when adult. Juveniles lack this distinguishing characteristic. The caudal fin resembles that of other species in the genus in its square, stout appearance. The body of adults is typically white along the first half and dark along the latter half. Upon maturity, terminal males turn a dark green along their entire body. Although feeding primarily on crustaceans, they sometimes eat brittle stars, mollusks, and even smaller fishes.

(7-B) Here is the other true honest no-trick Green fish. If he is male. If he is female, she is brown as wet rust. There is no doubt how Beakfish feeds his green belly. Look at the snout on him. Ease into coral-hole—suck out the worm. Poke into cave—nip out a fat shrimp.

There is another Green fish. If you agree an Eel is a fish. Which you must, won't you. Got gills, don't he. And they say he's not an Amphibian like a mud-puppy—scary wet sausage critter kind of cuddly when you get to know him. Won't ever bite. Lives in cavewater and wells and nobody ever sees him. Why Eel is fish is known only to nut who makes his living telling you an Elephant is not a Gnat and the Mosquito on your neck is not the Snapping Turtle. Something to do more with their insides, actual, than with their outsides.

Anyway, this Eel, the Green Moray, will bite you, you betcha, bad, and he sweats slicky snot or mucus or what have you to slither him safe in tunneling coral and disinfect him of coral scratch if needed. Underneath of all this body snot which is bright green in color and far more brilliant than plain old nose-drippings, why this Green Eel is brown as Beakfish female.

If you in any way become bitten badly of this critter, you fast rub off some of his snotty disinfect onto your bad bite and you will heal up Pronto—same as if your faithful dog had licked you or you plastered yourself with spitty spiderwebs.

There is no picture of Eel. Everybody knows what Eel looks like. If you don't, go get Reptile Book and study the Snake picture. Or dig up Worm in back yard. Put teeth on worm. 🐚

Species: *Labrus mixtus* (Linnaeus, 1758)

The cuckoo wrasse is a subtropical species found throughout the eastern Atlantic Ocean. This species is found throughout the eastern coast of Europe, the northern coastline of Africa, and the Mediterranean Sea. Adults of this species are commonly found along rocky shorelines; however, they can be found to a depth of approximately 200 m. Like most other wrasses, the cuckoo wrasse exhibits an elongate and slightly oblong body shape. The mouth is terminal and small with fleshy lips. The body is primarily blue with green striations along the upper portion. The ventral surface and fins are typically red or yellow, and the rear edge of the caudal fin is blue. Typically solitary, pairs can sometimes be seen near their young. Females lay their eggs in algae and are defended by the male. These fish feed primarily on crustaceans and other small invertebrates.

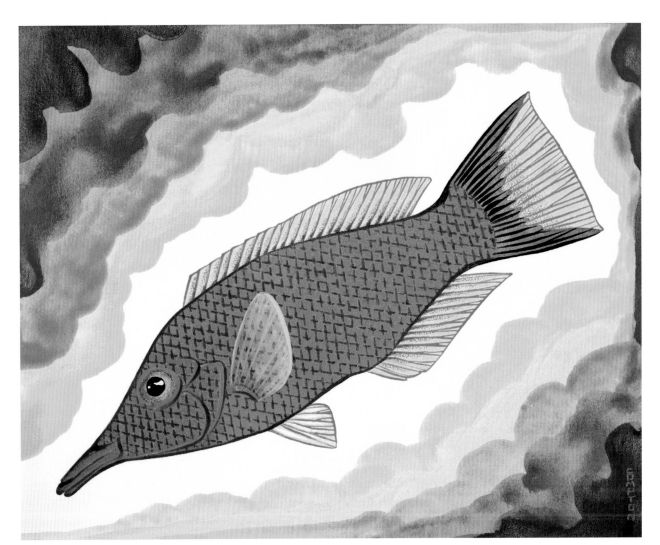

Bird wrasse

Gomphosus varius (Lacepede, 1801)

"Here is the other true honest no-trick Green fish. If he is male. If he is female, she is brown as wet rust. There is no doubt how Beakfish feeds his green belly. Look at the snout on him. Ease into coral-hole—suck out the worm. Poke into cave—nip out a fat shrimp."

(17-B) In 4,000 B. C. a tanned and sturdy lad in Polar Bear mini-kilt gripped his toes into the rough granite of Norway. In his left hand coiled 40 feet of deerhide thong circle—cut to be continual. His right hand jigged an ivory hook with shelled Winkle snail snubbed on. His tanned sister in Polar Bear mini-skirt fished beside him, Midnight Sun shone fjord to splendor.

"Hah-Yah!"

"Hah-Yah!"

Strong hands jerked. Fish flew in arcs of comet drops, fiery silver. Two more Cuckoo Wrasse, 12 inch, 14 inch, smacked behind fishermen onto reed mats spread before the summer wolftents of a coasting tribe. Women and the very young were smoking Wrasse. The hunter males ate and scratched and sang of Mammoths and Cavebear and commented unfavorably on the fishing and smoking skills of whoever in the lines edging the rocks didn't belong to them.

In 4,000 B. C. a tanned and sturdy lad in cotton mini-kilt and three gold neck rings knelt on the reed gunwales of a small Nileboat come to sea. With woven lithe and bronze hook he jerked the shining Cuckoo from the morning waters of the rocky Mediterranean, the inland sea. In blue-dyed, gold-starred mini-skirt and beaded neck drape his tanned sister jerked beside him.

"Hah-Yah!"

"Hah-Yah!"

Cuckoo wrasse
Labrus mixtus (Linnaeus, 1758)
"Biologist told his wife,
"Hon, I just read where even
way back in 4,000 B. C. the
Cuckoo Wrasse was being
caught and eaten in Norway
and Egypt."

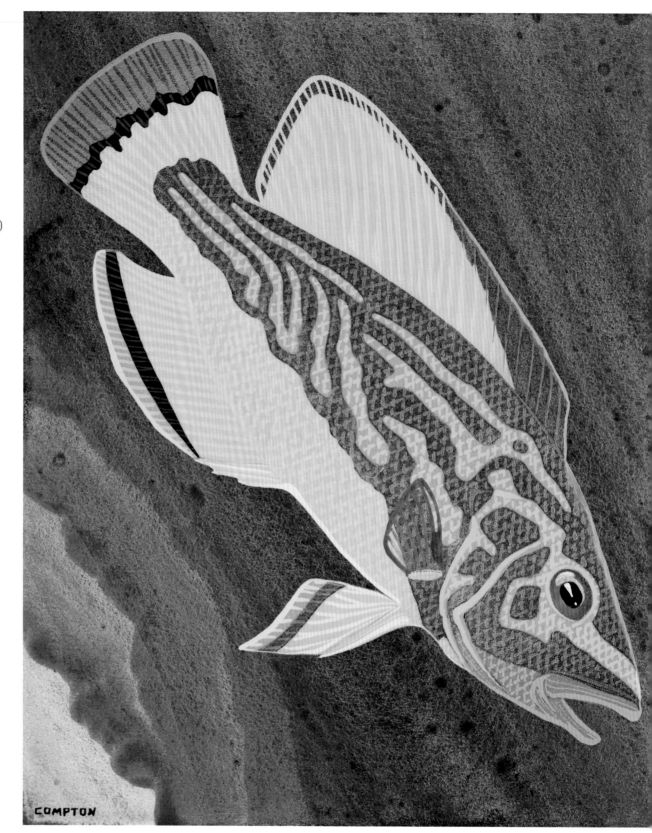

Strawboat was gunwale deep in flip-flop 13-inch orange and purple. Small sail lifted. Skim over turquoise wave to one of the many winter barges hewn from the wood of Lebanon anchored for smoking fish and trading slaves. Slaves fanned fish-smoke northeast to Phoenicia. Warrior males ate and scratched and sang of grey elephant and golden lion and commented favorably on the female slaves.

Biologist told his wife, "Hon, I just read where even way back in 4,000 B. C. the Cuckoo Wrasse was being caught and eaten in Norway and Egypt." He looked fondly at his pair of 4-inchers in 20 gallon tank complete with plastic rock and a frantic blow-bubble open/shut ceramic pirate's treasure chest active center sand. They would never be eaten by any human. At least any surviving human. If one of his nut friends ever tried it.

"That is the tackiest tank I have ever seen."

"I like tacky, Hon. That male has about figured out what makes that pirate lid burp up and down. When he does he's gonna disconnect 'er. Make nest box outa that chest. Lookit him try chase his mate into it."

"Huh!" said Wife. She was frying oysters and compounding hush-puppies at the giant kitchen table.

"Wisht I was warrior male an' had female slaves," says Biologist, Wistful.

"You and that fish have all the female slaves you can handle."

Species: *Thalossoma bifasciatum* (Bloch, 1791)

The bluehead is a small tropical reef fish found throughout the western Atlantic, Gulf of Mexico, and Caribbean. These fish inhabit reefs and protected bays and even can be seen among seagrass beds. These fish are easily distinguished by their unique elongate, compressed body and coloration. Juveniles, young adults, and older females are typically yellow with a dark stripe along the side of the body. A yellow stripe can be seen along the side of fish found within coral environments; otherwise, there is a white stripe. Large adult males possess a green body and a bright blue head, which gives this species its name. A pair of black vertical bars with a light blue band in between separates the blue head from the green rear. Another notable characteristic of this species is that both jaws possess conical teeth. As a diandric species, a certain percentage of females reverse sex during the course of their lives. This sexual change occurs during a period of approximately one month. Interestingly, this species also forms leks in which large aggregations occur during the breeding season. These fish are commonly seen feeding on parasites attached to larger fishes.

(17) The Bluehead, when he is young male is yellow. When he is she, young or old, she is yellow. Bluehead swarms the Caribbean thick as gnats. To the great enjoyment and relief of divers and real fish. For Bluehead is a fair de-louser. When he is young and yellow. When he is Big Blue Green-bodied White-collared Male, he puts his nose up at such picky activity and lets his kids and grandkids give Himself a bodyclean.

Now fish have lice (bitsy crab-creatures) same as humans (bitsy insect-creatures). And fish don't care for the comradeship any more than humans. The fish who needs a good clean goes to where the cleaners have set up a de-lousing station, puts his nose up, opens his mouth and spreads his gills to show the bloodfingers he breathes through for fish host worms and even small limp Goose-neck Barnacles among their gills. Cleaners hit him like new broom for they de-worm and de-barnacle also, and pick last meal from his teeth as well.

Nobody knows who started this removal service. Probably some fish who bit scales off an intruder and found himself with a welcome mouth full of lice. But before fish, crustaceans did it and still do. Big Morays go to coral cliffs where red shrimp live who are experts at it. Insects do it. Give a striped blue-eyed jumping spider a still chance not to scare him and he will pick all the flies off you. A Nile Plover enters a Croc's cave of teeth to do it. Rhino-birds, Elephant-birds, Buffalo-birds all do it. Monkeys do it all day long to other monkeys.

That Biologist who is friends of Moorish Idol told his wife, "Hon, I got a idea for a fine scientific paper. Make them University

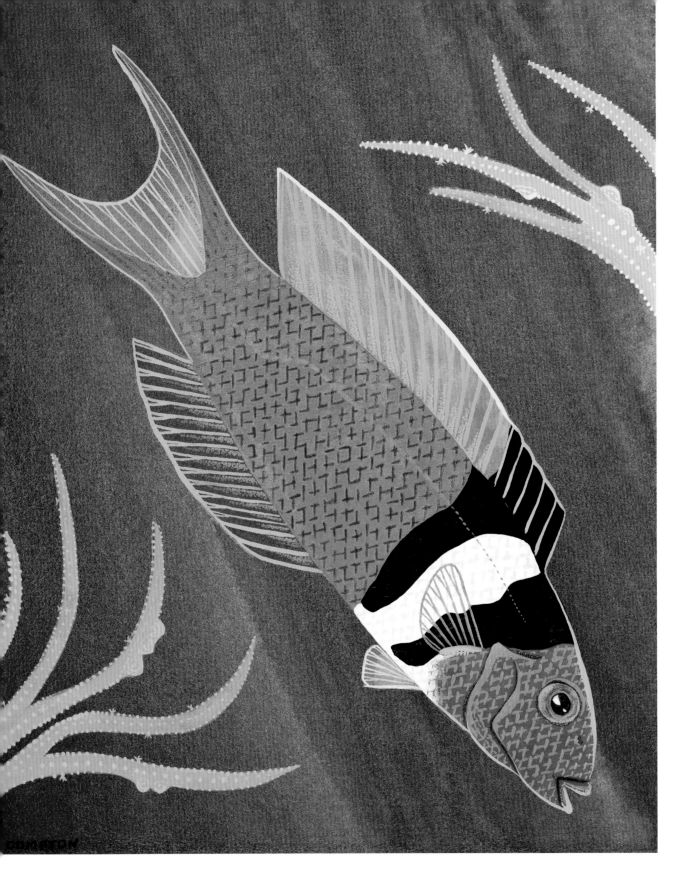

Bluehead
Thalossoma bifasciatum (Bloch, 1791)
"The Bluehead, when he is young male is yellow. When he is she, young or old, she is yellow."

marbleheads jump and holler. Might break into that great aquarium magazine you swear by."

"What idea?"

"Get one of my favorite fish some publicity an' credit. Why, divin' folks thinks he's common as sparrows and pay him no mind. I'm gonna change their attitudes."

"What idea?"

"Get some ticks on me and see do the Blueheads clean me off."

"Where on you?"

"We'll go up on Suwanee banks. Git us some big 'uns."

"Where on you?"

"ARMS, Hon. You think I want 'em all OVER me?"

"Nobody knows with you."

"You can rub repellent on me wherever we don't want us no ticks. I'll go lay up in Suwanee grass coupla hours. Get plenty."

"With two arms full you won't need any repellent. You can move your pajamas to guest room now. Pronto. Before we trek north."

On porch of Suwanee Sue's, Miss Beetrice and Biologist's wife drank morning iced tea and watched Biologist in brief bathing suit figured with Saber-Tooth Tiger heads, and most of him smeared heavily in gunk, smelling like La Brea Tar Pits, stop to pet Black Snake on head and feed him a hand-sized chunk of $10.00 a pound filet mignon laced with vitamins and brought special from Key West with 14 others, 10 not laced. Biologist played briefly with yard Goat and waded his intended way away from slow green river into high grass and low vine.

Miss Beetrice said with admiration, "Hers a real Nut, Honey. What in tunket is he up to now?"

"Didn't he tell you? He's told every filling station attendant and fastfood waitress from Marathon to you. They didn't listen."

"Oh, he told me all right. Are those fish supposed to like ticks? I didn't listen either."

"They'd better. If he collects any."

"He'll collect plenty," says Miss Beetrice.

"He eats his filets at separate table this night."

"You bet."

"He sleeps on the veranda with Black Snake."

"You bet, Honey. Black Snake is not subject to ticks."

Wife gritted her teeth and flew fast coming home. She and Miss Beetrice had come up against a bricktickwall in suggesting Biologist ride 347 air miles happy in fresh flowing air strapped like wounded on ropes above left landing gear.

"Won't them ticks be happier, Honey?" suggested Miss Beetrice.

"You two," says Biologist. "It's my airoplane. I'd fly her an' Jan can ride wheel outside but I need to sit calm and feed my ticks."

"He's trapped me there, Bea," says Wife.

But trip went well.

Biologist claimed he had 117 screwnoses dining on him and that that they were now hooked on second-hand rich-red-blooded filets and wouldn't leave him for a fat Elkhound. At home he was encouraged to stay out of the house as much as possible and sleep in backyard with Jaws the Turtle who was about as poor grazing for ticks as Black Snake. He accepted part of the offer and brought Jaws into the guest room for company.

His wife, Jan, wrote north:

Next day he decided he was ripe and we went to the reef. He was awesome sight to behold as you can imagine, Bea. Looked like a grapevine in full fruit. 117 horrible gorged swollen pea size pinky-grey tick butts. Ugh!

I will admit the fish performed as if he'd been training them. He may have, but we'll never know. You could hardly see him for yellow. The Big Blue Males forgot their dignity and remembered the days of their childhood and Plucked ticks with the rest. Took 20 minutes to clean him. Shot some fine pictures.

That night we found to my fiendish delight and his dismay that although we had lost 117 tickbutts, we still had 117 tickheads. Seems ticks must be butted with live cigarette so they unscrew the head. If bitten off behind, they leave head. "What does head do?" I asked him. "Keep on eating? Get down to bone? Lay eggs? What?"

"None of those and you can keep your imagination off my hide," he told me. Bitter but still bitten. "Fish weren't to blame. We had us left-handed ticks and fish had right-handed mouths. Couldn't unscrew the critters and 'course fish had no cigarettes. Shoulda thought of it. Now get these heads outa me, please Mam."

"With left-handed needle or right-handed needle?" I asked him but he just cussed.

He's fine now and doesn't have grapes. More as if some hunter thought he was covey of quail and shot him with mini-shot.

All for now,

JAN

P.S.—Sending Black Snake a dozen more filets. Make him share them with you. 🐚

Family: Lutjanidae (Snappers)

Snappers are moderate to large marine fishes that occur in tropical to warm-temperate waters of the Atlantic, Indian, and Pacific Oceans. These fishes, which typically inhabit reefs and rocky outcrops, are usually compressed and exhibit a perciform body shape. Due to this general perciform shape, members of this family are difficult to identify and are often confused with species belonging to the family Serranidae. Snappers possess a large terminal mouth that encloses sharp conical teeth, with several species having fanglike teeth on the upper jaw. Patches of vomerine teeth, those found on the roof of the mouth, are often found in either a crescent or V shape, while some teeth are anchor-shaped. This distinction is often useful in species identification. The body is typically covered in small ctenoid scales except near the eyes and mouth. These fishes exhibit a continuous dorsal fin that is slightly notched in most species. Caudal fin shapes range from truncate to forked. A vast majority of snappers are predatory and feed primarily on crustaceans and smaller fishes. There are approximately 125 species within 20 genera.

Species: *Lutjanus analis* (Cuvier, 1828)

The mutton snapper is a tropical species found throughout the western Atlantic, Gulf of Mexico, and Caribbean and along the northern coast of South America. Adults are commonly found along the continental shelf as well as nearshore reefs and surrounding islands. Adults live among rocks and coral, while juveniles are found over sandy bottoms such as those among seagrass beds. Possessing a typical perciform body plan, the mutton snapper has a compressed and relatively deep, stout body. The dorsal surface is primarily green, and the ventral surface is red. There is a small black spot present slightly above the lateral line, which distinguishes this species from others in this genus. These fish possess pointed anal and second dorsal fins, which are not seen in other species. These predatory fish feed on other fishes as well as crustaceans and mollusks. Like many other snappers, these fish are highly sought after by fisherman due to their quality as a food fish.

(23-A) Here is the way a coral reef builds land: The bottom of the ocean blows a hole in itself and all that hot stuff inside earth shoots a roaring mountain up thousands of feet to poke a hole in ocean and spit at the sun. After a while, no more spit. Just black mountain peak like dunce's cap having made so much bluster and irritated the sea birds. Sea birds crap on cap. This is fertilizer. Wind brings daisies as seed. Daisy seed is small and wind can carry it. Daisy seed is broad-minded and will grow in bird crap. Daisy roots push, pull, screw, tunnel, wedge, and bust up Dunce to gravel.

Meanwhile the dust-size little coral babies looking for a home, floating, find new black mountain and with wiggles of joy, stick their butts to it.

Daisy keeps rolling gravel down slope. Underwater coral builds up and gets chewed by Parrots to calcium sand washed up slope and where gravel meets sand and mountain meets sea, here's beach. Cokernut washes in and doesn't wash out. Here's tree. You got daisy, tree and beach, you got island.

Here is how Mangrove Tree grows land: The Mangrove is a many-footed vegetable with wet toes and all the toes arched and looped and buttressed for storm and like feet catch lots of toe-jam in form of tangled oysters and algae, worm houses and the drowned fisherman (fertilizer). Drowned monkey gone wild from zoo. Fertilizer. Here the Mutton Snapper lives when young, craps (fertilizer), and his sparkling color probably induced Mr. Monk to give him wet grab, fall in and belly-up first place. Fisherman was shot by drug runner who wanted his skiff and his ID. Good fertilizer.

Winds blow dust and empty newspapers also to clog Mangrove's legs so Mangrove must grow steadily outward from pollution toward water. Thus grew Florida.

Mutton grows to be line buster 25-pounder from New Orleans

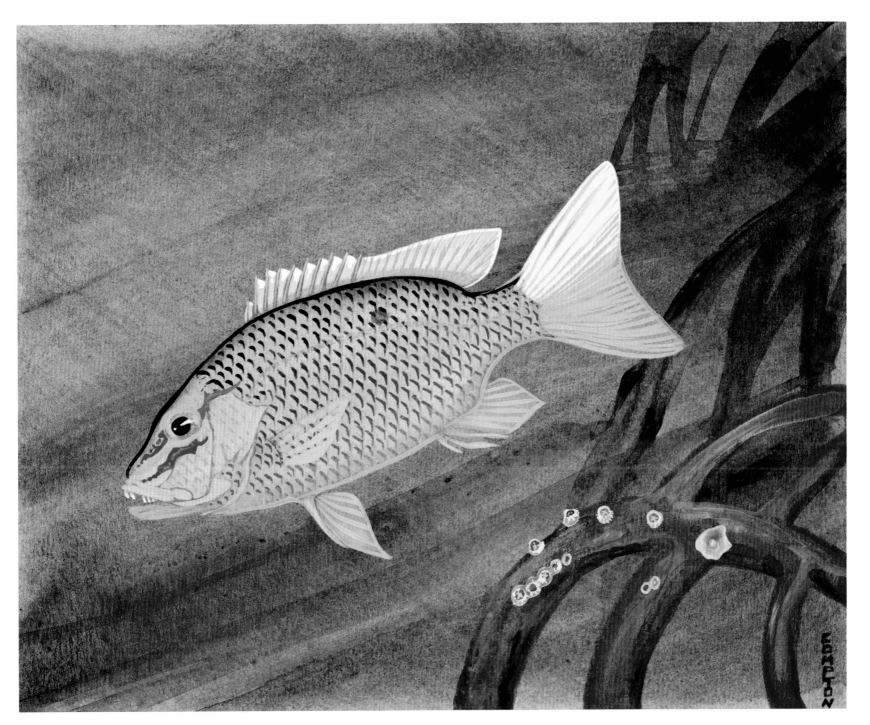

Mutton snapper

Lutjanus analis (Cuvier, 1828)

"Mutton grows to be line buster 25-pounder from New Orleans to Rio."

to Rio. Biologist has pet one lives under his dock at Key West. Says he's 4-foot long (2-ft lie) and trained to eat from hand only so's he can't be hooked nor poisoned. Not satisfied with small precautions, Biologist put up signs saying that Pus-Pocket will arrange hitman from Miami on any jerkhead dastardly enough to drop lure toward Mr. Mutton.

"You are growing inch X inch nuttier," said his wife Jan. "I and Pus get along fine. As you recall, when *Riff-Raft* is here, and we have Aunt Bea, we run you out."

Jan got a dreamy looking—forward look on face.

"You look like you getting sick."

"No. Thinking pleasant thoughts. That's get together time when we have an evening of eating Tripe Louisianne, Eggs Diablo and carrot/raisin salad."

"I'm getting sick."

"You will be. I catch you 'getting' Pus into real trouble and find my backyard full of sunk ships, hit-men and bleeding bodies." 🐚

Species: *Lutjanus sebae* (Cuvier, 1816)

The emperor red snapper is a tropical species found throughout the western Pacific, Indo-Pacific, and Indian Oceans. This species is also sometimes seen inhabiting the Red Sea. Like many other snappers, adults are typically found around rocky outcrops or coral reefs but have also been found in areas of relatively barren and flat areas. Interestingly, juveniles of this species are known to have a commensalistic relationship with sea urchins. Most juveniles occur nearshore and are common in areas of mangroves and shallow bays. Although possessing a typically snapperlike body, the emperor red snapper exhibits a deeply sloped head. The body is typically dark red or pink and is often darker on the dorsal side. Juveniles as well as smaller adults possess a dark red band from the start of the first dorsal fin through the eye to the snout. A second band can be seen from the midbody to the pelvic area and a third band from the second dorsal fin angled toward the caudal peduncle and caudal fin. These fish are often seen in large schools and feed on a variety of invertebrates.

(23-B) The scrolled fields of 12-inch Red Emperor and the snow unpeed on by penguins, of 1600 mile Greenland Ice Cap are the only WHITE outside flowers and butterflies existing natural. Greenland has no penguins who have dabbled Antarctica out of the contest.

Feeding on fringe of Australia, his beauty is stark and startling. Cap'n Eddie, from there, has running chat with Biologist who says Mr. Mutton gets bigger but Cap'n says no, Old Emp gets 'er to 50 pound and long as skiff, Chum.

Miss Beetrice once raised four abandoned children she caught stealing sneak out of the snakeland south of Suwanee. Black Snake was losing weight and Miss Beetrice found he was giving his fillets to four starving abandoned children. Also, Yard Goat was being milked. She lured the lost to front porch with fan blowing over pan of gingerbread.

"Names?" she says. "Don't cram an' choke so. There's more."

After surfeit came, with real refrigerator milk to swallow crumbs, she says, "You can line up—let me look you over." She donned her specs.

"Oh, my snakes. It's you bunch."

"Sure, Granny B."

There stood the boy, Green, who was color of Black Snake. The girl, Maria, tan of Georgia sorghum molasses. The girl, Song, the yellow of Minnesota honey. And the boy, Blacky, who was group's token whitey although he was only white, even when washed, when compared to Green.

"Hey! Granny B.? Where you get that red/white fish. Now that's WHITE. If we can scrub Blacky to that, we'll attain some sparkle to this troop."

"Never make it, Honeys. That WHITE is one fish, three birds and a handful of furred mammals. And no humans & snakes at all. Nor goats . . . don't change subjects. Why you back starving Black Snake and milking Yard Goat? You know her squeezin's are only good to water the petunias. Where's that no-good preacher you took up with? Singin' and galavantin'?"

"Skipped Granny B. We was working revival near Tallahassee see. Next to last night, preach faded with gate. And sheriff was not

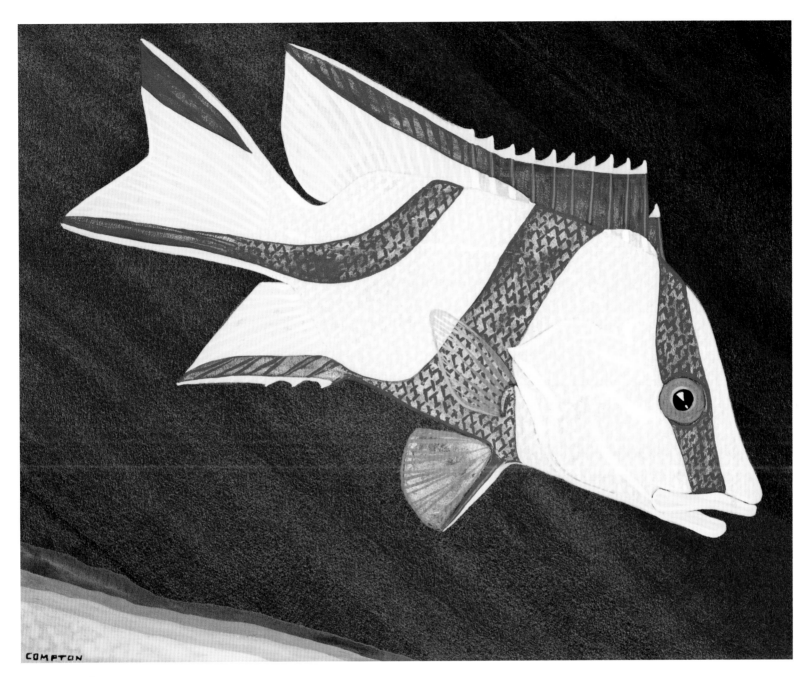

Emperor red snapper

Lutjanus sebae (Cuvier, 1816)

"The scrolled fields of 12-inch Red Emperor and the snow unpeed
on by penguins, of 1600 mile Greenland Ice Cap are the only
WHITE outside flowers and butterflies existing natural."

singin' Dixie. We went bush to you. You reckon he'll come for us? Preach took sheriff's out 'course in same pants he took gate."

"He does, his teeth is necklace. That preach hock your instruments again?"

"No, Mam." Out came Steel Guitar, Accordion, Violin & Drums. "Set an' listen, Granny B. We done changed our style."

Black Snake went into sofa's stuffing. Yard Goat, who was deaf as dirt, ate gingerbread and wagged tail. Miss Beetrice secretly switched her hearing aids off but for kindness, beat her feet to the blur of the drumsticks. 30 minutes. All the birds had flown to the other side of Suwanee and all the fish swum to the bottom of her. Pause for breath.

"Cap them bellows of hell for a mite," says Miss Beetrice. "I gotta use the phone."

When she returned, she looked 50-yr younger.

"How'd you like to book into Paris?"

"Paris, Texas? No thanks."

"Paris, France."

"When we leaving, Granny B.?"

"Ret Now. Biologist left his big plane here. I'll have you in New York in pronto time for next Concorde."

"You comin' with us to Paris? Hear our first concert?"

"I jes' can't right now, Honeys. Gotta get Black Snake a hearing device. But, you can rehearse on Concorde going over. See how you sound so close to preach's Heaven." Here regrettably, Miss Beetrice had a fit of some sort and required thumping on back.

"But you'll wave us goodbye outa N'yawk, won't you, Granny B."

"You bet I will, Honeys."

Thus is how that motley singing band, the "Muddy Rainbow," became the riprock rage of Europe. Joyful critics wrote the Continent had seen and heard nothing like it since the eruption of Vesuvius or the Battle of Hastings. ❧

Species: *Ocyurus chrysurus* (**Bloch, 1791**)

The yellowtail snapper is a tropical and subtropical species found in the western Atlantic, Gulf of Mexico, and Caribbean, and along the coastline of South America. Like other snappers, adults of this species occur among coral reefs as well in coastal waters. Unlike most other species of snapper, the yellowtail snapper is more pelagic and typically seen far above the bottom. This species possesses a somewhat more streamlined perciform shape and is lacking the large sloping head. The head is relatively small and rounded, with the lower jaw projecting slightly more than the upper jaw. The dorsal portion of the body is typically blue with yellow-orange spots, while the ventral surface is white. A yellow band can be seen from the snout to the caudal peduncle, and the fins are the same yellow. These fish also exhibit a deeply forked caudal fin that is almost lunate, or crescent-shaped. The yellowtail snapper feed primarily at night and prey on a variety of planktonic and benthic organisms. Like most other snappers, this species is a sought-after food fish.

(23) Some birds of feather adorn the spreading tree and eat of the bugs that infest him like fleas on the Antbear's bush. Some birds fly also to hunt the fields from the forest. Some fish of the reefs never leave their coral tree. Others hunt freely, too, the wide blue waters above. Depends on the bird. Depends on the fish.

The snapper is not a wren to stay in his bush. In schools he sweeps the coral of its slower darters and hiders, the Slippery-Dicks, the Joe-Wrasse and Angels too cherub to hustle. In schools he raids the wild blue yonder of surface—chasing more compact schools of minnows & mullet, herring & the jetted squid. Aquatic combat around Florida.

And the quick flashing Yellowtails flaunt the lightning-streak insignia of the great fighter planes of the world—the Sopwith Camels, the Spad 13, the Fokkers D. VII. The Typhoon & Spitfire, Junkers & the ME 109, & the svelte Morane-Saulnier. Warhawk & Wildcat, Mustang & Lightning & the gullwing Corsairs. The 80, the 86, the 104.

When Yellowtail grows too big (2-ft) to flitter, he spreads his rainbow sleek to the dream lances of the x-15 & the Blackbird and hurls to explore the blue mysteries of the Bermuda Triangle. ❧

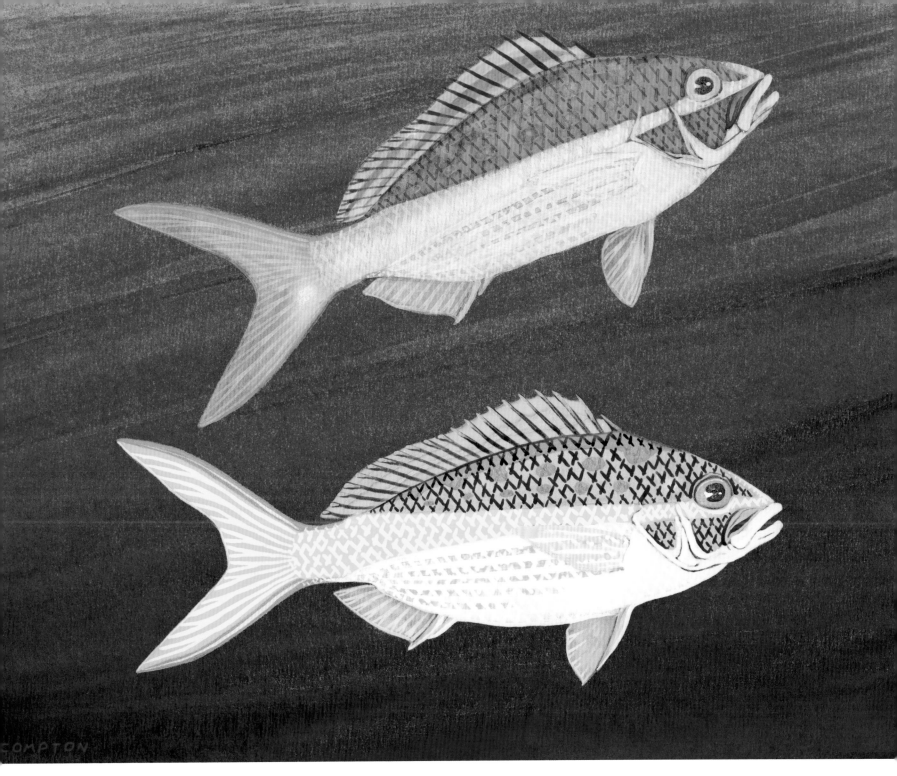

Yellowtail snapper
Ocyurus chrysurus (Bloch, 1791)
"And the quick flashing Yellowtails flaunt the lightning-streak insignia of the great fighter planes of the world."

Family: Microdesmidae (Wormfishes)

Wormfishes are closely related to fishes in the family Gobiidae. These fishes are found in tropical seas in nearshore waters. The family name derives from the Greek words *mikros* and *desmos*, meaning "small" and "bond," respectively. These small fishes can be found in coral reef, estuaries, and sometimes in tidepools. Most species are known to burrow into the substrate. Wormfishes resemble gobies in their elongate and compressed bodies, with many having an anguilliform, or eel-like, body plan. Most have a blunt snout and terminal mouth. Several species are known to lack scales; however, most possess embedded cycloid scales or a mixture of cycloid along the anterior and ctenoid posteriorly. They have a continuous dorsal fin and particularly small pelvic fins. Eggs are guarded by the parents while tucked into their burrows. There are approximately 90 species among 10 genera.

Species: *Nemateleotris magnificus* (Fowler, 1938)

The fire goby, sometimes referred to as the firefish or fire dartfish, is a small species found in tropical waters of the Indian and Pacific Oceans. These fish are found from the eastern coast of Africa, to the Indo-Pacific region, and across to the Hawaiian Islands. The fire goby is benthopelagic; it inhabits the slopes of outer reefs and is typically seen in depths of at least 15 m. The body is small and not unlike that of many species of gobies. The first two-thirds of the body is white, while the rear exhibits a red hue that progressively gets darker toward the caudal fin. A noticeable characteristic of this species is an extremely long dorsal spine, which the fish quickly moves up and down. It is not uncommon to see several individuals inhabiting the same hole or crevice. Although small, these fish tend to be highly territorial and will fight trespassers that venture too close into their territory. While facing the current, the fire goby will hover slightly above the bottom and feed on zooplankton. Although planktivores, they will also feed on small copepods and invertebrate larvae.

(15-A) Fire Fish is a Goby who was not caught sleeping on the sand. He likes sand tunnels; he burrows fine as any rabbit. He is 3–4 incher and requires a smaller Pistol companion than Goldhead's, if he is not to be permanent deaf. He lives all over the warm Pacific and, due to his spectactulary (flamin' flanks), in many aquariums where train goes. Or airplane. No ox-cart.

Many different Gobies crave companions. Some have a small crab living with them. Size and shape of spring English pea. Unpodded. This crab is called the Pea-Crab. Some have a small crab partner who is size and shape of dried Mexican pinto bean. Unpodded. This crab is called the Pinto-Bean-Crab or Enchilada Lollie or sometimes FreeHoley Fred. There are apparently, or at least visibly, no lima bean nor lentil crabs about. There are non-squeamish Gobies who live with burrowing worms.

There are Gobies from Australia to California to Madagascar who are blind and skin-grope in tunnel shelter with seeing eye Ghost Shrimp (who look for all to see just like pieces of discarded dirty white string, partly frazzled, suddenly given jerky life). If Seeing-Eye dies in some underwater manner, Goby must quick-quick find new one or perish. There must sometimes occur a dreadful scene—a fight—like two blind men fighting over a dog. 🐚

Family: Monodactylidae (Moonfishes)

The moonfishes can be found in both marine and brackish waters throughout the Indo-Pacific region. Several species have been encountered briefly in fresh water; however, members of this family are largely found in marine habitats. The body is compressed, deep, and almost diamond-like in appearance. These fishes are typically silver with small scales and exhibit extended dorsal and anal fins. The first several rays of the dorsal and anal fins are longer than the remaining rays. The family name derives from the Greek words *monos* and *daktylos*, meaning "only" and "finger," respectively. Interestingly, juveniles of this family possess small pelvic fins, while adult specimens exhibit vestigial fins or lack them entirely. The moonfishes can most often be seen in large schools,

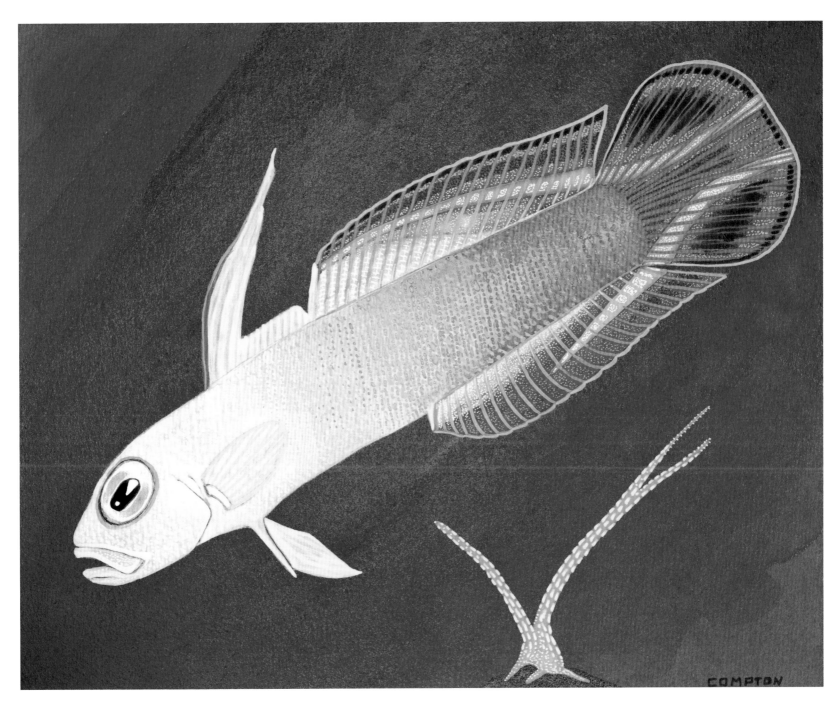

Fire goby

Nemateleotris magnificus (Fowler, 1938)

"Fire Fish is a Goby who was not caught sleeping on the sand. He likes sand tunnels; he burrows fine as any rabbit."

feeding on small fishes and invertebrates. This is a relatively small family consisting of only 6 species within 2 genera.

Species: *Monodactylus argenteus* (Linnaeus, 1758)

The silver moony is commonly found in tropical waters of the Indian Ocean and western Pacific. These small fish are primarily found in marine and brackish waters surrounding bays, mangroves, and tidal creeks and occasionally coastal reefs. Interestingly, these fish are also found along the Mekong Delta in freshwater tidal zones. Like other moonfishes, the silver moony is small and possesses a highly compressed body. Adults are a vibrant silver with dull yellow fins that have black edges. Juvenile specimens exhibit a brighter yellow along the dorsal fins and two black stripes along the forehead above the eyes. Pectoral fins of both adults and juveniles are transparent. They are commonly seen in schools as adults, but juveniles can be found individually or within small groups. These small fish feed largely on planktonic organisms and debris; although popular in home aquariums, these fish tend to be highly territorial.

(5-B) On the floor of the cave were lots of apartment sponges and the little crabs crawled in and out of the doors. Wouldn't that tickle the apartment? (Here giggling) We didn't know all those silver fish peckin' at those sponges. They nibbled our fingers, too, and pulled our hair. Nancy wrote she thought they were DiamondFish an' she caught 'em a lot off wharf where Mulga River comes to Reef and very good to eat and we're gonna catch some this very evening and make Fish Fry because those Mulga ones are big and delicious but ours were small and fun to play with and looked like dancers in ball gowns all silvery with yellow lace and black sashes.

 "That cave was size of *Riffie*'s cockpit cabin an' open three sides. You think us scoutdogs would let these dummies get into real cave outta our sight? They ain't scientific anyways. Thinking them fishes is dolly-dos."

 We are gonna write British Museum scientific how our fish can live in Mulga River and big sea same time. Won't they be surprised? We are not never to Fish Fry any of our big delicious fishes for Dummy Boys. Won't they be surprised? 🐚

Family: Opistognathidae (Jawfishes)

The gobylike jawfishes are distributed throughout the western and central Atlantic, Indian, and Pacific Oceans from California to Panama. Although resembling gobies, these are moderately sized fishes with very large heads and long tapered bodies. The family name derives from the Greek words *opisthe*, meaning "behind," and *gnathos*, meaning "jaw." Like other elongate benthic fishes, jawfishes tend to live in burrows around reefs. These fishes have a noticeably incomplete lateral line that runs high along the body and ends around the midpoint. These fishes are brooders; males of most species exhibit oral incubation of eggs.

Species: *Opistognathus aurifrons* (Jordon and Thompson, 1905)

The yellowhead jawfish is a tropical species that inhabits the western Atlantic to a depth of approximately 60 m. This species is seen throughout the Caribbean and Gulf of Mexico as well as a small portion of the coastal waters of South America. These small fish with their small round heads and slightly elongate bodies look like gobies. The fish is primarily tan with a blue tinge and blue dots along the body. The head, fins, and anterior portion of the body are bright yellow. The most notable characteristic of this species is its aptitude for burrowing. These fish move both sand and coral rubble and create their own burrows. During breeding season the male courts the female, and after spawning the male broods the sticky egg mass in his mouth until they hatch. Hovering above their burrows, these fish feed primarily on zooplankton.

(14-A) Center stage but not on camera, the coral sand bottom humped up 5 inches to a sort of crater firmed and interlocked with pebbles, shell splinters and dead coral rubble. The crater had a pit and the pit had a hole and a couple of inches above this pit-hole of

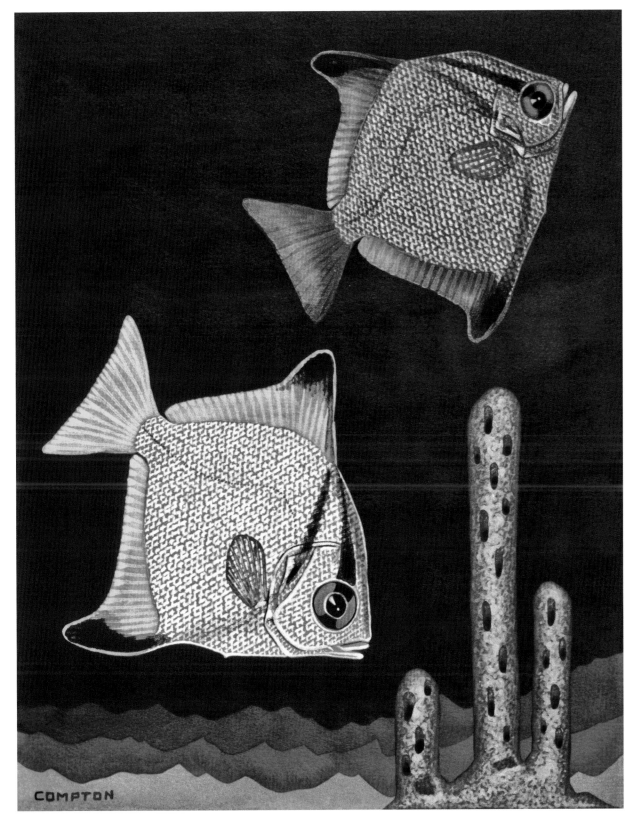

COMPTON

Silver moony

Monodactylus argenteus
(Linnaeus, 1758)
"Nancy wrote she thought
they were DiamondFish an'
she caught 'em a lot off wharf
where Mulga River comes to
Reef and very good to eat and
we're gonna catch some this
very evening and make Fish
Fry because those Mulga ones
are big and delicious but ours
were small and fun to play with
and looked like dancers in ball
gowns all silvery with yellow
lace and black sashes."

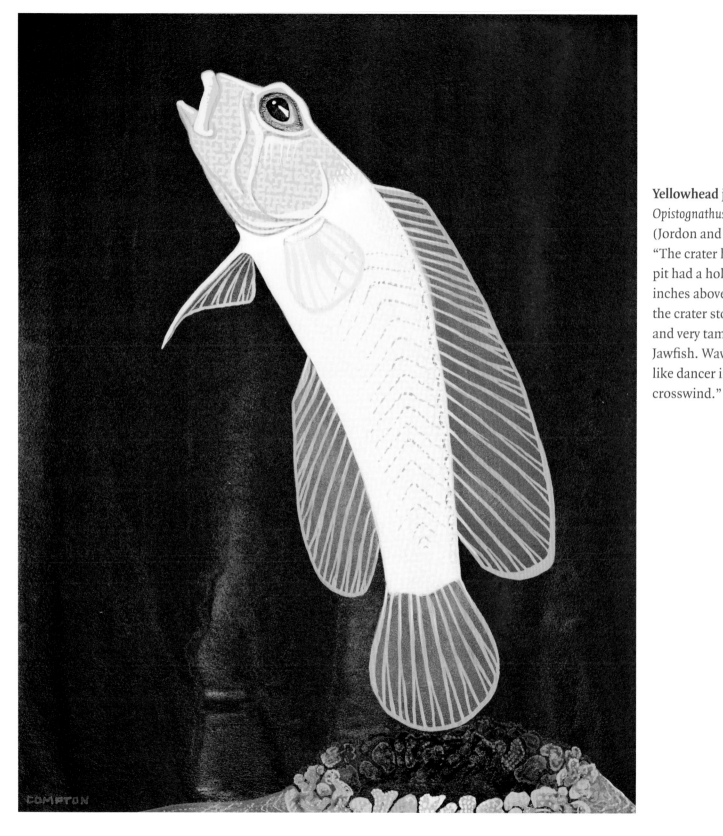

COMPTON

Yellowhead jawfish
Opistognathus aurifrons
(Jordon and Thompson, 1905)
"The crater had a pit and the pit had a hole and a couple of inches above this pit-hole of the crater stood waving a fine and very tame, much worried Jawfish. Waving gently much like dancer in nightgown in crosswind."

the crater stood waving a fine and very tame, much worried Jawfish. Waving gently much like dancer in nightgown in crosswind.

Mattie, running camera on Devils, said, "Feed that prima donna a Suwanee Redworm. She has been on screen so often she thinks I've lost my mind to aim this thing somewhere else."

Jawfish, distracted from jealousy, rose gracefully to take succulent Suwanee Worm-Half from fingers.

Miami Radio said, "Bureau bulletin . . . intensifying . . . evacuation should have already been accomplished for all low-lying areas. The Overseas Highway has been closed from Key Largo to Key West. Outbound traffic and emergency vehicles . . . repeat . . ."

Jawfish dropped shred of worm. Shred, curling and recurling, leafed down through tank water. Looking like a ghostly 2-inch, one-pincered Maine Lobster, the Pistol Shrimp scurried 8-legged from hiding, snapped up worm fallen by crater and dived into hole.

Jawfish left off nibbling fingers at surface, flipped elegantly, and dived into hole. Jawfish emerged backwards from hole with wildly jack-knifing Pistol in wide jaws, swam to rear of tank and spat Pistol behind two small Seafans. The shrimp, transferring his bit of worm to small claw, triggered a gunfight of angry Pops!

"Never learns, does he? I believe we will have to import him one of those Goby fish that will allow him to live in burrow as roommate."

"If it's from off The Yucatan you mean, I'll go."

"We will both go. Shrimp wants burrowing fish not bouncing senoritas." Mattie dismantled her photography. "This is first time for Devils and eggs, Salty."

Miami Radio coughed, dropped what sounded like breaking coffee cup and said, "Seventeen minutes past 1300—1:00 p.m., a dangerous storm is approaching the mainland of Florida." 🐚

Family: Plesiopidae (Roundheads)

The roundheads are a group of tropical fishes found throughout the Indian Ocean and western Pacific. The family name derives from the Greek words *plesios* and *ops*, meaning "near" and "similar," respectively. Most species attain a maximum length of only approximately 20 cm. Although small, these are elongate fish that exhibit large mouths and eyes on a somewhat pointed head. The

third branchiostegal rays, those bones found just below the operculum that support the gill membrane, form a protuberance along the margin of the branchiostegal membrane. Most of the species within this family are solitary. These fish feed largely on small crustaceans and other invertebrates. There are approximately 50 species among 12 separate genera.

Species: *Calloplesiops altivelis* **(Steindachner, 1903)**

The comet is found in tropical waters of the Indo-Pacific from the eastern coast of Africa, to the Red Sea, and across the western Pacific. Adults are typically found among reefs, especially near caves and overhangs. These secretive fish are nocturnal and hide in crevices during the daylight hours. The comet possesses a short perchlike body with large dorsal, anal, and caudal fins. Coloration is dark brown with small blue spots covering the body. A black eyespot on the rear edge of the dorsal fin is used to confuse predators. Eggs of this species are fiercely guarded by the male. Due to its striking appearance, this species has become very popular in the aquarium trade.

(24-B) *** Five-Inch Fireworks From Far Pacific *** they were sold as in old San Francisco in the early 1900s when 2–3 mad-people began to keep fish in big flat bowls of saltwater with a stand in the middle and on the stand a potted fern that grew fountain-wise like the tuft of a cannibal's topknot.

Hard-handed sailormen with pig-tails and earrings smuggled them back on the sailing ships in hidden casks emptied of the bully and worms. Casks received a new bucket of sea thrown in nightly. Comets loved the adventure and, by time they shouted Frisco Bay, were accustomed to most any hubbub and easily thrived in bowl in foyer of marble mansion. Even with potted fern. 🐚

Family: Pomacanthidae (Angelfishes)

Angelfishes represent a group of fishes that can be found in tropical waters of the Atlantic and Indian Oceans, with a vast majority found within the Pacific. The family name derives from the Greek

Comet

Calloplesiops altivelis (Steindachner, 1903)

"*** Five-Inch Fireworks From Far Pacific *** they were sold as in old San Francisco in the early 1900's when 2–3 mad-people began to keep fish in big flat bowls of saltwater with a stand in the middle and on the stand a potted fern that grew fountain-wise like the tuft of a cannibal's topknot."

words *poma*, meaning "cover," and *akantha*, meaning "thorn." This group was once associated with the family Chaetodontidae due to their similar anatomical appearance. However, members of the family Pomacanthidae were separated in large part because of several key differences. Unlike butterflyfishes, angelfishes typically exhibit a very blunt snout and a spiny element on the preopercle, made up of the bones that make up the cheek and gill cover. Most species are also much larger than butterflyfishes. In most cases the dorsal and anal fins have an extended filamentous appearance, and the caudal fin is lunate. Most species are brightly colored; however, juveniles and adults are known to exhibit a much different appearance. These fishes occur in shallow waters around coral reefs at depths of around 20 m with only a handful of species venturing below 50 m. Social interactions vary dramatically: some species are monogamous, and others exhibit harem behaviors. There are also several species within this group that are hermaphroditic. There are approximately 100 species within 10 genera.

Species: *Apolemichthys trimaculatus* (Cuvier, 1831)

The threespot angelfish, sometimes referred to as the flagfin angelfish or blue lipped angelfish, is a tropical species found primarily in the Indo-Pacific. This species is also found along the coast of East Africa; however, the highest concentration is seen from the northern coast of Australia and north to Japan. Associated primarily with reefs, this species is commonly seen from a depth of a few meters to 60 m. Similar in size and shape to other angelfishes, the threespot angelfish is identified by its bright yellow coloration, black-edged anal fin, and a black spot on the forehead directly in front of the dorsal fin. A small dark spot can also be seen directly behind the operculum in some specimens. A noticeable characteristic that gives this fish the name blue lipped angelfish is a pair of bright blue lips. Although juveniles are secretive and rarely seen, adults can be found in small groups typically at greater depths. Interestingly, this species feeds primarily on sponges and tunicates. Although difficult to care for in a captive environment, it is a popular aquarium fish and is often exported in the aquarium trade.

(3-E) Seabass or grouper who aims wide hard-lipped mouth at Three-spot thinks he shouldn't have eaten that fifteenth eel. Three eel too many. His stomach turned dizzy on his eyes. He saw spots. He saw triple. He saw too many eyes for any natural creature. Scared him. He had never seen a peacock's tail and never would. He shook his head best as he could, having no neck, and swam to a quiet cliff ledge he knew and concentrated on digesting his eel.

Factually, Three-spot chased him off. Not liking bass who were too big to eat, too nosy to put up with and not generally mannerly.

Now of course anybody at all who didn't have his head in his ear knew that Three-spot was not a butterflyfish. He was close cousin. But he was even plenty fiercer for a small fish and all feared the blue sharp cutting stabbing spines he wore either side at corner of his gill coverplates. Three-spot was twoswordsman to fence bass into hasty retreat with slash and thrust and parry. Robin of Sherwood Reef.

He and his mate guarded their red sponge which held no looted golden sovereigns but whose rosey tower belonged to them, being about center of their own protected backreef backyard and they didn't want any clumsy largemouth bandying with it. 🐚

Species: *Centropyge acanthops* (Norman, 1922)

The orangeback angelfish, sometimes referred to as the African pygmy angelfish, is found in tropical waters throughout the western Indian Ocean and is very common off the eastern and southern coasts of Africa. This species inhabits reefs and areas of coral rubble to a depth of approximately 40 m. Possessing a somewhat spade-shaped body, this small angelfish is most notable for its unique coloration. The head, dorsal region, and caudal fins are orange or yellow, while the lower portion of the body and anal fins are blue or black with numerous purple spots. The orangeback angelfish typically resides in small groups consisting of at least 10 individuals. Interestingly, spawning occurs at sunset; the male stimulates the female by biting at her abdomen and thus releases her eggs. Upon being released, eggs are abandoned in the open water and no parental care occurs. This species feeds primarily on

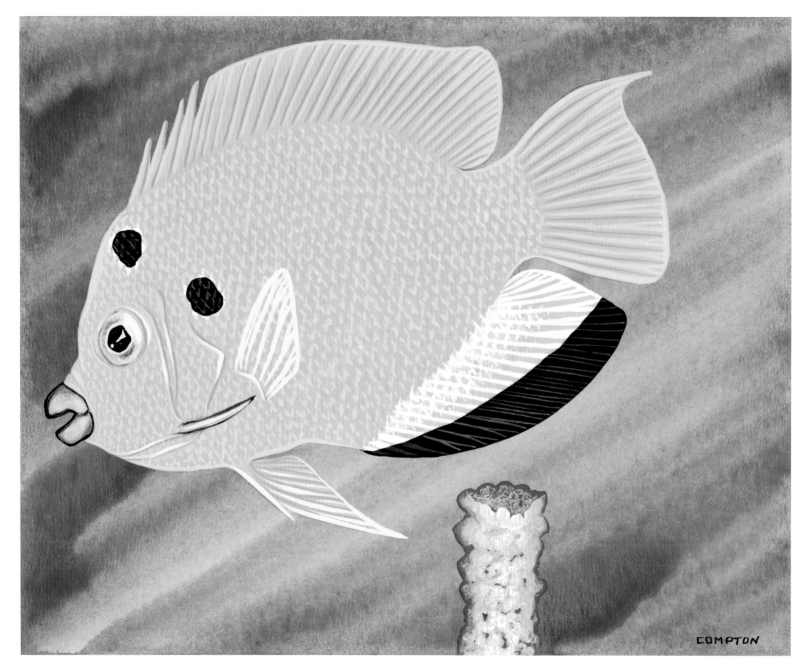

Threespot angelfish
Apolemichthys trimaculatus (Cuvier, 1831)
"But he was even plenty fiercer for a small fish and all feared the blue sharp cutting stabbing spines he wore either side at corner of his gill coverplates. Three-spot was twoswordsman to fence bass into hasty retreat with slash and thrust and parry. Robin of Sherwood Reef."

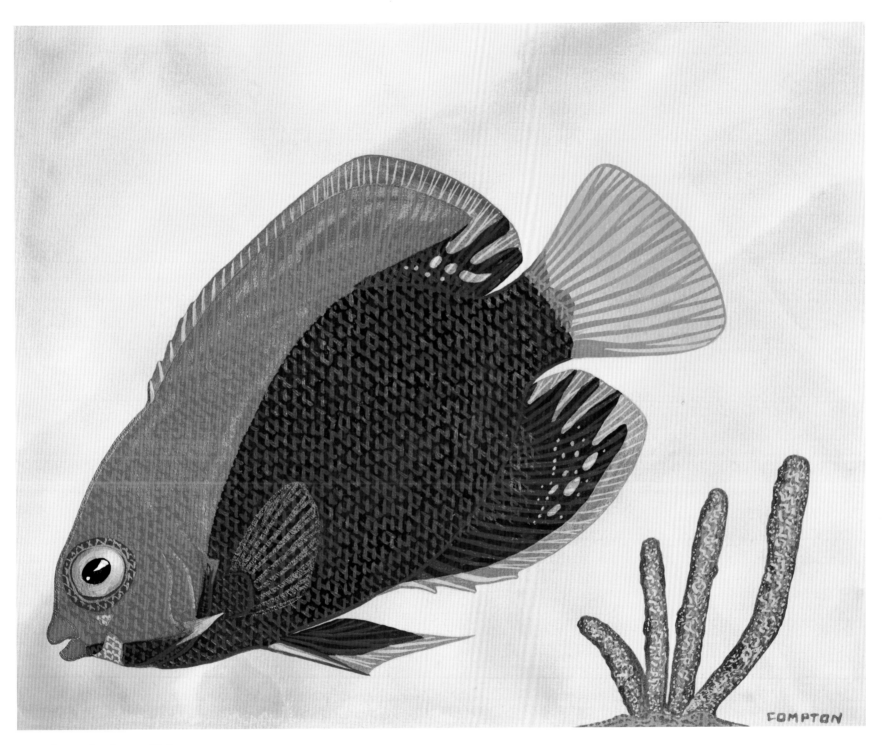

Orangeback angelfish

Centropyge acanthops (Norman, 1922)

"He is little Angelfish and is 5-incher and is fierce and ferocious."

algae and small invertebrates. The orangeback angelfish is a commonly exported and popular aquarium fish.

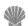

(11-B) Kevin: "I wanta bathing suit the colors of this 'un."

"He is little Angelfish and is 5-incher and is fierce and ferocious and will fight any jerks said I was 5-incher I ain't and me an' him will fight any jerks says we is and bloody his nose for him any jerks . . ."

Here Narrator was removed forcibly from crabtrap and hustled behind cabin from whence scuffle, shuffle, yelps and heavy breathings ensued. Johnny reinstalled rumpled Narrator behind stand of crabtrap and he was bade continue.

"Well, I'm a-goin' to, ain't I? Well, I don't remember where he come from, do I? I saw didn't I, I guess I know what I saw with my own eyes, don't I? Hit was the ole REDsea, weren't it? I guess I know it was, don't I?

"They was a lot of him and he was fightin' 2 octypus and 5 moray EEL an' all them sharks 'cause some Jerk called him Shorty and I was helpin' him and all us fightin' 2 octypus and 5 Moray EEL and all them Sharks 'cause some Jerk called us . . . NO! I'm gettin' to 'er ain't I? Why can't you letta man tell his speech an' this purty fish is most fierce an' colorful and when I get clothes like him he's gonna think I'm him and we'll sure bloody nose of some Jerk . . . NO!"

Here Narrator fled to cabin roof fleeing through galley to steal donut cookies on race to sanctuary. Narrator sat swinging legs off roof—eating, making faces, rolling eyes in delight and rubbing stomach. This provocative display aroused outcry and caused refreshments to be served main deck also. 🐚

Species: *Centropyge argi* (Woods and Kanazawa, 1951)

The cherubfish is found in tropical and subtropical waters throughout the western Atlantic Ocean, Gulf of Mexico, the Caribbean, and the northern coasts of South America. These fish tend to frequent areas of coral rubble and rocky coral reefs to a depth of approximately 60 m. The cherubfish has a deep body that is greatly compressed and somewhat ovoid in appearance. The snout is short and blunt with a terminal mouth. The margin of the preoperculum is highly serrated, and the operculum has a very long triangular spine at the lower corner directly in front of the pectoral fin. The dorsal and anal fins are not extended as seen in other species, and the caudal fin is round. A defining characteristic of this species is that the lateral line extends only to the soft rayed portion of the dorsal fin. Body coloration is typically dark blue with a yellow snout and operculum. The eye is ringed with blue, and a blue smudge can be seen along the corner of the mouth in some specimens. The cherubfish is believed to feed strictly on algae.

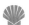

(11-C) Sharon: "I love my darlin' little Blue Angel an' she has darlin' little goldy nose all goldy cause she is cheery . . . cherry . . . chirp . . ."

Narrator was informed nomenclature of fish.

"Yes. He has all goldy face and he is smack-damn like them childrun on walls . . ."

Narrator was stopped and asked what kind of language she thought she was using but she didn't know.

"Yes. He's sma . . . he's 'zactly like all them childrun Kevin says hangs out smac . . . allus on them walls an' roofs in Homes where we saw 'em where Kevin says they can't fly none he laughs all them leetle ole skinny wings ain't nothin' to fly an' they is gonna fall onto they butts, OUCH!, if they try 'er an' if he had the Sharkgun he would shoot-em-off fast an' see could they fly they would fall-on-they-butts, yes."

Narrator was asked where this interesting encounter had occurred. "Yes."

Detail was requested of Narrator. "Yes."

More detail required. "In Romes."

Riff-Raft's cabin roof deck stated it did not recall any such conversation and had never even taken Sharkgun into "Romes."

"Yes. You took us all, Grampah, to we see them pictures where they was scared us and that young man without 'is skin on him 'cause he was holdin' it like a towel if he wanta dry hisself off."

There was lengthy pause. Narrator appeared to have run down. Narrator was told if she alluded to *The Last Judgement* that her opinions were most likely not those of the artist when he painted the mural. Cabin Roof stated it liked skinless man and

Cherubfish

Centropyge argi
(Woods and Kanazawa, 1951)
"Yes. He has all goldy face and he is smack-damn like them childrun on walls."

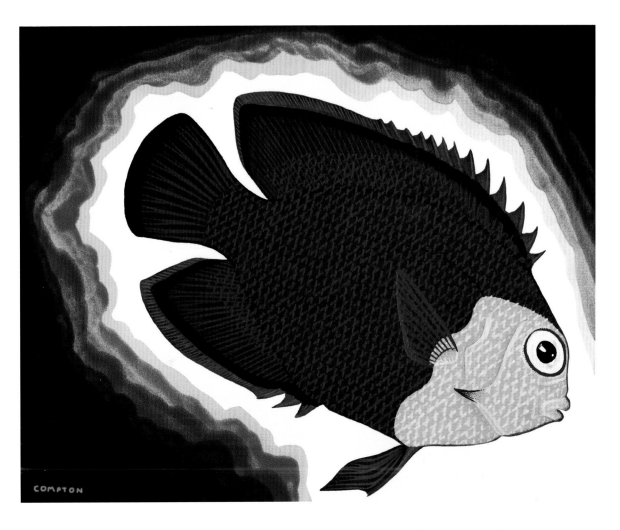

COMPTON

wished there was more of him. Narrator flowered to life again.

"Yes. We was losted from you, Grampah, and Kevin say he's gonna climb up wall and taunts one of them babies he ain't got the Sharkgun for us shoot-em-off. An' we gotta climb an' climb an' knock-em-off. To fly. Yes. An' we was gone an' caint find hide er hairs of you an' Kevin say we need that table to get us on wall but black lady in dress with her beard wouldn' let us on that table and she drug us and drag us and we come back to you an' was so glad."

Cabin Roof said if it was allowed to use Sharkgun more often it would not desire to "snuggle" Sharkgun to "Romes" to shoot babies off walls so they could fly, didn't they have wings, even if puny but Roof didn't believe they could do "hit."

Narrator seemed to have run down permanently and showed signs of desiring return to private life. Ecological discussion was closed. Narrator was praised for her discourse and convinced discourse was not a cuss word. All Narrators including Roof were lauded for their oratorical skills. 🐚

Species: *Centropyge bispinosa* (**Gunther, 1860**)

The twospined angelfish, sometimes referred to as the coral beauty, is a tropical species found throughout the Indo-Pacific. Primarily occurring from northern Australia to Japan, these fish can also be found in the waters of East Africa and throughout the Indian Ocean. This species does not occur in the southern Pacific Ocean or in waters surrounding the Hawaiian Islands.

Many other species of angelfishes are confused with this species until properly examined and identified. The twospined angelfish exhibits an elongate and oval body with a spine on the operculum and a short, sloped forehead. Body coloration is primarily a deep blue or purple with the dorsal, anal, and caudal fins all being the same color. The ventral portion of the body is orange. This orange coloration can also be seen laterally in the form of thin vertical stripes. Although sometimes found alone, this species may be seen in larger groups on occasion. The twospined angelfish is known to develop harems comprising up to seven individuals. These fish feed on algae found in and around reefs. Due to increased popularity in the aquarium trade, this species is frequently exported around the world.

(11-A) Sandy: "This is one of the little Angelfishes and she grows to be five inches long. He does also, before I'm stopped an' all these little Angelfishes don't look different when they are big and don't need any different bathing suits for they difference."

"I just love this little Angelfish and I'm gonna call her 'Sweetfire' because we saw her a lot and feed her off our fingers an' she looks like she's got a tiny dear candle inside all shinin' outa skin like Miss Beetrice says Angels do."

"Sweetfire lives all under all the Pacific we went under and into Africa but we have not to this date gone under in Africa. I use under to denote us diving. For your enlightening."

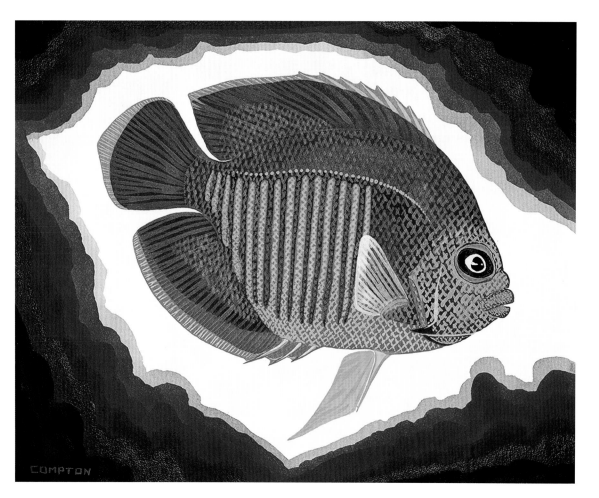

Twospined angelfish
Centropyge bispinosa (Gunther, 1860)
"I just love this little Angelfish and I'm gonna call her 'Sweetfire' because we saw her a lot and feed her off our fingers an' she looks like she's got a tiny dear candle inside all shinin' outa skin like Miss Beetrice says Angels do."

Here Narrator bowed, was stared at, and told she'd get her head dunked under sink drain first chance. ❦

Species: *Centropyge loriculus* (Gunther, 1874)

The flame angelfish is a tropical species found throughout the Pacific Ocean. These small angelfish primarily inhabit clear waters near lagoons and reefs to a depth of approximately 60 m. These secretive fish tend to stay near structures and may dart back in a reef or debris for shelter. As do most angelfishes, this vibrant angelfish has an ovoid body. These fish are bright red with several dark vertical bars along the sides of the body. The trailing edge of the dorsal and anal fins is blue. Like many other angelfishes, the flame angelfish feeds primarily on algae. This species is more often than not seen in small groups with harems comprising five or more individuals. Although similar species do not fare well in captivity, the flame angelfish does extremely well. Due to its peaceful nature and beautiful vibrant coloration, this is a sought-after species in the aquarium trade. Interestingly, specimens are often sold as "Hawaiian flames," which brings an increased price in the aquarium trade; however, many of these are not from the Hawaiian Islands and may come from as far as the Marshall or Cook Islands.

(11) Johnny: "The grown-up French Angelfish which Grampah wants swimpants like but he won't get 'em because them fool girls didn't bring cloth for big Frenchy which is one Heckus of a big Angelfish as is big around as the biggest Pizza we got some frozen and hope they are broke out tonight.

"Frenchy is the biggest of these here kind of critter but this here Flaming Angel is what they call a Pigmy Angelfish and is only 4–5 inches in his length like Kevin and Sharon is shortys. He is about my favorite for being a purty fish but he don't come from around here which is on the edge of Gulf of Mexico and spittin' distance of Texas if you is a Texan. Where this Flaming Angel comes is over in Hawaii which I can't spit that far. We saw him all the time down deep to 60 feet where we hadda to use mixed gases and had one of them new tanks and was . . ."

Here Narrator was told he was not only off the subject but was misinformed as well. As always.

"And a lot of tunicates also but he didn't eat none an' that's polite of him because a tunicate is our ancestor, and his, as you all know because ain't I told you before tryin' to put some sense into you and has backbone, yessir, just like us 'cept it ain't real bone but is stiff and keeps us all from being jellyfish and when tunicate is baby he looks tadpole and wiggles like mosquito in a rain-bucket. Then when he gets old he says I'm tired of it and he finds him nice black lavarock an' glues his butt to it an' looks like glass canteen an' blows his waters in-'n-out like sponge. Wuff!"

Here Narrator ran out of breath.

"There is plenty of brittle starfishes also. They move fast as five-legger spider but break off leg if grabbed to grow new one. Tunicates is called sea-squirts because only time we seen 'em up high-low tides up in Maine, US, in air lookin' like row of sodey bottles when pinched they shot water fountain into your eye. If I was allowed good tanks an' exotic breather mixtures I could scrape of plenty of them Deep little varmints to sell to collectors what never saw 'em and would Pay, Bro, to but me them . . ."

Here Narrator was told he was again away off subject and to step away from improvised lectern of up-ended crab-trap. ❦

Species: *Genicanthus melanospilos* (Bleeker, 1857)

The spotbreast angelfish can be found in tropical waters of the western Pacific near Indonesia to Fiji and south to the eastern waters of the Indian Ocean. Although most commonly seen along reefs near ledges and slopes, these fish may also be found in caves or in areas of dense coral near sandy bottoms. These colorful fish possess a body plan typical of that of angelfishes. However the spotbreast angelfish exhibits a slightly longer body that is less deep than that of most other angelfishes. The trailing edge of both the dorsal and anal fins is lengthened and comes to a point at approximately the midpoint of the caudal fin. Sexually dimorphic, females are brightly colored, primarily yellow or orange with tinges of greens and blues along the dorsal and anal fins, as well as the breast. The caudal fin is a dull blue with the top and bottom edge lined in black. Males

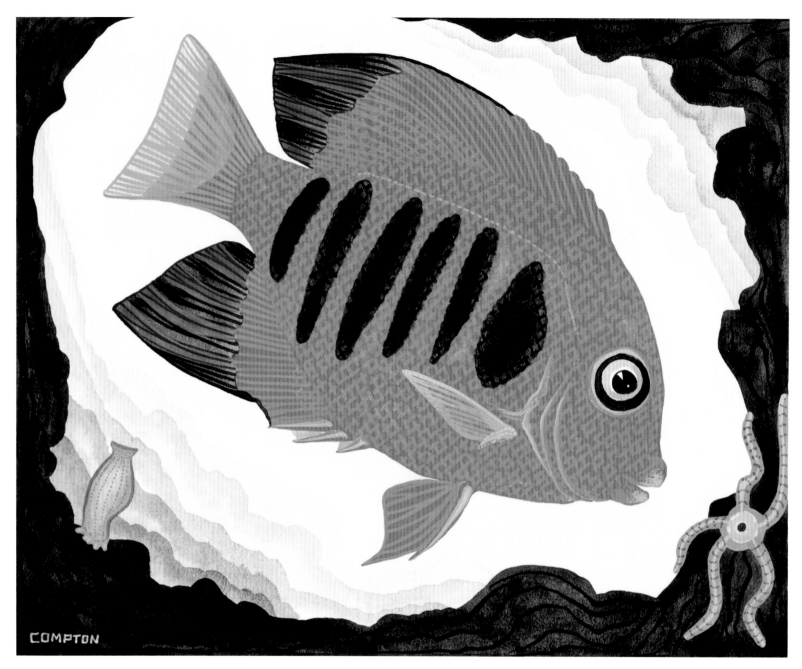

Flame angelfish
Centropyge loriculus
(Gunther, 1874)

"He is about my favorite for being a purty fish but he don't come from around here which is on the edge of Gulf of Mexico and spittin' distance of Texas if you is a Texan. Where this Flaming Angel comes is over in Hawaii which I can't spit that far."

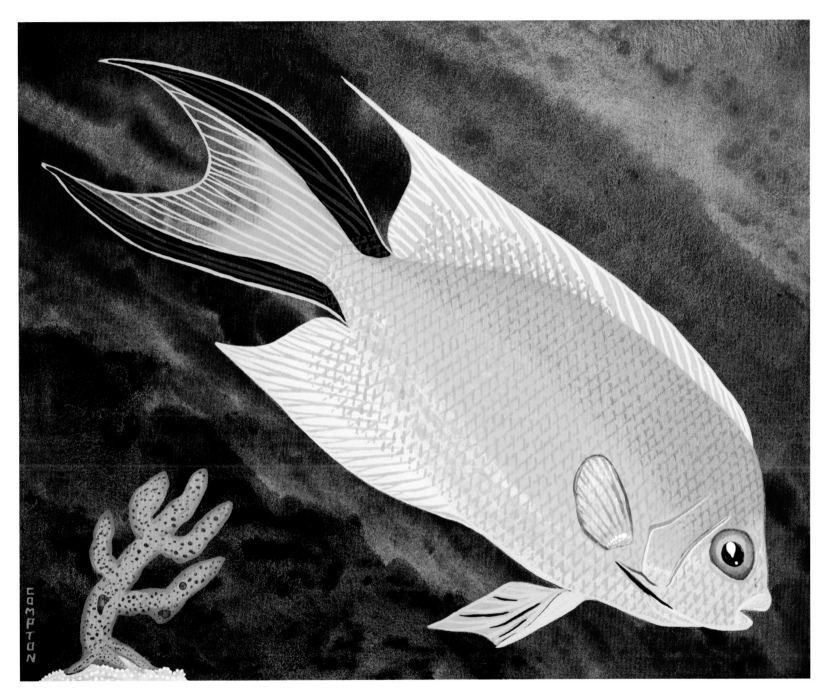

Spotbreast angelfish (female)
Genicanthus melanospilos (Bleeker, 1857)
"Johnny's worms go to the Stripers whom he considers his best
favorite there because female is gaudy and gold and green and
red and blue."

of the species are less colorful but still very striking. The male is light blue with dark bars running vertically along the body from the mouth to the caudal peduncle. The cheek and fins lack bars and are most commonly light blue or green, while the caudal peduncle is yellow with orange bars. They are commonly seen in small groups that typically consist of several females with only a single male. Males are somewhat territorial and may even fight males of other species that closely resemble themselves. These fish typically feed on planktonic organisms within the water column. Due to the beautiful coloration of this species, as well as sexual dimorphism, it is quite common in the aquarium trade.

(13-B) And Striper male is total different color and stud in chains and white dress shirt and Irish green pants for tail. Johnny's idea of Merman. Kevin says only some dumbolo like Johnny would like some Angelfish you can't even tell is Angelfish if he didn't have them good shark-stabbers on his faces. Kevin does not state his views loudly. Johnny is best all-goes fighter for his weight, and often beyond, in any waterfront the Shannons have visited.

Sandy states loudly that for first time in knowledge of world her brother shows some sense admiring a fish where female is prettiest and not like all those stupid birds. Sharon says, "My Johnny," in an awful syrupy prattle. Since she considers she saved him from that SHARK, she takes a firm motherly interest in him, leading to desperate threats of violent beatings if she does not cease. Right now! Threats are not made within hearing of Grampah, Deck Dog or Miss Fortune. ✿

(13-A) When he is on Great Barrier Reef, wearing his mermaid cap above and his tanks below, Johnny's worms go to the Stripers whom he considers his best favorite there because female is gaudy and gold and green and red and blue. This is Johnny's idea of Mermaid. ✿

Species: *Holacanthus ciliaris* (**Linnaeus, 1758**)

The queen angelfish is found in tropical and subtropical waters of the western Atlantic, Gulf of Mexico, Caribbean, and the northern coast of South America. This species is commonly found among offshore reefs to a depth of approximately 70 m. These large angelfishes are commonly seen among corals and seafans. Possessing the typical angelfish appearance, the queen angelfish exhibits a deep compressed body with the corners of both the dorsal and anal fins extended into long filaments. The snout is blunt, and the operculum is very broad and serrated with a large triangular spine. The body is typically deep blue or green with an orange spot on each scale. The caudal and pelvic fins are typically either yellow or orange. There is a black spot ringed with blue along the forehead. The tips of the dorsal and anal fins are also orange. Juvenile specimens are dark blue with yellow on the snout, chest, pectoral fin, and pelvic fin. Adults typically feed on sponges, while juveniles serve as cleaners and pick parasites from larger fishes.

(27) The Queen was once called in Latin, *Angelichthys isabelita*, or to say, Angel of Isabel, and known also as "Queen of the Seas." Later, fish-naming taxonomists renamed her, *Holacanthus ciliaris*, which is less regal.

Isabel was given another fish. The Queen is the very spirit of the Atlantic reefs from Florida to Brazil. The Queen may be a King. Foot-and-a-half fish are lookalike. Youthful fish, as with most Angels, look like Changelings dropped in crib at birth and have stripes.

There lives a wondrous large pair in secret place off No Name. As some unwary speargun hunting-people always like to put a hole in Queen and have picture taken, Biologist has running offer in Miami papers to speargut any speargunner trying to speargut Queen.

Offers to take that picture to later send bereaved relatives anonymously. ("I ain't gonna tell that Mouse-who-lives-in-the-sofa," he told his wife Jan.) And promises to take picture before loosing body with anonymous anchor off deepside Bermuda. Biologist says picture is waste of film and what nut would bereave over a Queen gutter, but then world is full of nuts. Wife Jan says, "Is." ✿

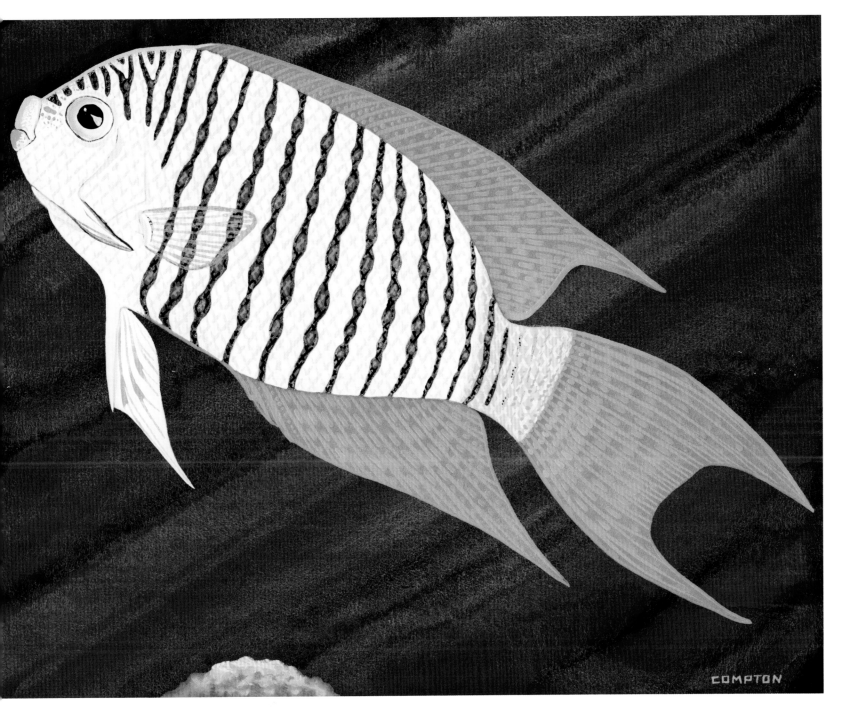

Spotbreast angelfish (male)

Genicanthus melanospilos (Bleeker, 1857)

"And Striper male is total different color and stud in chains and white dress shirt and Irish green pants for tail."

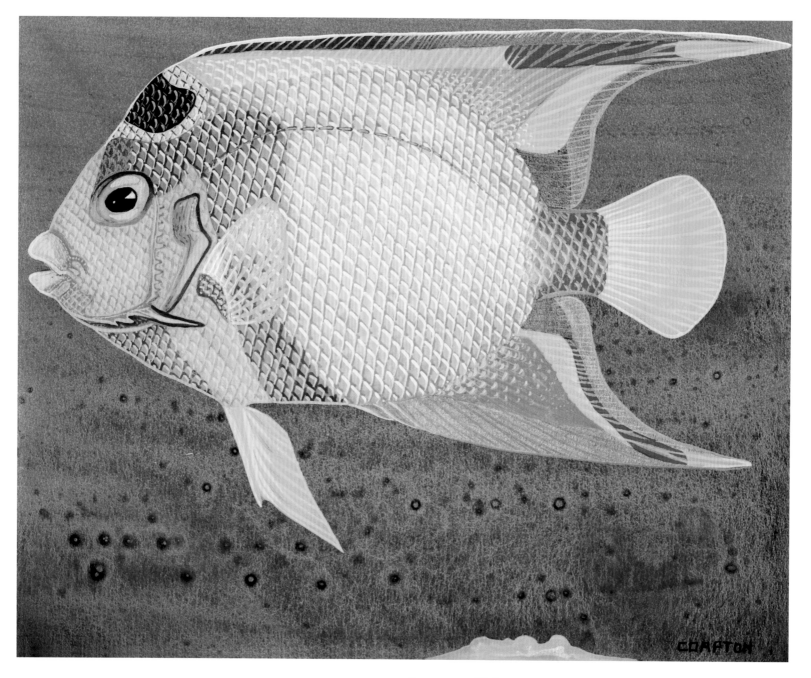

Queen angelfish
Holacanthus ciliaris (Linnaeus, 1758)
"The Queen is the very spirit of the Atlantic reefs from Florida to Brazil. The Queen may be a King. Foot-and-a-half fish are lookalike."

Species: *Holacanthus tricolor* (**Bloch, 1795**)

The rock beauty is found in tropical waters of the western Atlantic, Gulf of Mexico, the Caribbean, and along the northern coast of South America. This species typically can be found nearshore to a depth of approximately 40 m. The rock beauty is commonly found along jetties and rocky reefs and areas of dense coral growth. Juveniles are often seen among fire corals. The rock beauty has a deep, compressed body with a blunt snout. Like many other angelfishes, this species possesses dorsal and anal fins with filaments extending toward the posterior. These filaments are much shorter than those of other species. The caudal fin is rounded; however, it may have filaments similar to those seen on the dorsal and anal fins. The head and anterior portion of the body are typically yellow or orange, and the lips and posterior portion of the body are black. The fins are the same color as the anterior region of the body. Juveniles are often bright yellow with a black ocellus along the dorsal fin. As the fish ages, the spot grows until reaching the adult coloration. The diet of this species is diverse and includes tunicates, sponges, zooantharians, and algae.

(21-C) In old Atlantic from the sea islands of Georgia's lacey coast to the coral crown of Bermuda shot, up from the black abyss where in 800 inky fathoms Davey J. plays with little lighted goblins with jack-o-lantern on hide and nose, to Florida and thru the flung glitter of the Caribbean all the way round the muddy Amazon shoulder of Venezuela, down the mighty chest of Brazil to Livelytown, lives the most stark & stunning of all the Angelfish.

Even the eye-crossing optic art of the rocks of the broad walk in Praca Floriana to turn cartwheels on at Rio de Janeiro are not so bold as he. With teeth like a toothbrush, he cleans the rocks and reefs and piers and pilings of shrimps the size of the slit in a goat's eye the goat sees thru, crabs the size of the hole half a marble leaves in the sand, and many unfortunate minnows.

In Rio, an artist glazes pottery for table to his design and color. In Vera Cruz, artists paint him in metal for ashtrays and peanut bowls. Sometimes to hold salsa which eats thru the metal. In Key West, a marvelous old lady paints him on 12-inch life size wood as a personal blackboard for school children. School children hang him on wall above computer for personal ornament. 🐚

Species: *Pomacanthus annularis* (**Bloch, 1787**)

The bluering angelfish is found in tropical waters in the Indo-Pacific from the eastern coastline of Africa to Indonesia, to New Guinea, and north to Japan. This species typically occurs along coastal reefs to a depth of approximately 30 m. Juveniles are mostly seen among shallow inshore waters near areas of algae growth or rocky substrates. The body plan is typical of angelfishes: compressed and somewhat spadelike. The body is yellow or orange with blue stripes radiating upward to the point of the dorsal fin. A pair of blue stripes runs across and directly below the eye. A small spot along the dorsal surface behind the eye is also ringed in blue. Juveniles of this species are black with blue and white vertical stripes running along the body. Upon reaching adulthood, a complete metamorphosis occurs and these fish develop their adult colors. Juveniles of this species resemble juvenile specimens of *P. rhomboides*; however, these two species are rarely confused as they share only a small portion of their range near the coast of Africa. Adults are often seen in pairs. This species feeds on sponges and tunicates found along the bottom. A popular fish in the aquarium trade, the bluering angelfish is often exported from across much of its range.

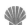

(13-D) While Sandy was still Pacific and off India and Ceylon (Sri Lanka), she favored an Angelfish who resembled pretty well a Butterflyfish. 🐚

Species: *Pomacanthus imperator* (**Bloch, 1787**)

The emperor angelfish is found in tropical waters of the Indian and Pacific Oceans. These fish are common from the eastern coastline of Africa, to the Great Barrier Reef, and across the Pacific to the Hawaiian Islands. They tend to inhabit areas of rich coral growth. Juveniles prefer the protection of ledges and holes in the reef, while

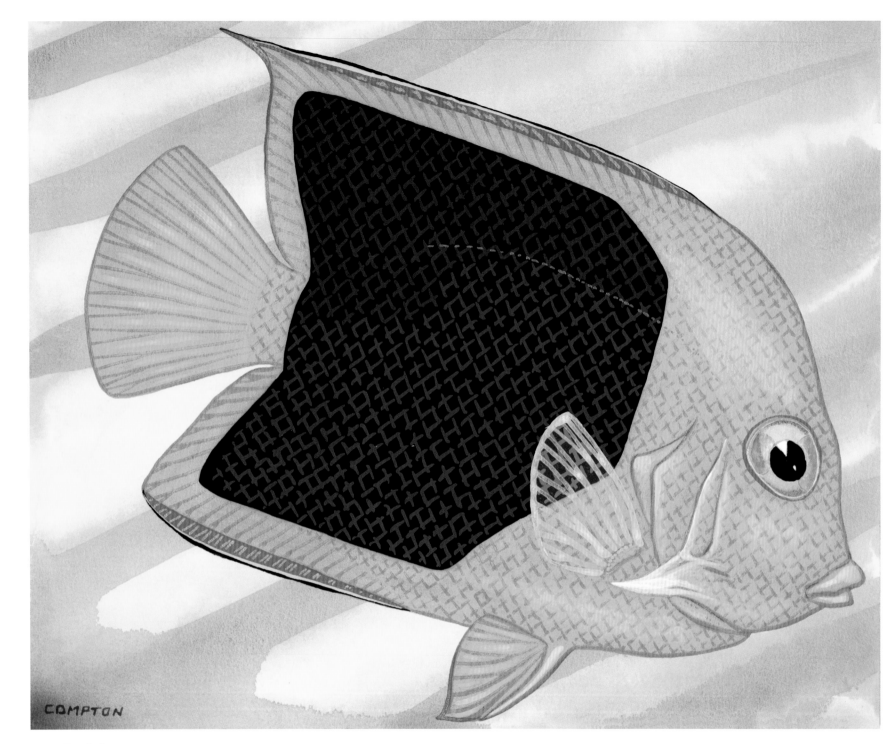

Rock beauty

Holacanthus tricolor (Bloch, 1795)

"With teeth like a toothbrush, he cleans the rocks and reefs and piers and pilings of shrimps the size of the slit in a goat's eye the goat sees thru, crabs the size of the hole half a marble leaves in the sand, and many unfortunate minnows."

126 ✳

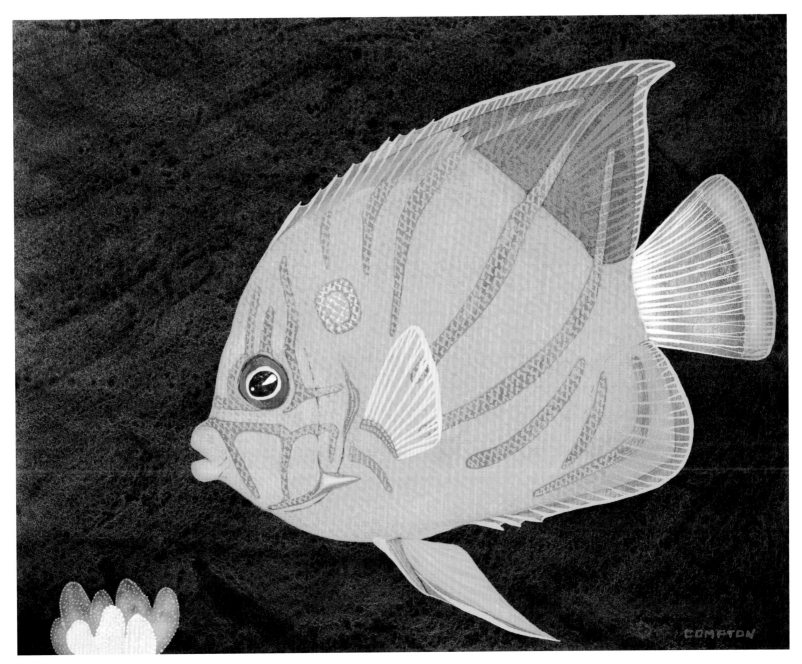

Bluering angelfish
Pomacanthus annularis (Bloch, 1787)
"While Sandy was still Pacific and off India and Ceylon (Sri Lanka), she favored an Angelfish who resembled pretty well a Butterflyfish."

Emperor angelfish (adult)
Pomacanthus imperator (Bloch, 1787)
"And," says Biologist, "here is what he, or she, class, is at 15-incher. All over the warm Pacific."

adults can be found throughout lagoons, channels, and reefs. One of the most widely recognized species of angelfishes, the emperor angelfish exhibits the typical angelfish body plan: deep and compressed. Juveniles are dark blue with white and blue bands along the body; bands along the latter portion of the body form a circular pattern. These circular patterns may also be present along the dorsal and anal fins. Adult emperor angelfish are known for their striking coloration, which is distinctly different from that of juveniles. The body is primarily blue to blue-green with a large black band covering the eye and cheek, as well as a black patch behind the head and along the neck. These bands are all lined with bright blue. The body is lined with bright yellow, as are the horizontal lines on the caudal fin and edge of the dorsal fin. These fish are most commonly seen in pairs and typically feed on sponges. Due to the popularity of this species, it is one of the more commonly exported angelfish for the aquarium trade.

(9-A) "And," says Biologist, "here is what he, or she, class, is at 15-incher. All over the warm Pacific." Bell rang.

"Pass out quietly. Do not waken Pus-Pocket if you plan to grow to beauty yourselves. Although without stripes."

But Pus-Pocket pushed his way through into hall, calling his wares.

(9) If you were an alley cat your ma might be a grey-striper and your pa long lean mean yeller Tom and you could of turned out black-and-white and fluffy. Who can say? But you would of gone on showing the world you were black-and-white and fluffy until you turned grizzled with age and lost your teeth. You wouldn't likely to have turned Red, except whiskers, between the time the first mouse scared you and you ate your 1000th.

Here is a fish that is born blue and white and grows to be something quite different. You will say that butterfly is about quite different from worm as is possible both in color AND shape of him. Then what's so hurrah! some fish changing color as he grows?

Emperor angelfish (juvenile)
Pomacanthus imperator (Bloch,
1787)
"Here is a fish that is born
blue and white and grows to
be something quite different.

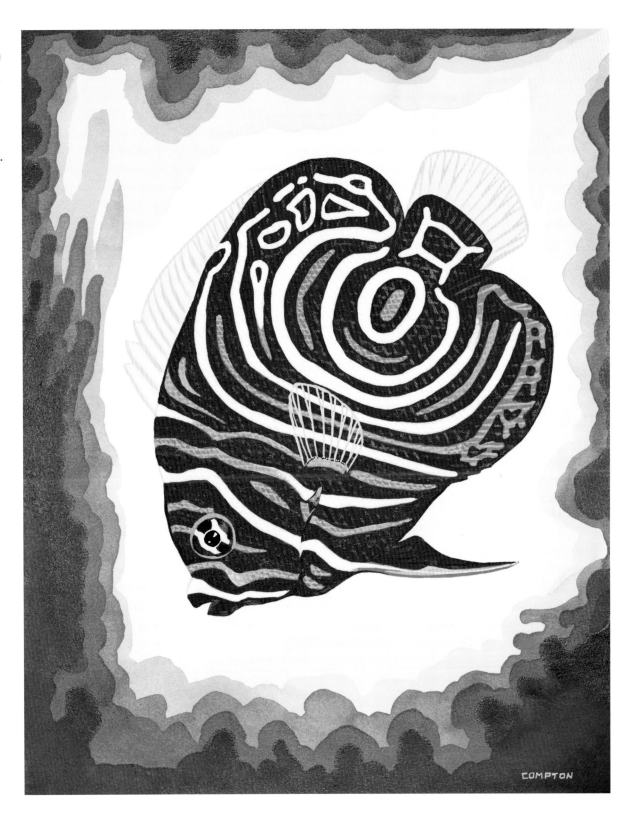

As the Biologist told his class one day, "All these UFO's come down to land in our swamps and buzz our airplanes and automobiles about every 16 years when new generation of readers grows up can handle funnypapers and television, why if those crews ever oozed their way out of UFO and were shown caterpillar and butterfly, why they wouldn't believe her. They know that everybody starts out as pebbles The Ancient Alien jams between his toes and wears 'em til his socks rot, when they hatch."

"We would have to give those UFOers something more simple," said Biologist, "like ole Imperial it took fish-namers a hundred years to realize baby and grown-up were same stock. Knew they were both fish. Give 'em that. Little Imperial starts to rearrange his decoration when he is 3–4 inch. Lines bust circle and line-out for horizon. His skin knows how to do this." 🐚

Species: *Pomacanthus paru* (Bloch, 1787)

The French angelfish can be found in tropical and subtropical waters of the western Atlantic from Florida, throughout the Gulf of Mexico and Caribbean, and south to Brazil. This species may also be located in the eastern Atlantic near Ascension Island and St. Paul's Rocks. These angelfish typically inhabit shallow reefs to a depth of approximately 100 m. The French angelfish has a compressed, ovoid body shape typical of fishes in the genus *Pomacanthus*. The snout is only moderately blunt. As in similar species, the dorsal and anal fins possess long, flowing filaments at their posterior edge, and the caudal fin is rounded. Both juveniles and adults are black. However, adults have bright yellow along the edge of each scale, around the eye, at the base of the pectoral fin, and along the filament to the dorsal fin. Juveniles have four or five yellow bands along the head and body. These bands may also be present on young adult individuals. Adults are commonly seen swimming in pairs around reefs, while juveniles prefer areas that offer some protection, such as crevices or holes. Adults feed on a variety of organisms, including algae, sponges, bryozoans, zooantharians, and gorgonians. Juveniles tend to stay near cleaning stations and remove parasites from larger fishes. This is not only a popular aquarium fish but a popular food fish in some areas of its range.

(10-A) "Got all your French Angels confused?" asked the Captain. "Got the younguns thinking you are their color cousin been poppin' vitamins? Got the adults convinced they been hatchin' GIANTS?"

"Oh, Grampah."

"And why is my swim shorts not dignified elderly tasteful and stylish in grey & black & gold? Do you four chuckles deny I am full adult in full charge?"

"No," says Sharon. "We drive you to 'straction daily an' stirrin' your livers."

"Keep me young, huh? Suppose you drive me back to baby an' gotta diaper me."

"Oh, GRAMPAH!" 🐚

(10) All of the Shannons had new bathing suits. This was Sandy's notion.

"We look like we have been shipwrecked a hundred years floating on a raft."

Johnny, who was fond of his holes and tatters and thought they made him look salty, said, "You'd a hadda be walked-the-plank by Blackbeard the Pirate when you was in diapers."

"I can't not remember," says Sharon.

"I can," shouts Kevin. "I cut off his head and legs with Cutlass. And froze him in our freezer for two hunnerd years."

"He is not still there," Captain told Sharon who was looking cross-eyed at the ice-pop she had been licking. "We thawed him out and sent him home."

"Made him walk-a-plank without his legs on 'im," shouts Kevin.

Deck Dog barked. Miss Fortune, deck cat, in two fur curves jumped ship for the smells of Suwanee dock. Shannons followed. Deck Dog barked disappointment and took over his watch.

"I want Red with Cutlasses and Pirates," says Kevin. "What you takin,' Johnny?"

"Pirates bold and Spanish gold. What you takin,' Grampah?"

"Why a nice bluey-greeny-greyey-muckle-de-dum for all of us, what do not show stain or accident. You stock such, Beetrice?" he

**French angelfish
(juvenile)**
Pomacanthus paru
(Bloch, 1787)
"Got all your French
Angels confused?"
asked the Captain.
"Got the younguns
thinking you are
their color cousin
been poppin' vita-
mins? Got the adults
convinced they been
hatchin' GIANTS?"

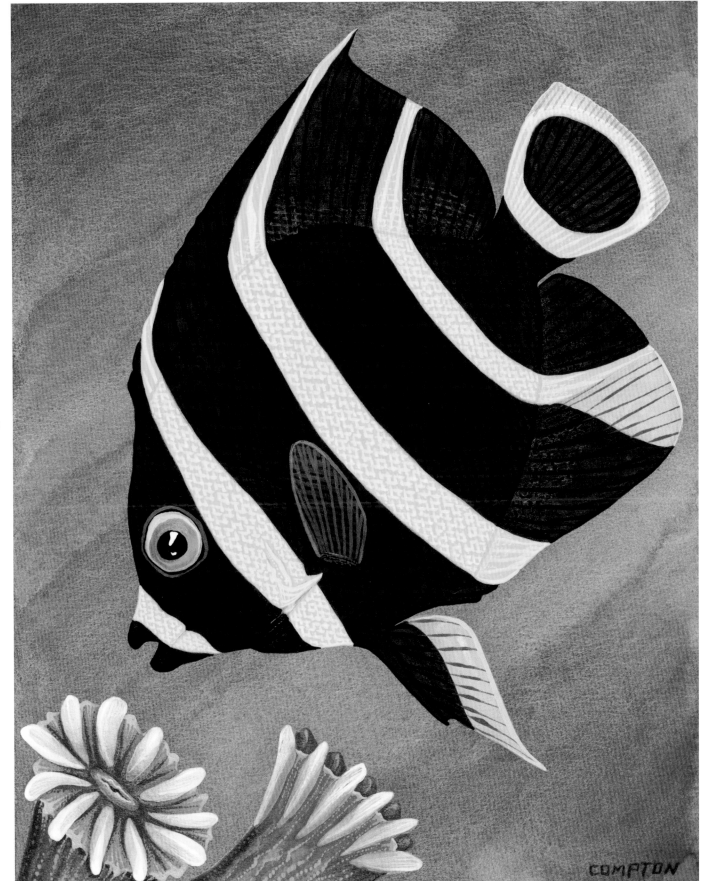

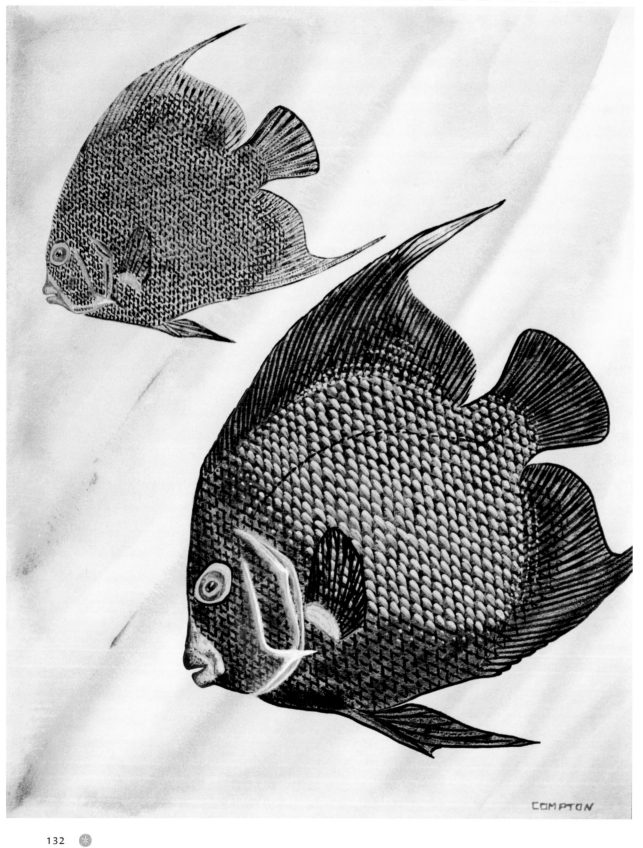

French angelfish (adult)
Pomacanthus paru
 (Bloch 1787)
"The Reef of the Angels
spread out in silky sunlight
three-feet below his frus-
trated nose was a swirl of
black and yellow like spilled
paint."

COMPTON

asked the proprietress of Suwanee Sue's Emporium & Fresh Fish Frog & Gator. "Some stout material color of fish guts, fumbled milk and occasional dog doings sat on where Deck missed his corner?"

"Jim, your young missies have previous selected. At first light over Suwanee and the whitebird flying alley to the sea an' Black Snake swimming over for his tuh-three frog I save 'im." With a flourish she spread four bathing costumes across counter.

"Black?" says Captain Jim.

"Won't have it on me," says Johnny.

"On me neither," says Kevin.

Sandy produced final ruling, "Granny will be so happy and pleased you wear 'em." This was the magic statement that mustn't be argued with.

"You know Granny don't want no mournin,'" said Johnny, getting mad.

"We left my sweet Granny out in the pretty blue seas, Miss Beetrice," Sharon told her.

"I know, honey. This three year gone. Days is flyin' from us."

"Our Granny follers us sometimes to see we don't foul us up sometimes, Miss Beetrice," Kevin told her.

"Beetrice," says Cap'n, "give them gloomy coverings to Sandy, this bein' her doin.' And we'll be going. We bought you about outa everything excepting that gator tail Deck wouldn't eat last time."

"An' me, too, Grampah," cried Sharon. "I was doin's, too."

"Load 'em both. River's a-pullin' and Gulf's a-waitin.' We got us a hunnernfifty good leagues to row before we are home. We'll get aboard and try these colorful drawers. Sandy's correct. We are about naked."

"I like bein' nekkid. Rain can get to me. Did the Pirates fight all nekkid with the Cutlasses, Grampah?"

"Doubt it, Kevin."

Johnny and Kevin jumped to cast rope and the river took the Shannons in dimpled swirl behind the two big engines push. Miss Beetrice, waving, vanished at first bend. Envoyage the blacksuits vanished. "Guess we wear our holes," Johnny said happily.

Destination. Secret reef. Mini-island. Home. Moon led the *Riff-Raft* to anchor midnight inside the wide ringing reef, its barrier coral white-horsing in circle of protection. Shannons moved dreamlike through mooring. At dawn the blacksuits reappeared. Sandy and Sharon shone with pride. The Captain, Johnny, Kevin, Deck Dog, Miss Fortune and three dolphin looking over stern gaped in astonishment. All over the black were sewn Zebra stripes in molten blinding yellow.

"Miss Beetrice found the ribbon."

"Miss Beetrice showed us just to cut so and sew so."

"Miss Beetrice says males need some color-about-em to cover they general dirt."

"Miss Beetrice says get pichur of varmints for posterity."

"Annie Beatrice O'Bregin will receive 'pichur' and other gifts," says Capin.

"We gonna send her a snake bite 'er, Grampah," asked Johnny, eyeing his intended wear.

"She's got a snake."

"Granny would be so . . ."

"Enough, Miss." Cap'n grabbed three male trunks in one hand and headed his males forward with other. "We go to prow to don our new splendor. Ladies kindly retire to their cabin for same."

Ladies retired giggling.

"Strip," says Cap'n. "One-two-three."

"Don," says Cap'n. "One-two-three. There. We resemble the wasps, we do."

"I'm a killer-wasper," shouted Kevin. "Where's me a spider?"

And even Johnny looked pleased at his striped self. At good sun-up, Sandy & Sharon Enterprises' strategy showed itself. Four of the Shannons were wet. Cap'n sat drying on stern with company of other two deck animals. Deck Dog had been in twice and back up diving steps twice to shake sea on his two friends. Cap'n had cursed him. Miss Fortune had scratched him. The Reef of the Angels spread out in silky sunlight three-feet below his frustrated nose was a swirl of black and yellow like spilled paint as 4 Shannons swam with 30 young French Angels who thought they had found the biggest playmates ever. With black & yellow fishes chasing black & yellow Shannons, Deck Dog knew where he wanted to be.

Deck Dog was in training but had not yet mastered snorkel much less SCUBA. He could not yet compete in the "Swimo"

as Kevin called it in happy splash before him. He was a tryer. With great BARK he sailed off stern to fur-bomb the researchers experimenting the attraction of color between species. He was received without welcome but patted and praised for his interest and shoved *Riff-Raft*-ward. Nose up, ears laid, prowing the shining water with happy grin, he dogpaddled to dive step. Aboard he barked and rained sea from his golden fur with all the vigor of one who has conquered elements and expects shout of applause. Capin cursed him. "Deck, you are fine faithful friend, you fool dog. You are mighty slow porpoise."

Deck Dog barked happily right full in Miss Fortune's face and was slapped with vigor. 🐚

Species: *Pygoplites diacanthus* (Boddaert, 1772)

The regal angelfish, sometimes referred to as the royal empress angelfish, is a tropical and subtropical species found throughout the Indo-Pacific. These fish can be found from the eastern coastline of Africa to the Red Sea, Great Barrier Reef, and New Caledonia. This species prefers areas of rich coral growth such as in lagoons and seaward reefs to a depth of 50 m or greater. This colorful species is yellow and orange with white bands along the body lined with bright blue. The eye is encircled with black or dark blue, which is also lined with bright blue. The rear portion of the dorsal fin is bright blue, while the anal fin has orange and blue bands. The caudal fin as well as pectoral fins are bright yellow. The regal angel can be found as a lone individual, in pairs, or in large congregations in some areas of its range. Spending much time near caves and overhangs, this species feeds primarily on sponges and tunicates. Although exported frequently as a popular aquarium fish, this species does not survive well in captivity.

(13) The Empress is Johnny's best favorite fish and he'll fight anybody try change his mind. He feeds Empress chopped big-red angle-worm dug from source on Suwanee River bank and grown all over world on *Riff-Raft* in old ice chest full of Suwanee River bank. Fed on oatmeal which he is thankful to hide and throw to worm. The fine muck dirt is covered by screening from Miss Fortune's attentions since threats proved ineffective.

Johnny feeds Empress all over Pacific on the reefs and he is always telling that he believes race would die out, wasn't for him. He tries to find new Jug Tunicates to transplant for their pleasure. Empress doesn't seem especially interested and Grampah says Johnny's gonna overturn ecology of world carrying Atlantic varmints to Pacific. And vice versey. 🐚

Family: Pomacentridae (Damselfishes)

Damselfishes occur worldwide from tropical waters to warm temperate seas. This family is most highly represented within the Indian Ocean and western Pacific. Damselfishes are commonly found throughout coral reefs and are often the most readily seen fishes in and around most reefs. Certain species within this family may also be found near coral rubble, on sandy bottoms, and in seagrass beds. Damselfishes have a compressed, oblong body. Most species exhibit a small terminal mouth with a protrusible upper jaw. A single dorsal fin and a deeply forked caudal fin are seen in most species. Most fishes belonging to this family are highly territorial and strictly guard their home ranges from intruders. Once eggs are laid, the male often guards them until larvae hatch and become pelagic. A large majority of species within this group feed on algae and small invertebrates. The family consists of approximately 300 species within 30 genera.

Species: *Amphiprion percula* (Lacepede, 1802)

The orange clownfish is a tropical species found in the western Pacific. The range of this species is primarily near New Guinea and the Solomon Islands and extensively along the Great Barrier Reef. It is not currently known to occur in New Caledonia or Fiji; however, specimens were recorded there during the 1950s. This species is often confused with A. *ocelaris*. The orange clownfish typically inhabits lagoons and reefs to a depth of approximately 15 m. Like other anemonefishes, members of this species inhabit several particular species of anemones, including *Heteractis magnifica*, H. *crispa*,

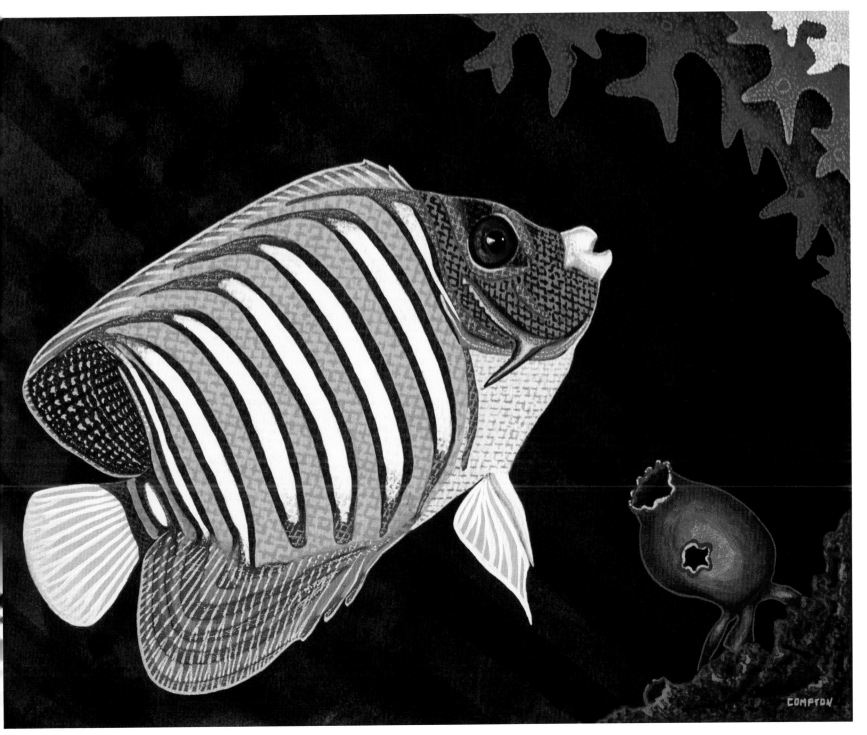

Regal angelfish

Pygoplites diacanthus (Boddaert, 1772)

"The Empress is Johnny's best favorite fish and he'll fight anybody
try change his mind."

and *Stichodactyla gigantea*. Unlike other fishes, anemonefishes are inherently immune to the anemones' stinging cells. This is due in large part to the mucus covering these fishes that carries the chemical signature of the specific anemone in which they reside. The fish is orange with three distinct white bands lined in black along the body. The outside edge of each fin is also rimmed with black. Like others within this group, the orange clownfish exhibits protandrous hermaphroditism. A group consists of a breeding pair and up to four nonbreeding individuals. The female is typically larger than the breeding male, and nonbreeding individuals are smallest. When the breeding female is removed from the group, the male then alters his sex and becomes the new breeding female. Upon doing so, the largest nonbreeding individual transforms into a male. This species feeds largely on zooplankton. Along with other anemonefishes, the orange clownfish is often exported for use in home aquariums.

(20) A sea anemone is a wading pool of fingers for certain small fish who swim caressed in danger. These anemones are no dinky thumb-size naked coral animals. These are large anemones whose surface disc of expanded wiggle is a two-foot table—four hundred fingers pointing way to numbing death by a hundred thousand coiling stings to needle out narcosis. Fired on contact.

Semi-center lies the slit smile of waiting mouth. Within the shag of this deadly carpet lives a curious collection of colored crabs and shrimp and various painted Damselfish. Different Clowns live with different anemones. All this is a speciality of the hot Pacific. Old Atlantic has her anemones but has no Anemone Fish to own them.

One time, the Biologist, with his customary thoroughness in nuttiness, conducted an experiment. On a midsummer morning, he and interested but skeptical Wife hung wingtip tanks on plane and flew from Key West International Air Strip to Dallas to L. A. (underwing tanks added) to Honolulu to Midway to Wake to the Marshalls, the Gilberts, the Solomons, and Fiji. Their passenger? A sullen giant-pizza-sized cream & green Cozumel anemone ripped from its home off The Yucatan and firmly folded as shut as a giant limber pizza can manage.

"Whew!" says Wife, stretching fingers eagerly to the rainbow water beside the white packed runway.

Passenger went on sulking folded.

"Oh! I love Fiji and the reefs the best and all the people the loveliest. Why wasn't I born Fiji?"

"Ask your Ma. Now quit gibbering an' help me move El Ear's tank to boat."

Without luck, passenger attempted tighter fold.

"El Ear?"

"He's about the size of a Elephant's flapper and about as purty. Dirty and grey an' wrinkled."

"Well, he's reason," said Wife, getting mad. "You've toted him God-knows-Where to him. I want him on good reef right now and if he doesn't any way like it, back he goes, toot haste and pronto."

"Sure, Hon. Grab aholt of his handle," but first Wife reached hand into deep flat can to pat. El Ear, sensing sympathy, expanded a bit.

On a secret reef three fathom down with fish like splattered paint and coral like fairy castles, El Ear came to new home. Biologist pressed the disc of his basal butt firmly onto a fine flat area cleared of tunicate and sponge and algae. Biologist and Wife sat on coral, weightbelts touching and bubbles mingled rising. All around were the big saucers of Pacific anemones with their damsels and their shrimps playing in fingers of gold and brown and green and cream. El Ear expanded to elephant cream & green.

Biologist fed him a shrimp and a cut of fish fresh that morning from Suva's market. El Ear accepted into his fingers this largesse and fired 500 of his many thousand coiled waspers against Biologist's hand. No luck. Wouldn't penetrate thick Biologist-hide. Wife fed him three fat Suwanee worms and he caressed her fingers without shooting.

No Anemone Fish came near him; no shrimp approached. Biologist dropped a piece of fish onto a Pacific anemone. Fingers clutched it competently. Fish inspected it, bit off a portion to eat and bit off other chunks to spit among other fingers. Shrimp and crab took their levy.

Biologist dropped handful of loose coral pebbles on Pacific anemone. Immediate bustle. Fish carried pebbles to perimeter side

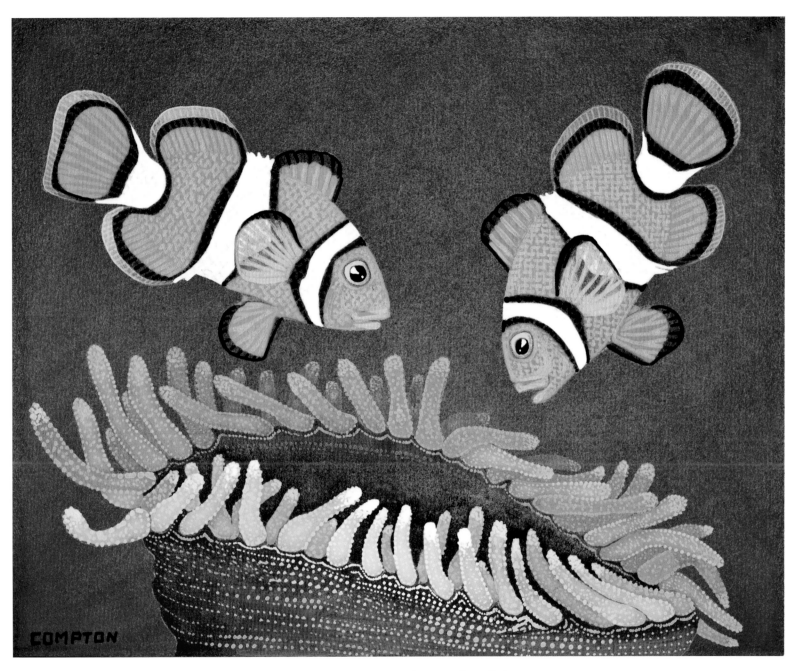

Orange clownfish

Amphiprion percula (Lacepede, 1802)

"Within the shag of this deadly carpet lives a curious collection
of colored crabs and shrimp and various painted Damselfish.
Different Clowns live with different anemones."

and spit them over. Shrimp and crab pushed pebbles up & over & in & out to perimeter and gave good shove. Fishes, shrimps and crabs looked up at Biologist without pleasure. With one swoop, Biologist caught them all in wide net and upended net over El Ear. No one was pleased. Pacific anemone folded. Atlantic anemone tried to fold. Shrimp and crab hid. Fish were obviously stung and acted drunk. Wife removed net from Biologist and El Ear.

Fish's built immunity saved them from death by strange stingers. They wobbled back to home. Shrimp and crab, undamaged but highly irritated, scrambled for home. Before anyone could build hopes, Biologist pried Pacific anemone off foundation, shook remaining crab or two out, shoved his now basketball body into plastic sack and swam surfaceward with him. Wife shook her facemask at the many small anxious faces of fish & shrimp & crab.

Back on secret reef off Cozumel, Biologist & Wife fed a listless replanted big Pacific anemone chopped shrimp, cubed fresh snapper and Suwanee Worms. Anemone ate part of a worm without enthusiasm. Back on beach under the rustling thatch of favorite cantina, Biologist's wife, Jan, became vocal, "This time your scientific meddling has gone too far. He's SHRINKING. He misses his friends."

"Some say he can't live without 'em, Hon."

"Don't call me 'Hon.' You knew this?"

"Heard of it."

"Well, hear of this, HON. He's dying and we are removing him home starting daybreak manana."

"Didn't know you had that gummy a feelin' for all your fellow creatures. How 'bout that fly on your shrimp you're about to gobble? How 'bout shrimp hisself? He once swam and frolicked."

Fly waved away. Shrimp eaten with relish and tongue stuck out briefly from eater.

"I just bet you're killin' about a million bacteria right this minute. Breathin' so."

"Oh, shut up. I didn't kidnap your menagerie from their happy homes to DWINDLE AWAY. He's dying and he doesn't even have a name."

"Don't tremble your mouth at me. I can give 'im 4–5 4-letter names."

At Fiji, Biologist and Wife were greeted with fete by many of their young friends, those who dove reef by day and with blinding grin, rustle skirt, ankle and wrist tuft, flower in hair—bra-ed females to glide wave, speared males to leap fire-danced the night for tourist.

"Miss Jan!" "Miss Jan!"

"Oh, we have missed you."

"My loves," says Jan.

"We have fed Monsieur Ear every day."

"Monsieur Ear does not require it."

"Non. He grows fat as the face of Big Ben."

"Our fish do not like him. He eats our fish. He has no companions. It is sad."

All broke into French. Jan was laughing and talking French.

"Now what?" says Biologist. "I thought all these kids on this archipelago yelped in the Queen's Lingo."

"They say one cannot make friends of one whom one intends to eat. But why this sudden burst of Gallic, my lovelies?" asked Jan.

"Tell Senor Biologist, the Fiji speaks all civilize tongues," said the lovely miss who held Jan's hand. She went to the Queen's. "Because that *Riff-Raft* was just here from Tahiti. All were speaking French for the feel of it. Ver-ver badly. Kevin and Danny were not to be heard sans extreme merriment. Miss Fortune and Deck Dog pretended to be deaf. It was all great fun, Miss Jan."

"Johnny," says the handsome 13-yr-old war dancer gripping Jan's other hand, "recognized Monsieur Ear at once as friend from way over his Cozumel. Why was Monsieur Ear lost in Fiji? We said nothing, Ma Jolie."

"What you say?" screams 9 female sirens.

"What we say," yells 9 male speardancers. "We would have the older woman. We Fiji would not take those yet children. We will have MaJole Jan. Eh?"

"Hey, my Jan," says Handgripper. "Why is this Biologist I see scowling? Is he to fight me for you with spear? Would he prefer warclub? All can be arranged."

"Nope, Honey." She was laughing. "He thought no one knew his secret reef where he plies his devilment."

"There is no secret reef to Fiji."

Just then, one of the bunch peering and prodding into transit tank

of homesick anemone yelled, "You have brought back The Dwarf."

"You did not like him?"

"The Dwarf?" says Biologist in a truly terrible voice.

"Yes. Every year he grows smaller and smaller and smaller and we think he is goner but no. Sudden all at once before us he splits hisself and becomes two."

"True. Mr. Biologist, are you gonna fight for your missus?"

"We always remove the one of him. For space. You see? Both of him gets bigger and bigger."

"Then he does it again. Small-small. Double. Big-big. Did he not like Cozumel? You would have two of him."

Great shout from tank. "He commences."

Jan began to really laugh. Some skyfaring weeks later, Biologist and Wife drank evening Keywesters at Dive & Fish.

"Can't I have some seasonin' in this blander," asked Davey.

"No," says Biologist and Salty Dog.

Mouse-who-lived-in-the-sofa could not make up her mind whether she preferred sitting on Davey's big bare toe to eat her imported exotic unsalted nutmeats fresh from the South Seas, or to sit on Jan's smaller bare one. "We're cloggin' her circuits, Jan," says Davey.

In big tank, Blue Devils, temporarily eggless, Jawfish with undecided stone in mouth, Hogfish guarding their beloved ball of coral, Pistol Shrimp and his shy peeping Goby had all been re-admired and fed tiny chunks of dried what Biologist called Sea Prang. "Hit's the gizzards of a kind of starfish an' every fish from Reef to Guam wants some of 'er."

"If you kill . . ." says Mattie.

"Matt!"

"All right. If it don't get outa hand."

Fish and Pistol examined Sea Prang. Tiny chunks of Sea Prang lay reproachful on aquarium gravel awaiting the siphon out.

"Wait'll it swells some," says Biologist.

"How much some?" says Mattie.

"Jus' to taste. Betcha Fat Eel wants some. Don'tcha, Bigsnake?"

Fat Eel, hearing the vibrations of his name, broke his water-skin and clackety-clacked his teeth charmingly.

Mattie, David and Jan snorted.

"You snort?" says Biologist.

"He'll bite hell outa you," says Salty. "He thinks you're prankin' with his vittles."

"We are knee-deep in Nuts," Biologist told Fat Eel's handsome hopeful face. "Here, Chum."

When Biologist was finally band-aided after considerable noise, Mattie said, "Now. Sir. We hear you have been proving our big Atlantic anemones will not accept Anemone Fish and big Pacific anemones will die without them. Get smaller and smaller an' shrivel and go."

"An' Twin." Jan gave a giggle-shriek that jumped the-Mouse-who-lived from her toe to Davey's. "We got The Dwarf."

When all was finally explained, Salty said, "Hell, you didn't prove nothin.' That anemone was not about to die for you."

But Biologist had been up this tree too many times in his life not to have parachutes handy.

"Salty," he said solemnly, "I proved you gotta go four times to Hawaii to get to Fiji twice."

"You are a full nut," said Salty. 🐚

Species: *Chromis cyanea* (**Poey, 1860**)

The blue chromis, often referred to as the blue reef fish, is a tropical species found throughout the western Atlantic. This species can be found along the eastern coast of Florida, throughout the Gulf of Mexico, the Caribbean, and the northern coast of South America. Adults are typically encountered among deep reefs and outer slopes to a depth of approximately 50 m. The blue chromis possesses a typical perciform body plan with a slightly pointed snout. The body is bright blue; the ventral surface is slightly lighter than the dorsum. There is typically a dark stripe along the outside edge of the dorsal, anal, and caudal fins. This species tends to form large aggregations near reefs and may retreat into crevices when alarmed. These fish form distinct pairs during the breeding season. They are oviparous, and eggs adhere to the substrate, where they are protected by the male. While in large groups these fish feed on zooplankton found within the water column.

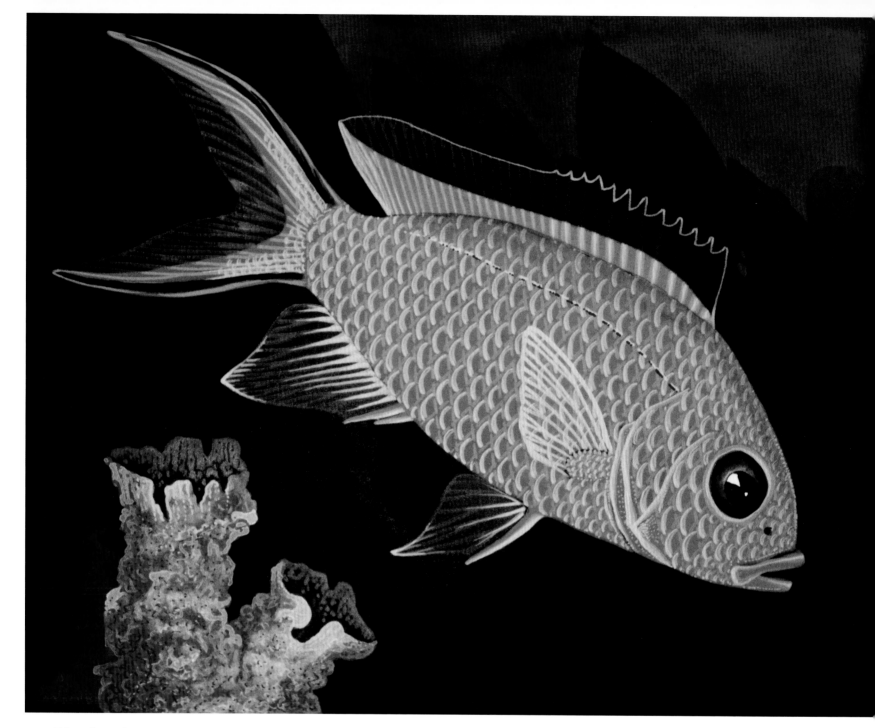

Blue chromis

Chromis cyanea (Poey, 1860)

"The Blue Chromis is from Florida and on down and across the Caribbean Sea where Cuba and Haiti and Jamaica and all the thousand islands shed the beauty of their small land into coral drops seaward to ring themselves."

(7-A) Blue is an absorption and grabbing of sunlight's Red, Orange, Yellow, Green, Indigo and Violet away from you and tossing back into your eyeballs only Blue. Fish have little black color cells in their skin also and crystals that bounce light around and make their scales glisten.

The Blue Chromis is from Florida and on down and across the Caribbean Sea where Cuba and Haiti and Jamaica and all the thousand islands shed the beauty of their small land into coral drops seaward to ring themselves.

The biggest blink-blank shark ship has not yet rounded to invade the Atlantic via Suez so we don't know yet if old Blue Chromis will jump at that monofilament sea algae to lay eggs on. Maybe those muzzled (tape on mouth) kids have taken over the ship (mutinied her) and won't allow the adult Sports to heave plastic pollution.

They, Dan & Little Nan, will learn as they progress to old Sport that one critter says, "Hey! That's garbage. Ugh, wugh!" and some other critter says, "Hey! Don't you want it? Lemmie at it. I'll eat it or I'll wear it or I'll put an egg in it." 🐚

Species: *Chromis viridis* (**Cuvier, 1830**)

The blue green chromis, or blue green damselfish, occurs in tropical and subtropical waters of the Indian and western Pacific Oceans. Adults are commonly found congregated near areas of dense *Acropora* corals in sheltered reefs, flats, and lagoons to a depth of only 10 m. Juveniles tend to stay near corals and do not stray far from cover. These small fish appear similar in body shape to most other damselfishes. This species closely resembles the black axil chromis (*C. atripectoralis*) but is lacking a small black dot at the base of the pectoral fin. The entire body is a bright blue-green. The snout appears more rounded than that of similar species. These fish are one of the more commonly encountered species among reefs. This species breeds over open sandy or rubble-laden substrates; the male prepares the nest and shares it with a group of females. Males guard and aerate the nest once eggs are laid and often feed on those eggs that do not hatch.

(7) Here is a green fish. A real GREEN fish. How many green fish have you ever seen? Probably only this one. Despite what you might think of that perch you jerked out of the lake. He wasn't green any more than Greenland is green.

Where does this fine color get to spread itself except amongst the plants? Man? Not likely unless he is from Mars and airsick. Pussycats? Monkeys? Elephants? Not but what he is painted for circus or ceremony. And don't you believe that tale of the few-toed Sloth growing verdant moss in his shaggy hair to make him look like part of a tree and not to be eaten. Tale says Sloth moves so slow moss thinks it's growing ON tree.

Insects like green some and parrots, Quetzals and 2–3 other birds. And the Carolina Lizard some folk call a chameleon for doesn't he wear two coats?

Way off, more than 6000 sailor-miles of 6000 feet apiece as man's silver bird would fly it from Charleston lie, in enchanted scatter, the Caroline Islands. Near the center squats Truk, that isle of bloody memory and in her lagoons and off her beaches are ancient warships sunk in times forgotten. Their guns and armor are rotted and grown now to coral tombs and palaces and halls of lace where swim the inhabitants of the region. They make great fishing holes.

Once there was a fishing boat jam-crammed with sports touring the sparkly skin of all the seas to catch all of the different biggest fish of all the world and stand beside them for color photography. "Mullet to mullet," said some critic but he was only pout-mouth and mean-mouthed because he never got invited on the tour. This fancy-pants boat anchored above the coral-garden skin of a great battleship. Around and through the broken beauty of this great battleship played 100's and 500's and hordes and clouds of Green Chromis to out sparkle seaskin.

All the sportsmen threw their lines over and jerked fish until the deck looked like map of Ireland. "What the blink-blank are all these sardines?" they shouted to Guide.

"Don't know."

"They ain't as long as our feet. An' skinny. They good for bait?"

"Don't know."

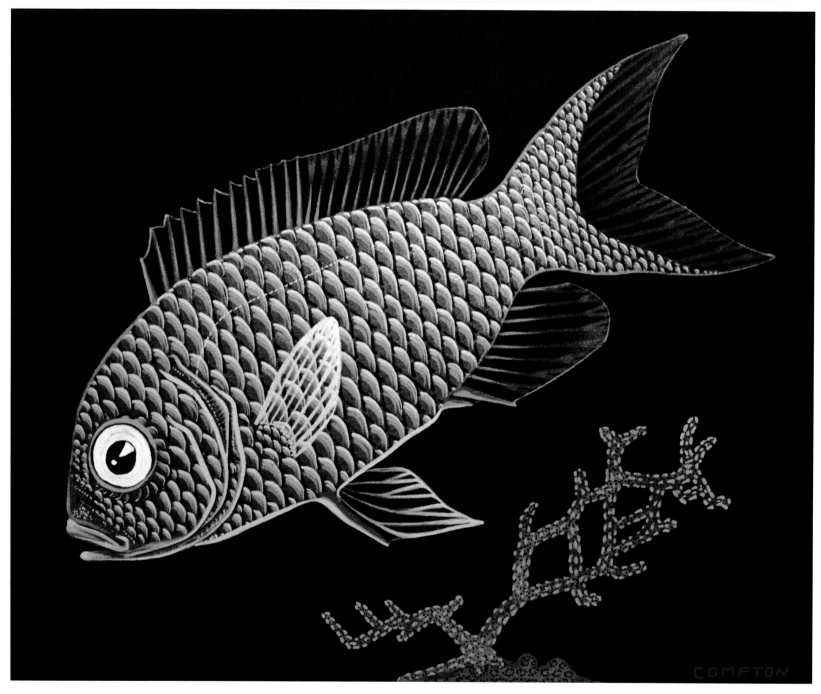

Blue green chromis

Chromis viridis (Cuvier, 1830)

"Here is a green fish. A real GREEN fish. How many green fish have you ever seen? Probably only this one. Despite what you might think of that perch you jerked out of the lake. He wasn't green any more than Greenland is green."

"Then why we catchin' 'em?"

"If you don't know, I sure can't tell you."

Lot of blink-blank.

"Aren't they pretty," says a wife. "Why they shine like my emeralds."

"Blink-blank your emeralds," says husbands, "we ain't after pretty. We are after BIG."

All this while, the children were playing with the beautiful green fish. With shining eyes and happy smiles small girls and boys hurried the gasping fish into buckets of water. The fish with shining eyes and happy smiles swam round and round the buckets with the help of small-finger-herding until they were just as well as new. Large boys and girls hurried the buckets to empty prow of boat and returned all to sea.

All was done in the silence of giggles, muffled shouts, whispers and hand signals smart as any monkey for children were not allowed to speak on this cruise. And could only be seen from right after dawn to right after dusk.

"Now," says Guide. "We will all replace the fishing line on our reels since we been fishing with it from San Francisco to Samoa and it is about wore out and we are headed for far Solomons where lives the biggest shark of the ocean, I been told."

"Hooray!" shouted all the sportsmen/women, and they stripped old line off their reels in snakey puddles, great clumps and massy tangles and over she went before the children could stop dumpage—not being allowed yelling or even speaking at all, at all, except to be excused at table.

Boat swung graceful to south to the Sollies. As the children threw their goodbye flowers (silently) (unbelievable discipline without face tape) to float soft back to Truk, little Nan wanted to cry but big Dan bent and whispered, "Them fine green sparklers will find some good use of that trash."

That they did. Green Reef Fish in hundreds backed fin, hung in place in curtains of shifting amazement as their ceiling dumped onto them a great grid of messy mesh looking like a seaweed they were used to and green as their green selves but not before had this ever tried to bomb them. They easily swam swift from under.

Blop! Plastic spider strands draped and hung the reef of the battleship flying verdure and every GreenFish within sight went

into action. Males selected nest of monofilament weave and each one's selected female laid and left. For 5 days, all a diver could have seen was many papas fin-fanning eggs to keep disease off and never eating a one.

Green is a reflection to you of the green out of sunlight and a grabbing and holding back from you Red, Orange, Yellow, Blue, Indigo, and Violet which would only confuse you so you wouldn't see Green. Simple? Works in water also. 🐚

Species: *Chrysiptera cyanea* (Quoy & Gaimard, 1825)

The sapphire devil, sometimes referred to as simply the blue devil, is found in tropical waters throughout the Indo-Pacific. This species commonly occurs among shallow reef flats as well as near coral rubble in protected lagoons to a depth of approximately 10 m. These fish possess a typical perciform body plan with a slightly rounded, sloping forehead. Both sexes are bright blue across the entire body with a narrow black bar across the eyes. In males the caudal fin may be bright orange. This species typically occurs in groups of a single male and several females with juveniles sometimes included. There may also be groups of only juveniles. Distinct pairs form during the breeding season; the eggs adhere to the substrate and are fiercely guarded. The sapphire devil feeds on algae as well as tunicates and copepods. The bright blue coloration makes this species attractive for aquariums.

(14) Miami Hurricane Center's bulletin of 1200 Thursday radioed and telly-ed into every ear from Cape Hatteras to Brownsville. People yelled in streets above the rising wind from Miami to Key West.

Mattie said to Salty Dogg, "You had just as well stop fidgeting. I am not leaving them."

"They can swim like fish, Matt. We can't."

Miami Radio said, "Received this information from 30 to 45 minutes ago. Winds had been ninety . . . yes . . . ninety miles an hour throughout the night and early this morning but now our Air Force Reconnaissance tells us the winds near the center of Hurricane George have reached 115 miles an hour . . . Yes! . . . What? . . . No! . . . have reached 125 miles an hour. The newest forecast for Miami

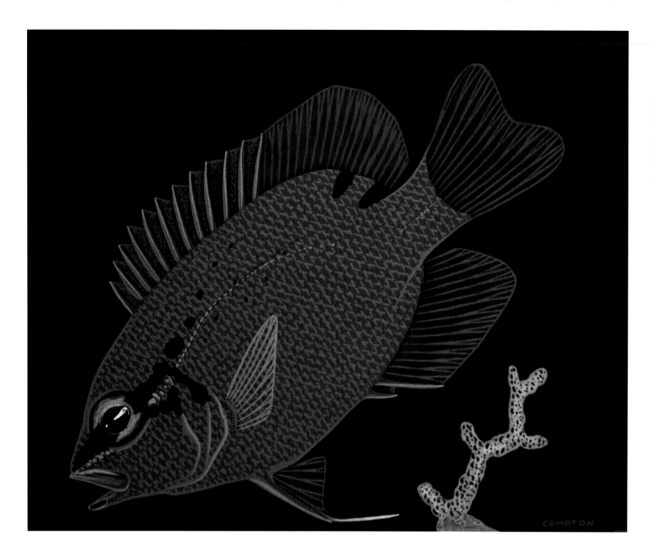

Sapphire devil
Chrysiptera cyanea (Quoy &
Gaimard, 1825)
"They can swim like fish, Matt.
We can't."

to Key West calls for tides up to 10 feet, up from 5 to 7 feet, that's been revised by Miami Weather Bureau this morning. New tides are expected up to 10 feet in the area near where the center of Hurricane George will touch land."

"They can't swim like fish in that," said Mattie. "And won't be asked. Isn't your middle name George, Salty?"

"Never use it. Don't blame me for this windy."

"Glad you've recovered your wits."

"Partial. Are you intending to finish before we are blown up to Pensacola?"

Mattie laughed. They were photographing. The long tank held five fish and a Pistol Shrimp with one long enlarged claw complete with cocking trigger to snap a Pop! that would break thin glass if in contact. The aquarium was thick glass and the Pistol Shrimp

hidden somewhere rear center. Occasional Pop! told that he lived and thrived. To left, a pair of Blue Devils imported from far Pacific had laid and were guarding caviar in a very small giant clam shell. As focus for Mattie's camera. 🐚

Species: *Microspathodon chrysurus* **(Cuvier, 1830)**

The yellowtail damselfish is a tropical and subtropical species that occurs throughout the western Atlantic. This species is widely distributed from Florida, throughout the Caribbean, and along the northern coast of South America. This small species is typically seen among shallow waters of approximately 15 m near coral reefs and is especially common near fire corals. Juveniles tend to take up residence near yellow stinging coral. The body plan is typical

of that of damselfishes. Adults are dark yellow or brown with the edges of each scale often darker. Blue spots may be seen along the dorsal surface of the body, and the caudal fin is bright yellow. Juveniles look drastically different from adults in that they possess a dark blue body covered in bright blue spots and have a transparent caudal fin. Adults feed on a variety of organisms, including algae, sponges, and various marine invertebrates. Juveniles tend to feed on coral polyps and serve as cleaner fish. This species is a popular aquarium fish and is often reared successfully in captivity.

(9-B) The dictionary says: demoiselle reads—young lady. Or dragonfly. The Jewel Fish is no lady. In fact, no Damselfish is a lady. From the time he is a half-incher, Jewel Fish will with pleasure and thank-you fight a six-foot buzzsawfish. If he ever saw one of the toothy varmints near the hole, crevice, cave, coral branch or reef he considered his own property and no buzzsawfish's concern.

Jewel Fish darts and dashes and generally fires the water up on belligerent fins protecting his personal front and back yard so maybe he does call to mind dragonfly snagging fly and mosquito under summer's sun.

Jewel Fish young has the sparkling sequins of stars and zodiacs

Yellowtail damselfish (juvenile)
Microspathodon chrysurus
(Cuvier, 1830)
"Jewel Fish young has the sparkling sequins of stars and zodiacs and comets on his hide which is as Prussian-Manganese-midnight blue as the mighty Gulf Stream that winds his homes from Florida south southeast as the map flies to where the Orinoco muddies Trinidad."

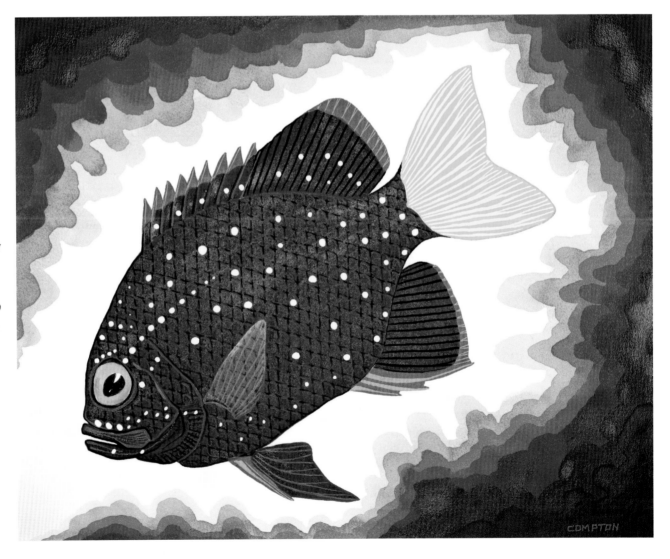

and comets on his hide which is as Prussian-Manganese-midnight blue as the mighty Gulf Stream that winds his homes from Florida south southeast as the map flies to where the Orinoco muddies Trinidad.

Jewel Fish adult is drab as used mud—being brownish with see-thru orangish tail. But if he grew up aquarium, he is now PET, jeweled by the heart and when pet cat by tail, gesture and smile suggests this swimming muddy mess could, to remove an eyesore, be given her to eat (she would do it, ugh! only to please her so-called owners), she is given in turn to understand her presence is not required near Aquarium. She isn't kicked. Pull-your-leg is the word for cats. 🐚

Species: *Stegastes adustus* (Troschel, 1865)

The dusky damselfish is a tropical species found in the western Atlantic from Florida, to the Gulf of Mexico, and throughout the Caribbean. These damselfish inhabit rocky shores to only a few meters in depth and are sometimes found in tidepools. Adults are typically dark gray with black vertical lines along the body and a black spot at the base of the pectoral fins. Juveniles appear light gray along the lower two-thirds of the body, while the dorsal surface is often red-orange. Bright blue spots can be seen along the forehead, and a large dark spot is apparent at the base of the dorsal fin, with another present along the caudal peduncle. This coloration disappears with age. These small damselfish are highly territorial. The dusky damselfish feeds on benthic algae and detritus and occasionally on polychaetes and copepods.

(9-C) Some poor nut named this Damsel "Dusky." He only saw poor old dusky adult. But another fine fishman from Florida wrote a book on salt-water aquariums for your very own home from true experience and he named Dusky—The Scarlet-Back Demoiselle.

Those black things on Scarlet-Back are black scales bordered in blue scales and the blue scales on the real live true fish glitters like broke glass as the Biologist said who chased them on a couple Texas jetties in and out of barnacled rock until he caught some

and had to use plenty iodine dots on his arms. Iodine splotches are just what they look like. The black splotches on Biologist's fish are called ocelli—eyespots. One would be ocellus. The Peacock, if no brat has pulled his tail, has upwards of fifty. The Peacock has ocelli. His wife the Peahen has none at all, at all. 🐚

Species: *Stegastes leucostictus* (Muller & Troschel, 1848)

The beaugregory occurs in tropical waters of the western Atlantic and is common from southern Florida, throughout the Gulf of Mexico and Caribbean, and along the northern coast of South America. This species typically occurs in seagrass beds; however, it is also found in coral and rock reefs to a depth of 5 m. In some areas these fish can also be found near mangroves. The beaugregory possesses a compressed, perchlike body plan. The upper half of the body is primarily blue, while the ventral surface is bright yellow. A spot is often seen along the lower edge of the dorsal fin and the caudal peduncle. However, this spot becomes much less apparent as the fish matures. Juveniles of this species tend to be much lighter in coloration than adults. Feeding primarily on benthic algae, they may also eat copepods and polychaetes if given the opportunity.

(9-D) Handsome Greg or Gregina have ocelli. Wouldn't you like your ringworms to be this colorful? Then you wouldn't mind being host to the varmints, would you. Beau Gregories have all the Damselfish fire but they do not lose their color with age. They remain beau at 4-inch as they were at a half.

When you visit Beau on his Florida and Caribbean reefs, sit down and let him fight your fingers for a while. He likes a tussle. When he finds you are worse than a Sea-Cow for clumsy and too dumb to remove yourself from his coral when asked, he will flash and threaten just in front of the window of your diving mask—trying to lure you out so he can get at the real you. He thinks the bulk of what he's been attacking is some kind of insane and unwieldy machine. There must be sense to it inside. Otherwise, he's got a real fight on his fins.

Bring him a can of dog or cat food. Preferably with fish and

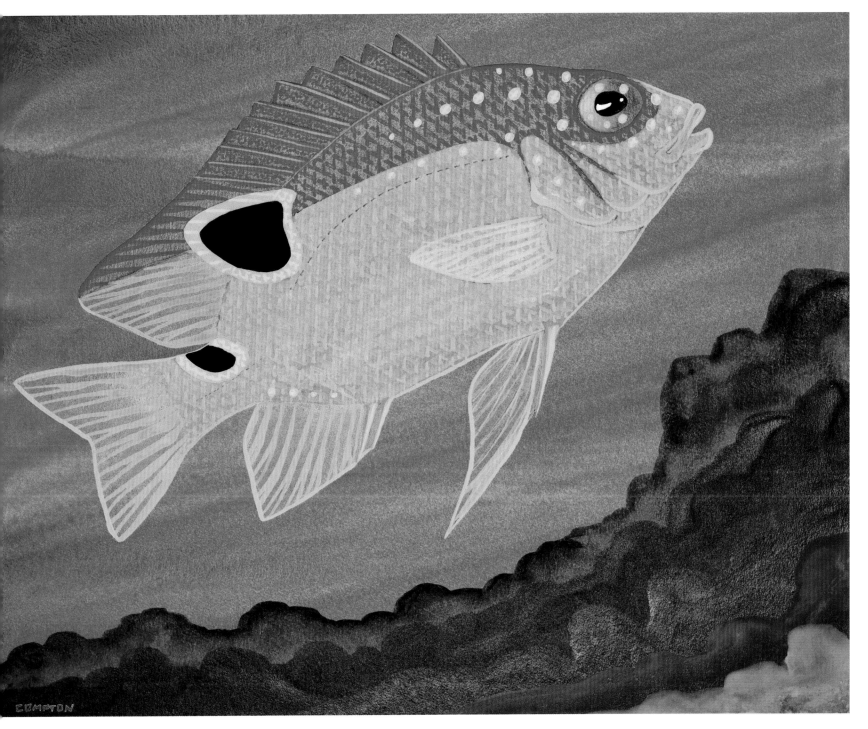

Dusky damselfish
Stegastes adustus (Troschel, 1865)
"Those black things on Scarlet-Back are black scales bordered in
blue scales and the blue scales on the real live true fish glitters like
broke glass."

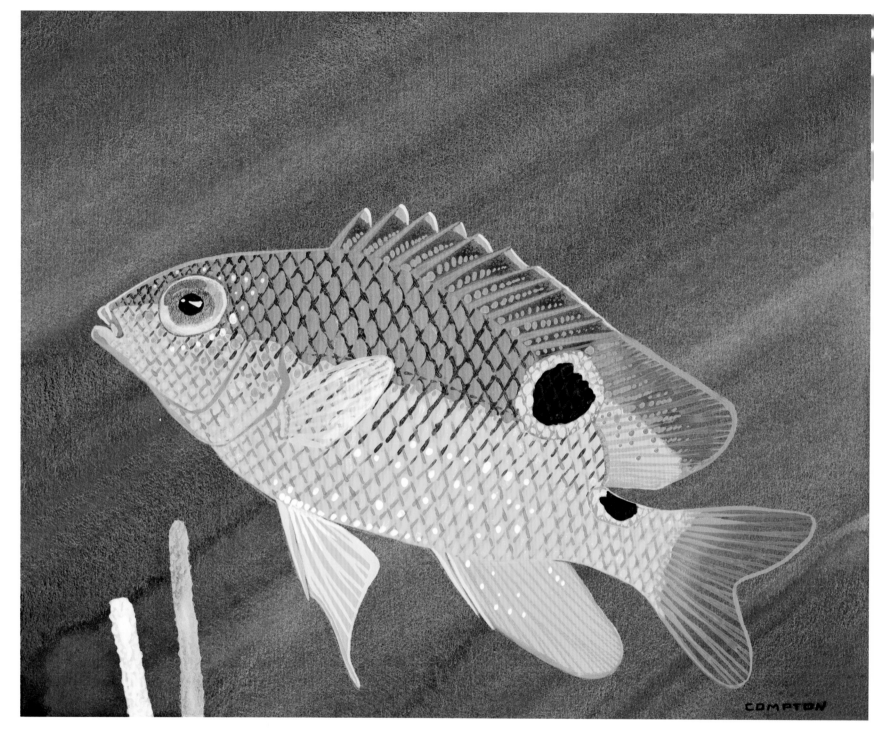

Beaugregory
Stegastes leucostictus (Muller & Troschel, 1848)
"Beau Gregories have all the Damselfish fire but they do not lose their color with age. They remain beau at 4-inch as they were at a half."

not horse in it. You'll have to open it for him. This is what dumb machines are for. Stir your finger in food so that cloud of debris floats up enticing. This cloud of tasty snacks suddenly mushroomed up into reef notice will please both Beau's appetite and his fighting heart. He will at once have more invaders than you to contend with.

When you sit down to play with Beau, do not sit down on Fire-Coral or you will honestly wish you hadn't. 🐚

Family: Scaridae (Parrotfishes)

Parrotfishes are a group found exclusively in tropical waters of the Atlantic, Indian, and Pacific Oceans near coral reefs. These fishes are heavy bodied, typically colorful, and exhibit distinct color phases during different stages of their lives. As in the wrasses, there may be phases for juvenile, adult, elder female, and elder terminal male. Several species may start life as female and then become male later in life. These fishes are known to occur in groups and may travel between locations in search of food. The most noticeable anatomical feature is the teeth, which are fused into a beaklike structure. This beak is used to scrape algae, sponges, and other organisms from rocky substrates. In turn, parrotfishes ingest a significant amount of coral, which is ground into a powder with the use of pharyngeal teeth. Due to this ingestion and grinding, parrotfishes are one of the primary producers of sand found near coral reefs. Active exclusively during the daytime hours, these fishes secrete mucus to enclose themselves into crevices in which they sleep. This is most likely to protect themselves from predation during the night. There are approximately 100 species found within 10 genera.

Species: *Sparisoma viride* (Bonnaterre, 1788)

The stoplight parrotfish can be found throughout the western Atlantic, from Florida and the entire Gulf of Mexico to the Caribbean. This abundant species is most often seen around dense coral reefs; however, juveniles can often be seen roaming in sea-grass beds. The body is slightly oblong and compressed with a sloping head. The most notable characteristic is the teeth, which are fused to form a beaklike structure. The body is dark brown along the dorsal surface and red underneath. A large white bar appears at the base of the caudal fin. Terminal males are bright green with yellow bands along the head and a yellow spot on the outer edge of the operculum. The stoplight parrotfish is strictly diurnal and spends nighttime hours sleeping along the substrate. These colorful fish feed on soft algae but also may graze on live coral. Along with other parrotfishes, this group produces a large amount of sediment as they break down coral while ingesting algae.

(12) When night came, the great fish had fed eleven times on cigar squid and torpedo tuna and mirror-sided mackerel. Two small sharks and a large slow turtle missing right fore-flipper from shark attack. Also a once sleek suede silver young female porpoise already dying of the bullets of a passing drug runner who yelled with manly if hazy delight whenever he shot porpoises, him not being manly or hazy enough yet to shoot his captain and assume command of *Dreamboat*. And a half-crate of rotten oranges drifting low surface and taken to be another turtle.

The poor pine of the Japanese crate joined in greatfish gut the tire-sandal of a Cuban fisherman and a sleeve and buttons of the tarred yellow raingear of a missing Maine lobsterman and the ivory comb of lovely black Melissa, once of the beaches of Mozambique. The great fish was without prejudice.

Feeding the clock around as was his nature, he swam random south. As you would flip a coin. Chance on a blue wave. If you were in his future he would gobble you. If you were safe & dry on big boat having cruise, or looping in airplane far above the curving slice of his mouth and you dropped your alarm clock by accident he would gobble the clock as it flashed and rang and whistled.

With night came Spring borning wild April over the Gulf and terrible squalls romped big-baby through the April night throwing lighted snakes down from the crib of heaven and dumping plenty rain undiapered. Kid was born with loud rolling drums and rattled the ears deaf of the flyingfish.

All of the foam-blowing seas north & south & east & west of Shannon Reef flickered in fire and thunder and Kevin & Deck Dog

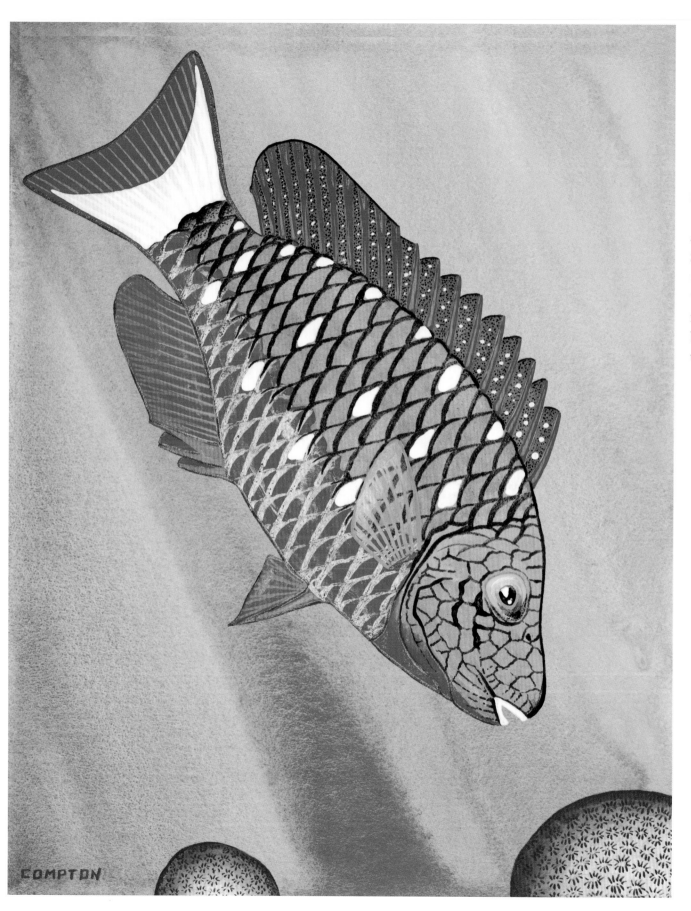

Stoplight parrotfish (female or young adult male)
Sparisoma viride
(Bonnaterre, 1788)
"These confusing fish were happily, busily chewing reef up into confetti."

COMPTON

& Miss Fortune piled in and slept with Johnny. Johnny made up some new 12-year-old cuss words.

At northend of the Reef where the shark-proof channel for *Riff-Raft* was barricaded with lift portcullis of chained and buoyed coral, an eighty foot, high floating mahogany tree, dead and skeleton, long traveled from the Amazon, came stormish alive, lifted white arms to the blazing clouds, whirled and danced on the tumbling seas and, with a skittish and playful rush forward, smashed Reef's closed gate open.

The great fish, having his eyes a yard apart, was confused and baffled by lightning on the left and lightning on the right. Having one nostril a yard from other nostril, he was smell-lost in ozone left and ozone right. His long graceful sensitive hide picked up the clash of a dozen different pressures the sea swatted him with. He ran into the tree just as the tree ran into the Reef.

The fish shook seafoam and skyfire from his yardwide head. He shook his tail free of mahogany splinters and coral plaster and a baby piece of chain. Waves no longer jumped 6-foot up and down on top of him; commotion fell to his tolerance level. Pressure told him he had 8-fathoms beneath him and far reef around him. He followed new scents and vibrations and hunted the night.

Dawn brought bang-up Wx. Lagoon smoked gently at sun-up. Johnny kicked his bedmates from their night's haven without gentleness. Deck Dog bit him. Miss Fortune bit him. Kevin was about to, but better judgement took over.

At midmorning Sandy and Kevin spread a hopeful feast before the Parrotfish of Spotlight Junction, Parrot Cove, Shannon Reef, east of Mexico City and west of a Spider Monkey eating his nits in a cage in Havana. On the sun-roped sand 48-feet down where herds of Parrots, face-down, blue ivory chompers to coral, grazed the reef.

There were young red, white & brown males and females, large r, w & b females and 19-incher turquoise, purple & yellow males. "Confusing as Heckus," Johnny always said. "Worsen Grampah's bathin' pants and them big and little Angels."

These confusing fish were happily, busily chewing reef up into confetti. Shannons were with experimental zeal offering substitute for their beloved Reef. Fish were chomp-chomp-chomp ignoring the luau laid before them and grinding Reef to rubble. The picnic

was very curious and, seen through crystal water without distortion, seemed to offer only 7 cantelopes. At least in shape. Plaster of Paris with canned spinach. Cement with canned spinach. Plaster of Paris with canned spinach & boiled barnacles. Cement with same. P. of P. with spinach and can of dog food. (Deck Dog was not told of this use of his rations. Shannons didn't dare try catfood. Miss Fortune counted her cans.) Cement with peanut

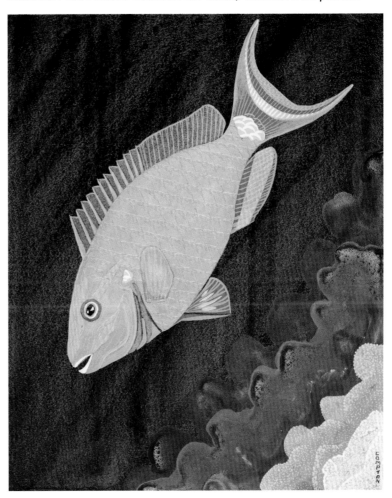

Stoplight parrotfish (adult male)
Sparisoma viride (Bonnaterre, 1788)
"Why, Honey, you got young red males and females and young red males grow into big green males and some young red females grow into big red females and some young red females change their sex and grow into big green males."

butter, boiled broccoli, canned peaches and French fried potatoes. (Sharon and Kevin's menu vs. all opposition.) Cement & P. of P. with pair of Kevin's socks Johnny wanted out of their cabin.

Socks were winning. Three red youngsters and one big blue daddy were chisel-nibbling. Kevin showed his teeth around his mouthpiece to Sandy and swam behind giant ball of Brain Coral to fetch shock-gun and rest of samples. Kevin grabbed rod of shock-gun and net sack of cantelope. He was planning new cantelope involving Johnny's socks and favorite billed cap with mermaid riding it. He flipped left to see had he forgotten anything he could be lamented for and stared square into the cold calm salvage left eye of the biggest Hammerhead of the Atlantic.

They were curving liquid on the same heading. For the silent moment motion carried them eye-bound. The long-long shark one, and Kevin's two behind his glass. He saw flat mop-legged dime of a shark louse scuttle in stopped time across and vanish under the boom of the eye. The shark swept eye up on its blade to bring to the crescent of his teeth this seal-size munch before him.

Kevin dropped net-sack. Hurled himself upside down. Rammed firing head of shock-gun in Hammer's gut. Lost to teeth in one sheer all of his right flipper to half-inch his toes. And was rolled tumbled and sanded under 19 feet of torpedo-ing shark hide.

Sandy, with half second to greet this avalanche pouring around coralhead, rammed second gun-head into Hammer belly before Kevin hit her. Shannons and shark raised coraldust in wet cloud of fast moving front down Reef valley. Tanks clanged once, belling havoc. Sandy ended upright with a Thump! on solid sand. She felt the pressures of the long power of the shark's body leave her. Her face was full of sandy water. She blew mask clear. She saw an ocean full of dirty-browny-creamy flank and tail curving away to surface.

Sandy found Kevin slammed against base of housesize coral, the brainy crenulations hard but not to cut or sting. She saw he was only groggy and had death-clamp on his mouthpiece and his regulator was honking wild with his breathing. Her regulator was honking wild with her breathing.

Two small Parrotfish were caved up behind him and one burrowed thru his lap to hide under leg. They refused to leave as Sandy set about righting her diving mate. He was plenty groggy all right and wouldn't open his eyes and tried to kick her. But nothing was going to take that mouthpiece away from him. His mask was on top of his head like a monkey's hat, or a fez. Sandy remasked him and blew him clear. He was either terrible out or too mad to cooperate. She pulled his hair and ears until he opened eyes and gave her a terrible look out his window. He tried a slow motion left hook on her which failed to complete.

All around them, Parrots lay deep-angled in the forests of the staghorn and hid among the stage flats of the sea-fans and the willow-blown soft gorgonian coral. Or buried at base of big Brains. Only fish in sight were the little minnow streakers and darters who were as afraid of a shark as a cloud of gnats is afraid of a camel. Glitter fell from far surface as blown coral sand settled from the ruckus.

Sandy found one stun-gun and reloaded 12-gauge shell. She and Kevin swam at bottom, slow, slowly spinning to cover their ceiling. Winding, skirting close to jag coral and down narrow ravines hung in sun ribbon. They began the swim under shark pressure to *Riff-Raft*. In center lagoon, the hull of *Riff-Raft* began transmitting the homing signal, and screaming in unheard sonics supposed to scare shark but the man who invented the system was eaten off Suva so proof lacked.

When Hammerhead received his double smokeless powder Whops! in quick succession, Cap'n said he musta felt about as sickish as any dumb shark could manage since dumb sharks as Johnny said would make him sick to watch them eat they own gut if it was bitten out where they could see it and swing jaws to it, but nineteen feet of cartilage-head was too much to expect any little old no-pellety shells to handle. Cap'n felt the double firing through the hull of *Riff*, jerked rifle from cabin clips, hit 2 switches, jumped to cabin deck, saw shark at far surface and set up firing pattern to circle him.

When Johnny in the western cove testing substitute reef on Parrots felt the fast percussion of the two Booms!, he shoved Sharon tanks and all into a shallow cave and knelt in front of her slanting his firepole into the uneasy water above them. Out of the

sun-shafts a long shadow came. Sun was gone. Pale teeth spread in two-foot curve. Wide poled eyes 3-foot part crossed themselves to Johnny. Target on. Johnny braced his flippers flat on hard sand, aimed lancehead up and launched 110 pounds of mad suntanned muscle and 10 pounds of lance skyward into the frolic of 2000 pounds of dim dumb maddened shark.

Lancehead fired inside the big grin of slanted shark knives. Concussion closed every open coral flower in West Parrot Cove. Filled Sharon's cave with frightened fishes. Firelance bent into U and somersaulted Johnny 18 feet above a patch of FireCoral to land with cushioned thud at base of Brain Coral twice as big as house.

Johnny dreamt he was flying. He clanked his Roman armor and fought and flew on winged feet and fought and jumped around and hacked a bear who wouldn't die but kept biting off his short hacking sword so he couldn't see any silver blade before his hand and his hand was empty but he was plenty lucky and he had bear bit in nose to kill him and he kept his teeth fanged hard so bear wouldn't get away but anyway he was a flying horse and he could bite hard but his wings kept losing feather when he wanted to spread to sky and something was riding him he had to carry.

Johnny snapped alert fast as Miss Fortune did when someone stumbled a coil of rope she napped on. He lay against smooth crinkled coral. Someone had replaced his facemask and blown it dry for him. That someone was Sharon. She straddled his chest and her legs and flippers cinched him like cowgirl trying to rouse tired mustang. She faced away from him. One hand held her short knife pointing; other hand—Johnny's long knife pointing. She searched the wet heavens for teeth. Johnny saw there was only calm reef again. Glittering fish. Blooming coral.

He thought Sharon looked from the back of her just like Miss Fortune that time just before Miss Fortune fought a Great Dane who shortly had forever his previous attitude toward the feline world changed. Johnny patted Miss Fortune then, being cautious as the panther blood of her great grandmother was still roused. Now he patted Sharon affectionately on her weight-belted butt and shoved her off him. She whirled and almost got him with his own long sticker. Behind her window her small face was fierce and relieved.

They retrieved the double-bent stun-gun. Useless. Firinghead

mashed crimp like mountain sat on it. Sharon in front, they streaked deep for the home-ponging hull of *Riff-Raft*. Captain bodily snatched Shannons up, large and small, tanks and all, out of a bubbled sea as they appeared very excited at dive steps.

"Not now." He raised eyebrows high at Johnny's U-shaped hotspear. "We got fast work before us. The Dolphins are into this fracas and they'll kill that stupid jugger, we don't stop 'em."

Wild chorus.

"Later."

"Hey! I'm wounded!" says Kevin with fearful grimace to denote pain bravely endured and end near. Everyone looked at the thin red line from thigh to ankle on Kevin.

"I'm turribul bitten. I don't care if ole Dolphin chew up that Bas . . ."

Captain sloshed Kevin with expert thoroughness from jug of alcohol/iodine mix. Kevin lofted a bitter cry that fluttered the aft mast diving pennants and fuzzed Miss Fortune's black tail from root up.

"Johnny, jump to the anchor. Take this soljer with you. Sandy, stow those tanks and tie Deck. Sharon, honey, lock Miss Fortune in any cabin but mine."

Decks cleared for action, *Riff-Raft* sped to rescue of shark.

(12-A) "Shark-Oh!" Johnny yelled from bow. "Lookit them Porpoise peashoot 'im off." For Hammer had got himself the fatal wreath of Dolphin. As Plains Indians were told to encircle wagons so he was ringed in fury. Dolphin leaped in weave and smacked tail and leaped and curved over and beat flukes. The din was audible a mile away. Surface sea looked like storm funnel with ole Stalk-eyes center, as Johnny said. When Stalk-eyes went hog-out for 10 Porpoise one side, why then 5 other slammed hard-nosed heads into his livers.

"He won't take too many of them ram jobs," says Capin. "Kevin, with that great scratch you broodin' on which that Hammerhead never gave you, you wanta take 30–30 to poop and chase him off premises humane like? Dolphins only want to see his blood. He's a baby-eater."

"You betcha!"

"Think you can shoot a pop this side and then a pop other side,

not too close, to herd him seaward? And not hit no Dolphin?"

"You betcha!"

"And not even think of holing that shark?"

"Don't know."

"Well, I know. Me. You hole 'im and your days with 30 are over."

"Yessir. Gimmie it." But Dolphins had formed an open square and within its hollow were driving a wobbly shark into the north channel.

Johnny from forward masthead called, "Shark doubles back. Shark hit by three Dolphin. Shark in channel. Shark like that drunk in Pensacola. Shark bouncing off reef walls. Dolphin bouncing off Shark."

Big Yell from mast.

"Shark in Atlantic. Shark churnin' for Cuba. Lookit 'im spread. He don't like us and them Dolphins for mates."

Captain jerked rifle from Kevin and rewalled it.

"Dern them Dolphins," says Kevin.

Returning Dolphin bounced around *Riff-Raft*. Everybody clapped. "They always want us to know they're somewhat smarter than us," says Capin.

"The Darlin's," says Sharon.

"Dern Dolphins," said Kevin.

Riff propelled herself into channel to block with boat where gate had gone. Dolphins 20 stood on tail and laughed.

"Give me fish for 'em," called Sandy, arm out over stern to finger-thump leader on nose. He always asked for that.

"No fish," called Sandy, finger-reading. "They want cookies from that last batch I made so delicious."

"And Me," Sharon called to the Dolphins. "Made delsuss."

"She did," yelled Johnny and Sandy, swinging Sharon out over stern to nose touch. Big Dolphin display of tailstands.

"Give 'em Miss Fortune," says Kevin loudly. "She scratched me bad this day week gone when I dropped bucket on 'er tail. I don't know where she keeps her tail twenty-four hour a day, do I."

"You are sure glutton for scratch," Capin told him. "I never knew you were expert on dates. We'll use you on Log. They like Miss Fortune and will tossball her to mutual fun and toss 'er back to us when she says. You know what mutual means?"

"No. And don't wanta." But Miss Fortune knew and island-hopped from poop to Kevin's stubborn knob to Johnny's to nose of leader Dolphin and playtime.

"Why is sharks?" asked Kevin. "What I wanta know."

"Why is humans," said Captain. "What shark wanta know. Forget shark. What developed with your great Parrot feed-off?"

"You turn yore back oncst, you see how fast I blow his butt-off. I'll blow ever butt-off in ocean. I don't have NO time for them mean Bas . . ."

"Ke-VIN."

"Don't you turn no back is all I says."

"Kevin, my tongue stays dry from flappin' it at you. To no visible effect. We don't kill animals on whim even if we are not fond of 'em. There are some poor souls who even like the critters. Mostly college souls where education has rattled their brain marrow to cupcakes. You remember that lady we took to Shark Island? Helped her fasten radios to sharkhide? Thought you liked her."

"Do," says Johnny with enthusiasm. "She was real NUT. She was plumb Crazy."

"Well, you don't want to make her sad by shootin' her friends. Now, I don't want to hear further on Shark. What went with your Parrot friends?"

"Chewin' Reef and crappin' sand," says Johnny. "As usual. Thousand year—won't be Shannon Reef. Be Shannon Beach."

"We'll chance it. Didn't like your gourmet goodies, huh?"

"Liked Kevin's socks, Grampah," said Sharon. "Ugh!"

Kevin beamed proud and proprietary. Honored.

"That material is gonna become very scarce," says Johnny. "You expect to ripen any more in my cabin."

"And mine. My cabin, too."

"You got no nose. You gotta be Told what to do with smells."

"Grampah," said Sandy. "There were ever so many new young pretty red Parrots with those big green ones. What you say they were?"

"Why, Honey, you got young red males and females and young red males grow into big green males and some young red females grow into big red females and some young red females change their sex and grow into big green males."

This often explained phenomenon was absorbed in silence.

"Why they wanta do such as that?" asked Kevin.

"Because they are crazy as that crazy shark lady and so dumb they'll lick Kevin's socks. Like Deck Dog was red female pup before he turned up as gold male dog. And that female black Miss Fortune playin' with the Porpoises is gonna tomorrow become white Tom. That'll surprise them Porpoise. If anythin' can."

"And Sandy an' Sharon is gonna grow up and we gonna have three Grampahs."

Everyone stared at Johnny in long silence. 🐚

Family: Serranidae (Seabasses)

As the common name seabasses implies, these fishes are found in temperate and tropical marine waters around the world. The family name arises from the Latin word *serranus*, meaning "saw." These perchlike fishes have a continuous dorsal fin that is often notched; the posterior dorsal spines are shorter than the rays. The spines of the dorsal fin have a serrated membrane that does not reach the tips of the spines. Most seabasses have an anal fin with three spines. This group is represented by hermaphroditic individuals who begin their lives as female and later transform into males. In some groups male and female reproductive organs are both functional, while others are strictly a single sex prior to the change. Several species are known to occur in a social group of a single male and several females. If the male is removed from the group for any reason, the largest female will then take on the role of a male and alter its sex. Coloration differs among species dramatically, with some drab and camouflaged and others brightly colored. Most species feed on a variety of organisms, including invertebrates, zooplankton, and other fishes. A rather large family, it consists of approximately 500 species within 75 genera.

Species: *Cephalopholis sexmaculata* (Ruppell, 1830)

The sixblotch hind, or sixspot grouper, is a tropical species found throughout the Indian and Pacific Oceans. This species occurs throughout the Red Sea to South Africa, and its range stretches as far as French Polynesia. It has also been noted to occur in seas around the Middle East; however, these observations have not been proven accurate. The sixblotch hind can typically be seen near areas of rich coral growth in both nearshore and outer reefs. This secretive species is most commonly observed near caves and overhangs. This species possesses the typical seabass body type, with a long, compressed body and a large head and eyes. The body is orange to red with six saddles along the dorsal surface directly below the dorsal fin. The body and fins are all covered with small blue spots. The preopercle is notably serrated in juvenile specimens but rounded in adults. Like others within this family, the sixblotch hind exhibits a continuous dorsal fin and a rounded caudal fin. This species may be nocturnal in shallow waters and diurnal if inhabiting deep water. Often seen in small groups, adults and juveniles alike feed on small fishes. Interestingly, this species is often seen in conjunction with the cleaner shrimp (*Periclimenes elegans*).

(4) The seabass or grouper, Freckles, who had just been run off by some three-eyed yellow varmint with swords just when he, himself, thought a little pranking with a red sponge would be the very exercise needed to use up all those eels inside him was not a Rock Cod as some surface silly had named him. He was not even a codfish who lived in big schools in deep cold water to be caught for the breakfasts of all those two-legged creatures who lived in Boston and got scrod every morning.

Freckles did not, himself, know these exciting fishy facts. They were of no use to him. He wouldn't have cared a finclap anyway. He only knew he was a handsome feller. Red and rambunctious (a fine down-under word for sheep behavior as playful oak-tree). Freckles was not aware of this word. He was aware he was a great hunter of eel, lobster and octopus. And he was sure gonna hunt that yellow pest out when he felt less full and his stabbed tail quit hurting.

With a grouper grunt he stretched his two feet (length) on his favorite sunny-currenty ledge. After routing a large octopus who had the blasted impudence to squirt black ink all over him before blasting off like balloon-headed rocket trailing eight monkey tails. Current washed ink off him in cloud drifting to blind seven crabs

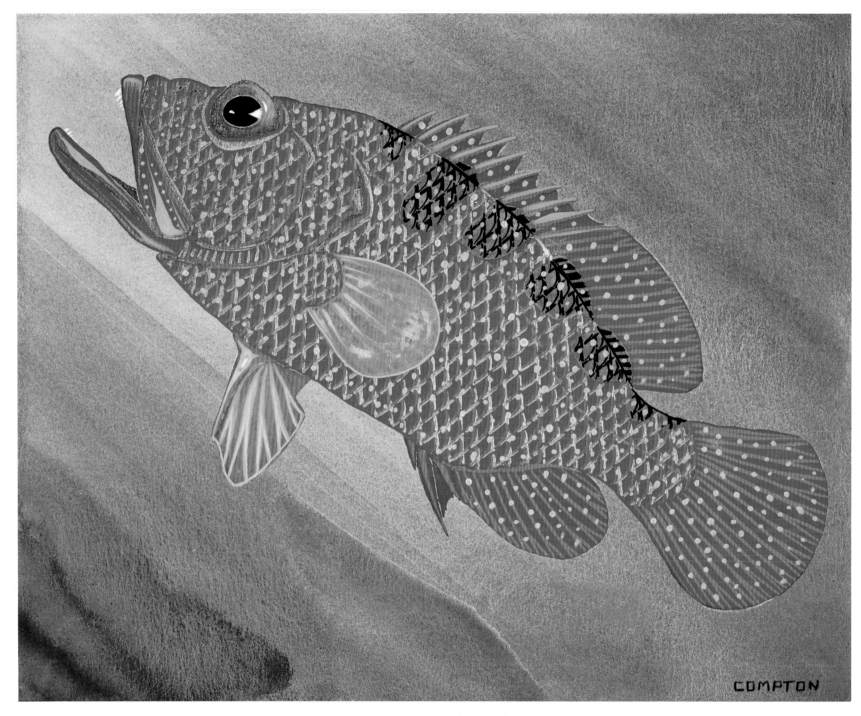

Sixblotch hind

Cephalopholis sexmaculata (Ruppell, 1830)

"He only knew he was a handsome feller. Red and rambunctious (a fine down-under word for sheep behavior as playful oak-tree). Freckles was not aware of this word. He was aware he was a great hunter of eel, lobster and octopus."

in shallow cave fighting over long dead lobster. Thinking it night again, they went to sleep. Lobster became longer dead. Freckles concentrated on getting his appetite back. Sun above slanted fresh coming morning at 7:30 Queensland time.

The huffy puffy clouds of eternal spring floated bluey shadow chasing green sparkling water as they drifted above the Great Reef. Drifting the Barrier also were those sea-roving Shannons. Every loudmouthed 4 of them with #5 Grampah sometimes in control, sometimes not.

"Heave anchor," shouts sturdy Johnny, legs spread sailor, barefeet clamped to control deck, ship's wheel in hand.

"Haint seasick, My-ate," yells Kevin at bow. He knew all the medical terms.

"How's my accent?" he asked his new friend. "Sir?"

"Right on the spot, chum," says Grampah's old chum Eddie Kelly who owned the marine research station and private resort for "THE EDDIE KELLY BEACH & BARRIER BUMS BANDED SOCIETY OF REEF RELICS & RESEARCHERS." Eddie had told them this himself and Grampah Shannon told them that he and Eddie were the relics referred to, "So don't ask."

Why just last night under the flame-flowered trees of the mainland with torches flaming the beach and the shining dark Pacific rippled gentle under the moon, Eddie Kelly and his 4 grandkids had initiated the Shannons into the SOCIETY. Bedded in the beach waited a 6-foot Giant Clam shell flute full of reef water stained with starfish dye. The Shannons waded the Clam while the Kellys and resort guests sang "Wadin' Wallaby" to the tune of "Waltzin' Matilda." What fun under the hung white glitter of the Southern Cross.

Every small Shannon was matched with a Kelly of same size and sex. 8-year Danny, impatient with Kevin wanting analysis of his coming footbath, gave him a good hard helpful shove. "Gaw on, Mate. She's safe." Kevin squawked, slipped, slid, sat and shouted. Kevin got his purple feet and the additional decoration of purple butt. Onlooking initiators cheered. Kevin bowed.

Cap Shannon declined to join SOCIETY. "Look at this example of foolishness before us. I decline to become such a sight to behold. My dignity and white hairs will not allow it, friends."

"Oh, Grampah!" shouted Sharon and the Clam-walk was waived and Grampah was voted in willy-nilly by acclamation.

Now all those purple feet trod the deck of The *Riff-Raft*, christened long ago by the Captain. Eight thundering pair since the Kellys had not been such fools as to allow a night Clam of colored reef to go unused just because they were already members. In fact the whole Resort had reinitiated itself with much enjoyment. *Riff-Raft* rode serene white trim and beaut on sea so clear it was like liquid air with her shadow floating over coral 20 feet below. The clamor was worse than mealtime at the Dingo pound.

Grandfather Kelly says, "No offense, Chum. Do your bunch always shout so?"

"Don't yours, Chum?"

"Only when awake."

"Let's have the devils tanked up and under this water. We'll have some peace."

"Too right. Still, reckon we're lucky. They as likely might want pot party on the poop. Get their butts tanned proper. Purple or no."

"Don't suggest it," Grampah says and shouts into the seething mass of Purplefoot, "Divers on deck. Pronto. Roll off ten minutes. Get the lead on."

"Silly Grampah," said Sharon.

"No no," said Sandy. "The Polly-'olly."

"You promised 'im!"

"'er!"

"Jim," says Eddie Kelly. "We are flying to England come winter. My mob never seen snow. They're practicing cockney."

"Gawd help LunnonTown."

"Right."

"And you promised Polly, you did. Heard you after that third grog on the beach. Expansive you were."

"Right. Seems I don't yet have the age on me to 'ave grown some sense."

"Too right," said Grandfather Shannon.

"Quiet you bums." Grandpa Eddie shouted the *Riff-Raft* mob to silence. "You are worsen sheep for millin' and considerable louder. Git your voice over here, David, and show off Polly."

The polly-'olly was shown to be a curious silver ball with hook hung below inside a skirt hoop of long pink feathers. Polly-'olly was greeted with shouts and some disbelief.

"Hers a octopussy," declaimed David. "Her has no barb on hook.

See." Immediate bloody thumb in demonstration. "Bloody ouch!"

"Ooh. You cussed."

"Hers alive."

"My brother's so-o-o stupid," Nancy Kelly told Sandy.

"David thinks he's so-o-o smarty," Nell Kelly told Sharon.

"No barb. Can't hurt ol' fish. Jerk 'im up fast into live-well and he swims right off alive for aquariums. Right, mates?" Shouts of approval.

David attached the homegrown lure to stout line on long cane pole. "Here's where Granpa allays sticks hisself." Wiping still-bloodied thumb on trunks and brown leg.

"Some morning I'll whale that kid," Eddie told his old friend.

"Line the rail, mates. Here's program. I jig ole polly up and down natural. Ol' fish can't resist 'er. When I jerk old fish up to us, we guide 'im to tank, not to bruise 'im, and everthin's di jobe, fair dinkum and Yank-Ho. Paps?" he yells to Granpa Kelly, "got your tank ready for whale?"

"Some pleasurable morning," Eddie told his old friend, Cap Shannon. "I'll skin that kid for eelbait. Might be a eel would eat 'im. Tis doubtful."

"Jiggey 'er goes," yelled David and the whole railside of *Riff-Raft*.

Four fathom deep, below, in morning calm and liquid beauty on his ledge, Freckles, if he had known what morning planned, would have highly approved the elder Kelly's intentions toward David and wished they had been accomplished the night before and the eels fed to bursting their sausage skins.

Freckles was feeling much refreshed by digestion and an agreeable emptiness. He was planning aggressive action on the person of that maddening 3-spot midget who had hurt his tail. Into this pleasant plotting dropped Polly-'olly. Dropped, juggled, jerked up. Dropped, jerked and jiggled. Shook feather in wild aquatic dance. In his young life, Freckles had had no opportunity of seeing a solely vertical pink and silver octopus gone nuts and dancing to the light of the sun. He attacked at once.

A sharp pain bit his mouth. He whirled to flee. A terrible Force held him taut. He drove for the bottom. He fought north—south—and east for freedom. To west was some large until now unnoticed surface animal sending down the scariest thumps and bumps and clangors. West he avoided. The Force pulled him always to exhaustion and western doom. In the struggle he flashed many times over the small holding of the Three-spots and their sponge. Impacting water. Stirring up many little sandwillies.

Three-spot and his mate watched their morning explode in unapproved activity. And here came the red idiot again. In final striving, Freckles' broad tail found the bottom and the sponge. SLU-WHAP! Over went sponge. In all their young lives, Three-spot and his mate had never seen their own personal sponge slapped spang off its moorings and vase flat in the sand. They attacked at once.

They stabbed hard and stabbed deep. Pain in his tail overcame pain in his jaw. Freckles shot skyward. With him went the Three-spots. Hesword and shesword over-enthusiastically planted holdfast into tail of rednut. The trio broke water in great arc spraying rainbows. Freckles spit the barbless hook. Like lightning, David threw canepole, whirling line and frantic menacing hook far overboard. A passing Tuna at surface grabbed Pollyoctopus and last was seen was jetstreak foaming canepole headed for New Guinea. *Riff-Raft* researchers never waved Polly goodbye. They were occupied.

Freckles and stuck cargo came aboard. Onto and into Shannons and Kellys fell 2-feet of thoroughly aroused grouper and 8-inches of attached yellow fury.

"Catch him Oh catch him Catch him."

"He bit me."

"He stung me."

Three-spot's mate flipped herself loose from the mighty melee, and over side. Freckles and Three-spot were caged in struggling arms. Three-spot pronged every one possible, unhilted his sword from nut-tail and went overside. With one bent-spring power jump, Freckles went through the resulting breech in arm cage to follow his yellow savior.

"He's GONE!"

The adults present were shouting and slapping their legs.

"GRAMPAH!"

"GRANPA!"

"Well, way that Bassie and his buddies went to market on you, figures you don't want no permanent acquaintance."

"Well, you all been punctured, bit, slapped and hurrahed. What else you want joy you?"

"Bandages on deck," cried Kevin.

"Oh," said Sharon. "The little fishes saved the big one. They did. They did."

Sandy was enchanted. "They did, Grampah. They stuck us and stuck us and we let that big fish go. Like the little mouse chewed right through the big lion's ropes 'cause the lion never ate him once. An' the lion ran away so glad. So the hunters never killed the poor lion."

"Don't chatter, missy."

"Oh, yes, Mr. Shannon," says little Nell, chattering, "And like all them antses what picked out the rice and beans and wheat and sand and raisinses. An' saved the be-yoo-ti-ful Princess."

"What was she saved from?" asked Kevin in the spirit of inquiry.

"From marryin' up to ole Dragon, mate," says David, defending his small sister.

"Well, I just like to know what a fish would do such as that for. I don't believe they do it."

"And they are Angel-fishes," says Nancy. "Jus' so sweet."

"Oh, I know," cried Sandy. "Grampah told us most of the fish before we came to the Reef."

"Well, he's wrong," shouts Johnny. "He's dead wrong if he thinks them Devils is Angels." He was sticking tape to two big toes.

"How'd they get your feet?" asked David. "I thought they was fully occupied with me." He was taping two big thumbs.

"Ask Grampah. He knows everythin.' Maybe they flew."

"Some morning, Ed," the Captain told his pal. "I'm gonna give that kid to you. Will him. You skin 'im for eel. Will it mess 'im up badly?"

"Badly."

"Good."

On deck: Diving preparations. Pairing two by two for buddy. Johnny and David to swim loose over all as watchdogs. Much barking. "Muzzle yourselves," said Captain. "Got your slates? Got your eyes? Can't hope for brains. I want some observation brought back up. You got 20 minutes based on smallest air. Me and Eddie'll stand shark watch. Get the cards, Eddie. We'll watch careful. Get the beer, Eddie. Now I don't want any mess-ups. Okay? One of you rats strangle yourself to surface flailin' around I'm likely think 'here's shark for sure' and shoot it. Understood? Then I'll shoot watchdogs for lettin' it happen. Ain't it nice and silent, Eddie? Why'ont we keep them mouthpieces plugged in 'em permanent?" He waved a big grandfatherly hand. "Git!"

Shannons & Kellys, each harnessed to his or her appropriate size airtank, spun off the side in repeating splash. *Riff-Raft* bobbed slightly, and gently rocked to morning serenity.

Below on Reef: Three-spot found his mate blowing to sight a tangled mass of blue worms revealed by the fallen sponge. Both fish puffed and ate writhing worm and circled and puffed and nibbled up plump twisters. Sand blew. Pit was blown at base of sponge in search of worm. No more worm. Three-spot gave it one more Phuh-h-h-h. No worm. Suddenly current uprighted sponge. Sponge stood in pit. Sand flowed in and sponge anchored. Three-spot saw his own personal Reefmark standing again firm and rosy. He swam a headstand to peer down into sponge's hollow. No worm.

Freckles on his ledge had eaten two eel, an octopus (not pink & silver) and three fat crab. A slight stinging in his tail was all kept him from going down after that yellow 3-eyed pest planting sponges. 🐚

Species: *Cromileptes altivelis* (Valenciennes, 1828)

The humpback grouper is a tropical fish found primarily in the western Pacific. Reports that have occurred in the Indian Ocean are largely unproven, while sightings from the Hawaiian Islands are likely due to aquarium fish being released into surrounding waters. This grouper tends to inhabit lagoons and seaward reefs and is often seen in areas of silty water. In some areas, specimens have also been noted in tidepools. This small species can be easily identified in large part due to its oddly shaped body. The anterior region of the head is relatively smaller than the remainder of its body. This species lacks canine teeth with the exception of a small pair along the upper jaw. The fish is often a green-white or green-brown with black spots covering the entire body, including the fins. The spots

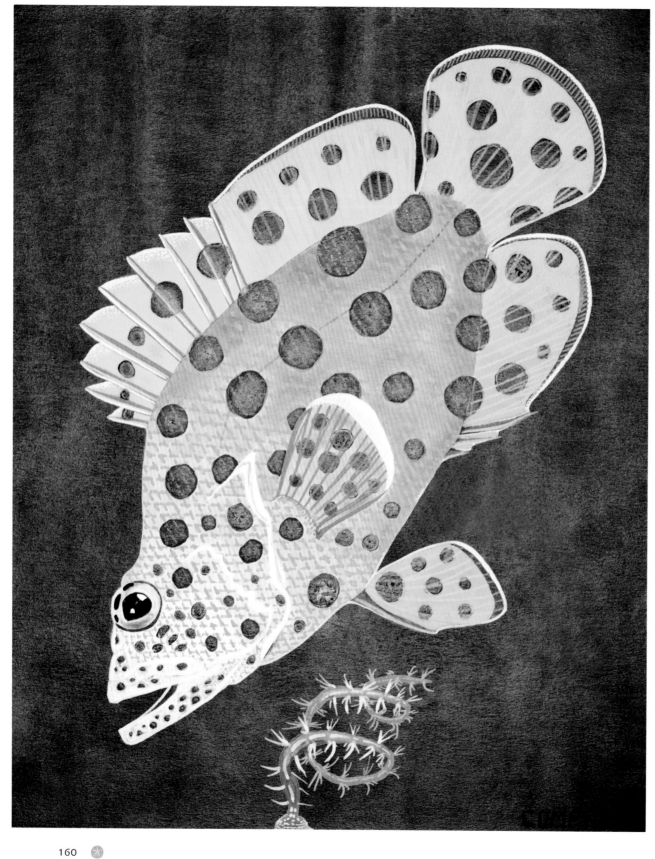

Humpback grouper
Cromileptes altivelis
(Valenciennes, 1828)
"Spots can be black holes
leading to high adventure."

along the body are typically much larger than those along the head or fins. This species typically feeds on small fish and crustaceans. The humpback grouper is commonly caught and exported into the aquarium trade, and adult specimens are taken as a food fish in some areas of the world.

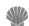

(24-A) Spots can be black holes leading to high adventure. On The Barrier, Guide took his Group to dive shallow and sit on concrete filled tubs same size elephants in circus sit on or stand one-footed on. Tubs arranged park-like 20-ft deep in reef amphitheatre where his favorite Polka-dots were always top bananas for style and show. All viewers wearing two tank rigs for lengthy stay and with easy access pouches of finger squid, fish & shrimps to feed fish like they were pigeons or even squirrels. Guide had got rumor of Kevin's socks and inspected each pouch for contraband. He had no intention of adopting Kevin.

Guide had planned a quiet and lovely undersea morning especially for his friend Fat Lady because her morning with 30-foot saltwater Croc capable of eating 18 of her and mean enough to fight Jeeps had been anything but quiet. For Croc, that is. Sea & River Park Reservation Warden had called Heron Island in a fury never before equaled over satellite telephone.

"What did the two of you do to our lizard?" he asked Guide.

"Nothin' he dint deserve. Fully."

"Let me put it this way. Every morning, before he met you two, he ate two hogs an' a Jeep tire with appetite and tried for the boss's wooden leg."

"Looks like you'd be pleased me n' her tamed him for you."

"More nobbled you did 'im. We found 'im lying stiller than natural an' crying. Which if he weren't Croc we woulda thought he was real tears. And he wouldna open his gawp to let them birds pick his teeth."

"Prolly no teeth left to pick on."

"What! If you and that female disheartened him so he can't eat tires for the tourists, where's our show?"

"Feed him the Director. Woodfoot last for toothpick."

"This is taped," yelled Warden, but Guide had hung up.

Guide & Fat Lady & Group had fine non-lethal morning with the Polka-dots.

"You wunt credit it, but we did," Guide told his Cobber that evening. "You know them fish. They so tame they smoother you. Well, she had on new spotted bathers and we lost her in all them spots a-brawling. Finally tied a red balloon to her tanks to kite in 'er bubbles so we could find 'er if needed. Bless 'er bones, 'ere she comes. Yikes!"

Through the sunset glow of the great Bar-Room at Heron strode the Fat Lady superb in magnificent tropic gown of black, all silver spots like champagne.

"Crikey!" says Cobber. "Throw away 'er balloon and keep them fish off an' give me an intro."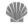

Species: *Grammistes sexlineatus* (**Thunberg, 1792**)

The goldenstriped grouper, commonly referred to as the goldenstriped soapfish, is a tropical species largely associated with the Indo-Pacific. This species can be found in the Red sea to Japan and New Zealand. This small grouper is most common in coastal waters near coral and rocky bottoms, to a depth of approximately 20 m. Seclusive in nature, these fish typically can be found beneath ledges and inside caves during the daytime. The goldenstriped grouper exhibits an elongate, compressed body similar to that of other members of the family. The snout is more blunt than in other similar species. Aptly named, the goldenstriped grouper's body is dark brown to black with yellow stripes running horizontally. Juveniles often have spots while very small and develop stripes over time. Large adults often lose these solid lines and instead may have a series of dashed lines. This species feeds almost exclusively on other fishes. Interestingly, the goldenstriped grouper is not considered a good food fish due to its bitter taste, caused by toxin-producing glands in its skin.

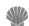

(18-A) A line is the result of a moving dot. On a piece of paper. On a fish, a line may be present from baby or form whole later. The red & white candy of Shannon's unscared basslet is a fact from birth. The golden lines of Goldstripe, a bass of 10-inches grown

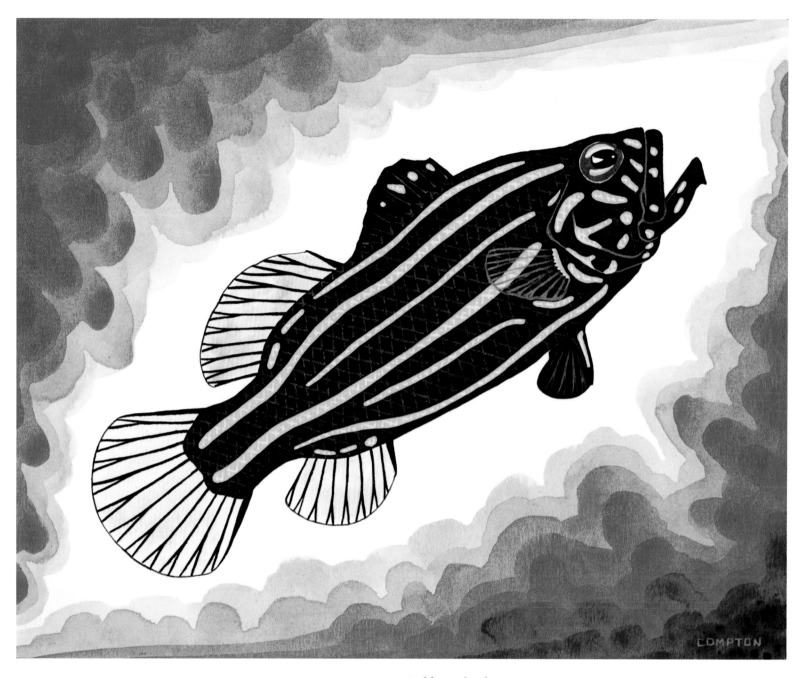

Goldenstriped grouper

Grammistes sexlineatus (Thunberg, 1792)

"The golden lines of Goldstripe, a bass of 10-inches grown who would love to eat 2-inch peppermint treat but lives in the wide Pacific which is wrong ocean, are somewhat more complicated. They start as dots, dots grow to dashes, dashes run to lines. First code then plain geometry."

who would love to eat 2-inch peppermint treat but lives in the wide Pacific which is wrong ocean, are somewhat more complicated. They start as dots, dots grow to dashes, dashes run to lines. First code then plain geometry.

At night, red is the first color to turn to black. Black is already black. So if Golden Striped Grouper met Peppermint Basslet at Panama Canal at midnight, GSG would gobble only white lines. And PB would only see his gobbler as fearful white simplified skeleton, or super highway. Yellow is next to last to turn to black, leaving a pale blue and then white just before. But it is said that white is not a color.

This grouper is not interested and will never swim to Panama anyway. 🐚

Species: *Liopropoma carmabi* (**Randall, 1963**)

The candy basslet, sometimes referred to as the peppermint basslet, is a tropical species found throughout the western Atlantic. This species largely occurs in the Florida Keys and Bahamas and along the northern shores of South America. The candy basslet is a secretive fish found among dense coral reefs to a depth of approximately 70 m. The compressed and elongate body is shallow and slightly more streamlined than that of other species in the family. The head is somewhat conical and fairly long. The head, body, and caudal peduncle are striped with alternating bands of orange-yellow and lavender. These stripes are typically separated by red lines. A black spot can be seen along the upper and lower edges of the caudal fin with a similar spot along the rear portion of the dorsal fin. Divers rarely see this reclusive species as it spends much of the daytime hours in caves and among rock overhangs.

(18) Down among the deadman's fingers 22-foot down where bones of pirates slept in nightmare encoraled in the silent reefs of far Barbados, a diver sat spread-legged before a massive coralhead he could not see. If he looked up he could see his dance of breathing, rising ghostly bubbles escaping the black pit of night before dawn. Between his legs sat a smaller diver. Dribbling ghostly bubbles up.

The watchers in the watery dark felt a visual shiver. A ceiling above began to ooze dawn down into the tomb. The great head of coral, a giant buried to his neck, began to move in tiny streaks of pale lines. The smaller diver dug fingerprints into larger diver's knees.

Just as crown of giant's head grew hair of flowing 2-inch locks of red/white fish come from secret caves as morning released them from the crypt of sleep, a long-palmed long-fingered ice-cold flaccid claw clutched the right knee of smaller diver. Eruption of bubbles to growing pearls above. Smaller diver chased the bubbles skyward. Larger diver fisted the arm that had the hand that held the knobby ice-cube-packed rubber glove; seeing same time bubble explosion spurt up far side of giant's head.

First up *Riff-Raft*'s divesteps was a Shannon—Sharon. On her flippered heels chine a Kelly—Nell. Clamoring there was Deadmans below.

"Where's the Grandfathers?" asked Nancy Kelly.

"You didn't leave them, surely," said Sandy Shannon.

"Did he get 'em?"

"Where are they?"

"He grabbed us."

"We could not stay. No."

"His hands was icey."

"An' his teeth!"

"He chattered at us."

"I saw his holler eyes."

"An' didn't have no ears."

"I want Grampah, Johnny," wailed de-tanked Sharon.

"I want Granpa, David," wailed de-tanked Nell.

"What you two skinny brats got to offer for salvage fee?"

But here was Grampah Shannon at steps, propelling deckward, Kevin and cold glove with more momentum than delicacy. And here Granpa Kelly, lofting Danny and glove.

"You tore his handsies off," screamed Nell and Sharon.

"Quick!" hollered Johnny. "Throw 'em back 'fore he come for 'em."

"He's a-comin'!" hollered David. "Lookit them white boners ar-broachint to starboard."

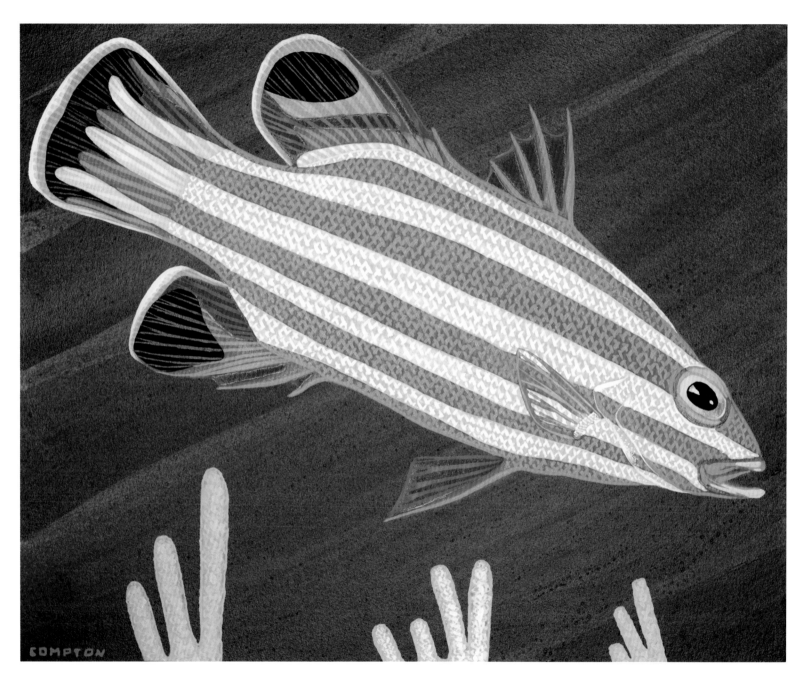

Candy basslet
Liopropoma carmabi (Randall, 1963)
"These Candyfish are seldom to be seen except at sun-up.
They hide so."

Screams. Four morning rain columns marched the misty water and shifted light and pearly shadow around the *Riff-Raft* in moving halls just right for Deadmen strolling, Johnny gave Deck Dog secret signal. Deck Dog coyoted his golden head up and howled as wild as any hound seeing grave push open under owl-blotted moon.

David gave Miss Fortune secret signal. Miss Fortune suddenly bared green eyes to starboard and caterwauled of mummies walking. Screams. Rubber gloves thrown wildly.

"Is he?" says two small male voices.

"Is he what?"

"Comin' for his handsies?"

"Not unless he wants 'em to scrub deck and keep his Boh-oh-ohny fingers white." Screams.

"You two reef-rats," says Grampah Shannon. "These Candyfish are seldom to be seen except at sun-up. They hide so. Now we have to set up same expedition tomorrow. Almost same. You two punkerpranks will not attend."

"Where we be?"

"Watch your sass, sirs. Because you are ironed in hold with *Riff-Raft*'s hoard of hungry Rats a-chewing."

Miss Fortune looked at Cap'n with amaze and disbelief.

"Now then. You two lads have any extenuating happenstances to offer before you face judgment?"

"We don't know them."

"Who put you up to this?"

Danny and Kevin looked into the cold sea eyes of Nancy and Sandy, Johnny and David, Miss Fortune and Deck Dog. They saw a bleak future in ratting. They shook their heads.

"I see," said Grampah Shannon. "Whole kaboodle is guilty."

"Dismissed for good intentions," said Granpa Kelly. "Jim, now they've scared us up a dijoe appetite for breakfast, what we havin'?"

Many-voiced shout.

"DOG VOMIT OMELET!"

Deck Dog looked at his friends with pleasure, knowing they had named after his tribe this concoction of eggs & whatever was handy. Excepting Kevin's socks. Deck Dog remembered with pleasure one blend of canned tuna, canned chili and bananas. Strange but warming.

"We were not never scared," says Nell and Sharon. "We did not wanted those pretty fishes be scared an' we let that skellington Dead-mans chase us so's he would leave them pretty fishes all alone weren't we brave." 🐚

Species: *Plectropomus maculatus* (Bloch, 1790)

The spotted coral grouper is a tropical species found throughout the western Pacific, most commonly in the waters near Thailand, Singapore, New Guinea, and Indonesia. Historically this species was said to also occur in the Indian Ocean before it was realized that it was being confused with *P. pessuliferus*, the roving coral grouper. The spotted coral grouper is found in reefs and is very common among inshore reefs; however, this species is rarely found in reefs in deeper waters offshore. The stout body is compressed and relatively deep with a large, sloping head. The fish is typically orange with blue spots covering a large portion of the body. Interestingly, this species migrates short distances and forms large breeding groups. Eggs float near the water surface until hatching, at which time the larvae become pelagic. Like other groupers, the spotted coral grouper feeds largely on fishes, with juveniles feeding on invertebrates as well. This species is considered an excellent food fish.

(24-C) When 90-ft H. M. S. *Lunnun Lil* took Thames tide in 1810, downhull and all sails set for the Islands of the Grand Ocean, she bore trade cargo of hooks and beads, knives and bracelets, mirrors and the wildest weaving of the mills of Manchester. King Cotton was the cloth. Red was the dye of metal Tin and bug Cochineal all mashed. Pattern of spots was accomplished originally accidentally when Bondboy slavey feeding bolts into dye vat suddenly sneezed all over one. He was soundly thrashed for ruining run but when product rolled out finish line, everybody shouted "Oh. La. La."

More Bondboys were enslaved and all were soundly thrashed if sneezes were not up to the quality control necessary for desired speckles. It turned out efficacious to stand Bondboys naked in buckets of ice water during their 15-hr shifts. This produced the best splattering sneeze and "Ohlala."

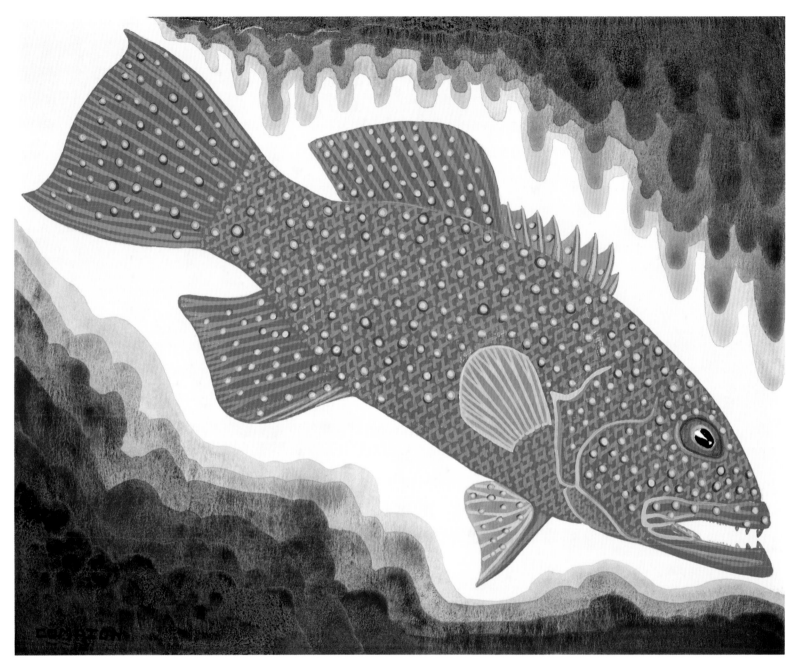

Spotted coral grouper
Plectropomus maculatus (Bloch, 1790)
"From Tahiti over The Barrier to roaring Timor, all the natives were enchanted that the Great White Father in Lunnuntown had pleased hisself to reproduce in strange body wrapping their favorite 4-foot bass of the reefs."

From Tahiti over The Barrier to roaring Timor, all the natives were enchanted that the Great White Father in Lunnuntown had pleased hisself to reproduce in strange body wrapping their favorite 4-foot bass of the reefs. They taught their new friends to troll the new hooks above virgin coral and all ate well. Their new friends taught the natives a few tricks also.

The natives were lucky that the ruffian crew of *Lunnun Lil* did not include on strength a sniveling Bondboy to give them the sneezes. They were Very lucky no-show Bondboy didn't have measles. For, back in the days of this history, one measle could have wiped out the whole antibodyless Pacific. 🐚

Species: *Pseudanthias dispar* (Herre, 1955)

The peach fairy basslet, sometimes known as the orange coralfish, is a tropical species found in the Pacific Ocean from Christmas Island to the Great Barrier Reef, Fiji, and Samoa. This species was found in the Indian Ocean before being displaced by P. *ignitus*, the flame anthias. The peach fairy basslet is most often found along outer slopes of reefs near areas of moderate currents. This species possesses an elongate and somewhat tapered body. The head is pointed, with the body deepest directly in line with the spinous dorsal fin. The remainder of the body tapers to a much smaller caudal peduncle. The dorsal fin is continuous and approximately the same height along its entire length. Pelvic fins of males are extended more dramatically than those of females. Coloration is typically orange with varying hues of peach and yellow across the body. Females are almost exclusively orange with a yellow tail. A pink line can also be seen from the snout toward the lower portion of the eye. Males have a bright red dorsal fin. This species forms large aggregations of both sexes along reefs where they feed on zooplankton.

(22-B) The Orange is 5-inches of festive spirit himself and swims his own Pacific holidays. His Christmas saddle-tree is a good deal more lively than diamonds as diver finds out as he messes with the branches and gets a handful of fire for gift. 🐚

Species: *Pseudanthias tuka* (Herre & Montalban, 1927)

The yellowstriped fairy basslet is a tropical species found throughout the Indian Ocean and western Pacific. This species is very common in waters throughout the Great Barrier Reef, Micronesia, the Philippines, and Solomon Islands. These fish are most typically encountered along continental reefs and outer slopes to a depth of approximately 30 m. Similar in shape to other fish within the genus *Pseudanthias*, P. *tuka* exhibits an elongate and compressed body that is tapered toward the caudal peduncle. This colorful fish is bright purple across the entire body, with males displaying a bright red sail-like dorsal fin. Males of this species can be distinguished from similar fish by a yellow snout. This species is most often misidentified as the purple queen (P. *pascalus*). Yellowstriped fairy basslets feed primarily on planktonic organisms and the eggs of other fishes.

(22-C) Her Majesty PQ & His Majesty PQ school loosely and play and fight alongside their Orange cousins. And sometimes among the Ice-Maiden's cave crystals of blue coral around Christmas Island. The one pronged under Java. Not the one looking up at the Equator far below Honolulu, where he has not yet spread his beauty. Give him time.

How the Ice-Maiden came to be warming herself damping toe in the Southeast Pacific & Indian Oceans and made warm coral has not been thoroughly researchered as Kevin & Danny & Sharon & Nell & Biologist would say. 🐚

Family: Zanclidae (Moorish Idol)

The family Zanclidae is a monotypic family consisting only of the Moorish idol. This family is closely related to the surgeonfishes; however. the Moorish idol possesses a more tubular snout and lacks a blade at the base of the tail. The body itself is round or circular, with the dorsal spines extended into a long, slender filament. This species is common among coral reefs. Although associated with a reef setting, larvae may drift along on ocean currents and distribute widely before settling. The larval stage is considered to

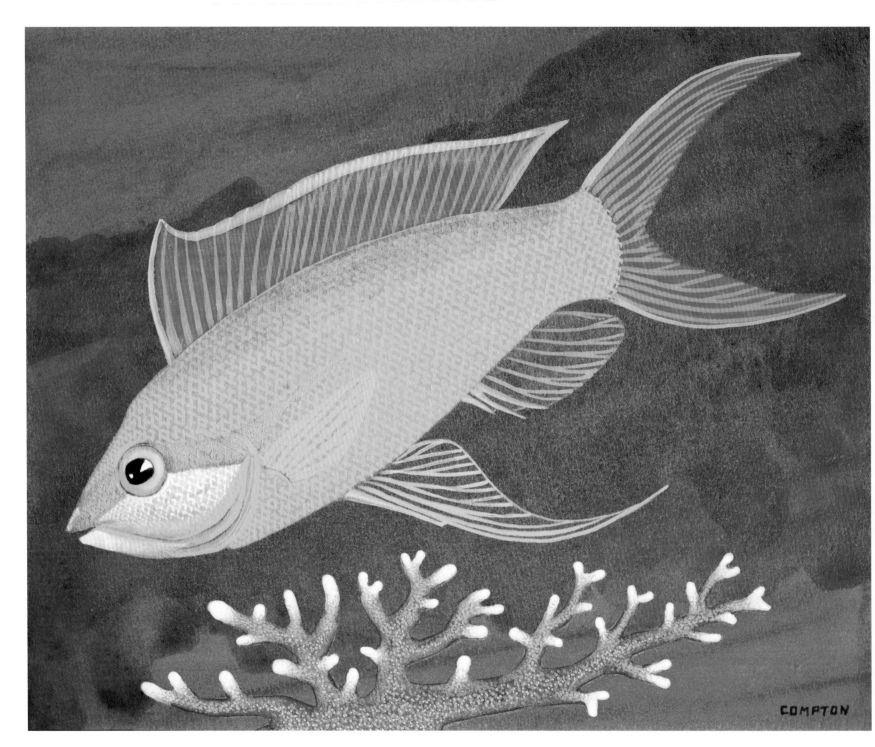

Peach fairy basslet

Pseudanthias dispar (Herre, 1955)

"The Orange is 5-inches of festive spirit himself and swims his own Pacific holidays."

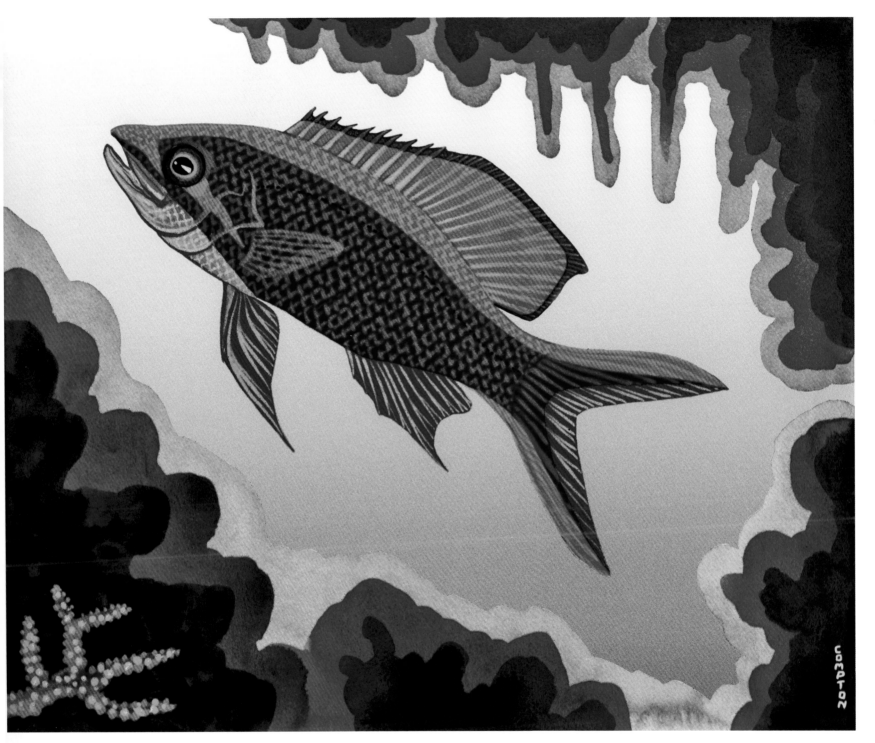

Yellowstriped fairy basslet
Pseudanthias tuka (Herre & Montalban, 1927)
"Her Majesty PQ & His Majesty PQ school loosely and play and fight alongside their Orange cousins."

be long, with larvae only settling at a size larger than 6 cm. This group feeds largely on sponges and marine invertebrates.

Species: *Zanclus cornutus* **(Linnaeus, 1758)**

The Moorish idol is a tropical and subtropical species that exists over a large area. It occurs from the eastern coast of Africa to the Hawaiian Islands and is even found along the eastern coasts of North and South America. This species is most commonly found along coral reefs but may be found in lagoons as well as rocky out-crops. The body is highly compressed and rounded. These fish possess a long, tubular snout with a very small mouth. The spinous dorsal fin is elongated into a long filament. The body has several alternating black and white bars. White bars may also have a yellow hue. There is a small orange saddle shape along the tubular snout. Adults may be seen as solitary individuals, in pairs, or in small groups. This species is known for its pelagic larvae, which require an extended period of development. This long period allows for dispersal of larvae over great distances, which has allowed this species to be distributed widely. It feeds mainly on sponges and marine invertebrates. Although this species is commonly sought after for the aquarium trade, it does not do well in a captive environment.

(6) This is the real Idol not the false one, the bull-headed long-finned look-a-like of those kids off Queensland. Which was a butterflyfish though who would know it with that shape. The two are not close kin. About like a cat and a dog.

Not only do the two fish resemble—they both have horns to butt heads with. But Real Idol has horns young and loses them as he grows. False idol has none young and grows them as he grows. The reason for this semi-mimicry and horn business is not known. This is very irritating to biologists who like reasons better than pickles and pizza.

Once there was one of these picky biologists who lived by the sea in Galveston, Texas. He had 20 big huge aquariums. In one aquarium he kept 2 goldfish. He didn't know they were both males so he never had babies. In 19 aquariums he was hot as brush-fire to raise Moorish Idols. He was a real nut.

"They are the king, queen and cat's moustache of fish. Graceful as the garb of Arabian dancers. Flowing as the robes of Moors. Creamy as the carving of the Taj Mahal and black as the shadows of night temples. Why do you think all artists paint them? And all photographers photo them? From the Red Sea by Arabia under India thru Malay, Philippines, Hawaii, all the bright islands of Pacific equator all the way to that thief in Mexico keeps selling me dying fish."

For the poor truth was: This biologist had no Idol thumb to grow them. His 19 tanks were miracles of hygiene. A germ would have had a fit trying to live there. The sea water was mixed from pure packaged pristine crystals. It was filtered and strained and bubble-blown to an inch of its life. It was so clean it squeaked.

Mexican shipment arrived. Dumped into healthy home. Shipment took sad-eyed look inside, and out to Biologist's pressed nose. Shipment refused all food—shrimps, crab, lettuce, coral animals, sponge chunks, worms, dead flies, dogfood and desperate donuts. Shipment looked out with great lovely eyes without hope and in nightime turned belly-up floaters.

"Maybe if I didn't name 'em. Tom. Duchess. Henryetta. Chinese say it's bad luck namin.' An' Apaches say so. Zulus, Irish, and that dog named 'Honk' got run over thinkin' that auto breakin' speed in front of house was calling him."

"You are a real nut," his wife told him.

Biologist flew his plane to Mexico and went to his fish supplier where a jungle river flowed to meet Pacific Ocean in a town of tropical beauty.

"Senor! What have you?"

"My fish is muerto. Bottom up. No bueno, amigo."

"But look." And there were big tanks bustling with Moors healthy as hogfish.

Biologist dabbled a puzzled finger at the surface. The fish tested it for flavor and seemed disappointed. Biologist tasted it for salt.

"Ah-eee! Senor. Do not lick the finger."

"What is the secret of your water that your fish live and my fish turn belly-up, rascally Fishman?"

"Sewage."

"Sewage?"

"That."

Moorish idol
Zanclus cornutus
(Linnaeus, 1758)
"They are the king,
queen and cat's mous-
tache of fish. Graceful
as the garb of Arabian
dancers. Flowing as
the robes of Moors.
Creamy as the carving
of the Taj Mahal and
black as the shadows of
night temples."

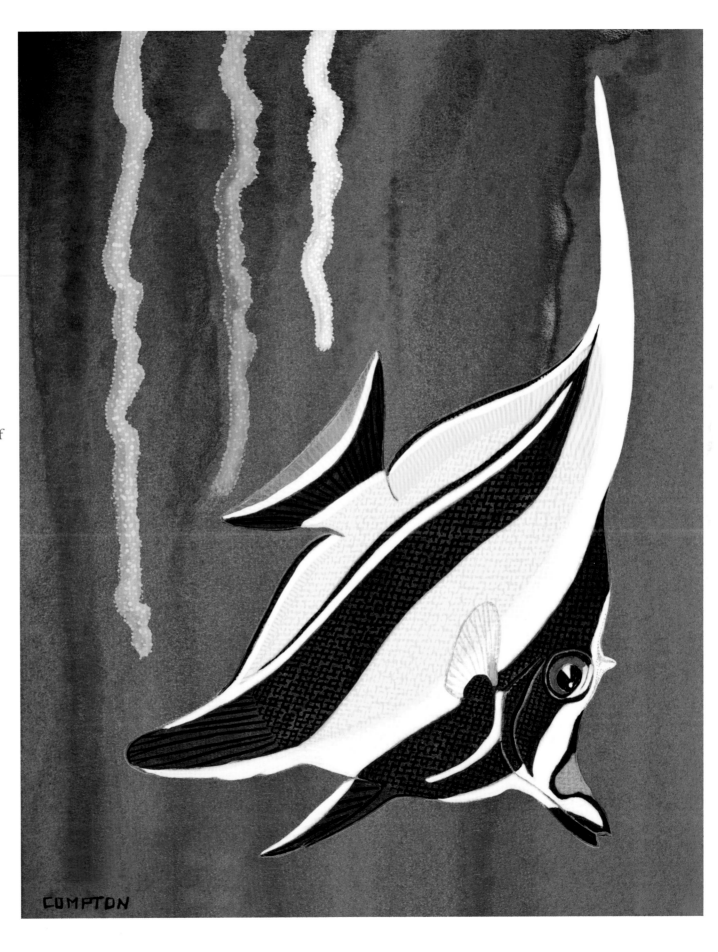

COMPTON

Biologist took his diving tanks and went with laughing children to an old wharf northside of the harbor. Here, twenty feet down in clear but darkish water, he sat on a decaying auto body with rotting coconuts, oranges, plastic bottles with octopus inside, cans with fat stone-crabs inside, toothless combs and a dead cat at his feet and fed tame Moorish Idols shrimp, busted land-crab, canned sardine (opened) and shredded tortilla all dived down to him by the children who made sure his hands grabbed firmly the bait before kicking themselves back to surface to emerge shouting with laughing. Biologist dropped emptied sardine can at his feet as the fish seemed to cherish their litter.

Down from the old pier supports hung swaying ropes of soft coral fuzzy with all the feeding stars expanded to lunch on the rich waters of pollution. Moorish Idols jostled to inspect Biologist's hide and to peer in to see what, if anything, was inside the face mask. "Bet they couldn't figure me out," Biologist later told his wife. "Who can," she said. "They come to the conclusion you were more litter?"

Biologist loaded all of plane, but where he had to sit to fly, with wharf water and fish.

Fish dealer says delicately, "But don't you in Texas have . . . ?"

"Sure, Senor. We got plenty excremento but ours will kill you fast with additives. Nobody leaves nothin' natural in Texas no more."

When Biologist flew low over plaza to waggle wings Adios, Fishman said to the waving children, "He is loco, our good amigo."

Today, Biologist has many happy in-tank Moorish Idols from grandmas to finny babies and visiting and envious experts ask him how and he tells them, "Secret. Just don't lick the water."

"You're a real nut," they tell him. 🐚

Order: Scorpaeniformes (Scorpionfishes and Flatheads)

Members of the order Scorpaeniformes can be found distributed around the world in all tropical and temperate waters. The name likely is derived from the Greek word *skorpios*, meaning "scorpion." This order is made up nearly entirely of marine species, with the exception of approximately 50 species in the sculpin family, which reside in fresh water. These fishes typically have a head covered in spines and in some cases ridges or bony plates. Individuals in this order often have well-developed spines associated with fins. This is a fairly large order comprising approximately 24 families and 1250 species within approximately 250 genera.

Family: Scorpaenidae (Scorpionfishes)

Scorpionfishes can be found worldwide from tropical to temperate and cold waters. These marine fishes inhabit depths ranging from coastal shallows to deep waters; most species are bottom dwelling. Heavy-bodied fishes, they typically possess large heads covered in numerous spines. Most species exhibit a single dorsal fin that is often deeply notched. Masters of camouflage, many species are difficult to detect. Aptly named, scorpionfishes are known for the toxicity of their venom. A large majority of species bear venomous spines on the dorsal fins. A sting could potentially be as minor as a bee sting, while others cause extreme pain and death in some cases. This family is known to contain several of the world's most venomous fishes. This family encompasses approximately 200 species within 50 genera.

Species: *Pterois volitans* (Linnaeus, 1758)

Although historically distributed among tropical reefs among the Indo-Pacific, red lionfish have spread around the world and have become highly invasive in some areas. The red lionfish typically inhabits lagoons and reefs ranging from coastal waters to a depth of approximately 50 m. It possesses a large head and tapered body. The most notable characteristic is large, flowing fins. Most species have large pectoral fins and long dorsal spines, which are typically longer than half the body depth. These aggressive fish use these long, fanlike fins to corral smaller fishes. Possessing a voracious appetite, these fish eat a variety of prey, including smaller fishes as well as invertebrates. Due to their beautiful appearance, several species of lionfish have become popular in the aquarium trade. However, with increased popularity, several species have become invasive where released in waters where they do not historically occur. Lacking

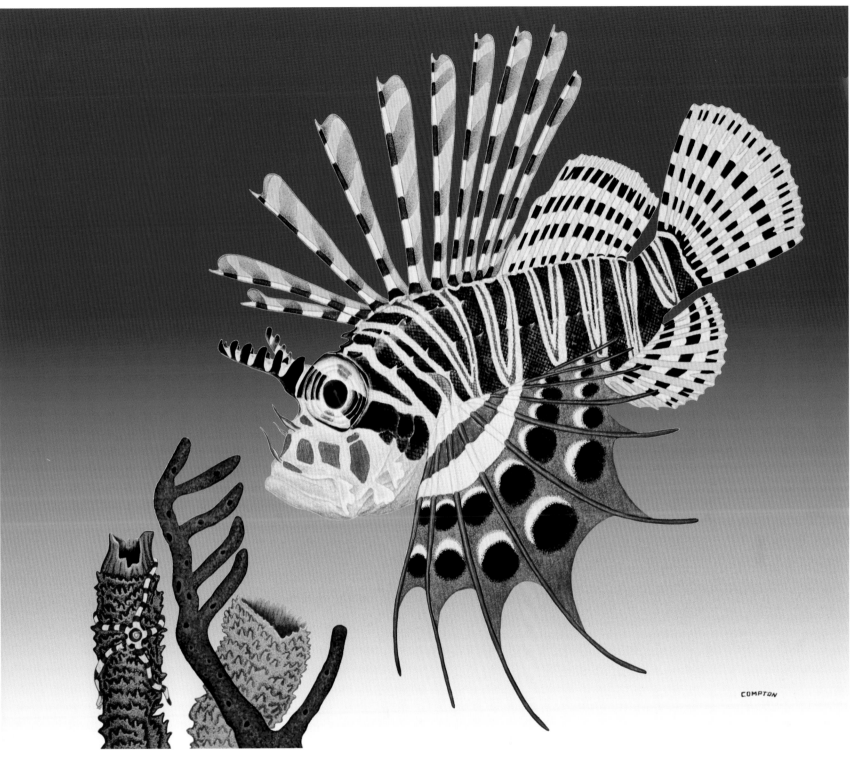

Red lionfish
Pterois volitans (Linnaeus, 1758)
"Our good old Lionfish is called a Turkeyfish an' nobody never knew that."

predators, these fish have populated rapidly and decimated marine life in areas where they have been released.

(30) Danny Kelly & Kevin Shannon * Narrators * :

"Here's our favorites fish."

"Yes. He's from Chiner Sea."

"He's got them spongers he's lookin' at comes from all over and RED Sea & Hawaii & Yucatans & prolly South Pole ha ha."

"And all over we don't know where all an' New York & Suwanee & Indias."

"Yes. We don't know where all that little ole wiggley starfish he looks at so fine come from."

"When you pull 'im he breaks up so don' you go pull 'im."

"Nan & Sandy says they caught him but we never saw 'em do it."

"Our good old Lionfish is called a Turkeyfish an' nobody never knew that."

"No. We show him 'cause he's so brave. He won't give up if mean man gonna kill 'im an' grab 'im YOW! he is stung and stung an' his ole tongue hangs out."

"His ole eyeballers all falls out an' he wets his pants an' dies mean man an.' . ."

"Daniel," says prompter.

"Yessir, an' if 'at mean man dump oil all over 'im or mash 'im up with mud he can't sting 'im no mores an' dies."

"Yessir. We wanta get with this 'cause one of them boogers about bit Kevin all up and left him scarry for life an' was plenty mean an' we gonna eat 'em all up get rid of 'um."

"That's me."

"Yessir. That's 'im folks all scarred and most eaten up . . ." Here narrators were run off dock with Mangrove switch.

But there were a number of fine conservation style Tee-shirts in sight. With appropriate fauna. "Save A Red Sea Redhead." "Pet That Parrot." "Squeeze That Squirrel—OUCH!" And so forth.

Black Snake had traveled from Suwanee in traveling cage but had been left in Key West at Dive & Fish where his cage had been nosed to Fat Eel's tank where the two of them spent happy hours staring in happy disbelief at one another. Biologist said it was

interPhylum communication and was going to write a paper some day.

Mouse-who-lived had come and was seated on a wedge of carpet in a Lazy Susan on Biologist's work table with water in dip bowl and 17 assorted nuts, cheeses, fruits, vegetables, grains and crackers. Mouse-who-lived always refused to remain home when Black Snake came to visit. She did not trust cages with snakes inside who might become outside. But she liked and considered Miss Fortune and Deck Dog to be only big clumsy mice and kept trying to teach them to eat peanuts.

Deck Dog cared nothing for peanuts. Nor fish. Refused to wear any silly slogan collar and dogged Salty's busy legs. Salty was bar-b-queing Black Angus on firepit 10-foot long. Deck Dog ignored Biologist. Biologist was boiling shrimps and lobsters and big blue crabs in cauldrons and marinating Dolphin to fry that evening.

Cap'n Jim, looking to the crowds on the sloping lawn to the Mainhouse, the planes chocked on the ramp, the boats in harbor, says, "All's here, looks like."

He was wrong. The blind twins, 7 Porpoises, 3 Octopus, 2 Tree-rats, a Monkey, an Elephant and Bad Daddy were not in attendance. As a fact, it was at that moment a lovely misty early morning on Lost Moon Lagoon in the Pacific around the Ball and the Monkey was marking, with Rick's knifepoint, 12 decks of cards so that the whole menagerie, sighted or no, could enjoy roustering games of Hearts, Spades, Old Maid, Bridge, Poker, Whist, Chemin de fer, Spit-in-the-Ocean and Fish.

Non-attendance was not an oversight on the part of Cap'ns Jim and Eddie. *Riff-Raft* was not destined by the Sea-Gods & Goddesses to even discover Lost Moon Lagoon until a stormy August night of the year 1997. There-after, every other reunion was held on Lost Moon, logistics proving it was easier to bring most of the rest of the world to Lost Moon than to haul Elephant & Bad Daddy to Florida.

Miss Beetrice was laughing and chatting with Fat Lady, Guide and Cobber when all their ears were wax-blown free by a long sleek very loud Jet of many colors buzzing the waving crowd before circling to land on No Name International Airstrip.

"There's my varmints," says Miss Beetrice. "Hit's 'Muddy Rainbow' bless their loud hides. Come from Paris, drat 'em. Now

don't you three wished you had my hearin' aids? Soon's them varmints thump nakid foot on asphalt, my batteries come out and into pocket. I don't trust 'em with my on-off switcher."

Into the vault of morning a sound, pear-shaped and mushroom-lifted, like the pipes of St. Peter and the hinges of Hell, rolled the sky and scrub of Florida and almost stalled in midair the plane of "Muddy Rainbow" on approach.

"Yikes," says Guide.

"Crikey," says Cobber.

Miss Fortune bounded leopard past on way to airstrip. "Now," says Miss Beetrice, "that black Sheba is a fool for them landin' to blast us." Miss Fortune was.

Miss Fortune considered "Muddy Rainbow" her own personal Bast Band. Did not their repertoire sing the wonderful wails of a long lean chew-ear favored midnight troubadour in London, Lisbon, Dakar, Capetown, Zanzibar, Marseille, Athens, Bombay, Calcutta, Rangoon, Darwin, Free-mantle, Sydney, Brisbane, Manila, Shanghai, Yokohama, Tokyo, Dutch Harbor, Frisco, L. A., Panama and Galveston? New York, Miami, Corpus Christi and Rockport? Did.

The high young day fired the diamonds on her collar as she leaped smooth sand and rough cedar to greet her friends. Miss Fortune wore the only practical non-sentimental workable conservation slogan of the day. Taut and truthful.

Her diamonds flashed **** CATS LOVE FISH ****. 🐚

Order: Syngnathiformes (Pipefishes and Seahorses)

The order Syngnathiformes comprises 5 families of elongate and tubelike fishes. Although seahorses are the most familiar, this order is made up of other tube-mouthed fishes such as pipefishes, cornetfishes, and trumpetfishes. Members of this order are closely related to those of the order Gasterosteiformes and are often included in this order in many taxonomic divisions. The name Sygnathiformes is derived from the Greek words γn, meaning "with," and *gnathos*, meaning "jaw." These fishes possess an elongate body encased in bony rings. Mouths are typically very small and located at the end of a tubelike snout. Although incorporating

5 families, the vast majority of syngnathines belong to a single family, the Syngnathidae, which includes several hundred species.

Family: Aulostomidae (Trumpetfishes)

There are only 3 known trumpetfish species within a single genus; only a single species is found in North America. These small fishes are similar to pipefishes and seahorses in that they also have an elongate body and a small mouth at the end of a tubelike snout. Easily distinguished from other families in their order, members of this group exhibit a chin barbel, a series of small isolated dorsal spines, and a soft dorsal fin placed far back along the body. These fishes typically occur on reefs and are often seen oriented vertically with their heads facing downward. Although small, reaching a maximum length of only approximately 80 cm, they are ambush hunters preying on small fishes and crustaceans.

Species: *Aulostomus maculatus* (Valenciennes, 1841)

The trumpetfish is commonly found in the western Atlantic, along the coastlines of the Gulf of Mexico and Central and South America as well as throughout the Caribbean. This small fish has an elongate, compressed body with a long tubular head and mouth. Although similar to pipefishes, trumpetfish have an upturned mouth, making them easy to distinguish. Typically brown, these fish exhibit both dull stripes and small spots along the dorsum. Like other members of the family Aulostomidae, they possess a dorsal fin with isolated spines that lack a membrane. Commonly found on reefs, this species often positions itself vertically in the water column near sea feathers to camouflage itself from prey such as small fishes and shrimp.

(18-D) The Trumpetfish is right at a line hisself. With a snout dribbled in shortlines for fashion. He sticks the tube of his snout into everyone's business. Sucking with sudden Slurp! perfectly unaware 3-inch Damsels and Basslets and grandfather shrimp from their coral holes and hideys.

"Oh, he's a long slim demon," Biologist told his bored class.

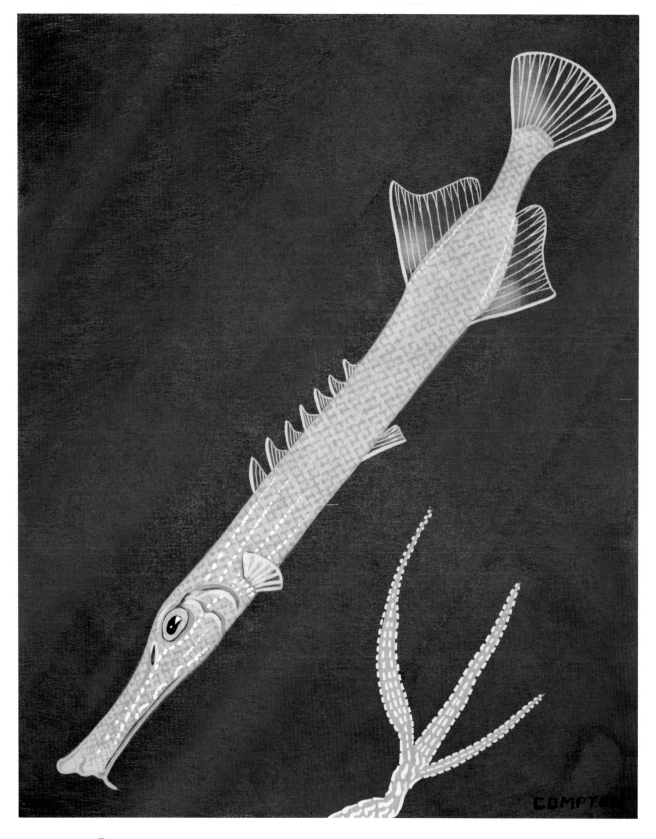

Trumpetfish
Aulostomus maculatus
(Valenciennes, 1841)
"The Trumpetfish is right at a line hisself. With a snout dribbled in shortlines for fashion. He sticks the tube of his snout into everyone's business. Sucking with sudden Slurp! Perfectly unaware 3-inch Damsels and Basslets and grandfather shrimp from their coral holes and hideys."

"He swims head down for action and hides like he's growing in the wheatfields and the cornfields of the soft coral, that wonderful gang of anemone critters building flexibility leather to live in 'stead of cold stone mansions. A-swishin' lazy back and forth an' to and fro with current's push. Did I get the picture into your pea brains?"

Class sighed.

"I've had him hide up my back when I was diving. Between the tanks. Swimming with me. Never knew the varmint was there until he come shootin' out around me to grab fish I wanted 'fore I could grab it. How's that for sense in fins?"

Class sighed.

"There is him suckin' reefs from Florida to Africa. He's got cousin on Barrier Reef. Your assignment for tomorrow is scientific evaluation of who he looks most like among fish families and how you think his family got split to Australia and us."

"Looks like my sawed-off pool cue," says Pus-Pocket.

"Pus?" says Biologist. "When you going diving with me? Help feed that Hammerhead Shark I got summat tame off Booger Reef?"

"Don't like water." 🐚

Family: Syngnathidae (Pipefishes and Seahorses)

Pipefishes and seahorses are distributed worldwide in tropical and temperate waters. The vast majority of species belonging to this family are marine with only a small minority found in brackish or fresh water. These fishes have a tubular face and body made of bony rings. Pipefishes are more tubelike, and seahorses have a somewhat thicker body, curved prehensile tail, and a head bent at a right angle. Species identifications are typically difficult and require a careful examination of external features. Pipefishes are distinguished by the number of rings encircling the body, length of snout, the number of rays within the fins, and in some cases the presence of an anal fin. Seahorses are typically identified by size, length of snout, overall shape, and color. Being relatively weak swimmers, seahorses typically use their prehensile tails to anchor themselves on plants, corals, or other surfaces. Pipefishes often simply rest along the bottom or on sheltered surfaces. These small fishes feed on invertebrates.

Species: *Hippocampus* **sp.**

Seahorses are found in coastal waters around the world and typically occur in areas with natural or artificial structures. A large number can be found within seagrass beds, among gorgonians and coral, and attached to floating *Sargassum*. Those found among coral reefs or *Sargassum* typically have fleshy tabs and protuberances that serve as camouflage for the respective habitat. Members of this genus have a head that is noticeably at a right angle to the body. Seahorses have a prehensile tail, which takes the place of the typical caudal fin. Due to the lack of a caudal fin, seahorses are very poor swimmers and employ camouflage to hide from predators. Utilizing a rapid intake of water, these fishes quickly suck in tiny invertebrates that stray too close.

(8) Once there was a blind child who lived on a small island with his blind twin. The sands of the island were blind also. And the palm-trees and coconuts that fell dangerous from their shaggy tops, but the blind twins could hear very well indeed and their tanned skins felt the vibration of air when nut fell or the Fairy Tern dropped one of the two shrimps caught in blue water the twins had never seen to feed her fuzzy young so the nest got only one shrimp. She dropped other one right at Rick's toes dug into the coral sand.

"She's got us one. Good bird. Must be just dawn."

Second Fairy Tern dropped a shrimp at Rachel's toes and, as Rachel ate her breakfast, F. T. brushed the child's long hair to neatness with her hovering wings. The Coconut Crabs, who opened milk and meat for the twins, kept Rick's shag clawed to comfort—a barbering every full moon attended with great hilarity by Rachel, the Octopussies occupying the moon-flooded seats of lagoon coral, their sac heads and large eyes alert above the pearly waters of the night, and the awakened BoobyBirds who always contributed 7 infertile eggs to the following feast but only partook of the shucked clams laid on by the Octopus.

Most of the fun of Haircut Moon was Rick's yelling that Crabs was killing him slow and why couldn't they sharpen they claws before they got hold of him.

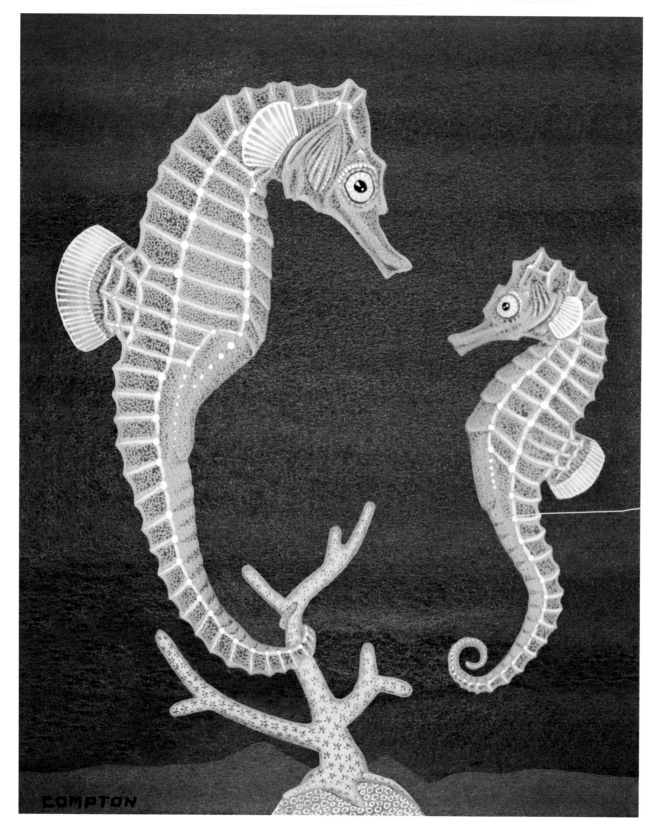

Seahorse
Hippocampus sp.
"And when poor Horsey fell into Sea, the SeaGoddess took pity on him and gave him fine fins and whip-tail so fine to hold onto the front of her wagon and pull her wherever she wished to go."

But the 7 Porpoise, who owned the lagoon and kept sharks out, pitch-talked they had never seen finer cut on human headbone, although why Rick and Rachel wanted that dumb moss on 'em, they didn't know. Rick and Rachel could talk very well with the Smallest Porpoise. To wet the new clip-job, and Rick hoped to slow it growing so fast as well, the twins and all the Porpoise went swimming moonlight lagoon.

Two of the biggest (6-foot) Octopus jetted each side the twins to see they never snagged on reef. The P's thought this redundant as outriggers on a flyingfish. They had the twins meshed in internet of sonic signals at all times. Didn't they? To know where they were at all times. Didn't they. They, the P's, would yet make sea-mammals of these skinny humans if the O's would stop their mothering.

Moon admired herself in the mirror of the sea. "Best time for swimmin'" Rick told the Smallest Porpoise. "Me and Rachel think we can almost see. By Moon's light."

First visit was to the Seahorses who lived off the beach of Bad Daddy Crab whom nobody liked but Rick. B. D. C. was so old he was shrinking away from his skin and this made him snap his claws at anyone come near him. Rick called, "Bad Daddy! Bad Daddy!"

"Snap-Snap-SNAP!"

Rick dropped some clam and coconut meat and Booby egg he'd saved into the snapping. He was afraid Bad Daddy couldn't climb trees much longer and would starve. Everybody else hoped Bad Daddy would.

"Snap-SNAP?"

"Eat while you got 'er, B. D.," Rick told what he couldn't see and could only feel the angry vibrations of about 2-inch off his toes.

"SNAP-snap."

Rick ran to the Moon's water guided by smell, beach slant and Smallest Porpoise doing loop-splash where deep began. Rachel sat in knee deep water and played with the Seahorses. They would wrap their tails on her fingers and search her palms. They monkeyed around into her long hair fallen each side her sweet searching face but Rachel was in the clean sea so often she never-never had lice so they found nothing to Whoosh-Suck to eat.

Smallest Porpoise came with Whoosh-Wave to prop his head happily in Rachel's lap. Seahorse all clung monkey tail to Rachel's hair and washed shoreward—washed seaward—shoreward/seaward til oscillation ceased and they found seabreath to tell this small Porpoise what they thought of him.

"Say I am worse'n that damn Turtle for blunders and splash."

Rachel patted and soothed his smooth round head and scratched around his blow hole for sealice. "Why, Honey, they only kiddin' you. They always like to swing on my hair. Wish I could talk to 'em. Where in the sea did they learn 'damn'?"

"Not from us," Rick told Smallest Porpoise. "Our Mom and Pop died after shipwreck too late to stop me learnin' it from Pop but he told me don't use it but for special important occasions. I use it generally when Bad Daddy mistakes my toe for his fooddrop. He always snaps apology. I'm worried. I think he is gettin' blind like me an' Rachel an' he's too old and cranky to put up with it." Nobody else at all was interested in Bad Daddy's problems.

Small Porpoise told Rachel, "These damn fish in your hair want you to tell us again how they were named."

"Why, you see," said Rachel, speaking to the silver sea, "you were named for a beautiful Horse who carried the Sun in a wagon but a bold bad boy jumped into the wagon to drive Horse faster to make Day sooner so he could go fishing but Sun didn't like this and kicked Horse and bold bad boy into Sea and went on makin' Day by his own self."

Smallest Porpoise interpreted. All the Seahorse curled their tails in delight. "Ouch," says Rachel.

"We'll get Bad Daddy to haircut you," says Rick. "Stop these horses running rein on you." He sat firm on sweet feeling sand in mirror sea to his chest, both hands spread-finger up on bottom and toes splayed up also that the larger Seahorses could wrap tail because Rick was rough and calloused and felt more to their tails like coral than did Rachel.

"And when poor Horsey fell into Sea, the SeaGoddess took pity on him and gave him fine fins and whip-tail so fine to hold onto the front of her wagon and pull her wherever she wished to go."

"That's purty, Rachel," says Rick, who always saw himself as bold brave boy who leastways tried to drive the old Sun he could feel on his skin to tell Day because Moon felt smoother for night.

"That's purty, Rachel," squeaks Smallest Porpoise. "Damn Seahorse says that's real purty, Rachel."

Came big bellow squeak from off beach in Moon Lagoon where the big Porpoise found depth to ride their tails to see and hear.

"That's Pa," says smallest P. in small sad squeak, poking his small snout for protection under Rachel's arm.

"Hey!" said Rick kindly, losing some curled tails temporarily from left foot and giving Smallest Porpoise a good braving toe-rub on belly and flukes.

"Hey!" yelled Rick, putting his blind and eager face to sea. "You are scaring S. P."

The two biggest Octopus, who did not like beaches with seaweed here and there and no caves, each sprawled a restless 7 with No. 8 gently suckering one of the twins, felt Rick's anger and Rachel's concern and began to flush color onto their moonlit skin—red for Rick and white for Rachel.

Big Daddy Porpoise, knowing Octopus were better to friend than to tangle with, squeaked calmer, "S. P., you tell your friends if they stop teaching you to cuss an' use them words they musta learned from some ship-wrecked sailor, I won't smack 'em proper with me flukes."

"I always love that sweet tale of the Seahorse Rachel tells us," squeaked Big Mama Porpoise. "Come children. Sleeping time for your island. Tell your Seahorse mates tis watch below."

About the time the first Christian was fed to some reluctant Lion who would rather have had a fat Zebra than some sweaty Human, a man named Pliny the Elder named a Seahorse he saw, "Hippus," which means horse. He was a great writer of nature and believed like all great writers in unicorns, men with umbrella feet to sunshade their heads, and the friendship of Dolphins.

On August 24, 0079, Mount Vesuvius roared to clear her throat. The cities Herculaneum and Pompeii died under bitter rain. Pliny the Elder died also on shore of the Bay of Naples which the Dolphin had fled three days previous. It is unknown if he was responsible for the present name of Seahorses—Hippocampus, which means horse-caterpillar. 🐚

Order: Tetraodontiformes (Puffers and Filefishes)

The order Tetraodontiformes comprises a large and diverse group of fishes. The name derives from the Greek words *tetra*, meaning "four," and *odous*, meaning "teeth." Members of this order are distinctive in that they have a reduced number of vertebrae, specialized teeth, and in some cases a ventral spine in place of pelvic fins. Some individuals lack scales, while others have spikes covering much of their bodies. Although mostly marine, several species can be found in either brackish or fresh water. This order contains 9 families, of which 7 can be found in North American waters.

Family: Balistidae (Triggerfishes)

Triggerfishes can be found throughout both tropical and temperate waters worldwide. These marine fishes can be found among rocky coastal outcrops, coral reefs, and seagrass meadows, as well as in the open ocean. Most species are diurnal carnivores that lead solitary lives. These fishes are known for their compressed bodies covered by thick, diamond-shaped scales. The dorsal fin is composed of two separate fins. They are called triggerfishes because the first dorsal spine can be locked into place. These fishes lay eggs in the demersal zone near the seafloor and guard them aggressively. While protecting their nest, they have been known to rush and even bite divers who approach too closely. Young are typically pelagic and are often found near floats of *Sargassum* and floating debris. There are approximately 40 species found worldwide among 11 genera.

Species: *Balistoides conspicillum* (Bloch & Schneider, 1801)

The clown triggerfish can be found among reefs of the Indo-Pacific. Uncommon throughout much of the known range, these solitary fish are found in clear waters of reefs near steep drop-offs. Although seen on occasion by divers, adults often retreat when approached by predators or divers. Juveniles can be found in small caves. This species of triggerfish is rather large at around 50 cm in length. Strikingly colored, the clown triggerfish is known for its dark-colored base with large white spots along the ventral surface and black spots on a

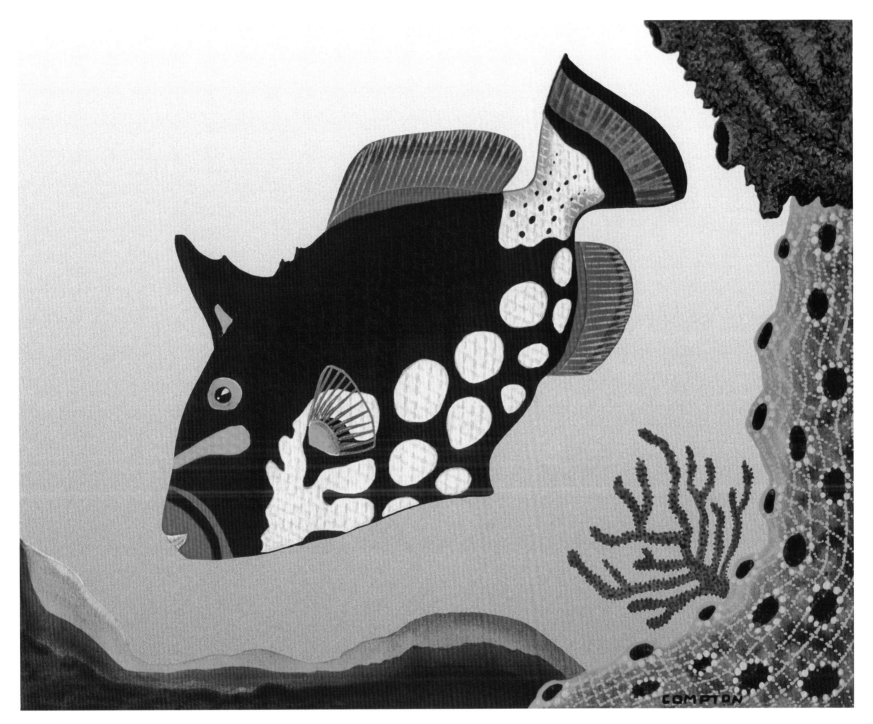

Clown triggerfish
Balistoides conspicillum (Bloch & Schneider, 1801)
"Little Clown crunched all in his strong teeth and grew out of his
yellow nose and the 47 white baby spots on his black body."

yellow background along the dorsal surface. They also display large yellow lips on a terminal mouth and a yellow band in front of the eye. Like most other members of the family Balistidae, these fish can have a fiery disposition if threatened. Diet typically consists of small invertebrates such as crustaceans and mollusks.

(19) The little Clown lived in the cup of a red sponge between a great coral saucer and a table of knobs and fingers and bones and tufts and hollows and smears, all colors, as if a banquet had spilled there and been allowed to grow. All was growing but was less food than feeder. The red cup & all belonged to the Giant buried to his chin a few yards south. The little Clown had never seen over the vast rim of his home to the table & saucer. Sometimes looking up and south he could see far looming the domed rise of the Giant's exposed brain. This was only distant mountain on sun-drowned horizon. He was not yet journeying. He was 2-inch oval of leather hide, baby prickly to touch, not rough as shark nor yet smooth as eel. He stayed to home on north bottom sponge curve inside his fine cup.

Large caves, running deep, tunneled his red wall. The sponge breathed out. He set up his crib-camp on netted floor of largest where he could observe all in the valley of his cliff dwelling. Big wet wind current blew from his tail to his head. Kept him cool. Ten thousand small holes up and down cliffside breathed in sea and kept him fed for they sucked in the Spongecup's minute dinner and the crabs and shrimps and mini-minnows followed for a bite. Little Clown crunched all in his strong teeth and grew out of his yellow nose and the 47 white baby spots on his black body.

Once came drifting into cup softly softly nosing, the yellow stick of Flutemouth, sneaky yard-long piece of mischief slurping at sponge's exhalation holes for hidden goodies. In his homey tunnel of scarlet ribboned wall, Little Clown erected his backspine and locked it in place with a cunning muscle-drove bone wedge. He was anchored in the interstices of his cavern wall. Hurricane tore through cavern. Old flutemouth Trumpetfish was far craftier than that wolf blowing piglet's houses into the next pasture. Like jet intake, he inhaled Little Clown out of sponge and home.

Little Clown tore loose bringing sponge fence with him. Huge suck-tunnel yawned at him—big mean eyes far back crossed on him. At last nanosecond before engulfment, he twisted stiffly frantically and slammed into chin of old Trumpet. Grabbed the sensitive hanging rope of feeler there with shell-crushing babyteeth. Bit hard and held on.

Big Ouch! for Trumpet. Worse than beard pull. Little Clown went for bronco-rocket-runaway train ride. Out of Giant's cup, swished in Giant's saucer, mopping Giant's table and shaken loose over Giant's very own crinkled coconut. With inch of chewed off Trumpet feeler still fanged. Trumpet was no longer cane-walking looking for little fellers to suck and gobble. No. Trumpet vanished like shot spear to far edges of Barrier.

Little Clown ate his feeler. He bared his 20 some fangs at a passing Butterfly and, now he'd seen the wide world, swagger-swam to his sponge to do some growing. Some years later he had and was king and jester of his acre of Reef. He was 13 inches of the colors of circus.

He was never satisfied with his little acre. Moving a tunicate here, a coral tuft there, a loose ball wrestled yonder. He couldn't lift Giant and Giant's diningtable, etc., so he built and rebuilt around them. A warm vista here, a cool alley there, a large bed of clam he kept clean of starfish who could armsuck open a clam and throw a stomach inside to eat it fast as a fat man could down two roast ducks.

Big Clown would grab a star by one leg, jerk him loose from bottom, where his hundreds tubefoot suction threads moved and held him, and carry him out of area. Never ending chore but Big Clown also liked his clams at times, crushing them with audible underwater Crunch! and scattering messy mess of meat and shell all over.

One sun-latticed morning, he noticed 3 or 4 moplike many-legged horny starfish on his coral and where they moved and grated and grazed they left trail of dead-dead coral with all the little staranimal polyps plucked from their cement pithomes, and poor coral bare as duck bones. This was not welcome in well conducted coral acre.

Big Clown eyed his mate, as beautifully enameled as he, and whom he had once made danger strown trek 2-miles north to bring

back. She eyed him. They eyed this Crown-of-Thorns intruder with spikes on his armey legs like the round bone bayonets of the tail of a Stegosaurus. Each set teeth and tussled a menace to their endangered reef off to dump.

But third fell upside down. The waving feet in radiating paths inward to working mouth had all the aspects of a meal and triggered the appetites of the Clown-triggers and they went to lunch. Very tasty. From then on the Clowns gnawed every Crown to reefdust and while increasing pockets of the Barrier became tombstone under the mouths of the horny sea stars, the coral of Circus Reef bloomed year long like April.

On Heron Island, roughly 400 miles south, Biologist and wife, Jan, sat with Guide at bar with longsleevers, deep-nosers, foambearders set pleasantly before them.

"You got much trouble here," Biologist asked Guide. "Some. Got more in Guam, I hear."

"Yeah. Got folks poisonin' and folks scaldin' and folks telling tourists they are tasty and so make a market for 'em. That'll clean 'em out in a hurry. Now, I'd advertise worldwide that if you cared to swaller one pill a day of this miraculous seawitch ground and bottled, why, you would stay young to 110, chase women to 108, or, in wife's case—men. And find gold in the backyard."

"Hurrar for it," says Jan & Guide.

"Yep," says Biologist. "That would doom the poor animal. Old Thorny can't help it he eats something humans wanta look at. Hell, he's pretty hisself. All engineered in Browney purple reddy green an' all them stickers."

"I'm with you, Chum," says Guide. "I believe what's gonna happen has already nibbled at your sleeve but don't praise Thorny too much round here. We'll both get hempneck worsen sundowner."

"Won't. And, I don't believe one word of that bull about Clown Triggers clearin' a reef of those sea stars because they was landscaping. How come that clown wrote it never gave no coordinates? We'd go check his lies." Biologist drowned his jealousy in a deep-noser. "Now I got some Idols might do 'er. With training."

"Honey, hush," says Jan. She swung to Guide. "Will you tell us again Fat Lady and the Croc? Please?"

Jan was already laughing.

"She was a bosker, she was," says Guide. "Croc is still in shock." 🐚

Family: Monacanthidae (Filefishes)

The family Monacanthidae is sometimes combined taxonomically within the family Balistidae. However, filefishes are known to have a narrower and more compressed body. These fishes also exhibit a single large dorsal spine in most species. When present, the second dorsal spine is usually reduced. A well-developed pelvic bone is hinged to the pectoral girdle and covered by a flap of skin. Some individuals exhibit pigmentation that is likely used in courtship of potential mates. Members of this family occur worldwide from tropical to temperate waters, with a vast majority of species found in Australian waters. The family name arises from the Greek words *monos* and *akantha*, which mean "only" and "thorn," respectively. Most species of filefish feed on small invertebrates, while a few species have become more specialized, eating corals or zooplankton. Like their relatives, filefishes lay demersal egg masses that are often guarded by both parents. Several species are known to release eggs within open waters of subtropical regions. There are approximately 100 species within 40 genera found around the world.

Species: *Oxymonacanthus longirostris* (Bloch & Schneider 1801)

The harlequin filefish is found throughout the tropical waters of the Indo-Pacific among coral reefs to a depth up to 30 m. Found in clear waters, these small secretive fish are commonly seen in pairs living among coral reefs and clumps of algae. Possessing an elongate and compressed body, these fish reach a maximum length of 12 cm. They also have a very long snout with a small mouth. Often considered the most beautiful species of filefish, the harlequin filefish is easily recognized by its bright green and blue coloration with bright orange spots along the entire body and long stripes of the same color along the snout. A small, noticeable patch of dark blue with white spots is found along the ventral surface near the pelvic fins. Young of this species live in small groups, while adults live in monogamous pairs. Interestingly, these small fish feed almost entirely on coral polyps of *Acropora* sp.

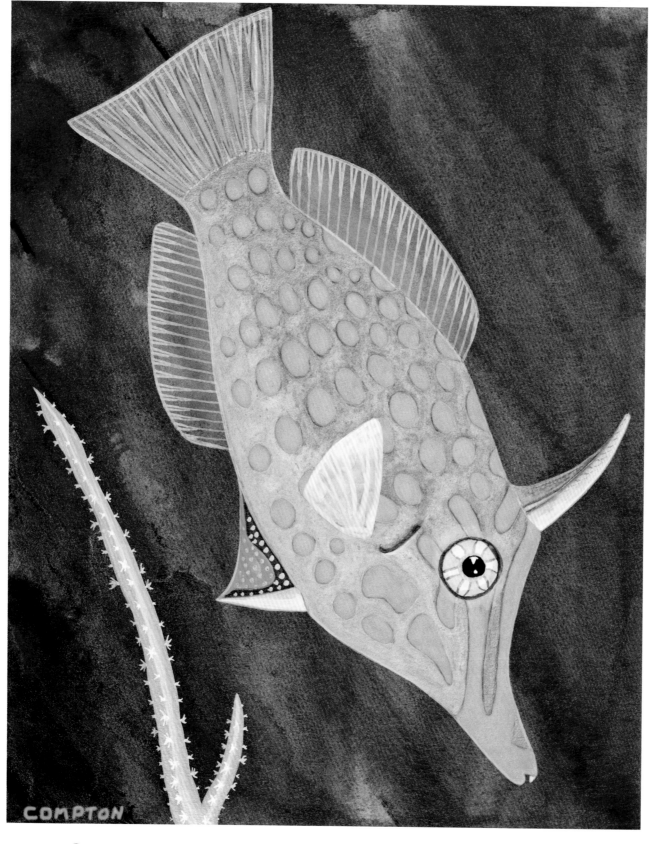

COMPTON

Harlequin filefish
Oxymonacanthus longirostris
(Bloch & Schneider 1801)
"He swam very slowly
with his tail up and his
nose down and he looked
and looked at us shyly
with his wonderful blue
and yellow pinwheel
eyes."

(5-D) NELL & SHARON'S FISH

"Those two Tusk-chasers knew we wouldn't shoot them. They made jesters at us oughta get 'em walloped, Grampah. Did we snitch."

"Granpa, they know there ain't no pellets in them shells. Little powder. Sting 'em some. Heh-Heh. Shock is what runs ole shark off. Shark very weakish to shock, he be."

"That is enough. I don't want to hear any more on underwater foolishness nor sharks. Shark is no jester. You ask No-legs Lonnigan. He'll tell you."

"Yes. BadBoys," says Nell. "We are 'bout to report us. We don' want you to talk."

"Report," says Grampah.

"Beside a black wall we found a lovely little Filefish just twice as long as our hand. He swam very slowly with his tail up and his nose down and he looked and looked at us shyly with his wonderful blue and yellow pinwheel eyes. We don't know if he saw us like we were spinning. Only Filefish and some Blennies have such wild eyes. Nobody knows whys. Nobody doesn't know a lot of things whys. The Filefish is so called because the big spine on his back has little teeth on it to feel rough. He would not let us feel him. They say somebody says his spine stays erected all the time. He does not snap it down and snap it up hardhold like his cousin the Triggerfish does. He would not let us try this.

"Where he was grew a lot of pretty soft coral like reeds and rushes grow. It let us feel of it since it couldn't move. When we touched on it, all the twinkly little star animals disappeared into it where they had built it for their homes. Then they popped right back out all wanting to eat we did not want them to be hungry we did not grab them so much.

"We thought our little Filefish was hungry and we mashed a sea-urchin for him and he ate the cloudy ooey mush coming out of the sea-urchin. He was so happy. We don't know how he can swallow up. We don't believe we could do that standing on our heads. We are not supposed to mash things of the Reef and we are sure sorry we squashed that dang urchin because an urchin is like a pin-cushion with all the pinpoints sticking out wrong side out and we got us stuck. Those urchin needles are brittle and two broke off in our finger and there they will stay, Dang us, until they rot away and more likely two finger with 'em.

"We drew this real fine picture of the Filefish and his coral on black slate with colored chalk. We did not draw urchin. He is only a bad kind of round starfish with a jillion pins and too many to draw. We promise not to mash up no more Reef."

"GRANPA—GRAMPAH!" immediately yelled 6 voices.

"Them two never wrote all that," yelled David and Johnny. "You wrote it your ownself."

"We can't not write so good," says Sharon and Nell.

"You can't not write at all."

"You never draw such a lovely picture either on slate," says Sandy and Nancy.

"We did so."

"That ain't no loverly picture that ain't even good as Babykid's drawin's," yells Danny and Kevin.

"Kevin. Bring me the dullest old rusty cobwebby fish-scaley knife you can find out of galley. I'm gonna skin both 'em this minute, Ed. Won't wait for morning to shine."

"Eels for belly-ache. Hurrah." 🐚

Species: *Pervagor spilosoma* (**Lay and Bennett, 1839**)

The fantail filefish can be found in tropical waters of the Eastern Pacific, most commonly among the Hawaiian Islands. These small fish inhabit areas of coral reefs, rock outcrops, and sometimes sandy bottoms. This species possesses a typical filefish body plan with a pointed snout and compressed, tapered body. The fish is yellow and white with black spots along the body and blue stripes along the mouth and side of the head. The caudal fin is bright orange with a black and yellow stripe along the trailing edge. During years of high population increase, this species is noted to die in large numbers and wash up along beaches. Like most other filefish, the fantail filefish feeds largely on algae and small invertebrates.

(24) If this fish were a four-legged canine he would answer to name of "Spot" and chase old time fire engines with small boys, all bare-foot as sea anemone back in the time when Hawaii had

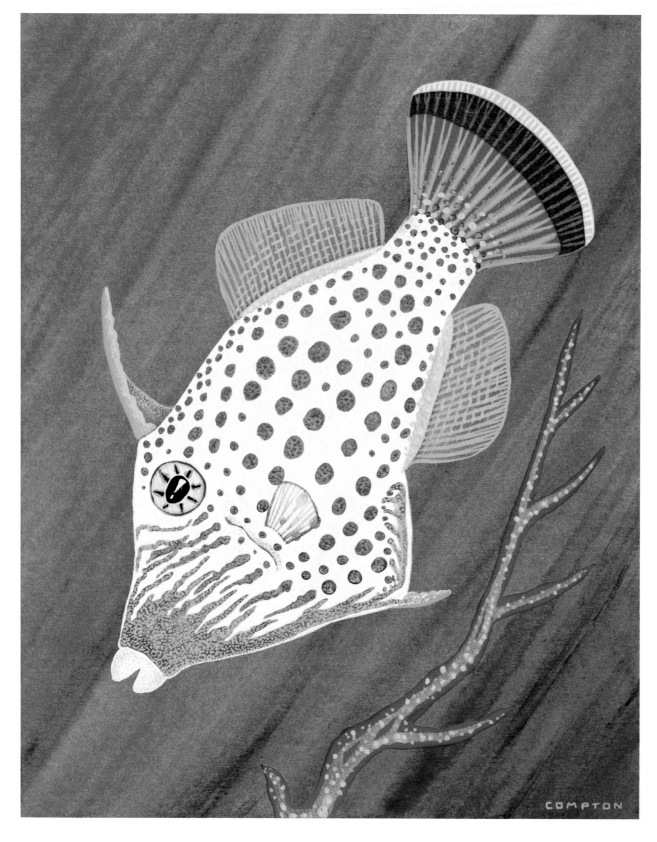

Fantail filefish

Pervagor spilosoma (Lay and Bennett, 1839)

"If this fish were a four-legged canine he would answer to name of 'Spot' and chase old time fire engines with small boys, all bare-foot as sea anemone back in the time when Hawaii had red Pumpers & Ladders. Has blue flames on nose and full fire on tail, but there silly analogy must cease because no dog yet has come up with spoke-wheel eyes."

red Pumpers & Ladders. Has blue flames on nose and full fire on tail, but there silly analogy must cease because no dog yet has come up with spoke-wheel eyes.

Biologist has 5 cherished adult 5-inchers who will eat nothing but Kevin's ripe socks and would starve without *Riff-Raft's* continual Air Freight care packages sent from all wet corners of world. Wife Jan says this is all Biologist's fault for making nutty dietary experiment in first place.

Johnny says fish must be nutty and this is cruelty to animals and punishable in any enlightened area which Biologist's tanks are guess not and he is tired of directing Kevin how to address freight since no human but Kevin will even lick the stamps for it.

Jan says would be simpler all round if they just adopt Kevin. Biologist says NO. Kevin says double NO. But if Jan gets shut of Biologist, She can adopt him and they will share la bonne vie. 🐚

Family: Ostraciidae (Boxfishes)

Boxfishes can be recognized instantly by their peculiar body shape. The family name arises from the Greek word *ostrakon*, meaning "shell." As the name implies, these fishes are enclosed by bony hexagonal plates formed by modified scales. This rigid shell covers a large proportion of the body, leaving only the mouth, fins, and eyes to move independently. Despite an immovable body, these fishes can move relatively fast with only the use of the fins. Like pufferfishes, boxfishes rely on poison to deter predators. When disturbed, boxfishes will secrete a toxin known as ostracitoxin, which is capable of poisoning other organisms and in some cases even other boxfishes. Some species with hornlike projections on the head are often referred to as cowfishes. Boxfishes are very territorial and are known to be haremic in mating preferences. Occurring worldwide in tropical to warm-temperate seas, these fishes are known to frequent shallow areas near coral reefs, rocky outcrops, and grass meadows. There are approximately 30 species worldwide in as many as 14 genera.

Species: *Ostracion meleagris* **(Shaw, 1796)**

The whitespotted boxfish is found in waters ranging from the eastern coast of Africa across the Indian and Pacific Oceans to the Hawaiian Islands and along coastlines of North and South America. These small boxfish inhabit clear waters of lagoons and reefs to a depth of approximately 30 m. Solitary in nature, adults and juveniles alike are commonly seen in shallow, calm waters and perhaps even by beachgoers near calm beaches. As the name implies, they have a rectangular body covered in bony plates that act like armor. The only openings within these plates are for the mouth, gills, eyes, nostrils, sensory canals, anus, and fins. The background color can range from brown to black and blue. Females are typically darker and always covered with an assortment of white spots. Males tend to be much more colorful and often exhibit a bright blue coloration along the sides and ventral surface; the dorsum is similar to the female's, with a dark base and white spots. It is interesting to note that males are found with gold spots from all regions of their range with the exception of males found among the Hawaiian Islands, which lack this gold coloration and are considered by some to be a separate subspecies. These fish feed on a variety of items, including sponges mollusks, algae, and polychaetes. When frightened, the whitespotted boxfish releases a mucus that is poisonous to most other organisms.

(26) The seven Porpoises who owned Lost Moon Lagoon had set up an intensive educational program for their adopted blind twins.

"We ain't Sick," yelled Rick. "We only blind. What you got against the Blind?"

"One of the blind," roared Papa Porpoise, sounding like steam whistle when disaster blew. "You!"

Rachel had sweetly already finished Her lessons. She and Smallest Octopus were seated in foot deep water. They sat firmly on piles of selected shells. They were playing the complicated shell game, Two UP, which consisted of stealing opponent's shells without being caught. Much giggling and squirting of water. Opponents were well-matched thieves. Smallest Porpoise was rules master, mainly to see that Smallest Octopus used only

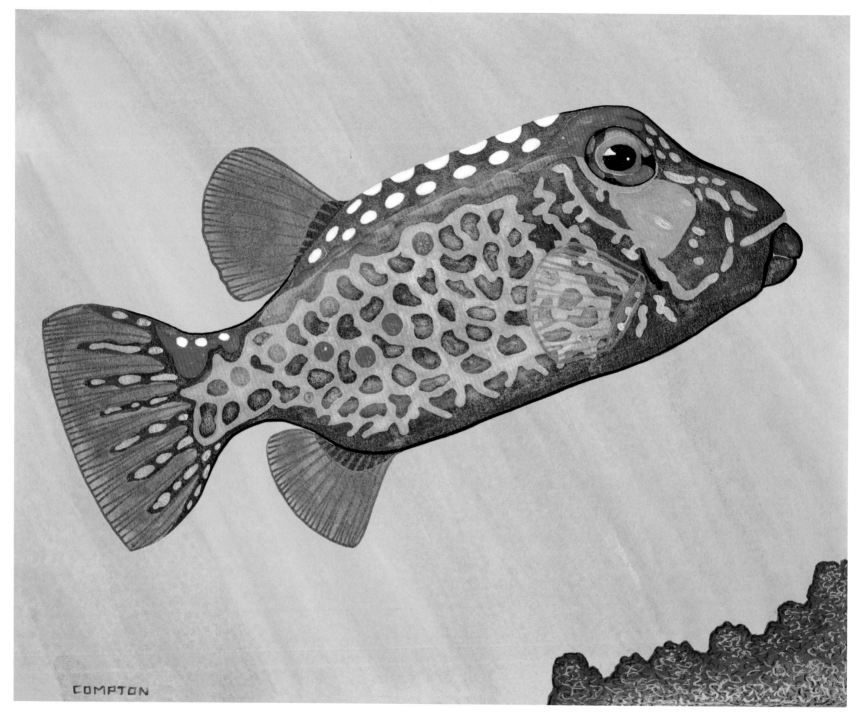

Whitespotted boxfish

Ostracion meleagris (Shaw, 1796)

"Now, we have a fish got some separate and distinct colors on him which is good illustration. Here they is."

two arms to raid and kept his eyelids smack Shut and that Rachel forbore hiding high value shells in her hair. Everybody cheated.

"All right," said Rick. "Let's get this over with." He smoothed out his letters on the sand and set another open book on stand facing deep channel where Papa Porpoise stood on tail and taught. The wrecked ship had a very large library high and dry above the coral and Rick had shored it further by touch from harm. A carpentry he was now beginning to regret. He dumped some more sea on his sand slate.

Rick and Rachel knew all their spelling, had 500,000 word vocabularies and were now throwing writing straight and sharp in wet sand without use of guiding stick. This day's exercise was really to teach the Fairy Terns, one Booby, and a lost Petrel hovering above how to read & write & math.

"Roll dough thin."

"Roll dough thin," Rick wrote. Papa Porpoise craned head and gave squeaky grunt.

"Line plate. Meanwhile in bowl mix 1 cup sugar, 1/4 cup flour, 1 tbs. cinnamon, 1/4 tsp. salt . . ."

"What the Hell is this?" yelled Rick, jumping up and putting hard toes on 1/4 tsp.

Papa Porpoise peered closer at page. "Makin' apple-pie, you blind Swab. What you think it was? Bully & Biscuit?"

"Knew it weren't ice cream. And barrel's empty, Papa. Fact. You wanted last apple an' said it need fish-guts on 'er." Rick felt delicately to right where Fairy Terns had been beak-writing exact to toe-prints on 1/4 tsp. "Now look what you done. Now them birds will all-ays believe 1/4 tsp. is written with foot on it."

"Four of 'em will believe it. That Booby ain't up to any of it and Petrel left at your first mark to go find hisself a storm. Avast. Dint you plant none of them seeds like Rachel told you?"

"Did. Ain't one of 'em one foot tall. You want us wait ten year for pie? I be too old for pie then. I'll be a-cravin' an' a-ravin' fer Bully Beer & Porpoise Steaks."

"Bah."

"Ne'er mind, Rick honey," squeaks Mama Porpoise in her loverly contralto. "Why don't we all play a quick round of 'Bung the Sailor'? That all-ays puts us in high fettle."

"Yes-Yes," Smallest Octopus suckered in braille on Rachel's arm. It was his favorite game.

Rick carried books to wreck. On way, he knelt by fire-pit with feeling hand and ear to check progress of big pot of soft-popping stew of shrimps, winkles, clams, sea-cucumber, bamboo shoots, sea-lettuce and what Rick hoped was wild onion he found on mountain.

Two Tree-rats jumped on his knee to ask if stew was ready. If he read their squeaks correctly. Only S. P. could interpret fully. Telling Tree-rats to keep their whiskers out of hot-stuff, Rick dumped school and raced Rats back to beach. Smallest Porpoise sent wave of echo squeaks and Rick threw light wavering Sailor to center of them. Sailor was large sponge bailed to ball with palm fiber. Small hole at south pole allowed Smallest Octopus to pull his legs inside and so make ballast.

"Bung the Sailor" was merely team keepaway catch. Rick & Rachel had center positions on short quay with 2 teen-ager Porpoise guarding each side and S. P. standing tail off end. Mama, Papa and the 2 giant Octopus formed outer U. Object—guards & S. P. to try keep Sailor from Rick, Rachel & the U.

Much shouting. Many squeaks. Octopus changing color in waves which was how they shouted. Mama & Papa threw net of echoes above Rick & Rachel so that at all times they knew where Sailor shock-waved the air. Guard Team, leading off, kept Sailor just out of their reach. Like grapes for Tantalus. Nose-toss Left Guard Forward to Right Guard Rear to S. P. to Rt. Gd. F. to Lt. Gd. R. Rick & Rachel knew just where Sailor flew but couldn't reach him.

Then finally P. O. did his specialty of tentacle-slamming Sailor low between Lt. Gds. Swat! to Rick's toes. Rick kicked Sailor straight up, caught him, dropped him and kicked him Swat! to A. O. between Rt. Gds. But, Woe, here Rt. Gd. R. caught Sailor on fast flipper slamming him into quaywall to bounce back to nose and into play for Guardside.

U Team considered this a foul. Papa had learned man-jabber from a shipwrecked sailorman whose cussing was almost as proficient as a Parrot's. Papa considered this a great foul in no uncertain vocabulary. The Fairy Terns, being referees, ruled fair. Papa described what kind of referees were Fairy Terns. Chief

Fairy Ref. merely shrugged wings and deposited birdlime on Papa's nose.

When the ensuing uproar had abated and Mama cleaned nose, game resumed and Mama often got to do her specialty. She balanced Sailor on head, backed, water in maelstrom, as if she were curtsying; lowered head to roll Sailor to nose and with SWOOP! hurled him high above F. Ts. to fall straight as plumb to Rick.

All Guard Team sent up frantic squeaks to jam echo.net but never to avail. Rick could see Sailor perfectly on the inner sonar screeners of his mind and he never missed but usually pretended to do, so he could stagger around bumbling Sailor or even fall on his back to juggle Sailor with his toes before tossing him with great shout always back to Mama. All of U Team enjoyed these antics.

All but Rick and Smallest Porpoise were tiring somewhat when Smallest Octopus ended game. It was part of S. O.'s role and joy to squirt ink out his hole in Sailor on any player so unlucky as to catch with hole aimed. Rick, teenage Porpoise and S. P. were all soon black as Lead Guitar of "Muddy Rainbow." Mama & Rachel were ruled exempt. Papa & Giant Octopus were not tampered with for fear of reprisal.

Day's main lesson began.

COLOR.

"Ma said sky and sea was blue," says Rachel. "Sometimes."

"Pa said sun was yellow and fire was yellow," says Rick. "Sometimes. And sometimes they was red but both was allus plenty hot if you got next 'em."

"So," Rick summed up, "Blue is wet an' airy and red/yellow is hot, PaPa. So what else you is gonna cram into us?"

"That you is wrong for start."

"You callin' Pa & Ma liars? Now they is buried on hill with the sailors and can't refutes?" Rick aimed the father of frowns on his handsome belligerent blind face to where he placed Papa.

"No, you blanky torment. They jus' dint go far enough. Figgered they had more time. What's 'refutes'?"

"Don' know."

"Then don't use it.

Papa Porpoise shook himself thoroughly and rained on school. "Color," he squeaked pedantly, "ain't always alone. Leaves is green an' rat turds is brown but leaf fall on beach and rat do on it, where are you?"

Here Tree-rats squeaked excitedly. They had never noticed this effect before.

"Stow it. Now, we have a fish got some separate and distinct colors on him which is good illustration. Here they is." Papa looked down encouragingly to where 17 and a half Boxfish bravely fought to hold position downstream in the millrace of Papa's tail. Papa looked closer. "S. P., ask these damn trapezoids what the hell they mean bein' only 4 of 'em what I want an' the rest can go home."

Underwater conference.

"They say only Papa-1 an' three sons is rally colored. Wives & teeners & thet baby is only spots."

"Nose-toss me that big boxcar male, if that's what he claims he is. One with most red & white on 'im."

Underwater conference.

"He say only livin' bean gonna touch any of 'em is Rachel. You don't like it, PaPa, you can take flyin' porpoise jump thru you . . . I ain't gonna say it."

"You wise. Damn & Blast & Bilgewater . . ."

But came interruption. "CLACK! Click, clack-click!" Here came Bad Daddy Crab 8-legging it down beach, two claws throwing sparks.

"It's Bad Daddy!" yelled Rick. "He's a-runnin' straight as a liner. He ain't blind no more."

Rick threw himself prone on beach and crossed his muscled brown forearms for deck. Bad Daddy climbed aboard. Bad Daddy plucked a couple of sun-gold hairs. "Ouch," says Rick. "Cl-cl-cl-cl-cl-click," laughed Bad Daddy.

The two regarded one another, stalkeye to blindeye, with great great affection. Rick, with delicate callused fingers, cleaned the silica sand, the flint dust and the iron flakes from the knife-edge of Bad Daddy's great claws so he wouldn't spark so and get himself hot.

"Clack. Click, click, clack clack clack click clack. Clack? Click click clack Clack-Clack. Clack! Clickedy-clickedy-clickedyclickedy. Clack, cla'k click? Click, cl'ck, click. Clack. Clcl-clack. Cl-cl-cl-cl-Clack!"

Rick jumped to feet, setting down triumphant Bad Daddy to face audience. "B. D. says he couldn't shed an' couldn't shed and 'course his old shiny hard calcium hide was over his eyeballs as well as rest of him which was why me n' him been fatten him up so he bust loose but he don't bust loose and we at doldrums 'til I remembered them prunes in wreck's galley. We figgered if one's good, three's better. B. D. downhatched. Three was PREscription. Man, but he shed fine. An now kin see well as anyone."

"Click, Click, CLACK!" says Bad Daddy.

"And, after dried an' hardened, felt so bully he went to climb 17 cokernuts for us. AND clipped all weeds on Ma & Pa & Sailors."

Audience did not believe this. No one but Rick believed Bad Daddy. But Fairy Terns said it was so.

"Yeah?" squeaks Papa. "Them Refs.? Now kick that blink-blanking blink-blanker outa classroom. We got lessons."

"Before you start," squeaks S. P., "them fish want you to know they is Trunkfish not Boxfish like what you thought. Says if you don't know the difference you kin . . ."

"That'll do for you too, Varmint."

After that, lesson went swimmingly.

Rachel drew her fine feel of Male-1 Trunkfish incise in wet sand. With Papa's instructions, she placed round shells where white was. Surf-round coral marbles and ribboned sponge where red was. Netted palm fiber where blue was. Rick felt bas relief. "It's good, PaPa."

"Clack CLACK!" says Bad Daddy.

Rick and Bad Daddy molded Rachel's Trunkfish in blue clay from pool by volcanic mountain waterfall. Had to pat & carve & mash & fiddle and jam in swimfins to Rachel's touch.

"Clack CLACK! Papa," yells Rick. "We're sculptures."

17 1/2 Trunkfish had to be shown this product, quickly dipped before it melters says Rachel. B. D. and Rick and the Rats ran it fast to firepit to smelters it says Rick.

S. P. says Trunkfish wants copies.

"Tell 'em we need more hands than we got for that mob to . . ."

"She Blows!" crack-squeaked biggest Teen-Porpoise. "Where?" yelled Rick.

"Comin' to reef. North Pass."

"A whale?" says Rachel.

"That kid," squeaks Papa, "is wantin' flipper on 'is scutes ever since we read that book . . . OOF!"

In flying leap from quay, with telescope from wreck in left hand and swim-run sturdy legs clamping, Rick was astride Papa.

Rick held scope for Papa. "Hope it's cow. If we can get snow we'll have ice cream. All round. B. D.'s never ate ice cream."

"Might's well wish for monkey. All else we need is two of you."

Long tail-surging head-steady scope-steady silence. "Well?" shouts Rick.

"It's monkey. Red hat on 'im. Playin' some kinds music-box. I seen it in a drown magazine off Darwin. He's a-ridin' a keg. Prolly apples."

"A mon-Kee?" shouts everybody in their various tongues. All in high happiness.

"Two Monkeys," says Papa, not even squeaking.

The other monk, full furred with usable tail, was female Capuchin, most vivacious and lovable of primates, trained in the Academie de Singes Royale just off Rue de Chat Noire in Paris (France). Graduate of the Royal Academy of the Queen's Monkeys square on Piccadilly Circus in London (England).

Stellar Comedienne of Galaxy International Shows and, until 4 days past, a happy voyageur on ocean liner bound Australia for star appearances. When disaster struck. Fire-Eater finally gone down-right crazy from sniffing petrol, and trying to light a Roman candle with his breath, blew up the stage fireworks in Hold 3. Capuchin and her co-star were only survivors.

Papa was wrong. The monkey was not riding an apple barrel. She sat on low prow of a very curious Vessel. A great barge of so low freeboard it was not seeable at any distance. Most of barge, like iceberg, was below sea. Basement hold was a marvel of plat-forms and hydraulic lifts.

Seeing the approaching arcing escort with comely youth like sea-sprite riding center, monkey rummaged in her box of acces-sories de toilette, kohled her eyes, combed her platinum singe fringe, and pulled hidden lever at her feet.

At island, Bad Daddy and Tree-rats had climbed palm. One Giant Octopus held S. P. aloft to see. Other held up S. O. and,

below, explained to bewildered Trunkfish the sequence of events. S. O. explained loudly with suckers that he was upside down. Rachel, riding Mama, held telescope. Mama was newscaster.

"It's Monk, all right. Ain't no claret tub that beast is on. Why, it's a bally boat o' some sort."

"The boys is there. Rick is leaped up with monk. He's throwin' hawsers."

"My Land! That thing is a-openin' up like Jack-o-the-Box." Mama went to soprano.

"Yawks! Papa! It's a ELEPHANT!"

As barge rounded into Lagoon under enthusiastic tow of Teen-Porpoises, all at shore but Rachel & Trunkfish got a full eyefull. The barge had erupted to mirrored sides, scarlet plush, silver stars, three fake palms, four fake parrots, a stuffed snake and a live Elephant.

Elephant was Indian male of 12-foot tall and 6-ton heavy. As highly educated as Miss Cap but no less attractive. With paint where-ever there was space. Plenty space. With 18-carat gold-capped tusks, jeweled ears and diamond toenails. Answering to name of Bubba. On pearl-draped head of all this splendor sat cross-legged cross-armed Rick, solemn as Sultan and wearing on his shoulders a concertina-playing Capuchin singe. Monkey, seeing the only remaining performers of Galaxy Troupe had again out-done Cleopatra, flashed a coquette smile that out-did Elephant and broke into "Over The Waves."

Papa Porpoise shut both eyes firmly and closed the small holes of his ears. ✾

Appendix

DIGITIZING THE ARTWORK

LARRY J. HYDE

The 93 pieces of artwork reproduced in this book were digitized from two media formats. The first was the original artwork itself. In cases where the original works were not available, an alternative proxy was found in a collection of 35 mm transparencies photographed by Compton himself.

Only 71 of Compton's original 93 *Fishes of the Rainbow* paintings are preserved within a known collection. However, all of the paintings were photographed by the artist using both print and slide film. His primary motive in documenting his work in this way may have simply been for organizational or filing purposes. Prints, for example, were found attached to individual files containing specific information about the subject of each photograph. Compton's purpose in using slide film is less evident. But it is hard to imagine that his intentions were motivated by anything more than a compulsion to redundant documentation based on the casual manner in which images were captured. Little regard, for example, was given to angular perspective or lighting. Even so, these slides allowed for the preservation of an amazing body of work that would have been impossible for the artist to foresee.

Compton's original artwork was rephotographed for this project using a Nikon D3 D-SLR coupled with a Nikon 28–70mm f/2.8 AF-S lens. The camera was mounted on a tripod with a fully adjustable head. Oriented for horizontal/landscape framing, the camera was tilted down, allowing the lens barrel to be perpendicular to the floor and the camera sensor to parallel both the floor and the painting resting on it. A spirit level placed alternately on the camera's rear LCD panel and floor allowed precise parallel alignment between canvas and camera sensor. Proper parallel alignment in this way required a means to flatten the canvas, which in most cases was warped to some degree. This was corrected by taping the back corners of each canvas to the rubberized side of a large and heavy piece of sectional carpet.

A focal length of 70 mm was used for all exposures. This moderate telephoto setting allowed a comfortable working distance between canvas and camera while preserving an accurate image perspective. Distortion in perspective for 35 mm cameras becomes increasingly problematic at focal lengths less than about 43 mm. The problem is typically seen as a spatial distortion (e.g., convergence of vertical lines and/or divergence of horizontal lines).

The digital resolution of any given subject can be improved by increasing its size or the number of pixels it represents in an image. This principle was used to maximize resolution by adjusting the composition of the canvas in the camera's viewfinder so that horizontal margins (i.e., long sides) of the canvas were aligned with the respective margins of the viewfinder. Precise alignment and maximum use of sensor pixels in this way is possible only with a camera viewfinder that allows 100 percent frame coverage.

A simple yet effective lighting technique was used for this work. Experiments with multiple strobes and configurations in a nonreflective darkroom proved less successful than comparable images exposed with natural light. As a result, available light in the shade of a building under midday overcast skies was used exclusively.

Camera shutter speed was determined by incident light measurements from a Sekonic L-608 light meter. Aperture remained fixed at f5.6. Depth-of-field considerations were negated by a flat subject. This allowed the luxury of a midrange aperture setting where lens performance is generally optimized. ISO, or light sensitivity, of the camera remained fixed at 200, the lowest available setting on a Nikon D3. There is an inverse relationship between ISO and image quality. In general, this is expressed by the amount

of noise introduced into the digital file. So, as ISO decreases, image quality increases. ISO setting requirements are determined by the amount of available light. The abundant available light used during this project allowed a consistently low ISO. This assisted the creation of highly accurate files. With fixed aperture and ISO settings, shutter speeds ranged in value from $^1/_{100}$ to $^1/_{150}$ second. Minor variations in ambient light levels ($^1/_3$ stop) produced by shifting cloud cover required frequent light measurements and shutter speed adjustments.

Color accuracy was assisted by use of a WhiBal gray card. The card was inserted in a vacant area of each composition and photographed along with the canvas. In this way, individualized postcapture color calibration was achieved through Adobe Photoshop CS4 and its white balance tool.

Digital photographs of Compton's original artwork were captured as "raw" files in Nikon's proprietary NEF format. These 16-bit files are uncompressed and retain 100 percent of the original image data. Although substantially larger than compressed files, the raw alternative provides a substantial benefit in postcapture editing. This advantage is directly related to image size, or number of pixels, which accommodates significant latitude in exposure and color adjustments without compromising image quality.

Compton archived copies of his *Fishes of the Rainbow* series of paintings using 35 mm Kodak Elite Chrome EB-100 film. These transparencies were converted to digital files using a Nikon Super Coolscan 5000 ED 35 mm/APS (IX240) film scanner. Accurate color reproduction at every step of a digital workflow is challenging. Optimal results require calibration with a reliable "target" specifically designed as a standard for the type of film being scanned. A generic Kodak Q60E3 IT8 target was used for this project. In general, generic targets, like this Kodak model, are not highly regarded for their accuracy compared to more reliable, but expensive custom options. So it was not surprising that some scans revealed variable shifts in hue from that of the original transparency. These deviations were most conspicuous in the green to blue tonal range. Scans appearing on a 23-inch calibrated Cinema HD Apple display were compared to the original slides using a Pana-Vue 1 Slide Viewer. This anachronistic hand-held device is designed for casual viewing of individual slides using an incandescent bulb projected through a translucent plastic background. Manual correction of color deviations from the original slides was accomplished in Photoshop CS4. These adjustments were highly effective in rendering the colors depicted in the original slides. However, it is important to note that the true accuracy of these edits was necessarily limited by the unknown fidelity of color reproduction in the original transparencies.

SilverFast Ai Suite, a software product from LaserSoft Imaging, Inc., was used to convert analog information from original transparencies to digital files. SilverFast HDRi (High Dynamic Range infrared) produced high-resolution 64-bit RAW images with embedded infrared information used to map the location of dust and scratches on scanned transparencies. The infrared data was used by SilverFast iSRD (Infrared Scratch Dust Removal) to remove obvious, as well as minute, multipixel defects from the digital images with great precision. Comparisons between original analog transparencies and rendered digital files revealed an obvious improvement in terms of introduced noise. However, SilverFast technology is unable to recognize and thus correct aberrations in the actual canvas (e.g., mold, abrasions, and scratches). Alterations/damage to the original artwork visibly translated by the digital photograph or scan required manual correction with a variety of Photoshop tools.

Computer hardware and software for postprocessing of digital images included a MacPro 3.1 and Snow Leopard operating system. Images were visualized on dual 23-inch Apple Cinema HD displays with pixel depth of 32-bit color (ARG8888) and resolution set to 1920 × 1200. The displays were calibrated with a Datacolor Spyder3Pro. Digital edits were performed with a variety of adjustment tools provided by Adobe Photoshop CS4. Images were edited as 16-bit files in a ProPhoto RGB color space. Four edit types were performed. First, deviations in color from the source material were corrected in terms of both hue and intensity. In spite of efforts to achieve perfect color translation from analog to digital file (e.g., WhiBal gray card for original paintings and IT8 scanner calibration for 35 mm slides), residual discrepancies were still found. These were treated with a variety of global and local corrections. Additional adjustments were made to improve contrast, color saturation, and

exposure range. Second, cropping was required to accommodate discrepancies between the aspect ratios of paintings, 35 mm slides, and digital camera sensor dimensions. Cropping provided a secondary benefit of correcting the perspective distortion described for the 35 mm images. Third, restoration of minor alterations in the original artwork was required. Some 20 to 29 years may have passed between the time the paintings were made and the time they were photographed for this project. Storage conditions during this time were probably less than desirable as indicated by the presence of mold on some paintings. Other paintings were marred by minor scratches and abrasions. These defects were corrected almost exclusively with Photoshop's Clone Stamp Tool. Finally, to compensate for loss of contrast produced by the pixelization of analog information, a Photoshop plugin, PhotoKit Sharpener, was used to apply capture and output sharpening to all images.

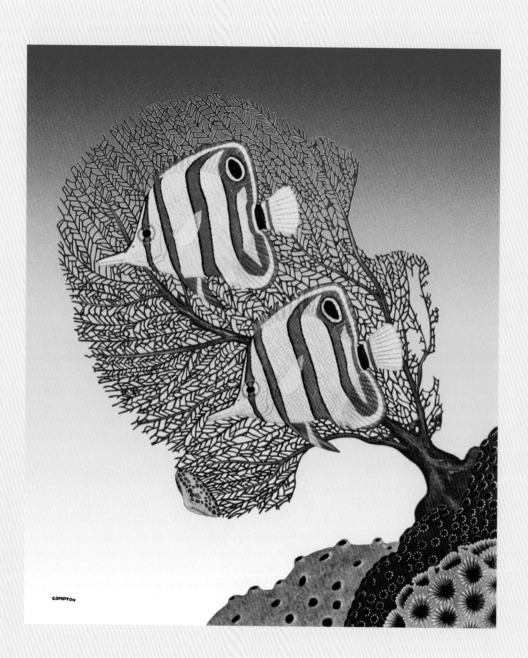

COMPTON

References

Allen, Gerald R. 1972. *Anemonefishes*. Neptune City, NJ: T. F. H. Publications.

———. 1985a. *Butterfly and Angelfishes of the World*. Vol. 2, *Atlantic Ocean, Caribbean Sea, Red Sea, Indo-Pacific*. Melle, Germany: Mergus Publishers.

———. 1985b. *FAO Species Catalogue*. Vol. 6, *Snappers of the World: An Annotated and Illustrated Catalogue of Lutjanid Species Known to Date*. FAO Fisheries Synopsis No. 125, Vol. 6. Perth, Australia: G. R. Allen.

———. 1991. *Damselfishes of the World*. Melle, Germany: Mergus Publishers.

Asoh, K., and T. Yoshikawa. 1996. "Nesting Behavior, Male Parental Care, and Embryonic Development in the Fairy Basslet, *Gramma loreto*." *Copeia* 1996 (1): 1–8.

Axelrod, Herbert R., and Warren E. Burgess. 1987. *Saltwater Aquarium Fishes*. Neptune City, NJ: T. F. H. Publications.

Bianchini, F., G. Mazza, and M. Oliver. 1977. *Simon and Schuster's Complete Guide to Freshwater and Marine Aquarium Fishes*. New York: Simon and Schuster.

Burgess, W. E. 1978. *Butterflyfishes of the World: A Monograph of the Family Chaetodontidae*. Neptune City, NJ: T. F. H. Publications.

Carroll, R. 1988. *Vertebrate Paleontology and Evolution*. New York: W. H. Freeman.

Eschmeyer, W. N., E. S. Herald, and H. Hammann. 1983. *A Field Guide to Pacific Coast Fishes of North America*. Boston: Houghton Mifflin.

Gilbert, Carter R., and James D. Williams. 2002. *National Audubon Society Field Guide to Fishes of North America*. New York: Alfred A. Knopf.

Gomon, M. F. 2006. "A Revision of the Labrid Fish Genus Bodianus with Descriptions of Eight New Species." *Records of the Australian Museum*, Supplement 30:1–133.

Heemstra, P. C. 1984. "Monodactylidae." In *FAO Species Identification Sheets for Fishery Purposes: Western Indian Ocean (Fishing Area 51)*, ed. W. Fischer and G. Bianchi, vol. 3, *Bony Fishes Families: Lutjanidae to Scaridae*. Rome: FAO.

———. 1986. "Chaetodontidae." In *Smiths' Sea Fishes*, ed. M. M. Smith and P. C. Heemstra, 627–31. Berlin: Springer-Verlag.

Heemstra, P. C., and J. E. Randall. 1993. *FAO Species Catalogue*. Vol. 16, *Groupers of the World (Family Serranidae, Subfamily Epinephelinae): An Annotated and Illustrated Catalogue of the Grouper, Rockcod, Hind, Coral Grouper and Lyretail Species Known to Date*. Rome: FAO.

Helfman, G., B. Collette, and D. Facey. 1997. *The Diversity of Fishes*. Malden, MA: Blackwell Science.

Hoese, D. F., and H. K. Larson. 1994. "Revision of the Indo-Pacific Gobiid Fish Genus *Valenciennea*, with Descriptions of Seven New Species." *Indo-Pacific Fishes* 23:1–71.

Hoese, H. Dickson, and Richard H. Moore. 1998. *Fishes of the Gulf of Mexico*. College Station: Texas A&M University Press.

Hoover, John P. 1993. *Hawaii's Fishes: A Guide for Snorkelers, Divers and Aquarists*. Honolulu: Mutual Publishing.

Humann, Paul, and Ned Deloach. 2008. *Reef Fish Identification: Florida, Caribbean and Bahamas*. Jacksonville, FL: New World Publications.

Hutchins, J. B. 1986. "Review of the Monacanthid Fish Genus *Pervagor*, with Descriptions of Two New Species." *Indo-Pacific Fishes* 12:1–35.

Lieske, Ewald, and Robert Meyers. 2002. *Coral Reef Fishes*. Princeton, NJ: Princeton University Press.

Lourie, S. A., A. C. J. Vincent, and H. J. Hall. 1999. *Seahorses: An Identification Guide to the World's Species and Their Conservation*. London: Project Seahorse.

Masuda, H., K. Amaoka, C. Araga, T. Uyeno, and T. Yoshi. 1984. *The Fishes of the Japanese Archipelago*. Vol. 1. Tokyo: Tokai University Press.

Matsuura, K. 2001. "Balistidae: Triggerfishes." In *FAO Species Identification Guide for Fishery Purposes: The Living Marine Resources of the Western Central Pacific*, vol. 6, *Bony Fishes: Part 4 (Labridae to Latimeriidae), Estuarine Crocodiles*, 3911–28. Rome: FAO.

McEachran, John D., and Janic D. Fechhelm. 1998. *Fishes of the Gulf of Mexico*. Vol. 1, *Myxiniformes to Gasterosteiformes*. Austin: University of Texas Press.

———. 2005. *Fishes of the Gulf of Mexico*. Vol. 2, *Scorpaeniformes to Tetraodontiformes*. Austin: University of Texas Press.

McIntyre, Alasdair D., ed. 2010. *Life in the World's Oceans: Diversity, Distribution, and Abundance*. Oxford: Wiley-Blackwell.

Michael, Scott W. 2001. *Marine Fishes*. Neptune City, NJ: T. F. H. Publications.

Myers, R. F. 1991. *Micronesian Reef Fishes*. 2nd ed. Barrigada, Guam: Coral Graphics.

Nelson, J. S. 1984. *Fishes of the World.* 2nd ed. Hoboken, NJ: John Wiley and Sons.

———. 2006. *Fishes of the World.* 6th ed. Hoboken, NJ: John Wiley and Sons.

Palko, B. J., G. L. Beardsley, and W. J. Richards. 1982. *Synopsis of the Biological Data on Dolphin-Fishes, Coryphaena hippurus Linnaeus and Coryphaena equiselis Linnaeus. NOAA Tech. Rep. NMFS Circular 443. FAO Fisheries Synopsis No. 130.* Washington, DC: US Department of Commerce, National Marine Fisheries Service.

Palmer, G. 1986. "Lamprididae." In *Fishes of the North-Eastern Atlantic and Mediterranean,* ed. P. J. P. Whitehead, M. L. Bauchot, J. C. Hureau, J. Nielsen, and E. Tortonese, 2:725–26. Paris: UNESCO.

Polunin, Nicholas V. C., and Callum M. Roberts. 1996. *Reef Fishes.* London: Chapman-Hall.

Pyle, R. 2001. "Pomacanthidae: Angelfishes." In *FAO Species Identification Guide for Fishery Purposes: The Living Marine Resources of the Western Central Pacific, vol. 5, Bony Fishes: Part 3 (Menidae to Pomacentridae),* ed. K. E. Carpenter and V. H. Niem, 3266–86. Rome: FAO.

Quignard, J.-P., and A. Pras. 1986. "Labridae." In *Fishes of the North-eastern Atlantic and the Mediterranean,* ed. P. J. P. Whitehead, M.-L. Bauchot, J.-C. Hureau, J. Nielsen, and E. Tortonese, 2:919–42. Paris: UNESCO.

Randall, J. E. 1956. "A Revision of the Surgeonfish Genus *Acanthurus.*" *Pacific Science* 10 (2): 159–235.

———. 1968. *Caribbean Reef Fishes.* Hong Kong: T. F. H Publications.

———. 1986. "Grammistidae." In *Smiths' Sea Fishes,* ed. M. M. Smith and P. C. Heemstra, 537–38. Berlin: Springer-Verlag.

———. 1998. "Revision of the Indo-Pacific Squirrelfishes (Beryciformes: Holocentridae: Holocentrinae) of the Genus *Sargocentron,* with Descriptions of Four New Species." *Indo-Pacific Fishes* 27:1–105.

———. 1999. "Revision of the Indo-Pacific Labrid Fishes of the Genus *Coris,* with Descriptions of Five New Species." *Indo-Pacific Fishes* 29:1–74.

Randall, J. E., G. R. Allen, and R. C. Steene. 1990. *Fishes of the Great Barrier Reef and Coral Sea.* Honolulu: University of Hawaii Press.

Robins, C. R., R. M. Bailey, C. E. Bond, J. R. Brooker, E. A. Lachner, R. N. Lea, and W. B. Scott. 1991. "World Fishes Important to North Americans: Exclusive of Species from the Continental Waters of the United States and Canada." *American Fisheries Society Special Publications* 21:1–243.

Robins, C. R., and G. C. Ray. 1986. *A Field Guide to Atlantic Coast Fishes of North America.* Boston: Houghton Mifflin.

Sale, Peter F., ed. 1991. *The Ecology of Fishes on Coral Reefs.* San Diego, CA: Academic Press.

———, ed. 2002. *Coral Reef Fishes: Dynamics and Diversity in a Complex Ecosystem.* San Diego, CA: Academic Press.

Sheppard, Charles R. C., Simon K. Daby, and Graham M. Pilling. 2009. *The Biology of Coral Reefs.* New York: Oxford University Press.

Smith, C. Lavett. 1997. *National Audubon Society Field Guide to Tropical Marine Fishes of the Caribbean, the Gulf of Mexico, Florida, the Bahamas and Bermuda.* New York: Alfred A. Knopf.

Steene, R. C. 1978. *Butterfly and Angelfishes of the World. Vol. 1, Australia.* New York: Wiley.

Tunnell, John W., Jr., Ernesto A. Chavez, and Kim Withers, eds. 2007. *Coral Reefs of the Southern Gulf of Mexico.* College Station: Texas A&M University Press.

Wagner, Nicholas C., Owyn E. Snodgrass, Heidi Dewar, and Johyn R. Hyde. 2015. "Whole-Body Endothermy in a Mesopelagic Fish, the Opah, *Lampris guttatus.*" *Science* 348 (6236): 786–89.

Index

Note: Page numbers in *italics* denote illustrations.

Other Books in the Gulf Coast Books Series

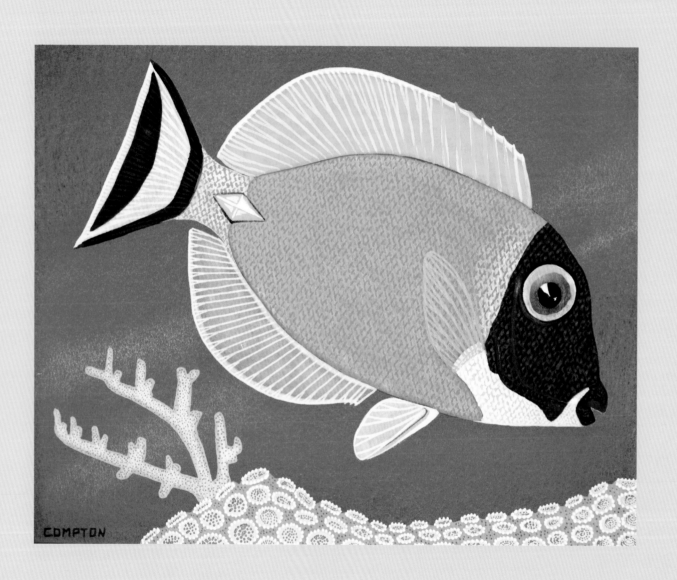